7198

P9-DTB-707

Ivan Albright

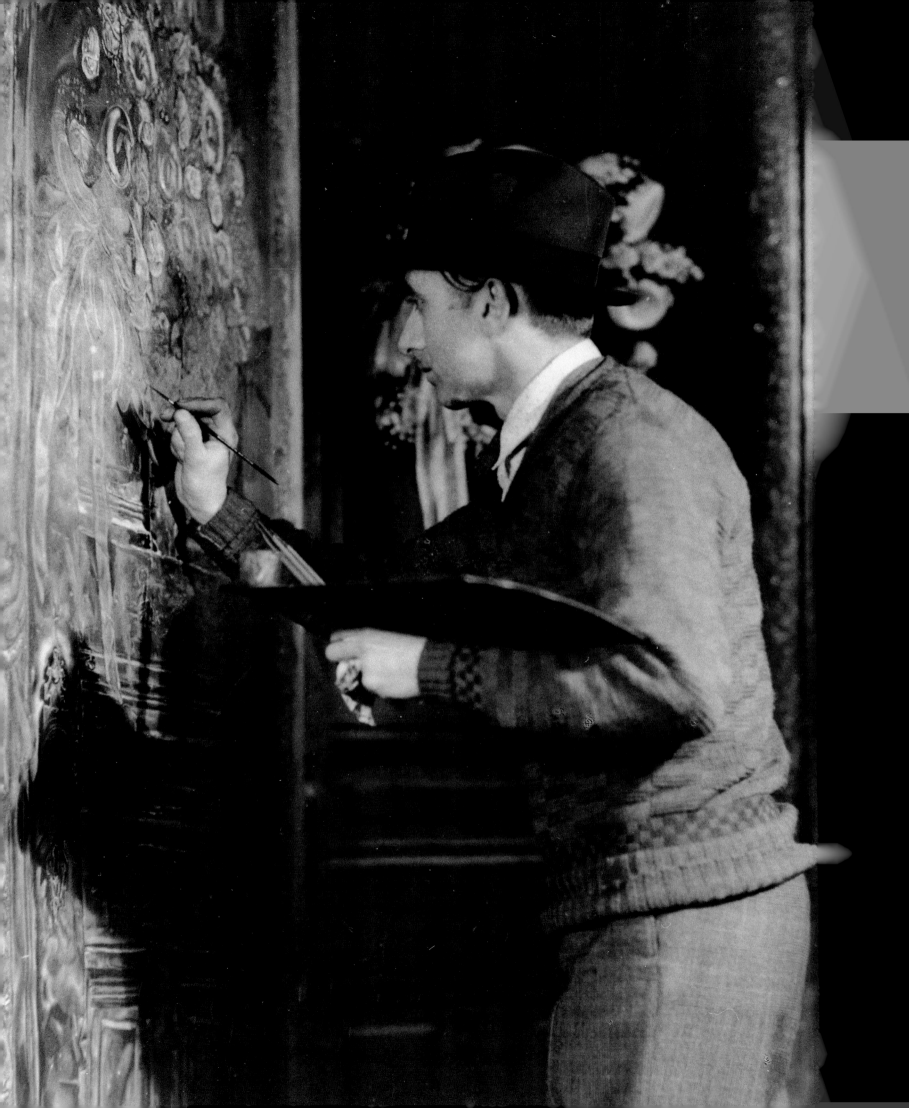

Ivan Albright

ORGANIZED BY COURTNEY GRAHAM DONNELL

WITH CONTRIBUTIONS BY COURTNEY GRAHAM DONNELL,
SUSAN S. WEININGER, AND ROBERT COZZOLINO

EDITED BY SUSAN F. ROSSEN

THE ART INSTITUTE OF CHICAGO

DISTRIBUTED BY
HUDSON HILLS PRESS, NEW YORK

This book was published in conjunction with the exhibition "Ivan Albright," organized by The Art Institute of Chicago and shown at the Art Institute (February 20–May 11, 1997) and at The Metropolitan Museum of Art, New York (June 10–September 7, 1997), under the title "Ivan Albright: Magic Realist."

The Chicago presentation of the exhibition "Ivan Albright" is supported by the Mr. and Mrs.Wesley M. Dixon, Jr., Endowment Fund and the Members' Exhibition Endowment.

Front cover: Ivan Albright (American, 1897–1983). *Self-Portrait*, 1935 (no. 29).
Frontispiece: Ivan Albright putting the finishing touches on *That Which I Should Have Done I Did Not Do (The Door)* (no. 24), c. 1940. Photograph by Helen Balfour Morrison, The Art Institute of Chicago, gift of Helen Balfour Morrison (1978.1139).

Edited by Susan F. Rossen and Sarah E. Guernsey
Production by Daniel Frank and Sarah E. Guernsey
Designed and typeset by Steven Schoenfelder Design, New York
Color separations by Professional Graphics, Rockford, Illinois
Printed waterless by Litho Inc., St. Paul, Minnesota
Bound by Midwest Editions, Inc., Minneapolis, Minnesota
All photographs of works in The Art Institute of Chicago are by the Department of Imaging and Technical Services, Alan B. Newman, Executive Director.

Photography credits for Plates: no. 1: Stephen Longmire; no. 3: Larry Sanders; nos. 4, 8, 18, 19, 27, 33, 44, 49, 53, 55, 66a, 66b, and 93: Michael Tropea; no. 32: Gregory Schmitz, NYC; no. 46: Craig Smith; no. 58: Tim Thayer; nos. 69 and 70a: Nicholas Whitman; no. 70b: Kennedy Galleries, Inc.; no. 71: © Serge Domingie, Marco Rabatti, Florence.

© The Art Institute of Chicago. All rights reserved. No part of this publication may be reproduced in any manner whatsoever without permission in writing by The Art Institute of Chicago.
Distributed by Hudson Hills Press, Inc., Suite 1308, 230 Fifth Avenue, New York, NY 10001–7704
Editor and Publisher: Paul Anbinder
Distribution in the United States, its territories and possessions, Canada, Mexico, and Central and South America through National Book Network. Distribution in the United Kingdom, Eire, and Europe through Art Books International, Ltd. Exclusive representation in Asia, Australia, and New Zealand through EM International.
First Edition

Library of Congress cataloging-in-publication data
Donnell, Courtney Graham.
Ivan Albright / organized by Courtney Graham Donnell; with contributions by Courtney Graham Donnell, Susan S. Weininger, and Robert Cozzolino; edited by Susan F. Rossen.—1st ed.
p. cm.
Catalogue of an exhibition held at the Art Institute of Chicago, Feb. 20–May 11, 1997 and at the Metropolitan Museum of Art, New York, June 10–Sept. 7, 1997.
Includes bibliographical references.
ISBN 1-55595-136-8 (hc) — ISBN 0-86559-142-3(sc)
1. Albright, Ivan, 1897– —Exhibitions. I. Weininger, Susan. II. Cozzolino, Robert, 1970– . III. Rossen, Susan F. IV. Art Institute of Chicago. V. Metropolitan Museum of Art (New York, N.Y.) VI. Title.
N6537.A437A4 1997 709'.2—dc21 96-49866 CIP

709.2
DON
1997

Contents

Lenders to the Exhibition

Private Collectors

Marjorie and Charles Benton
Curtis Galleries, Minneapolis
Richard L. Feigen & Co.
Doris and Marshall Holleb
Lawrence M. Pucci, Caryl Pucci Rettaliata
Philip J. and Suzanne Schiller, Chicago
Jean and Alvin Snowiss
Mrs. Eileen Trlak
and five anonymous collectors

Public Institutions

The Art Institute of Chicago
The Butler Institute of American Art, Youngstown, Ohio
The Detroit Institute of Arts
Galleria degli Uffizi, Florence
Hood Museum of Art, Dartmouth College, Hanover, New Hampshire
Los Angeles County Museum of Art
The Metropolitan Museum of Art, New York
Milwaukee Art Museum
The Museum of Modern Art, New York
National Academy of Design, New York
National Gallery of Art, Washington
National Museum of American Art, Smithsonian Institution, Washington
New Trier Township High School District 203, Winnetka, Illinois
Phoenix Art Museum
University of Chicago Library, Department of Special Collections
Wadsworth Atheneum, Hartford, Connecticut

Foreword

James N. Wood

Ivan Albright and The Art Institute of Chicago are in the tenth decade of a profound dialogue. This was the first fine-arts museum he experienced; he wandered its European and American galleries as a child. Here he had his initial exposure to the avant-garde when the institution hosted the Armory Show in 1913; and here he absorbed the technical, stylistic, and spiritual lessons its collections and exhibitions provided an aspiring, young artist. After his return from duty as an army medical draftsman during World War I, Albright decided to pursue a career in art and enrolled at the School of the Art Institute, matriculating with distinction in 1923. In 1931 the museum honored him with an exhibition, shared with two other artists, of over a dozen works, including his recently completed and seminal *Into the World There Came a Soul Called Ida* (no. 17). As a professional artist and resident of the Chicago area for nearly seventy years, Albright not only continued to exhibit in the local and national competitive exhibitions the Art Institute sponsored but also to revisit its collections and exhibitions—especially those related to the Old Masters—as a way of nourishing his soul and revitalizing his art.

In turn, the Art Institute and its public are fortunate to have had the opportunity to consider this artist's powerful work over many years and in great depth. The museum purchased its first composition by Albright, *Ah God, Herrings, Buoys, the Glittering Sea* (no. 35), in 1941. It became the beneficiary of many generous loans and gifts from the artist, his family, and his patrons. Years before the Art Institute was able to acquire his masterful *That Which I Should Have Done I Did Not Do (The Door)* (no. 24), he allowed the museum to hang it in its galleries, where visitors flocked to admire its technical virtuosity and ponder its message. In 1964–65 the Art Institute organized, with Albright's support and in cooperation with the Whitney Museum of American Art, New York, his first major retrospective, featuring sixty works of art, in a variety of mediums. It is perhaps significant that this took place as the Albright family was in the process of moving from Chicago to Woodstock, Vermont; for, in this way, he indicated his full allegiance to the city and museum in which he and his art had been nurtured.

In 1977, on the occasion of his eightieth birthday, Ivan Albright gave The Art Institute of Chicago an extraordinary gift, comprising most of his major paintings, as well as sculptures, works on paper, working diagrams, setups, and props. Upon his death, his wife, Josephine Patterson Albright, presented the museum with twenty moving self-portraits, the results of the artist's last, major campaign, on which he had labored until only days before he died. She also gave the museum some fifty-one notebooks, in which he had recorded his thoughts and activities, sketches and project plans, quotations from teachers and passages from books he admired, and his own poems and short stories, for over sixty years. This now forms the core of the Ivan Albright Archive, which, together with his work in our collection, constitutes the greatest concentration anywhere of materials by and concerning the artist.

To mark the centenary of Ivan Albright's birth, The Art Institute of Chicago is proud again to organize a retrospective exhibition of his work, this time in partnership with The Metropolitan Museum of Art, New York. This endeavor is the result of the enthusiastic hard work of many, but it would never have happened without the dedication and heroic efforts of its organizing curator, Courtney Graham Donnell, Associate Curator in the Art Institute's Department of Twentieth-Century Painting and Sculpture. For many years, she has steadfastly and devotedly studied the life and career of Ivan Albright, building in the process a team at the Art Institute on which she could count for assistance with the many aspects involved. While it is impossible for me to thank all of them by name, I would like in particular to mention Barbara Mirecki, Exhibition Coordinator, for so capably overseeing the organization of the exhibition; and Susan F. Rossen, Executive Director of Publications, for her dedication to making the book that accompanies the exhibition an important resource for future Albright studies. In addition, I wish to thank, at the Metropolitan Museum, Philippe de Montebello, Director, and William J. Lieberman, Jacques and Natasha Gelman Chairman of 20th-Century Art, for their much-appreciated support of this project. And finally, this undertaking would not have been possible without the continuing generosity and cooperation of the family of Ivan Albright: his wife, the late Josephine Patterson Albright; his children, Alice Arlen, Joseph, Adam, and Blandina Rojek; and his niece, Marjorie Albright Lins.

Nearly fourteen years after his death, we offer this exhibition and book as an opportunity to reassess the accomplishments of an artist whose unique and unrelenting vision has led some to consider him as regional and idiosyncratic. Indeed, his philosophic and aesthetic meditations on the conundrums of human existence must be understood not just as those of a Chicagoan, a midwesterner, or an American, but above all as a cosmopolitan and passionate citizen of the world.

Acknowledgments

Courtney Graham Donnell

In the summer of 1990, I made my first trip to Woodstock, Vermont, to interview the wife of Ivan Albright, Josephine Patterson Albright. From that moment to this—the inauguration of a major retrospective of the artist's oeuvre and publication of the first monograph on him in nearly two decades—I have been sustained by the interest and support of a large group of people, only some of whom I can name here.

The Art Institute of Chicago's rich and wide-ranging holdings of Albright's art, as well as his notebooks, scrapbooks, and other documentary material, made this the logical institution for such a project, one it undertook enthusiastically. Throughout, Director James N. Wood has been behind this effort, as have my curatorial colleagues, including Richard R. Brettell, former Searle Curator of European Painting; Neal Benezra, former Curator in the Department of Twentieth-Century Painting and Sculpture (and now Chief Curator at the Hirshhorn Museum and Sculpture Garden, Washington, D.C.); Charles F. Stuckey, former Frances and Thomas Dittmer Curator of Twentieth-Century Painting and Sculpture (now Patrick and Aimee Butler Curator of Paintings at The Minneapolis Institute of Arts); and Madeleine Grynsztejn, former Associate Curator of Twentieth-Century Painting and Sculpture (now Curator of Contemporary Art at the Carnegie Museum of Art, Pittsburgh, Pennsylvania). For their belief in this exhibition, I thank them first and foremost.

The only other substantive museum survey of Ivan Albright's work occurred over thirty years ago, when the Art Institute organized a retrospective that was also shown at the Whitney Museum of American Art, New York. Thirty-three years later, we are able to underscore the artist's national and international importance by sharing our presentation of his achievements with The Metropolitan Museum of Art, New York. My thanks go to William J. Lieberman, Jacques and Natasha Gelman Chairman of 20th-Century Art, and to Anne L. Strauss, Research Associate, for their interest and support.

To examine anew Ivan Albright's long life and career required extensive research. For two years, I was fortunate to have the consistently excellent help of Jennifer Stone and Nicholas Juett. Their teamwork made a mammoth task manageable. I have also appreciated the dedication of interns Cindy Elden and Rachel Goldsmith, as well as, in the early stages, Carole Tormollan. I also wish to thank Michael Croydon, Albright's biographer, for his willingness to be consulted on a number of issues, for his support of the project, and for his generous gift of Ivan Albright-related materials to the Ivan Albright Archive.

In recent years, I have been ably guided by Exhibition Coordinator Barbara Mirecki, who always has exceedingly useful suggestions and has kept the pathways straight and uncluttered for me. I was instantly cheered to be associated with Susan S. Weininger, Associate Professor of Art, Roosevelt University, Chicago, who, in her essay, has made an unprecedented effort to consider Albright's work in local, national, and international

spheres; she bolstered my flagging spirits whenever needed. The devotion to the artist of Robert Cozzolino, Archives Assistant, Ryerson and Burnham Libraries, can be seen in the information he compiled and assessed, through long hours of dedicated study of materials in the Ivan Albright Archive, that is contained in the entries, Chronology, and other materials he contributed to the catalogue.

Our ambitious catalogue was conceived, nurtured, and produced by our hard-working Publications Department, edited by its Executive Director, Susan F. Rossen, whose interest in Ivan Albright's life and work was crucial to the exchange of ideas that resulted in the scope of the publication. I wish to thank Daniel Frank and Sarah E. Guernsey for their devotion to achieving the highest quality in design and color printing. Sarah Guernsey also performed an editorial role with a thoroughness and optimism on which we all came to depend. In addition, I wish to acknowledge the editorial assistance of Susanne Breckenridge, Morgen Cheshire, and Kate Steinmann. We are grateful as well to Dennis Alan Nawrocki, whose involvement with the manuscript at all stages and many ideas for its improvement were invaluable. The book's elegant design is the work of Steven Schoenfelder. We are also grateful to Pat Goley, of Professional Graphics, Rockford, Illinois, for his outstanding color separations; and to Paul Anbinder, of Hudson Hills Press, for his belief in this book.

All of us have benefitted from the encouragement and aid of others on the staff of the Art Institute. They include, in the Department of Twentieth-Century Painting and Sculpture, Kate Heston, Barbara Nobares, Daniel Schulman, Jeremy Strick, and especially the department's proficient preparators, Nicholas Barron and John Tweedie, as well as its many volunteers and interns over the past seven years. On the staff of the Ryerson and Burnham Libraries, we wish to acknowledge the help of Jack Perry Brown, Anne Champagne, Ann Jones, Barbara Korbel, Natalia Lonchyna, Bart Ryckbosch, Deborah Sue Webb, and Mary Woolever. The Department of Imaging and Technical Services provided its usual superb visual materials: my thanks go to Annabelle Clarke, Christopher Gallagher, Robert Hashimoto, Robert Lifson, Annie Morse, Alan Newman, Greg Williams, Iris Wong, and Julie Zeftel. The Department of Conservation deserves special thanks for its thorough inspection of the works by Albright in our care, and its recommendations for presentation, as well as its treatment of the artworks and manufacture of frames: I am grateful to Emily Dunn, Barbara Hall, Timothy Lennon, John Mancini, Suzanne Schnepp, Steven Starling, Kirk Vuillemot, Faye Wrubel, and Frank Zuccari. In the Department of Prints and Drawings, I wish to thank Anselmo Carini, David Chandler, Caesar Citraro, Douglas Druick, Suzanne Folds McCullagh, Mark Pascale, Stephanie Skestos, and Harriet Stratis for sharing our enthusiasm for this project, for their expertise in conservation matters, and for most generously devoting gallery space to show works on paper from their

holdings. Others to be thanked include Teri J. Edelstein, Deputy Director, and Dorothy Schroeder, Assistant Director for Exhibitions and Budget. I thank as well Barbara Scharres of the Film Center of the School of the Art Institute, Joe Cochand of Graphic Services, David Stark of Museum Education, and their departments. I am also grateful to the departments of Museum Registration, Operations, Public Affairs, and Special Events.

This exhibition could not have been realized without the generosity of a number of individual and institutional lenders, listed separately on page 6. We are also grateful to a number of people who provided help in myriad ways: Betsy Arvidson, Susan and Frank Anthony, Dr. Henry Bangser, Olga Barsanti, Wesley Baumann, Colleen Becker, Susan Benjamin, Father Virgilio Biasiol, Georgi Bohrod, Richard Born, Stuart Brent, Lillian Brenwasser, Arthur Breton, Helen Brooks, the late Louise Bross, Anne Campbell, Mikki Carpenter, Anna Chomentowski, William Z. Cline, Dr. Robert S. Conte, Kevin Davis, David Dearinger, Sid Deutsch, Claire Dienes, Bram and Sandra Dijkstra, Michelle Elligot, Nancy Escher, Barton Faist, Brother Wenceslaus Farlow, OFM, Richard L. Feigen, Eileen Flanagan, Ruth Flynn, Joan French, Joseph Friebert, Dr. Leslie Gable, Mary Mathews Gedo, Mr. and Mrs. Basil Georgeson, Billi and Bobby Gosh, Michael Hall, Robert and Christine Harris, Hurd Hatfield, Dean Heywood, Richard Holland, Dee Hoover, Walter Keener, James M. Keny, Marisa Keller, Betsy Kornhauser, Angela Lansbury and Peter Shaw, Edward and Larry Lasker, Cheryl Leibold, Kristine McGuire, Jonathan McKernan, Joy McLeod, Dr. Manola Garcia Maldonado, Martyl, Garna Muller, Antonio Natali, Dr. Benjamin S. Odom, Dr. Antonio Paolucci, Kelly Pask, Eden Pearlman, Joan Redding, Gregory M. Reppen, Michael Rhode, Lynn Springer Roberts, Joyce Robinson, Ida Rogers, Anne Rorimer, Rona Roob, Cora Rosevear, Dorothy Sadowski, Barbara C. A. Santini, Suzanne and Philip J. Schiller, John Paulus Semple, the late Mr. and Mrs. Joseph Randall Shapiro, W. Angus Shorey, Irene Siegel, Peter Fox Smith, Ellen Steinberg, Pat Stockner, Jim Strong, Dr. David Teplica, Michael Tropea, Sandra Ullmann, Dominique Vasseur, Gian and Donna Visconti, Ethel Wachs, Helena and Clarence Wilson, and Judith Zilczer.

Finally, I am indebted to the members of Ivan Albright's family: his daughters, Alice Arlen and Blandina Rojek; his sons, Joseph and Adam; and his niece Marjorie (Tishie) Lins. They have always been ready to answer the smallest of questions and to give continually of their time, memories, and resources. Albright's wife, Josephine Patterson Albright, died in January 1996, just over a year before the project was realized. From the start, she was behind all my efforts unfailingly. I hope she would have been pleased as we honor Ivan Albright's unique and important contribution to the world of art, in the centennial year of his birth.

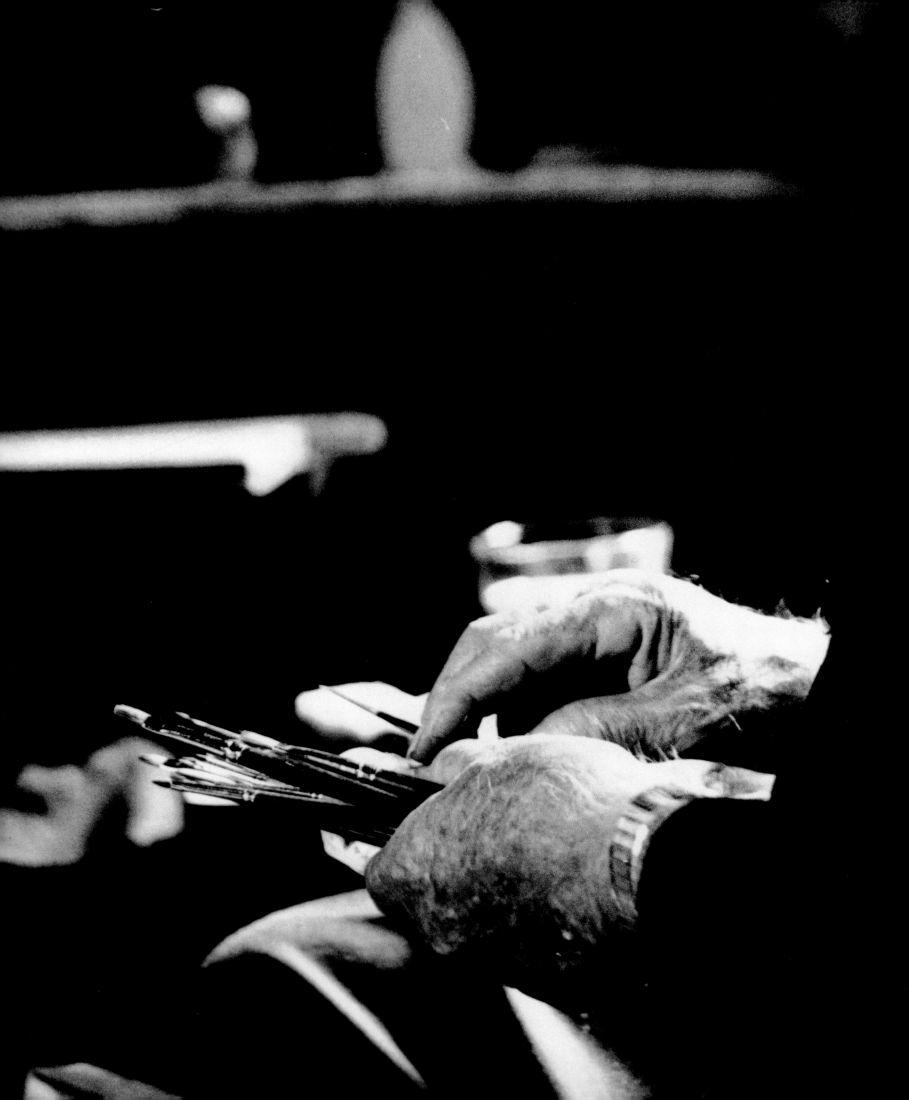

A Painter Am I: Ivan Albright

Courtney Graham Donnell

A painter am I
Of all things
An artist who sees
The door and chair
And sees on smooth things a flaw there
And sees on round things a hollow there . . .
And colors are not just colors to him
But each a dream in a fantasy
That makes unreal this world of yours to him
To this painter man.[1]

The son of an artist and twin of another, Ivan Albright refused to be a carbon copy of any-one and forged his own way. For over half a century, in his art and writing, he pursued his singular vision, searching for answers to life's mysteries and for effective ways to put his discoveries on canvas for all to ponder. The dedication and concentration he brought to the task of giving form to the soul and laying bare the human condition only partly define the man. The diminutive artist—he was only five feet three inches tall—was never still. Thoughts rushed from his mouth so fast he stuttered to finish them. Often likened to an elf, he was mischievous, fun-loving, and full of life.

In many ways, Ivan Albright was the complete artist. He painted and sculpted. He drew in charcoal, graphite, india ink, and colored pencils. He worked in watercolor and gouache. He tried many forms of printing, favoring lithography earlier on and etching near the end of his life. He made his own charcoal and paints and carved his own frames. He painted images on his kitchen walls, garden gate, tool shed, and the exteriors of his studios. He did figure and character studies, portraits, landscapes, and still lifes. He wrote about art. He composed poetry. He invented stories to help his wife fall asleep and recorded them, as well as his technical discoveries, formal artistic concerns, and philosophical mus-ings in a series of over fifty notebooks, begun when he was an art student. Highly com-petitive, he entered hundreds of juried exhibitions over the years, drawn particularly to those that awarded prizes, of which he won his share. While he was born, raised, and was active as a painter in the Chicago area, he was an inveterate traveler, especially in his later years when, accompanied by various family members, he crisscrossed the globe. He found he could work anywhere, and he did. From the 1920s on, he made art ceaselessly, stopping only days before he died, in 1983.

Ivan Albright was the son of Clara Wilson Albright (1862–1939; fig. 3) and Adam Emory Albright (1862–1957; fig. 2 and Chronology, fig. 1). Clara Wilson came from a highly educated family. Her father was a physician; her mother attended the Oxford Col-lege for Women, Oxford, Ohio. Clara graduated from the University of Kansas, Lawrence,

Figure 1. Ivan Albright's hands, c. 1975. Photograph by Molly Shallow. Unless otherwise noted, all of the illustrations accompanying this essay are in the Ivan Albright Archive, Ryerson and Burnham Libraries, The Art Institute of Chicago.

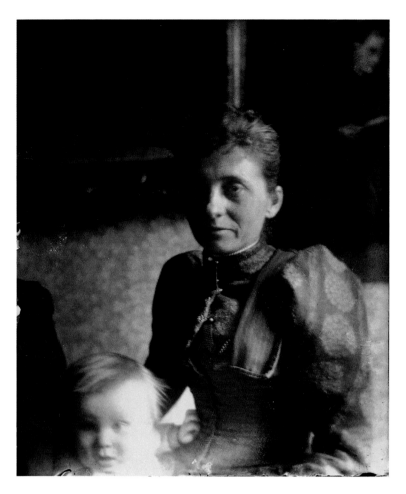

Kansas, in 1888. After her marriage to Adam Emory, however, she seems to have assumed the traditional role of wife and mother. Descended from a German family (which had changed its name from Albrecht) of master gunsmiths, Adam Emory was born in Monroe, Wisconsin, and raised on an Iowa farm by a father who, as family lore has it, had been prevented by his own father from becoming an artist. When Adam Emory determined to pursue the fine arts, he left Iowa at age eighteen, with his family's blessing, but nearly penniless. By early 1882, he was in Chicago. After training at the Chicago Academy of Fine Arts (forerunner of The School of The Art Institute of Chicago), he went to the Pennsylvania Academy of the Fine Arts, Philadelphia, where his teachers included the renowned painter Thomas Eakins. Like many of his generation, he completed his artistic education in Europe, studying in Munich with the Milwaukee-born artist Carl von Marr, as well as in Paris in the atelier of Benjamin Constant.

Adam Emory had known Clara since childhood, when, for a period, they lived near each other.[2] He obviously did not forget her, for, after his return from Europe, he went to Kansas for Clara's college graduation. They married on Christmas Eve, 1888, in St. Louis. The couple settled in Chicago, where the young artist set up a studio on Dearborn Street and started accepting portrait commissions. Adam Emory and Clara Albright had three sons, naming each after an artist. Perhaps, like Charles Willson Peale a century before, Adam Emory hoped to create a modern American artistic dynasty. The eldest son, Lisle Murillo (1892–1958), was named for the Spanish Baroque artist. Ivan received the middle name Le Lorraine, in honor of the great seventeenth-century landscapist Claude Lorrain (about 1950, after he realized that Claude's name was spelled differently, and wanting as

Figure 2. Adam Emory Albright (1862–1957), c. 1900.

Figure 3. Clara Wilson Albright (1862–1939), with one of her sons, c. 1893/98. Photograph by Adam Emory Albright.

Figure 4. Left to right: Ivan and Malvin Albright in a carriage, Edison Park, Illinois, 1897. Photograph by Adam Emory Albright.

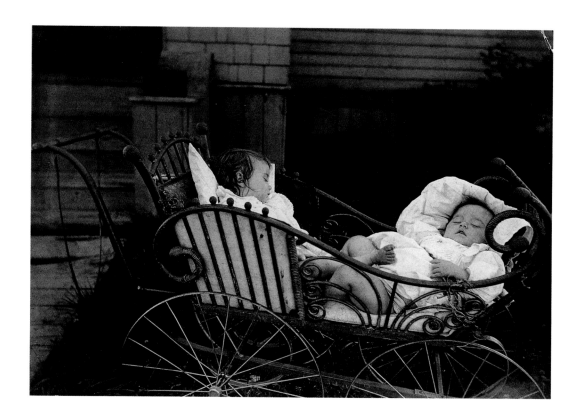

well to shorten his own, Ivan stopped including "Le Lorraine" in his signature). His iden-
tical twin brother was called Malvin Marr, after Adam Emory's teacher in Munich.

Ivan and Malvin Albright were born prematurely, each weighing about three pounds,
on February 20, 1897, in a rented house in North Harvey, Illinois, on Chicago's southern
edge. It must have seemed miraculous to their parents that these two tiny boys survived
such a beginning, and in the dead of winter. As Adam Emory recalled in his memoirs:

*The twins were . . . the most unpromising mortals I have ever seen. . . . [The] nurse, bless her soul,
how she worked with those little fellows. . . . That wicker basket contained two of the most distin-
guished artists in America.*[3]

The Albright family moved the following year to Edison Park, Illinois, which is now
part of Chicago, adjacent to the suburb of Park Ridge. Working out of a log studio and cot-
tage (see Chronology, figs. 4 and 5), Adam Emory built a career specializing in sunny
country scenes populated with children playing or daydreaming (see Weininger, fig. 2), for
which all three of his sons often served as models. His success is reflected in the numer-
ous one-person exhibitions he enjoyed in the first years of the twentieth century at The Art
Institute of Chicago.[4]

In 1910 Adam Emory moved his family to a large log home he designed and had con-
structed in Hubbard Woods (now Winnetka), a suburb on Chicago's North Shore. Named
the Log Studio, the residence was large (see Chronology, fig. 6) and could accommodate
the artist's wide circle of friends and acquaintances in the art world and patrons from
Chicago society.[5] A photograph of the interior of the residence (fig. 5) reveals a combina-
tion of rustic brick fireplace, Victorian bric-a-brac, and lace decoration, elements that
would reappear in Ivan Albright's mature work.

To inform and expand Adam Emory's subject matter, every summer the Albright clan
visited spots on the New England coast such as Noank, Connecticut, and Annisquam,
Massachusetts; as well as Pennsylvania "Dutch" country and Brown County, Indiana. In

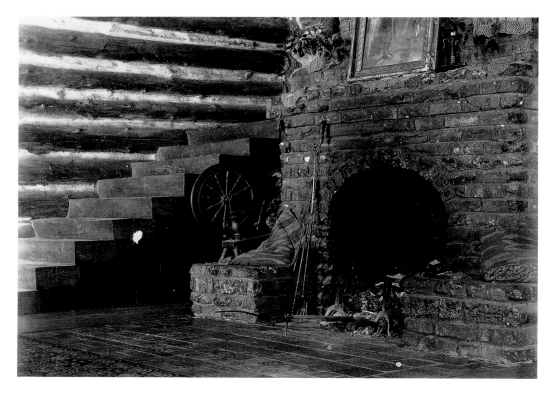

Figure 5. Interior of the Albright family residence, the Log Studio, Hubbard Woods, Illinois, c. 1910. Photograph by Adam Emory Albright.

1917–18 the Albrights traveled to Caracas, Venezuela, for an extended stay. At the end of World War I, the family began to winter in southern California, visiting the Southwest en route. The Albrights would continue these winter and summer trips regularly until the Depression forced their curtailment. Thus, Ivan Albright's propensity for travel, and for working trips, was ingrained in him early in life.

• • • • •

"There is not one, there are two of us, and which one I am,
I know not. . . . We had a language of our own, which was not a
language, but more like two chickens clucking."[6]

Paradox is constant in the lives of twins. A twin is not only "a human mirror but also an ideal companion, someone who understands [the other] perfectly."[7] It is no wonder that two beings, so connected and so alike, often follow similar paths. A study of twins found that "behaviors as diverse as smoking, . . . marriage and divorce, choice of careers and hobbies . . . all . . . have far higher rates of concordance for identical than for fraternal twins."[8] Twins can be closest friends as well as greatest rivals. They begin to compete in the womb for space and nutrition. It hardly needs be said that, with such complex forces at work, identical twins have an especially difficult journey to separate one from the other and to define themselves as individuals.

Clearly, identical twinness was a powerfully determining experience for Ivan and Malvin. According to the family, Ivan was the first born (he later said he was not sure who came first). In any case, Ivan was the more dominant. Ivan's daughter Alice Albright Arlen relates that, from a very early age, Malvin followed his twin everywhere. Ivan could not escape him. When he tried to do something on his own, such as take a train into Chicago,

Malvin would turn up on the same one. The twins spent half a century living, working, and traveling together. They were immensely proud of each other's achievements, but they were always rivals as well.[9] Ivan's marriage, in 1946, eventually weakened this bond, so that, from the early 1950s until 1977, when they were reunited on the occasion of their eightieth birthday (see fig. 29), their contact was significantly reduced. In what is evidently not an unusual occurrence for identical twins, Ivan died only eight weeks after Malvin. In order to completely understand Ivan, one must also investigate the life and work of Malvin, a subject that is introduced here but requires further study (see also Weininger, pp. 74 and 75).[10]

In addition to Malvin, Ivan had to contend with an older brother, an athletic child (unlike his younger siblings) whom his father is said to have favored over either twin. While a photograph exists of Lisle at about age three, seated before an easel (Chronology, fig. 1), this son resisted the magnetic pull of his father's profession, excelling in sports at Northwestern University, Evanston, Illinois, and becoming a successful businessman. And finally, there was Adam Emory himself, a force so strong that he too became a foil against which Ivan continually measured and defined himself.

• • • • •

"Art Is a Family Affair for the Albrights"[11]

Adam Emory Albright taught his boys to draw and exposed them at an early age to the world of museums. Ivan remembered visiting The Art Institute of Chicago when he was five; his childhood experiences of the place made a deep impression on him:

I used to go to the Chicago Art Institute when the pictures were put in shadowbox frames that [reflected] in your eye. . . . All the walls were lined with gray-green velvet, muted brown, red, pearl-gray white. . . . The pictures themselves were . . . from France and from other places, very detailed.[12]

In the museum's Old Master galleries, he certainly saw the monumental altarpiece *The Assumption of the Virgin* by El Greco, whom he came to admire, as well as paintings attributed to Anton van Dyck and to someone he would always revere, Rembrandt van Rijn.

In the 1915 yearbook of New Trier High School, Wilmette, Illinois, which Ivan and Malvin attended, they are listed as "The Albright Twins: Two heads are better than one," without captions accompanying their photographs to distinguish between them.[13] Both young men had ambitious goals that, significantly, were scientific rather than artistic. As Ivan later told an interviewer, "In chemistry I wanted to look for an element. . . . My brother wanted to be an inventor. When he was in high school, he spent most of his time working on a perpetual-motion machine. We didn't have any brains between us. . . . I think we were divided, cut in two, and he has all the mechanical ability and invention."[14]

The yearbook indicates that the twins intended to follow separate educational paths: Ivan planned to attend Northwestern University, following his older brother, and Malvin was accepted at Chicago's Armour Institute (today the Illinois Institute of Technology).[15] Indeed, Ivan spent his freshman year at Northwestern but was, as he put it, "bounced out" after devoting too much time to the student newspaper and failing German and chemistry. At this point, the twins decided to let chance put them on a future course. "Actually, Malvin Marr Albright, my . . . identical twin, [and I], we tossed up a coin, . . . whether we'd go in for chemical engineering or architecture. The coin came down . . . , [and] it was architecture."[16] The following fall, Ivan registered for architecture classes at the University of

Illinois, in Urbana. The incident of the coin toss reveals not only the intensely close tie between Ivan and Malvin, as they placed both of their futures at stake, but also a lack of seriousness and commitment, at least on the part of Ivan, to any profession. Mostly, he knew what he did not want to be: an artist, like his father. As he said,

I was raised in art. . . . My father was known in the city. . . . We entertained . . . club women, . . . and they'd always [ask me]: "Little boy, are you going to be an artist when you grow up?" And I got to hate it, . . . and I said, "I'll never be an artist. I'll be an architect, an engineer, anything. I'll dig a ditch, plaster a wall, but I don't want to be an artist.[17]

Despite his resistance, he could not suppress his talent. In 1917–18, when he was about twenty and he and his family were in Venezuela, he was evidently commissioned and paid to execute portions of an altarpiece (location unknown) for a church. Described as the Ascension of the Virgin, it also included pastoral scenes. Also in 1918 a work by him, *The Oaks in Winter* (location unknown), supposedly a watercolor of Hubbard Woods, appeared in The Art Institute of Chicago's thirtieth annual Exhibition of Watercolors.[18]

Ivan studied architecture at the University of Illinois for one year, and then the United States entered World War I. All three Albright sons enlisted in the army. Ivan and Malvin spent part of 1918–19 at a base hospital of the American Expeditionary Forces in Nantes, France (see Chronology, fig. 7). Alice Albright Arlen described the twins' experience: "They went in together. Daddy as usual got a good job—doing medical drawings for officers and getting to miss reveille—and Malvin spent the war on guard duty."[19]

Of the eight medical sketchbooks that Ivan filled, each with about fifty drawings, three survived (nos. 1 and 2).[20] Despite the great interest these pages have generated in relation to Albright's art, he always maintained that his war work had no impact on him, except for his new-found respect for X-radiography. It would be hard to believe that an impressionable man in his early twenties could remain impervious to the experience, repeated many times, of peering into open wounds and having to replicate visually what he saw. Later, he recalled having come upon a human hand in a refuse bin,[21] an image that could certainly have prompted the mysterious hands that appear in two of his major compositions, *That Which I Should Have Done I Did Not Do (The Door)* (no. 24) and *Poor Room—There Is No Time, No End, No Today, No Yesterday, No Tomorrow, Only the Forever, and Forever and Forever without End (The Window)* (no. 40). Instead of being horrified and repelled, Albright was fascinated by what one could call human engineering: his anatomy courses began on the battlefront. Executed in the operating room or in hospital wards, the medical sketches are the artist's earliest extant works. Abbreviated contour drawings with occasional washes that indicate open wounds, they are not polished artworks, nor were they meant to be. Yet these sheets reveal a clinical attention to detail and a feeling for the vulnerability of human flesh that would become critical aspects of Albright's vision.

After their discharge, the twins stayed on in France for a short time, on the pretext that they would study at the Ecole des beaux-arts in Nantes, which apparently they attended for only a few days. They also visited Tours, Orléans, and Paris (where they toured the Musée du Louvre). Upon his return to Hubbard Woods, Ivan floundered about, in search of an occupation. He resumed his studies at the University of Illinois but left, after only one week, to work for the Chicago architectural firm of Perkins, Fellows, and Hamilton, followed by a stint with the advertising department of Albert Pick & Company, a large hotel chain headquartered in Chicago. The commercialism of these fields was as disturbing to him as his father's constant cultivation of clients and catering to prevailing taste.[22] Finally, after fighting for so long against the pressure to take up Adam Emory's

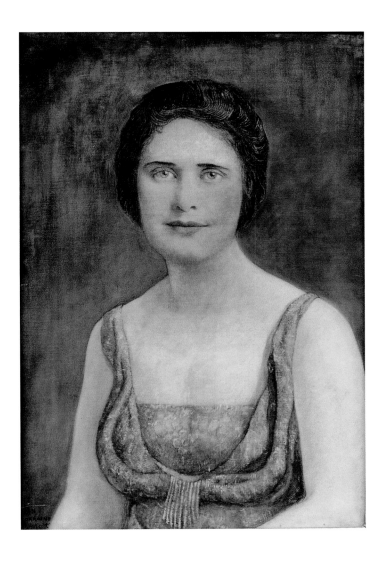

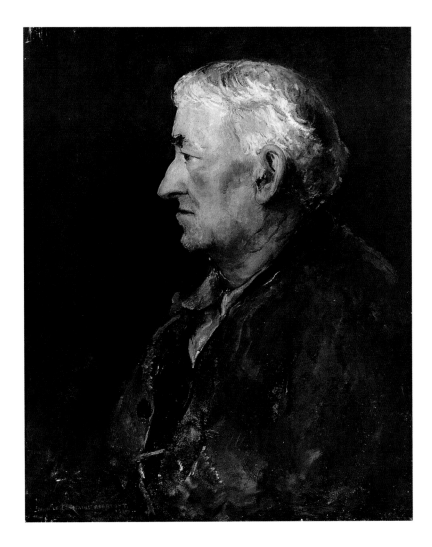

Figure 6. Ivan Albright. *Portrait of Marie Walsh Sharpe*, 1921. Oil on canvas; 76.2 x 50.8 cm (30 x 20 in.). Marie Walsh Sharpe Art Foundation, Colorado Springs, Colorado. Photograph by W. L. Bowers.

Figure 7. Ivan Albright. *Portrait of a Man*, c. 1924. Oil on canvas; 61 x 45.7 cm (24 x 18 in.). Billi and Bobby Gosh Collection, Brookfield, Vermont. Photograph by Ken Burris.

profession, Ivan decided to study art. "[It was] the only recourse I had," he later explained. "The only thing I could do was paint." Whether Malvin shared Ivan's confusion or simply followed his brother's lead is not known. In January 1920, the twins enrolled at The School of The Art Institute of Chicago, enjoying full-tuition scholarships during their years there.[23]

Probably to minimize the competition between them, as well as the way they could be easily confused with each other, Malvin pursued sculpture and Ivan painting. It is possible that Adam Emory made this decision for them. The School of the Art Institute, like the museum at this time, was traditional in its philosophy, offering standard, academic training in the fine arts, as well as an extensive list of courses in the applied arts (see Weininger, pp. 56 and 57). When the twins graduated, in June 1923, they had kept to their plan: Malvin earned a degree in sculpture; and Ivan one from the Department of Drawing, Painting, and Illustration, with a faculty Honorable Mention for life and portrait painting. In fact, they could each draw, paint, and sculpt, and would do so all their lives.

Three works by Ivan from the years 1921/24 indicate the degree to which his training helped shape and develop his skills. In a conventional, half-length portrait (fig. 6), the sitter, a former Gibson calendar girl, Marie Walsh Sharpe, turns slightly to the left, her light, blue-gray eyes gazing directly at the viewer. While a competent portrayal of a pretty woman, the painting suggests little of the artist Albright would become.[24] The dark, plain background and pose of the figure in *The Philosopher* (no. 3) reflects the traditional foundation he received at the Art Institute. This painting has the distinction of being the first

19

ALBUQUERQUE ACADEMY LIBRARY

work Albright exhibited outside Chicago (it was included in the Pennsylvania Academy's 1924 annual exhibition) and the first by him to enter a public collection. In 1927 he donated it to the Layton Art Gallery (now the Milwaukee Art Museum), which probably accepted it in part because he was his father's son; Adam Emory—who had been born in Wisconsin—was well known in Milwaukee, where he often exhibited. A profile portrait by Ivan of an unknown sitter (fig. 7), also dating from the early 1920s, hints at the young artist's interest in character studies.

Not yet ready to declare themselves fully professional, the twins sought additional training on the East Coast. They spent the fall 1923 term in Philadelphia, at the Pennsylvania Academy of the Fine Arts, a choice Ivan later attributed to the fact that Adam Emory had studied there and that, unlike the School of the Art Institute, it focused more strictly on the fine, rather than applied, arts. For the spring 1924 term, they moved to New York City, hoping that Ivan could study with the renowned American realist George Bellows at the Art Students' League. Finding that Bellows was abroad, Ivan enrolled for a semester at the National Academy of Design; and Malvin attended the Beaux-Arts Institute of Design (see Weininger, p. 58).

With a solid academic year of East Coast training behind them, Ivan and Malvin returned to Illinois. In their absence, their parents had moved to Warrenville, a small country town some thirty miles west of Chicago. There Adam Emory had acquired an abandoned Methodist church (fig. 14), a Civil War-era structure with a checkered history that included a period as a dance hall. The building was big enough for him to remodel into a studio for himself and his twin sons.[25] The peripatetic family, however, did not spend much time in Illinois in 1924–25, making extended visits to several places in California, as well as to Arizona and New Mexico.

From the fall of 1925 to the spring of 1926, the twins rented a studio in Philadelphia, on Cherry Street. During this time, Ivan executed several paintings that begin to exhibit some

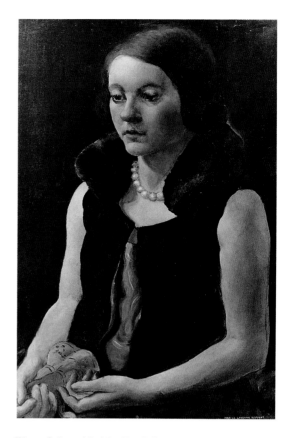

Figure 8. Ivan Albright. *Fur Collar (The Baskerville Portrait)*, 1926. Oil on canvas; 76.2 x 50.8 cm (30 x 20 in.). National Academy of Design, New York. Photograph by studio nine, inc., New York.

Figure 9. Ivan Albright. *Samson (I Am He of Whom He Spoke)*, 1925. Oil on canvas; 66.4 x 51.1 cm (26⅛ x 20⅛ in.). Coral Gables, Florida, The Loew Art Museum, gift of Mr. and Mrs. Myron Hokin. Photograph by Roland I. Unruh.

Figure 10. Malvin Marr Albright. *Ivan Albright, Portrait Painter*, 1927. Plaster; 50.8 x 20.3 cm (20 x 8 in.). Private collection. Photograph © Michael Tropea.

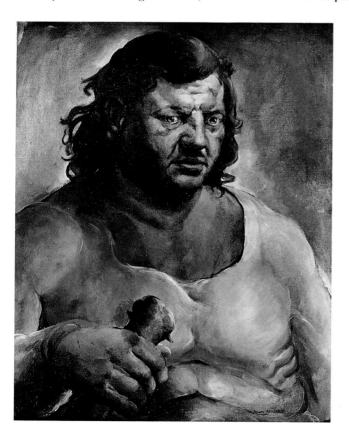

of the characteristics associated with his mature vision. He gravitated to non-professional models (professional models, he later declared, "all strike poses like the Statue of Liberty"[26]). He also started to suggest narratives by including an identifying or telling object in the sitter's hands and assigning his works extended titles. A comparison of a 1926 painting, *Fur Collar (The Baskerville Portrait)* (fig. 8)—depicting a student at the Pennsylvania Academy—with the earlier depiction of Marie Walsh Sharpe shows Albright attempting a more sober and ambitious composition, extending his image of the sitter to include her hands and lap, where she fingers a handkerchief.

A newspaper delivery man served as the model for Albright's rather sketchy *Samson (I Am He of Whom He Spoke)* (fig. 9). This massive Old Testament figure holds a club in his right hand, ready either to do battle or to defend. The model for *Paper Flowers* (no. 5), which Albright later declared to be his first serious work, was a vendor the young artist found on the streets of Philadelphia, an alcoholic selling artificial flowers to support his addiction. Despite his unshaven face, watery eyes, and dirty undershirt, his clear and dignified expression is compelling, evoking our sympathy. But more than any other painting from this time, *Burgomeister with Key* (no. 6) anticipates Albright's future style. The model's strictly frontal pose reveals all flaws; his lumpy, sagging flesh is meticulously described. Albright succeeded in transforming the most anonymous and ordinary of models, a street peddler, into a sympathetic and archetypal symbol of aspirations that are at once empowering and futile.

• • • • •

"If He Paints, He's Ivan; If He 'Sculps' He's Malvin"[27]

In October 1926, Ivan Albright won his first award, an honorable mention for *Paper Flowers* in the Art Institute's annual American Exhibition. This signaled to the young man that he could indeed be his own kind of artist and encouraged him, finally, to pursue an artistic career seriously. In the fall, as well as the following spring, Ivan and Malvin worked in California, first in Oceanside, north of San Diego, and then in a studio in San Diego's Balboa Park. It was here that they did simultaneous portraits of each other: Ivan entitled his painting *Maker of Dreams (Man with a Mallet, Maker of Images)* (no. 8), and Malvin called his sculpted bust *Ivan Albright, Portrait Painter* (probably fig. 10). A comparison between these two works, and their titles, reveals Ivan to be more ambitious and poetic in his aims than Malvin, who produced a more straightforward and uncomplicated image. There is nothing unusual about two artists deciding to produce images of each other. But a special set of circumstances was operating in this particular project: Ivan and Malvin were in fact mirror twins. When one looked at a reflection of himself, he saw his brother, and when he looked at his brother, he saw himself. Thus any image—no matter how particularized—one made of himself or of his twin was never simply a representation of a single individual. As a process of self-definition, which this double-portrait project in part must have been, the act of depicting each other was, for the Albright twins, no simple matter.[28]

While Albright occasionally painted California's indisputably scenic areas in a suitably bright palette (see Weininger, fig. 4), he was not particularly moved by the region. Moreover, he grew to dislike the art world he found there, especially what he considered its crass commercialism and the apparent lack of interest in meaningful subject matter. "In 1926 to 1930," he reminisced, "nearly every artist down there would have his studio right near a stop sign so people would come and buy . . . paintings . . . [of] wisteria and so forth."[29] Essentially a studio artist, Albright chose not to paint pretty, saleable landscapes and still lifes. In these years, he worked fairly quickly: between October 1926 and April 1927, he produced at least five paintings—four half-length character studies (see nos. 7, 8, and 11)[30]—and a full-length portrait (no. 9). They reveal concerns he would explore throughout his career: the meaning of life, the relationship of matter and spirit, the effects of time, and the inevitability of death. His formal language began to shift as well. His use of light is expressive, recalling the flickering illumination of his beloved El Greco. He paid

considerable attention to defining aging skin, and to invigorating his renderings of inanimate objects, as if to suggest that all matter is related and equally subject to decay.

Rather than depict the romantic, old missions of California, as so many artists were doing, Ivan and Malvin preferred to focus on their more evocative residents, a pair of elderly Franciscan monks (see fig. 11) who lived at the San Luis Rey Mission. While Malvin worked on a bust of his model (Chronology, fig. 9), Ivan executed his first full-length figure composition of a still-vigorous octogenarian, Brother Peter Haberlin (no. 9). The project stimulated so much local interest that the twins' photographs appeared in the February 13, 1927, *San Diego Union* under the headline "If He Paints, He's Ivan; If He 'Sculps' He's Malvin." Much indebted to the full-length portrayals of mystics and saints by El Greco and Francisco de Zurbarán, *I Walk To and Fro through Civilization and I Talk as I Walk (Follow Me, The Monk)* is the first of Ivan's subjects to be situated in a specific place. In a corner of a room—perhaps a monastic cell—a brown-robed figure stands, apparently deep in prayer. Light streams in from a small window at the left, defining the friar's aged features, his gnarled hands and toes, and the folds of his robe. Illumination comes from behind and below as well, suggesting that a divine light emanates from the monk himself. Albright must have been drawn to this subject not only because of Brother Peter's advanced age, but also because of the implicit faith of the man, the ordinariness of his work (he served as the mission's blacksmith and baker for many decades), and the anonymity and simplicity of his existence.[31]

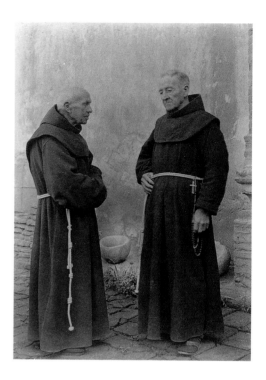

Figure 11. Left to right: an unidentified monk who posed for Malvin Albright's *The Monk (Saint Francis)* (Chronology, fig. 9), and Brother Peter Haberlin, who posed for Ivan Albright's *I Walk To and Fro through Civilization and I Talk as I Walk (Follow Me, The Monk)* (no. 9), San Luis Rey Mission, Oceanside, California, c. 1926.

Figure 12a and 12b. Ivan Albright's *The Lineman* (no. 10), featured on the cover of the May 1928 issue of *Electric Light and Power*, created a controversy among the trade magazine's readers. In response, the periodical used a more upbeat photograph, "The Modern Lineman," for its August issue cover.

• • ● • •

"My lord, I would have loved to have been able to write."[32]

The title *I Walk To and Fro through Civilization and I Talk as I Walk (Follow Me, The Monk)* must refer to the commitment of missionaries to achieve universal conversion to their faith. Its genesis was the result of what was for Albright a lengthy process, since he considered a title to be a significant element of a work. When he started a composition, he gave it a provisional, generic name (in this case, *The Monk*). He assigned a final title only after he considered a work complete and sometimes, as is the case with this painting, not for many years. He elaborated on his naming process in relation to *The Vermonter (If Life Were Life There Would Be No Death)* (no. 60): "Only when I have . . . finished [the work], I'll look at it for two or three weeks, and I'll write out maybe fifty titles in which I'll try to convey . . . some meaning and philosophy."[33]

There were a number of reasons for Albright's interest in long, evocative titles: one was his need to distinguish himself from his father, and another his ambitions for his paintings. "My dad and all the artists of that period—I'm talking about from 1903 up through 1912–14—used titles such as 'Boy with Sunflower,' 'Sunbonnet,' 'Man Standing by a River,'" he stated. "I get tired of [titles] like 'Young Girl' and 'Winding Path.' Mine are intended to illuminate the pictures. A painting should be a piece of philosophy—or why do it?"[34] Finally, Albright was intensely interested in writing. "When I was a student at Northwestern University," he related, "I tried to write. . . . I thought that here [in art] I had not only had a chance to paint, but if I made the titles long enough I could write. In those days, I was writing poetry."[35]

Albright did in fact write about three hundred poems before his marriage, in 1946, after which he stopped composing them as often, perhaps because so many had been inspired by romantic yearnings. Often reiterating themes found in his art—such as loneli-

ness, impermanence, the deception of appearances, the inevitability of decay and death—the poems are not as accomplished as his visual art. He himself suggested why this is so: "I chiefly use the subconscious in my poetry—[poetry becomes] something of a rest from the reaction [I have] to my painting. Usually [each poem takes] less than a minute to write."[36] His need to write must also have related to a lifelong struggle with stuttering (a problem his twin did not have). A poem about achieving vision could reflect as well his frustration at the difficulties he had with verbal expression: "Blind/The surging mind/Enclosed/Rushing from wall to bone wall/Seeking an outlet/Hoping to find/Vision."[37] Writing in his journal, making poetry and art—these activities allowed him to give form to his nonstop ideas and to command his emotions.

· · ● ● ·

"I hope to control the observer, to make him move and think the way I want him to. . . I want to jar the observer into thinking—I want to make him uncomfortable."[38]

By mid-1927 the twins were back in Illinois, sharing the former Methodist church in Warrenville that Adam Emory had made into a studio. For roughly two years, they all worked in and around this space: Ivan used the old choir loft, Malvin occupied the main floor, and Adam Emory usually painted out-of-doors. All three utilized the main floor to exhibit their work. In Warrenville Ivan began his second, full-length figure painting, *The Lineman* (no. 10), in which he portrayed a Warrenville neighbor, Arthur Stanford, who worked as a lineman for a utility company. In 1928 the painting won a $500 prize at the Art Institute's Chicago and Vicinity exhibition, where it must have been noticed by a member of the staff of the trade magazine for utility companies, *Electric Light and Power*, then published in Chicago. The composition's appearance on the cover of the May 1928 issue (fig. 12a) prompted the first controversy over Albright's art. His depiction of a worker, bowed by

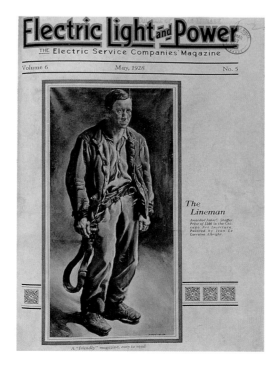

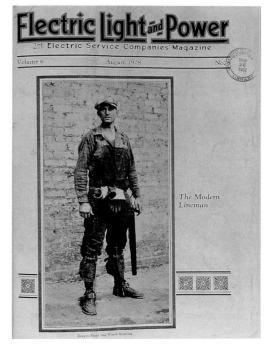

exhaustion, elicited a barrage of angry letters from readers with such comments as, "This man's posture and his expression are indicative of absolute hopelessness, a condition that cannot be attributed to the average American workman and certainly not to the alert lineman working for a modern utility company." The magazine's editors responded, in the June issue, with an apology, proclaiming the virtues of the modern lineman and disassociating themselves from Albright's composition, declaring: "We do not know where the artist found his model or how he conceived the idea."[39] They made a further attempt to nullify any lingering bad effects from the Albright incident with their treatment of the August issue, whose cover featured "The Modern Lineman," a photograph of a handsome, sturdy, and smiling young man (fig. 12b). Both Albright's *Lineman* and his third full-length composition, *Among Those Left (The Wheelwright, The Blacksmith)* (fig. 13), deal with the theme of labor. The latter painting portrays a muscular town blacksmith, holding onto a large, dented wagon wheel to which he will apply hammer and tongs. Honoring a profession that was fast becoming outmoded, *Among Those Left* helps to clarify the meaning of *The Lineman*. Rather than trying either to symbolize the oppressed working class or to denigrate laborers, the artist presented two images of men whose dedication to work is all-defining and consuming. His compassion for and connection with these subjects are deeply evident.

Albright's paintings of 1928 and 1929 are further transitions to his mature style. Instead of continuing to paint full-length figural compositions, he gravitated to half-length figures, following a format he had used in two California compositions, *Maker of Dreams* (no. 8) and the 1927 *Memories of the Past* (no. 11). *Memories of the Past* is a disquieting image, caused by the young sitter's wistful, downcast expression and the vulnerability created by her transitional state of undress. Half-length studies done later in Warrenville, such as *Flesh (Smaller Than Tears Are the Little Blue Flowers)* (no. 12), *Woman* (no. 13), and *Fleeting Time, Thou Hast Left Me Old* (no. 14) distinguish themselves from the California canvases in a number of ways. The figures are now bathed in harsh, overhead light and fill the canvas almost entirely. Albright transformed his sitters by magnifying particulars, capturing and enlarging upon every facial wrinkle, birthmark, stray hair; and every blemish and bulge of the exposed skin of arms, hands, and chest. In *Flesh*, a neighbor, Arline Stanford, whose husband had served as model for *The Lineman*, became the subject of a haunting meditation on longing, the fleeting nature of beauty, and the unexpected reversals of life. Here also Albright continued to explore the means by which he could invigorate the nonhuman elements of his compositions. To fully capture the essence of the glass bowl held in the sitter's lap, the artist looked at the object from multiple points of view, which he then synthesized into the form we see. Discussing this painting many years later, Albright declared, "We're taught about hollows. But who can tell which way [a form is] hollow? It can be convex or concave."[40] Albright's desire to capture a sense of simultaneous vision is similar to the investigations of Paul Cézanne, which in turn became central to analytic Cubism. But, as curator and writer Katharine Kuh pointed out, Albright's interest in the phenomenon of simultaneity was less concerned with structural and spatial definition

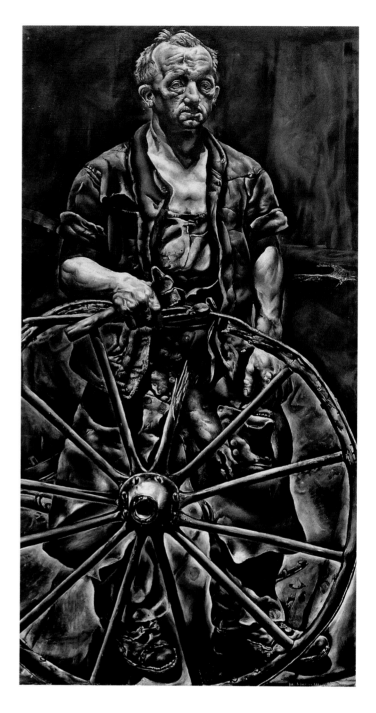

Figure 13. Ivan Albright. *Among Those Left (The Wheelright, The Blacksmith)*, 1928–29. Oil on canvas; 185.4 x 91.4 cm (73 x 36 in.). Pittsburgh, Pennsylvania, The Carnegie Museum of Art.

than with his expanding awareness of the relativity and impermanence of all things, animate and inanimate.[41]

An even more arresting half-length female from this time is *Woman* (no. 13), for which another neighbor, Vina Marion Heywood, served as model. Most disturbing about this painting is its assault on conventional feminine beauty; the sitter, whom the artist deliberately aged (she was actually thirty-six), sits before us, proud but in ruins. When *Woman* was included in an exhibition at the Toledo Museum of Art in the summer of 1929, the public outcry was so intense that museum officials removed the work from view for a short time (eventually, it was rehung). Writing the following year about this work, a critic was prompted to compare the visions of Albright and the nineteenth-century writer Edgar Allen Poe. He asked, "Why should he paint a woman with the flesh the color of a corpse drowned six weeks?" But he also admitted, "There is a frightful fascination about [Albright's work] that makes the beholder return to the scene of the torture."[42] *Woman* may have been the first painting to earn Albright the reputation of a painter of horrors.

In 1928–29 the artist painted a powerful male counterpart to his studies of the process of aging in women, *Fleeting Time* (no. 14). While Albright used bright light to magnify the sitter's facial imperfections and the ways time had ravaged his face, the image seems more forgiving than *Flesh* and *Woman*. Perhaps this is because the artist used relatively youthful models for these previous works and had to draw upon his imagination to age them, whereas, in *Fleeting Time*, he had a natural subject in his model, the seventy-eight-year-old horse trainer Byron McCain. In 1965 this painting prompted art critic John Canaday to remark: "[Here] Albright treats the theme of old age as Rembrandt [did], to show the spirit battered but indomitable, even enriched by the assault, behind the crumbling prison of the flesh."[43]

Back in California during the winter of 1929, Albright experienced severe lower-back pain and eventually had to have a ruptured kidney removed. At the age of thirty-two, he apparently considered his illness a brush with mortality. It intensified his efforts with a major composition, *Heavy the Oar to Him Who Is Tired, Heavy the Coat, Heavy the Sea* (no. 16). "I wanted to do one damned good thing before I croaked," he later told his biographer, Michael Croydon.[44] Paradoxically, in the face of his own vulnerability, Albright chose to depart from the darkness and sense of decay that characterize previous works. While, as usual, the artist set his figure in an interior (he was clearly loathe to depict figures out-of-doors, contrary to the way his father preferred to work), he did allow a little California sunshine into the enclosure and chose a palette of primary colors rather than the usual dark hues.[45]

• • • • •

"The Albright twins [have gone] far to illustrate the old libel, 'The preacher's boy is the worst boy in town.'"[46]

In 1929 Ivan and Malvin each built a studio—two modest stucco bungalows, side-by-side, next to the former church in Warrenville (see fig. 14), which they and their father continued to use to display their art. They established some rules, forbidding visits to one another's workspaces and permitting comments only after they considered their work finished.[47] For the first time, Ivan had a light-controlled studio environment of his own design. In this, and in subsequent studios, he inserted an angled skylight into the roof (see Chronology, fig. 10) and devised a system to regulate the amount and direction of the resulting overhead

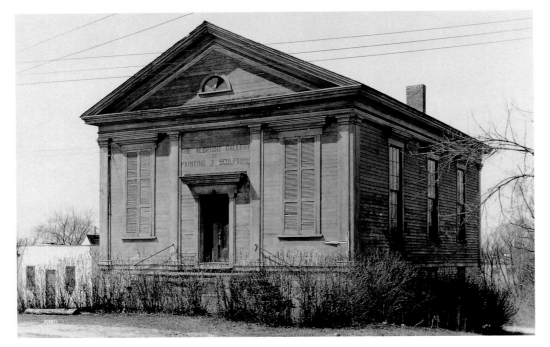

Figure 14. "The Albright Gallery of Painting and Sculpture" (later called "The Albright Studio"), the former Methodist church in Warrenville, Illinois, that Adam Emory Albright purchased in 1924 and remodeled as a studio and exhibition space for himself and his twin sons. This photograph dates from sometime after 1929, when Ivan and Malvin Albright each built a modest, Spanish Mission-style studio alongside the church (one of which is seen at the far left). Photograph courtesy Ryerson and Burnham Libraries, The Art Institute of Chicago.

illumination. "I like a powerful white light on the head," Albright declared. "[It] shows the form the most."[48] Furthermore, he painted his studio walls black. According to one report, he darkened the Warrenville studio's walls "with tempera containing three dozen egg whites and vinegar to prevent light reflections and to create a dismal atmosphere." He even wore a black shirt when he painted, to cut down on reflection.[49]

The optimistic quality produced by the high-key palette of his most significant California composition, *Heavy the Oar,* does not reappear in the figure paintings the artist produced subsequently in his new Warrenville studio—among Albright's most successful and compelling works. In *Into the World There Came a Soul Called Ida* (no. 17) and *And Man Created God in His Own Image (Room 203)* (no. 20), the artist elaborated on the surroundings into which he put his sitters, thereby expanding their meaning. His model for *Room 203* was a Warrenville neighbor, George Washington Stafford, a bartender, square-dance caller, and president of his trade union and of the local school board.[50] Albright transformed this vital and energetic, two-hundred-pound man into an inert mass of flesh. The painting's working title, *Room 203,* suggests a setting in a transients' hotel. To create the background, Albright borrowed a rickety wooden bed and the derby hat from his model and incorporated wallpaper he had steamed off a wall in the large Warrenville studio. This is an early example of Albright's need to construct elaborate setups for his paintings, expanding the single attributes associated with earlier figure studies into fully realized environments. Stafford posed for over a year for this project, a drawn-out process that became characteristic of Albright's increasingly meticulous productions. The sardonic message of the painting's final title, *And Man Created God in His Own Image,* was so controversial that, when the work was shown in the South, it was called *God Created Man in His Own Image.*[51] Whether God is a human invention, or humanity is God's, Albright gave us a sorry creature to contemplate.

Room 203 was preceded by one of the artist's most unforgettable compositions, *Into the World There Came a Soul Called Ida* (no. 17). In this painting, he developed an idea he had introduced in *There Were No Flowers Tonight (Midnight)* (no. 15), showing a dramatically lit, full-length female, seated, with legs crossed, in an enveloping darkness. The sitter for the

later canvas, Ida Rogers, was a young mother, not yet twenty years old, when she answered the Albright twins' advertisement for a model. Over a two-year period, she posed for three hours a day, splitting her time between Ivan and Malvin, who did a bust of her and a sculpture of her hands (the location of both is unknown). Rogers recalled, "[Ivan] had a little platform, a dais, and he put me on it and walked around. . . . He had little whatnots he put on the table. . . . He'd spend days and days on a little bit. . . . He was very slow."[52] Seated before a small bureau, she looks dejectedly at her image in a mirror or perhaps stares into the void beyond, as she tries pathetically to stave off the ravages of time with her powder puff. Albright transformed his attractive, young model into an archetypal, modern-day *vanitas* figure (see Weininger, pp. 61–63). The painting's symbolism was understood early on. At the time of its second public showing, at The Art Institute of Chicago, in 1931, one reviewer declared, "It is an intensive psychological study of the simple primitive universal types that Mr. Albright offers in his realistic pictures. They are the simple folk [who] have kept the world going from time immemorial whether found in Spain, Sweden or Warrenville, Ill., the priest, the man who wields the mallet, the fisherman, the blacksmith, the dreamer, and the fanatic, and the sordid 'Ida,' who, despite her tawdry accessories, is groping after soul states."[53] In works such as *Ida*, Albright challenged his father's sentimental portrayals of carefree youths living in a sunny, friendly world. Always critical of the ways Adam Emory and his generation played it safe, Ivan took chances. Ida is alone, aging, and sad; she sits in the darkness of a bleak room. There is nothing innocent about her; Albright stripped her of pretense and revealed both the vulgarity and pathos of her vulnerability.

Albright, as mentioned above, wrote poetry as a way to relieve the intensity of his painting sessions. Sometime during the execution of *Ida*, he scribbled the following on the back of an envelope:

Tis Ida the holy maiden I dream of
Too perfect her face for eyes of man
Too godlike her figure for artist to paint
She dwells best in my heart . . .
What care I for the ways of the world
For Ida—sweet Ida is my godlike girl
I dare not look at her for fear I portray
The emotion within me—will lead me astray.[54]

Albright's poem indicates that the very act of transforming Rogers into something pitiable and repugnant perhaps helped him control impossible feelings for her. On the floor, along with a handkerchief and a peanut shell, is a torn piece of paper, singed at the edges, bearing several indecipherable lines. While it evokes the scroll, inscribed with the words *omnia vanitas* ("all is vanity"), found in traditional *vanitas* compositions, the scrap, according to Croydon, is a remnant of a poem Albright had written "cursing the model's habit of continually cracking peanuts and scattering the shells on the floor." But the truth may be closer to Ida Rogers's account: "Once [Ivan] gave me a big sheet of poetry. . . . I looked at it and started to giggle, and he took it and tore it up. You know how he wrote . . . , things like 'too perfect for eyes,' and I just laughed."[55] The crumpled sheet may signify Ida's rejection of Ivan's advances.

Lisle Albright married in 1921; by 1926 he had two daughters. His siblings, on the other hand, remained bachelors, so closely allied that no other attachment seemed possible. While they had active social lives and numerous girlfriends, the twins never wandered

far from each other. For example, in the early 1930s, Ivan dated an aspiring actress, Marie Engstrand (see no. 27); and Malvin dated her sister, Ruth. In letters Ivan wrote to another romantic interest, a young student named Dorothy Elfrink, he not only chronicled his activities and achievements, but also those of Malvin.[56] Sometimes the twins befriended the same women, as was the case with Chicago artist Gertrude Abercrombie (see Weininger, note 60); and we know that Malvin regularly accompanied Ivan and his future wife, Josephine Patterson Reeve, on their dates.

Albright's interest in young women obviously created conflict in him, and he only occasionally indulged in making images of youthful female beauty. His ambivalence is apparent in an unfinished work of 1930, *Three Love Birds* (no. 22), a full-length view of a ripe and fleshy nude standing in high heels next to an unoccupied birdcage on a tall stand. A later lithographic version of this composition (no. 38) shows two birds in the cage. That he likened the young woman to a third bird, its life devoted to song (and, by inference, to love), reveals something of his attitude toward the opposite sex at the time.

•　　•　　•　　•　　•

"In spite of nationalism and regionalism a slice of bread and
a glass of wine are the same food and drink whether they are here
or in Bordeaux, and out of a paint tube come colors;
and the sun lights half the world at a time."[57]

The 1930s were busy years for Albright, even though the nation was in the throes of the Great Depression. When asked what he remembered of these bleak times, Albright said, "Oh, the Depression didn't affect me at all. I wasn't making any money. . . . I didn't know there was a Depression. . . . You know, they never bought my stuff whether times were good or bad, [so] it didn't make a bit of difference to me at all."[58] One wonders how he survived during this period. Certainly, the occasional awards he won for his art—$100 here and $300 there—could not sustain him. Neither twin seemed particularly interested in selling his artwork, since each was prone to put high valuations on it, especially Ivan. (In the 1930s, when most Chicago artists were charging $300 to $500 for an oil, Ivan listed prices ranging from $8,500 to $13,000 for his major paintings.[59]) This outrageousness may have been prompted by the twins' well-developed senses of humor, as well as a touch of arrogance: Malvin once, in print, called himself a "great artist," and Ivan later would say that his only true competition was Albert Einstein.[60] We know that Ivan did not really like parting with his works; as his wife later recalled, he became attached to them as if they were his offspring.[61] The end result of course was that the twins' art did not sell. They apparently made ends meet by doing odd jobs, in particular by renovating old houses in the Warrenville area. Under the supervision of a contractor, Ivan did carpentry (a skill that served him well in the construction of his setups) and Malvin the electrical work and plumbing. They were also undoubtedly supported by their father, whose art sales and savvy suburban real-estate investments helped him build a reasonably solid financial situation. The relative absence of financial stress may explain in part why Ivan Albright did not become radicalized or his art politicized, as happened with so many of his contemporaries. In addition, Albright was, by his very nature, an intense individualist, which probably made him loathe to join forces with others and underlay his essentially conservative political views.[62]

In the early 1930s, Albright experimented with sculpture, even though he was supposed to leave the medium to his twin. He was clearly predisposed to exploring three-

dimensionality, always seeking to capture a sense of volume in his paintings. As he once explained, "The straight-on . . . sight of an object [appears] flat, and if you paint with only that one viewpoint, you paint flat. One must think all around an object all the time in order to make it appear solid."[63] His first clay model since his student days, *Now a Mask* (no. 19), dates from 1930 but was not cast in bronze until the 1960s. The artist's penchant for dramatic disfiguration appears in the sculptured head of his girlfriend Marie Engstrand (no. 27), in which the young woman's face, fashioned by crude and rapid modeling, appears masklike, more a suggestion of the sitter than a likeness. In 1935 Ivan made a bust of Adam Emory at age seventy-three (no. 30). He deliberately approached the left and right halves of his father's image differently, working one side into greater finish than the other, and leaving the back incomplete. The imbalance this creates, along with the exaggerated, elongated form of the head and neck and the rough, expressionistic handling of the surface, brings to mind similar—albeit later—images by the Swiss artist Alberto Giacometti, whose work Albright would come to admire. According to Ivan, Adam Emory was "furious" with his son over the conception of this work.[64] The elder Albright later joked about his rebellious twins: "If I like something they've done, they paint it out."[65] The ever-defiant Ivan must have enjoyed the power not only to infuriate his father but also to redefine and reshape, according to his own vision, this *éminence grise* in his life.

Despite Albright's aversion to polemical art, he did participate in the first of the New Deal art programs, the Public Works of Art Project (PWAP; see Weininger, pp. 68–70). In addition to *The Farmer's Kitchen* (no. 31), which, more than anything else he did, conforms to the guidelines for artists supported by federal funds to depict typical American scenes, he produced an intriguing self-portrait (no. 28). Rather than portray himself as an artist or worker—as did many others employed by New Deal projects—he appears here as a man-about-town, wearing a bow tie and vest, seated behind a table holding a large, glass dish poised to catch the ashes that will fall from the cigarette he smokes in a holder. The PWAP lent this painting to the 1934 Century of Progress exhibition, at the Art Institute, which resulted in the artist attracting his first major patron. The Chicago advertising executive Earle Ludgin, who, along with his wife, Mary, was to amass a significant representation of the artist's work (see Weininger, fig. 8; and nos. 16, 29, 30, 43, 47, and 48), was so taken with Albright's depiction of himself that he asked the artist to paint a second version (no. 29).[66] Generally regarded as his most accomplished self-portrait, the Ludgin canvas is similar to the first, except that it is more elaborate, especially in the area of the still life, which now includes wineglasses and a decanter. Although Adam Emory was a teetotaler, Ivan is known to have enjoyed his liquor, so he must have been pleased to witness the end of Prohibition in 1933—two years before this painting was executed. On the round stopper of the decanter can be seen a miniature, upside-down reflection of the artist. The inclusion of this second, tiny self-image might reveal, albeit unconsciously, something about Albright's life as an identical twin, always cognizant of Malvin, his double.

As he began to assemble more and more objects for inclusion in his figure paintings, Albright became increasingly interested in still life as an independent genre. In 1944 *Life* proclaimed his 1931 composition *Wherefore Now Ariseth the Illusion of a Third Dimension* (no. 21), which it reproduced in color, "not only Albright's greatest masterpiece of still-life painting but perhaps the best that has ever been done in this country."[67] In this complex and ambitious composition, the artist confronted such difficult issues as the definition of space and time. Convinced that these concepts, along with others such as motion, color, and form, are not constants but are instead human inventions, he saw reality as a mental projection: "If I stir, [objects] stir. If I stand arrested, they become motionless."[68] Thus, to

suggest the way we actually experience things, the way we make them come alive, Albright moved around his subjects, examining them from every possible perspective. Rather than unifying the composition, the light, as it bounces off and through objects, becomes "an instrument of fragmentation."[69] The result is a dynamic, dizzying composition that surges up and down, in and out, back and forth, with a top and bottom that seem totally arbitrary. In the 1970s, the artist would return to the idea of an all-over composition (see no. 66a and 66b) that can be appreciated from a number of vantage points by turning the canvas sideways or upside down.

· · · · ·

"The body is our tomb."[70]

In 1931, the same year he painted *Wherefore Now Ariseth*, Albright began work on two other compositions, *Show Case Doll* (no. 23) and *The Door* (no. 24). For both of these meditations on death, he chose a long, rectangular format, not unlike that of a coffin. In the enigmatic *Show Case Doll*, a sweet-faced, recumbent doll, her arms upturned and legs twisted, lies in what appears to be a glass display cabinet. Since the artist considered this composition to be among his most important,[71] it is curious he never completed it. But its unfinished state reveals the artist's painstaking technique and skill as a draftsman. For ambitious undertakings such as this, Albright typically spent weeks gathering and arranging elements for his setups. This accomplished, he drew the entire composition in all its detail, with charcoal, on prepared canvas (in his later years, he primed his surfaces with a mixture of zinc white and glue).[72] Albright's extraordinary abilities as a draftsman are demonstrated here in his successful definition of a variety of patterns, textures, and surfaces in the not-very-exact medium of charcoal.[73]

Only when the charcoal drawing was complete and he had applied fixative did Albright begin to employ color. Because he had already worked out what the composition would look like when finished, he could concentrate on specific areas of the painting, bringing each to completion separately. Toward the end of Albright's life, the museum curator and director Jan van der Marck observed him working on *The Vermonter* (no. 60):

After fixing the drawing . . . , he begins to paint right over it, averaging one half of a square inch each five-hour working day, and never retouching or correcting what has been finished the day before. He grinds his own colors, mixes them with poppy instead of linseed oil, uses hundreds of Winsor and Newton brushes, sizes 1 to triple 0, cut down to a single hair, and scorns varnish. For each object pictured, Albright arranges a separate palette to fit that object's local color, and he distributes his colors in a triple row of minuscule mounds. The resulting thinly painted surface tends to have the iridescence of oil-stained water. At the end of each working day he puts tiny pins in what has served him as a model to locate the area from where to continue the next morning, and on his canvas he pinpoints the corresponding area with minute white specks.[74]

In *Show Case Doll*, only a few, small areas of the doll's face are colored. The composition's central theme—the immutability of death and the tragedy of a life not fully lived— was so potent for the artist that he pondered it in a concurrent composition, which at the time he was calling *The Door*. He found himself torn between the two paintings:

I had ["The Door"] . . . and . . . "Show Case Doll" . . . started. I worked on one in the morning and one in the afternoon. . . . I found that I was running back and forth from one [setup to] the other. The light would get good over one, say "The Door," and I'd run over and work on it. Then I'd run back to the other one. Finally I said to myself . . . , Albright, make up your mind; it's got to be one or the other.[75]

Figure 15. Ivan Albright with his setup for *The Door* (no. 24), in Warrenville, Illinois, 1941. Photograph by Lester B. Bridaham.

Figure 16. Detail of frame carved by Ivan Albright for *Room 203* (no. 20).

In the end, he picked *The Door* (no. 24), which took ten years to complete. Albright scavenged far and wide for the components of this painting's setup. He found the door in a Chicago junkyard ("I looked around until I found an old door that looked kind of drab, like [something out of] Charles Addams or from a ghost house. . . . You want to pick something that looks as if it's lived its life"). He bought an artificial funeral wreath, preferring it when it began to fade (he ended up having to buy several over the years); and paid thirty-five cents for a discarded door sill. The model whose hand he used ("I thought a girl's hand would give it a little human interest") posed two hours every Sunday for two years; understandably, she lost her patience and stopped coming, forcing the artist to make a plaster cast (see fig. 15), which he discovered suited him well.[76] The initial frame (location unknown) Albright made for the composition reinforced the painted door's warped shape and its strong expression of death. The frame had curved sides and was edged with actual casket lining. He told an interviewer, "I carved three figures for each side like casket handles. I laid them with silver leaf, and I sent [the painting] to the Carnegie International exhibition [in 1938], . . . but they wrote about the frame instead of the picture."[77] When the work was finally completed and exhibited in Chicago in 1941, it bore a conventional surround.

Albright often made frames for his compositions by refurbishing old, wooden ones, to which he added carved and/or routed designs (see fig. 16).[78] While his female figure study *After the Race* (no. 32) seems unfinished, it is bordered by an elaborately carved wooden

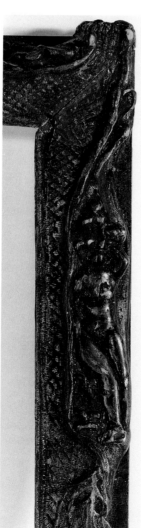

frame, dating probably from the nineteenth century, which the artist covered with silver paint and embellished with pieces of inlaid mirror. A smaller still life from 1940, the oddly named *This Ichnolite of Mine* (no. 39), features a frame studded with marbles and bits of mirror.

By the summer of 1930, Albright's reputation was sufficiently developed to warrant his first one-person show. Nine paintings were included in the "First Collected Exhibition of American Paintings by Ivan Le Lorraine Albright," in the art gallery of the Walden Book Shop, located on North Michigan Avenue, Chicago.[79] The following summer, fourteen of his paintings went on view at The Art Institute of Chicago, in an exhibition Albright shared with a pair of Chicago artist-brothers, George and Martin Baer.[80] The critics took notice of him. One, who noted Albright's "infernal skill," likened his images of women to a passage from Milton's *Paradise Lost*: "No light, but rather darkness visible." Another praised him as "one of Chicago's strongest independents," and went on to say, "Albright's art is a sort of distilled realism. Not made to sell but rather for the sheer fun of painting them, his pictures may belong in museums rather than in homes."[81] That his career was on the rise in the 1930s is indicated by a number of firsts he experienced: In 1932 he was invited to participate in the Whitney Museum of American Art's first biennial. The next year, he had his first solo exhibition outside Chicago, at the Dayton Art Institute, Dayton, Ohio, followed two years later by another in West Virginia.[82] He was now frequently mentioned in the national art periodicals; and in 1936 he was

the subject of an article in the national magazine *Esquire*. He was invited to teach figure painting at The School of The Art Institute of Chicago in 1938; and, the following year, he wrote the first of several book reviews that he would publish in Chicago newspapers.[83]

• • ● ● •

"Ivan Le Lorraine Albright is becoming a legend of Dali-esque proportions."[84]

The 1940s proved to be momentous for Ivan Albright, both professionally and personally. His work appeared in more prestigious exhibitions than ever before (or ever again). These included important shows at museums in New York and London. His ten-year opus, *The Door*, now poetically titled *That Which I Should Have Done I Did Not Do*, was completed in 1941; and at each of the exhibitions in which he showed it—in Chicago, Philadelphia, and New York—it won a top prize. Most significant among these was first place in "Artists for Victory: An Exhibition of Paintings, Sculpture, Prints" at The Metropolitan Museum of Art, New York. The $3,500 purchase award would have placed *The Door* in the permanent collection of America's foremost art museum. But, in Albright's opinion, the painting was worth much more; he priced it at $125,000, an extraordinarily high figure for a living artist just establishing a national reputation. He turned down the prize, accepting instead a First Medal, which allowed him to keep the composition.[85]

In 1941 The Art Institute of Chicago purchased its first work by Albright, *Ah God, Herrings, Buoys, the Glittering Sea* (no. 35). The museum's director, Daniel Catton Rich, said at the time, "I consider Ivan Albright one of the most original artists in America today. His vision is as extraordinary as his technique. . . . As a still life, [*Ah God, Herrings*] is far more than an exercise—it is full of meaning, as well as remarkable paint quality."[86] The artist rarely used oil to depict landscape (see, however, *Divided and Divided* [no. 36], focusing on a coastal spot on Deer Isle, Maine), reserving it for his figurative and still-life compositions. Nonetheless, he enjoyed depicting the out-of-doors especially on his travels, using such mediums as gouache, pen and ink, pencil, and watercolor for quickly realized images. He explained his preference for the figure and still life over landscape as follows: "I find that my thumb close up is as big as the highest mountains of the Andes or the Alps—I would in that case rather paint my thumb, because I can get around it easier and see what it is all about."[87]

In 1942 Albright was named an Associate of the National Academy of Design (he was elected a full Academician in 1950), one of many honors he was to receive over his career. In July of that year, he was featured in an article in *Time*, accompanied by an almost full-page reproduction of *Ida* and a smaller one of his 1935 *Self-Portrait*.[88] In 1942–43 Albright's painting *Room 203* was included in a traveling exhibition of modern portraiture organized by curator Monroe Wheeler of The Museum of Modern Art, New York. The Albright twins were both represented in the exhibition "American Realists and Magic Realists," organized by the Modern's founder and director Alfred H. Barr, Jr., and curator Dorothy C. Miller. This exhibition, which was seen in Buffalo, Minneapolis, San Francisco, Toronto, and Cleveland as well, included eleven paintings by Ivan (see nos. 9, 13–16, 18, 21, 24, and 29). Malvin was represented with two paintings—both among his most outstanding—*Victoria* (Weininger, fig. 27) and *Girl in Red* (private collection).[89]

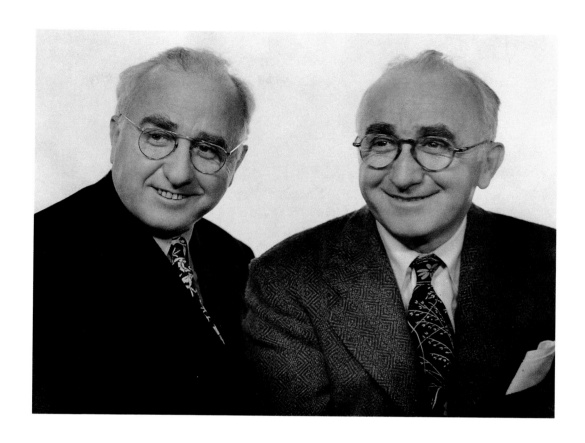

Figure 17. Left to right: Malvin and Ivan Albright, in a publicity photograph taken during their work on "The Picture of Dorian Gray," Hollywood, California, 1943/44. Photograph © 1945 Turner Entertainment Co. All rights reserved.

• • • • •

> "All art is at once surface and symbol.
> Those who go beneath the surface do so at their peril. . . .
> It is the spectator, and not life, that art really mirrors."[90]

In 1943 Ivan was invited to Hollywood by the writer and director Albert Lewin to execute the eponymous painting for a movie version of Oscar Wilde's 1891 novel *The Picture of Dorian Gray*. The work that resulted (no. 41) became, in a way, the star of the motion picture and made one of its creator. In Wilde's Faustian tale, the young, handsome, and innocent Dorian Gray has his portrait painted by his artist-friend Basil Hallward. Contemplating the finished work, the young sitter wishes that he could always remain as his portrait depicts him. His wish is fulfilled, but at a terrible price. Gray proceeds quickly to sully the perennial youth he is granted through debauchery and evil. Although his physical appearance does not change, his heinous deeds are horrifyingly inscribed on the painting, which physically reflects his moral decay and reveals the sordid truth of his life.

While it is not known how Lewin selected Albright for his project, he could have seen the artist's work in a national magazine or have been made aware of the artist through the aforementioned exhibitions at the Metropolitan Museum and the The Museum of Modern Art, New York. Certainly Lewin would have been drawn to an artist whose work prompted one very upset critic to proclaim *Room 203* "the most hideously cynical picture" in the Modern's twentieth-century portraiture exhibition.[91] However Lewin came to Albright, he found the perfect artist to do justice to the *vanitas* theme central to Wilde's combination horror-and-morality tale. As one critic put it, "Albright is a writers' artist . . . , and his paintings seem to reflect their values." For his part, the artist became deeply involved in Wilde's novel, copying whole portions of it into a notebook.[92] Albright seems to

have found the narrative particularly resonant, both philosophically and personally. Here is a story about a man with a split personality, who was able to use his double—a portrait—to achieve eternal youth. The portrait, which he locked away in the upstairs nursery where he had once played and studied, allowed him to lead an unspeakably evil life that, secretly and steadily, transformed his painted double into a terrifying ghoul. Whether or not Ivan and Malvin ever thought of themselves, or were distinguished by others, as "good" and "bad" halves is not clear. But we do know that, in addition to being the more inventive and talented of the two, Ivan was, by all reports, more aggressive, blustery, and rebellious than the more sensitive and easily hurt Malvin. It is therefore fitting that Malvin ended up painting the unsullied portrait of Dorian Gray (fig. 19) and Ivan its demonized counterpart.

∙　∙　●　∙　∙

> "Albright arrived [in Hollywood]—two of him. 'His name's Malvin,'
> [Ivan said]. 'No, it's Zsissly,' corrected Malvin. 'My painting name.
> Never used the Malvin. Too confusing.'"[93]

The Hollywood publicity machine went to work promoting Albright's participation in the film, and rumors abounded that he was to earn $75,000 for his work.[94] While one columnist reported that he was to do two paintings, most of the papers claimed he was hired to do four, showing Gray in various stages of decay. Given the artist's perfectionism and painfully deliberate working methods, it seems unlikely that he would have agreed to a series of pictures. As for the amount Albright was paid, he did not discourage reports that he was earning large sums for his art. But, in fact, the artist's contract with Metro-Goldwyn-Mayer states that, beginning in October 1943, he was to earn $10,000 for his work, plus expenses, including round-trip rail transportation between Warrenville and Los Angeles.[95] It was also

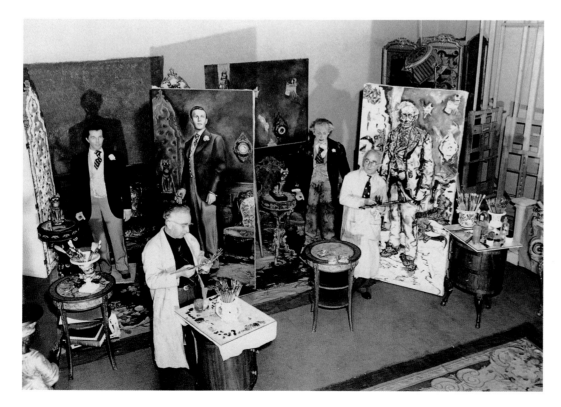

Figure 18. Publicity photograph showing, left to right: Malvin and Ivan Albright with their Dorian Gray setups, dummies, and paintings (fig. 19 and no. 41), Hollywood, California, 1944. Photograph © 1945 Turner Entertainment Co. All rights reserved.

Figure 19. Malvin Marr Albright. *Picture of Dorian Gray*, 1943–44. Oil on canvas; 216 x 106.7 cm (85 x 42 in.). Private collection, Seattle.

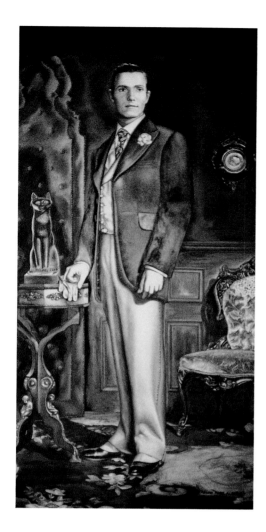

reported that Ivan arrived in Hollywood with Malvin without having told MGM that his twin was part of the deal. Ivan was quoted by one reporter as explaining, "My brother . . . always goes where I go. Never separated in 47 years."[96] In fact, while Ivan did insist that Malvin figure in the arrangement, he did not spring him on MGM without warning. The contract specified that Malvin was being hired to assist Ivan, that both would be paid for their transportation across country, and that each would receive a per diem.

The Dorian Gray project kept the Albright twins in Los Angeles for almost a year. Malvin finished his portrait of the good-looking youth in four months.[97] As it turned out, his painting was not used in the film. According to one insider, "Some genius decided [that] their pristine Dorian wasn't sufficiently sex-appealing. A commercial artist [the Portuguese-born painter Henriqué Medina] was smuggled in and given the task of prettifying . . . Hurd Hatfield [the actor who starred as Gray]. The Albrights weren't supposed to suspect."[98] Ivan's portrayal of Dorian Gray had to be completed in eleven months, a constraint the artist had never before encountered. He followed many of his habitual techniques—gathering props for an elaborate setup, having mannequins of Hatfield constructed (see fig. 18) so the twins could work when no model was available.[99] While the movie was shot in black and white, for shock effect, two of the times Ivan's painting is seen on screen, it appears dramatically in full color. For these inserts, his painting was to be filmed under powerful klieg lights, which prompted him to intensify his palette, to compensate for the loss of color that inevitably would occur. This was to have several long-lasting effects on his subsequent work. Not only would he begin to experiment with a lighter and more brilliant palette, but he would also continue to use a system of painted "color wands" or "sticks" that he had devised in order to determine the hues his Dorian Gray canvas required. Most easily described as resembling lollipops (see no. 61), the color wands, when held up to the eye and stared at intensely under strong light, produce afterimages in varying, opposite colors. Albright was interested for many years in such aftereffects and would employ them in the future (see, for example, nos. 42, 60, and 66a and 66b).

While "The Picture of Dorian Gray" was not a commercial success, it was nominated for three Academy Awards (winning one for cinematography) and has since become a cult-film classic.[100] It firmly established Ivan Albright's notoriety and, for a brief moment, a wave of public interest in art. After filming was completed, the two artists returned to Warrenville with their Dorian Gray canvases—per the contract with MGM, they were allowed to retain possession of their artwork—and began to exhibit them (see Weininger, fig. 1). When Ivan's painting was shown at the annual American Exhibition at The Art Institute of Chicago in 1945 (see Chronology, fig. 14), the *Chicago Sun* reported that the work had clearly helped attract over twenty thousand more visitors than normal to the exhibition and sell an unusually high number of catalogues.[101]

The use in films of original artwork so intrigued Albert Lewin that, for his next film, "The Private Affairs of Bel-Ami" (1947), based on a novel by Guy de Maupassant, he and writer Harriet Janis, wife of the art critic and future dealer Sidney Janis, organized an international competition. Unlike the open invitationals sponsored by museums, in this competition, eleven artists, "only artists of highly creative talent, among them some of the foremost of our time," were invited to participate: Americans Ivan Albright, Eugene Berman, O. Louis Guglielmi, Horace Pippin, Abraham Rattner, and Dorothea Tanning; the Belgian painter Paul Delvaux; British painters Leonora Carrington (then living in Mexico) and Stanley Spencer; the German artist Max Ernst (who had emigrated during World War II to the United States); and the Spanish master Salvador Dalí. They were given four months to produce work on the theme of the Temptation of Saint Anthony,

which they were to submit to a jury consisting of Alfred H. Barr, Jr., artist Marcel Duchamp, and Sidney Janis.[102]

For Albright the chance to treat the subject of Saint Anthony—the terrible struggle of a man who must overcome his attraction to the material and sensual temptations of physical life in order to reap the spiritual rewards of ascetic existence—and to compete in such an international arena must have been greatly satisfying. Painting in his Warrenville studio, he managed to complete his submission (no. 42) on time. While Ernst's was the winning composition (see Chronology, fig. 15), Albright's took second place (Delvaux's came in third).[103] Harriet Janis praised Albright's painting in *Arts and Architecture* magazine:

Combining [Anthony's] phase of lust with the advanced stages of emotional crisis, Albright turns out a molten, writhing mass of animate and inanimate degradation that literally glitters with evil.... This painting, like Ernst's, is ... similar in spirit to a Cranach woodcut.... Yet the mythological hybridization of animals, birds and reptiles in such German "Temptations" is replaced in the Albright by a realistic presentation of these existing on the American scene—jackals, mice, rats, bats, moles, frogs, sturgeon, salamanders, serpents—cannily painted to strike animalistic terror in the heart.[104]

Janis's use of the word "molten" is apt, for, as Albright later told Michael Croydon, the range of florid colors that the artist spun into a kaleidoscope of forms was inspired by his memory of the extraordinary colors and shapes of burnt glass after a fire at a neighbor's house.[105] In the context of his oeuvre, this painting is notable in that he seems not to have used a setup, creating the composition entirely from his imagination; and in being practically the only major work by him to include more than one figure.[106]

•　•　•　•　•

"Alike as the brothers are in build and feature . . . , their work is entirely different."[107]

"There are also moments when [Albright] paints exactly like Zsissly, and since half the time Zsissly paints just like Albright, the effect is confusing."[108]

In 1945–46 the Associated American Artists sponsored what it misleadingly called the "First Joint Exhibition: The Albright Twins." In fact, in the spring of 1942, Ivan's and Malvin's work had been exhibited together at the Findlay Galleries in Chicago. Evidently, because the brothers had shown mainly watercolors, this earlier event stimulated relatively little interest.[109] In any case, the Associated American Artists show was the first time their art was featured together in New York, and the brothers made sure that their most important works were included. Installed in the association's Manhattan gallery in the fall of 1945, the exhibition continued, in somewhat altered form, at its Chicago space in the early spring of 1946. Among the twenty-eight works by Ivan listed in the catalogue are many of his major figure compositions in oil from the mid-1920s on (see nos. 5, 7–17, 20, 22, 23, and 32).[110] The reviews were mixed. *Newsweek* reported, "Many visitors—including most artists—were horrified by the fantastic amount of bad painting in the show—hammy things, inept things, and tricks." Some of the critics found their art confusingly similar; others were struck by the differences. "Zsissly's work is as deliberately simplified and light as Ivan's is detailed and somber," wrote one. "What has been long indicated," stated another, "now becomes entirely apparent: that while Zsissly's painting is able, animated,

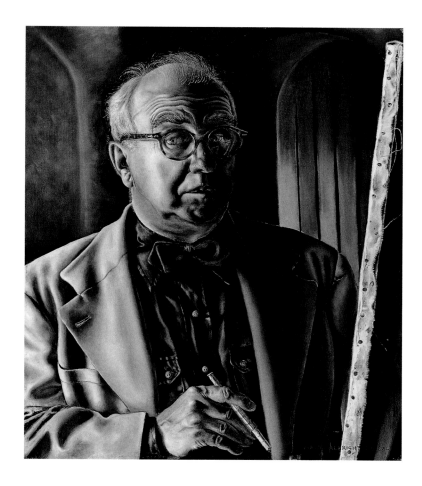

Figure 20. Left: Ivan Albright. *A Guttated Self-Portrait—A Nutant Lycanthrope Seen in Glass*, 1942. Gouache on paper; dimensions and location unknown.

Figure 21. Right: Malvin Marr Albright. *Self-Portrait at the Easel*, c. 1948. Oil on canvas; 61 x 50.8 cm (24 x 20 in.). Private collection. On loan to The Art Institute of Chicago (52.1994).

and resourceful, Ivan's discloses a remarkable mind and talent. . . . His talent, contrasting sharply with his themes, is vigorous, zesty, and vitally keen."[111]

Although Ivan was quick to express what he felt to be the limitations of the art of his father and his father's generation, he was always supportive in his comments about Malvin's work. The very few published statements by Ivan about Malvin's art are positive or, at the least, objective: "Malvin always strove for wholeness in his work. I wanted to break up form."[112] This can be seen in self-portraits they each did in the 1940s, Ivan's *Guttated Self-Portrait—A Nutant Lycanthrope Seen in Glass* of 1942 (fig. 20)[113] and Malvin's *Self-Portrait at the Easel* of about 1948 (fig. 21). Ivan's now-lost gouache is much more direct than the dandyish self-representations that preceded it (nos. 28 and 29), in which he used a still life to separate the viewed from the viewer. In *Guttated Self-Portrait*, the artist's casual attire—cap, wire-rimmed glasses, open work shirt exposing a hairy chest—and his frontal position up close to the picture plane combine to give the work great presence, even in a black-and-white reproduction. While clearly introspective and well-executed, Malvin's more traditional image was achieved with smooth forms and unifying light that produce a less confrontational and ultimately less original result.

The overall positive response to the exhibition prompted the Associated American Artists to commission large-edition lithographs from both Malvin and Ivan. Ivan had begun to explore this medium in 1931, with his friend and fellow Chicago artist Francis Chapin. Chapin had access to a lithographic press at the School of the Art Institute. Albright's initial attempts were often compromised by such major accidents as broken stones. This would explain why so many of his early lithographs were produced in tiny editions (see nos. 25, 37, 38, and 43). Moreover, unlike most of the social realists of his day,

Albright was not compelled out of a sense of moral responsibility to distribute his images as widely as possible by making multiples of them. When he and his brother were given the opportunity to produce large-edition lithographs, they both decided to reprise earlier paintings: Malvin selected *Victoria* (Weininger, fig. 27) and Ivan his 1928–29 oil *Fleeting Time* (no. 14). Redrawn by the artist with great care, *Fleeting Time* was printed by the association's master printer George C. Miller. This was not the first lithograph Ivan had executed based on a previous composition; he produced nine such prints over his career, beginning in 1938 with *Heavy the Oar* (no. 37; see also no. 48). While the majority of these prints replicates original paintings, the medium also gave the artist an opportunity to fill in portions of unfinished compositions, as in *Three Love Birds* (no. 38); or to create still other versions of his paintings, as in a lithographic self-portrait (no. 43) that incorporates details from two earlier oil self-portraits (nos. 28 and 29). Only two of his sixteen lithographs are landscapes (see no. 56).[114]

In 1946 *The Door* figured in "American Painting from the Eighteenth Century to the Present Day," a major exhibition of over two hundred works, at the Tate Gallery, London. The show opened just after the end of World War II, at a moment when the British were enthusiastic and curious about anything American. Some of the twentieth-century artists featured, in addition to Albright, were Preston Dickenson, Morris Graves, Walt Kuhn, Ben Shahn, and Grant Wood. But Albright's European debut was particularly spectacular: "Albright, as the [London newspaper] *Daily Mail* reported, 'stole the show.' *That Which I Should Have Done, I Did Not Do* packed them ten deep around."[115] Albright again placed the prohibitively high price of $125,000 on the painting. But he clearly did not intend to part with it; it was destined to be a wedding gift for Josephine Patterson Reeve, whom he married later that year.

•　●　●　●　•

"Good time to get married and have it stick."[116]

Sometime in 1943 or 1944, Ivan Albright was introduced to Josephine Medill Patterson Reeve (1913–1996) at the home of mutual friends, the artist Clinton King and his wife, the former Narcissa Swift. On August 27, 1946, they were married in a small ceremony in Red Lodge, Montana; their only witnesses were Malvin Albright and Alicia Patterson Guggenheim, Josephine's sister. The groom was forty-nine; his bride thirty-two. By her early thirties, Josephine Medill Patterson Reeve (see no. 50) had already lived a remarkable life. She was the younger daughter of Captain Joseph Medill Patterson (1879–1946; see no. 57). Patterson, who retained his World War I army title, much as his cousin Robert McCormick was called Colonel while he ran the *Chicago Tribune*, was founder, editor, and publisher of the *New York News*, grandson of the owner of the *Chicago Tribune*, and its major stockholder.[117] The newspaper magnate was particularly demanding of his namesake, pushing her relentlessly to achieve. And achieve she did: Her several careers included becoming, in her late teens, a licensed mail pilot, followed by a stint as a crime reporter for the *Tribune*'s rival paper, the *Chicago Daily News*. From 1949 to 1952, she wrote a column about her family, "Life with Junior," for *Newsday*, which was published by her sister. An intrepid traveler, she reportedly left her debutante party to go to India with Alicia, where Josephine bagged a tiger. In the 1930s, she assumed ownership of an Illinois dairy and pig farm, turning it into a successful business; later at Three Spear Ranch, her property in

Dubois, Wyoming, she raised horses. The feisty and fearless woman was also a philanthropist, giving much time and financial support to animal-rights causes and, after her sister's death, establishing the Alicia Patterson Foundation to provide fellowships for journalists. In 1968, when she was fifty-five, she received a degree in liberal arts from Goddard College, Plainfield, Vermont.[118] At the time Josephine and Ivan met, she was separated from her husband, Jay Frederick Reeve (they were divorced in 1944), with whom she had had two children, Joseph (born 1936) and Alice (born 1940). She and Ivan began to see each other (as "pals," Josephine later stated), and Malvin always accompanied them. For about two years, Josephine, who was substantially taller than her husband-to-be, went out for a weekly dinner with an Albright twin on each arm. According to a friend, on the first night Ivan took Josephine out alone, he proposed to her.[119]

Ivan's decision to marry effected profound transformation in his life. He adopted Josephine's children from her first marriage (see fig. 22 and Chronology, fig. 20). While he continued for a while to work in his studio in Warrenville, he moved, with his new family, to a large townhouse at 55 East Division Street, on Chicago's fashionable near-north side. A son, Adam, was born in 1947; a daughter, Blandina, followed, in 1949 (see fig. 22). Albright and his family now moved in two worlds—one of artists and the other of people with social and civic prominence—worlds they brought together at frequent parties and events. Changes in Albright's life are suggested in the lithographic self-portrait he made in 1947 (no. 43). The print's background is filled with details of his new home; the foreground still life includes an opulent, silver cooler holding a bottle of champagne or wine and a cut-glass cigarette box embellished with silver.

In addition to their townhouse in Chicago and the ranch in Wyoming, the Albrights spent time at Josephine's sister's estate in southern Georgia, along the St. Mary's River, a property they eventually inherited. At each of these locations, Albright set up a studio (see

Figure 22. Back row, left to right: Alicia Patterson Guggenheim, Blandina, Ivan, Josephine, and Adam Albright; front row, left to right: Alice and Joseph Albright, Three Spear Ranch, Dubois, Wyoming, 1954.

Chronology, figs. 22 and 27). After his marriage, he commuted from Chicago to his Warrenville studio, but then decided to work closer to home, occupying a studio briefly at 1521 North State Street (this space is probably that depicted in the background of a self-portrait [no. 45]). In 1948 Albright purchased a building at 1773 Ogden Avenue (see fig. 23 and Chronology, fig. 25) in Chicago; the building's subsequent remodeling included the addition of an elaborate skylight that allowed Albright to work with controlled, natural light, as he had done in his Warrenville bungalow studio. He painted here until 1963, when the city prepared to tear down the building to make way for a shopping mall, precipitating the family's move to Woodstock, Vermont.[120]

Ivan's marriage inevitably altered his relationship with his twin, which must have already been strained as Ivan's career took off and Malvin's did not. We know that Malvin spent time—typically holidays—with Ivan and his family in the early years of the marriage. The twins continued to exhibit in the same shows and participate in Chicago artists' circles. For example, early in 1947, the Chicago restaurateur, artist, and art patron Ric Riccardo commissioned six large paintings depicting the arts to hang over the bar in his restaurant. These included Ivan's *Drama (Mephistopheles)* (fig. 24) and Malvin's *Sculpture* (private collection).[121] Over the years, the art crowd gathered for raucous good times at Riccardo's (see Weininger, fig. 1). In 1950 it was the site of the "Albright Family Exhibi-

tion." This marked the first occasion the work of Adam Emory, then approaching ninety (see Chronology, fig. 21) and that of the Albright twins were exhibited together; it prompted the inevitable comparisons. The senior Albright, critic Frank Holland informed his readers, was "represented by a series of typical works—barefoot children on sun-lighted paths—in direct and almost violent contrast to the paintings of his internationally known sons—particularly to those of Ivan."[122] Another reviewer noted: "Malvin Mar [*sic*] seems to be more one with his father than is his brother."[123] Ivan and Malvin showed their portraits of Dorian Gray; in addition, Ivan included *Three Love Birds* (no. 22) and Malvin four views of Maine.

In 1954, when he was fifty-seven, Malvin married Cornelia Fairbanks Poole Ericourt, who, like Josephine, came from a prominent newspaper family.[124] They had no children, and divided their time among residences in Chicago, Florida, and Maine. In quick succession, the twins lost their father (he died in 1957) and their brother (Lisle passed away the following year;

Figure 23. Ivan Albright's studio at 1773 Ogden Avenue, Chicago, where he worked from 1948 to 1963.

Figure 24. Ivan Albright. *Drama (Mephistopheles)*, 1947. Oil on canvas; 228.6 x 106.6 cm (90 x 42 in.). New York, Sid Deutsch Gallery.

Clara Albright had died in 1939). Over the next thirty years, Ivan and Malvin rarely saw each other, communicating, for the most part, over the telephone. When they spoke, they found that they often had been thinking the same thoughts and sometimes even wearing similar ties.[125] Despite the fact that they each succeeded at leading an independent life and career after reducing their interaction to a minimum, one wonders just how separate they ever really were.

• • • • •

"There are few pictures as alarming as those of Albright."[126]

A number of years before his marriage, Ivan Albright had begun a painting that would preoccupy him, on and off, for the next nineteen years. He worked on his epic *Poor Room— There Is No Time, No End, No Today, No Yesterday, No Tomorrow, Only the Forever, and Forever and Forever without End* (no. 40), which he provisionally called *The Window*, in three campaigns: from 1942 until 1943, when he became absorbed by Hollywood-related projects and then his marriage; from 1948 until 1955, when he stopped to focus on a commissioned portrait (no. 51); and from 1957 until 1963, when he finished it. The setup he constructed was particularly ambitious, involving a wall (see fig. 26) he built himself using bricks he selected for their color, framed by dead apple-tree branches and encrusted with wasps' nests (he elaborated the encrustation in the painting; in photographs the setup looks much more spare). Through a window in the center, hung with dusty lace curtains, we see a room (see Chronology, fig. 26) conceived like a stage set and with numerous props ("philosophical toys," as he called them[127]) scattered about. A slashed hand rests on the window sill. We are meant to understand that something violent and terrible has occurred.

Once the artist had finalized this elaborate setup,[128] he drew a detailed master plan to guide him in his color choices, lighting direction, placement of objects, and sight lines. Finally, he spent nearly a year drawing the complex composition in charcoal on his white, gessoed canvas. He filled many notebooks with sketches, diagrams, and comments to help him along the way. When the artist moved his studio from Warrenville to Chicago, he numbered each component of the setup so he could reconstruct it exactly. But since this proved impossible, he had to regesso the canvas and execute another charcoal drawing from scratch (see fig. 25).

He stretched the canvas over a device of his own design; made of lead piping, it was flexible enough to bend in the direction of the light he sought for each particular portion of his painting, and provided adjustable corners for painting at awkward angles. Because the composition's execution spanned decades during which Albright became well known, its progress was documented in articles, photographs, and even in film.[129] A 1950 article in *Art News* on the painting reveals that, some thirteen years before he considered *Poor Room* complete, its final composition was more or less established.[130]

In 1951 the French artist Jean Dubuffet visited Chicago to deliver an important lecture, "Anticultural Positions," at the city's Arts Club, which was hosting a show of his work.[131] Evidently, on a tour of the Art Institute, he was deeply impressed by *The Door*, then on temporary loan from Albright; and the museum's administration arranged for the two artists to meet. At Albright's studio, Dubuffet saw, among other things, *Poor Room* and its setup. Some years later, he wrote of the work:

Of our former ideas of beauty, nothing remains. For them is substituted a howling tumult, . . . a

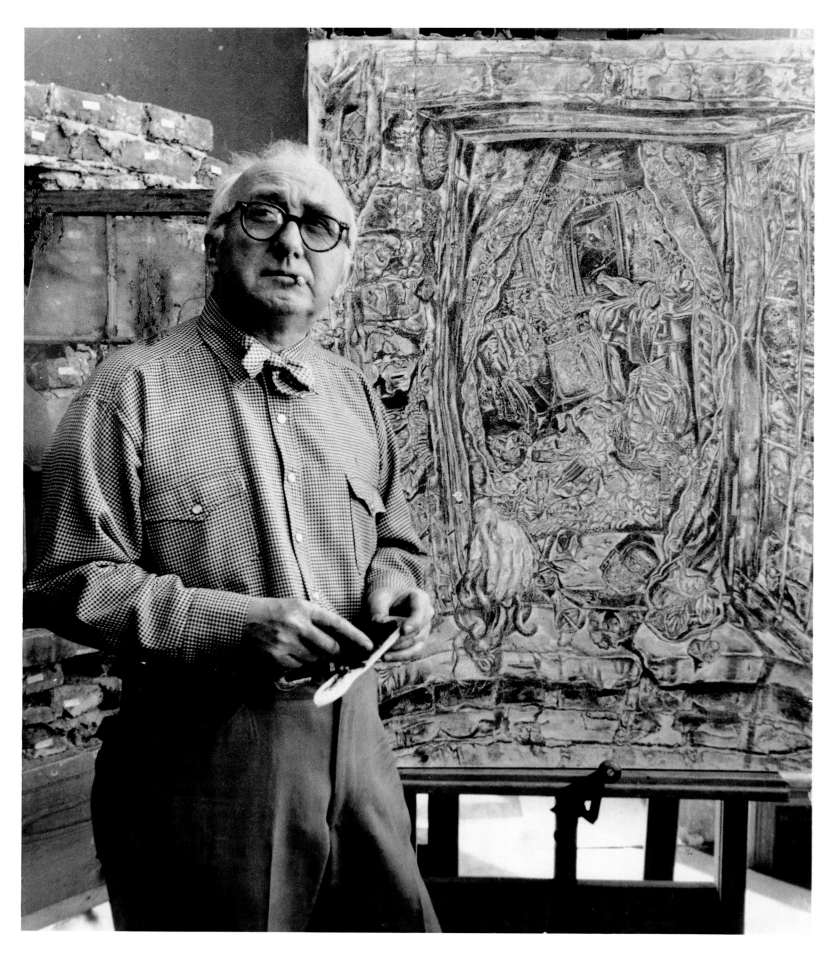

42

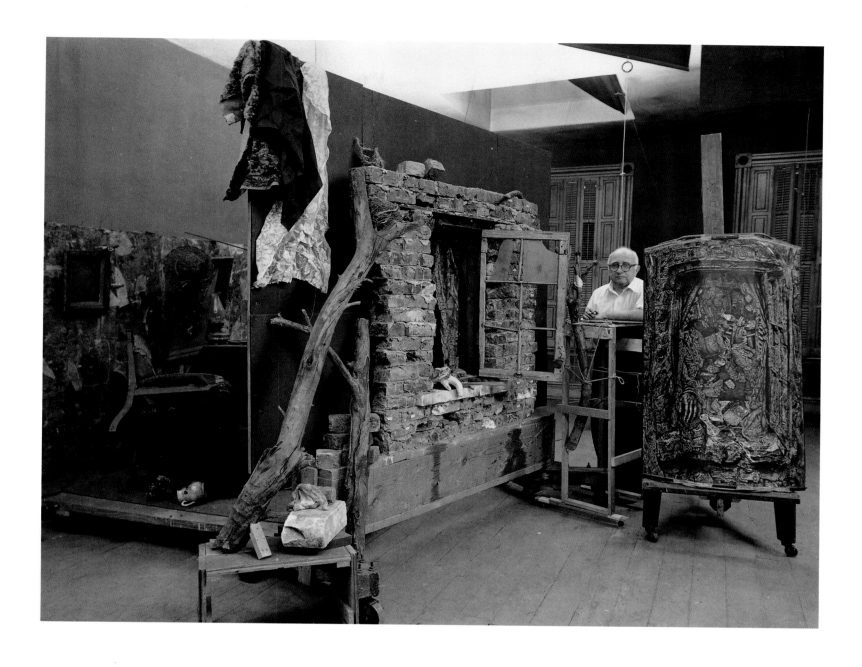

Figure 26. Above: Ivan Albright in his Ogden Avenue studio with the setup for *Poor Room* (no. 40) and the painting, as yet unfinished, c. 1961. Photograph by Arthur Siegel.

Figure 25. Opposite: Ivan Albright sharpening charcoal in front of *Poor Room* (no. 40), whose charcoal underdrawing is seen here, 1950. Photograph by Peter Pollack.

Gehenna of forms entirely delivered to delirium. . . . Each of the painted objects perpetrates its flowering without, it seems, the slightest thought of its surroundings. The center of the picture is everywhere at once; all being is center. And it is from this which doubtless comes the feeling of fear that the painting of Albright gives to many people.[132]

This tour de force confronts, perhaps more than any other painting by the artist, essential questions about the nature of reality and how, if reality cannot truthfully be conveyed, it is to be approached by an artist working in two dimensions. Further developing ideas the artist had introduced in his first major still life, *Wherefore Now Ariseth* (no. 21), Albright played with the idea of projection and recession. As he stated about *Poor Room*, "Some objects are falling, others are rising . . . [or] spiraling. . . . I compose in motion. I wish to create tension and conflict."[133] While the fragmented light, numerous perspectives, and sheer volume of information produce the disorientation he aimed for, he maintained a sense of balance with his obsessive rendering of microscopic detail. "The reason I use an extremely minute technique is to tie down, to fuse, to crystallize various discordant

elements so that my painting has a composite feeling." The end result, as has been noted, "is one of carefully controlled chaos in which everything exists in a state of suspended gravity and halted animation."[134]

• • • • •

> "Albright's life may be seen, through his art as well, as divided almost literally in half. Until his marriage . . . , [his] works had been death-haunted and lugubrious. . . . Since [then, he has] not at all focused upon the "corrugated mush" (his words) of the flesh."[135]

In 1955 the socialite and art patron Mary Lasker Block (see Chronology, fig. 23), who was the Albrights' neighbor and a friend of Josephine's, approached Ivan with a request to paint her likeness. At first, he resisted, because he had not executed a serious portrait on commission since Earle Ludgin had asked him, in 1935, for a version of his 1934 self-portrait (nos. 29 and 28). However, encouraged by his wife to accept the commission, he eventually agreed. As the background for the Block portrait (no. 51), Albright used the reverse side of the window he had constructed for *Poor Room*, a deliberate and ironic choice as a backdrop for someone of such great wealth. He rejected the dress Block first brought to the studio as a "fluffy thing like the ladies [wear] in Gainsborough paintings" and asked her to select "something so that in fifty years you'll still be dressed in style."[136] Purchased in Paris, the red and black cut-velvet creation she wears in the painting is in fact so timeless that it recalls the costumes of royal sitters in European Old Master portraits. The *vanitas* character of the portrait is suggested not only by two white roses on the table, but also by a small clock and the flimsy, dusty curtains that frame Block's regal, gray-haired head (she was in her early fifties). While the artist resisted the usual Albrightian touches—an abundance of wrinkles, facial blemishes and irregularities—he fixed her stare, making her face appear masklike, and imparted a clawlike character to her ungloved hand, with its hard, red-polished nails. A provocative likeness, the painting apparently pleased the Blocks, if not everyone else. The sitter's defense of her choice was quoted in the media: "If I had merely wanted a portrait as such, . . . I would have had a color photograph taken. But I wanted one of the great artists of this country to do a suggestion of me, which would also be a great painting."[137] The artist did two other portraits over the next five years, including a sculpted head of his wife (no. 50) and a painting of his father-in-law (no. 57), the latter requiring that he work from photographs and other people's recollections, since the newspaper magnate had died some sixteen years before.

In the 1950s and 1960s, with the exception of *Poor Room* and *Portrait of Mary Block*, Albright painted fewer large-scale works. His horizons expanded. He spent time in Wyoming and Georgia. He took to decorating his properties with wall paintings (see Chronology, fig. 22). He did still lifes (see no. 63) and landscapes, mainly in gouache and watercolor (see no. 55). With Josephine and sometimes with the children, as they grew older, he began to travel widely, constantly recording what he saw in quick sketches, using a variety of materials but especially gouache (see nos. 53, 54, and 64; and Chronology, figs. 28 and 29).

Most noteworthy are a number of technically remarkable oils and gouaches with western themes, inspired by time spent at the family ranch, which Albright produced between 1948 and 1964. Wyoming's vast spaces and dramatic skies did not seduce the artist

into working out-of-doors; rather, he brought the Wild West inside, creating elaborate still lifes in the studio (see Chronology, fig. 27), where he could control the light. In a composition of 1950–51, *The Wild Bunch (Hole in the Wall Gang)* (no. 46), Albright used the device of a window opening onto a landscape on the left, as he had in his Maine still life *Ah God, Herrings* (no. 35). But now the light and view of rocks and snow-covered mountains beyond are blocked by the dramatic silhouette of a pair of spurs and horse bits. The artist cannily arranged cowboy paraphernalia around the majority of the canvas in such a way that the eye is swept from one to the other in circular fashion. The palette is dark and the multitextured volumes masterfully defined by highlights and brooding shadows.

The Rustlers (no. 52), which Albright began in 1959 and completed in 1965, is a more claustrophobic image, since there are no openings to the outside. Jam-packed with accumulated detritus of the American West, *The Rustlers* resembles *Poor Room*, which the artist had finally finished in 1963. Clearly all of the works in this group draw upon the tradition of trompe-l'oeil painting as practiced in the nineteenth century by William Harnett (see Weininger, fig. 24), John Peto, and others. But the unrelieved character of surface texture, the unsettling lack of clear indication as to how to enter the composition visually, the tug of war between detail and overall pattern would lead at least one critic in the 1960s—when nonobjective painting reigned supreme—to consider such work formally, even abstractly. In 1967 Katharine Kuh stated, "[Albright's] visual facts are merely the raw material he manipulates and totally transforms. He is, paradoxically, an abstract artist who deals with reality only to destroy it by bending all images to his unique metaphysical bias. . . . He paints solely what he thinks, sometimes what he wants, but never what he sees. What he sees acts only as his point of departure."[138]

• • • • •

"It came as a great surprise to me . . . that Albright's [Ida] . . . was unfamiliar to . . . people. . . . I would have guessed that, in the field of American painting, Ida was as familiar as Mona Lisa."[139]

In 1964–65 The Art Institute of Chicago and the Whitney Museum of American Art, New York, collaborated on Albright's first museum retrospective. The artist was sixty-seven years of age, and the exhibition surveyed some forty years of his work. The majority of the show was devoted to his paintings, but it also included gouaches, watercolors, lithographs, drawings, sculptures, and two of his medical sketchbooks from World War I. The sixty-page catalogue included a few color reproductions (among them a folded, pull-out illustration of *The Door*), a commentary by Jean Dubuffet (some of which is cited above), and remarks by Albright.[140] It is interesting to consider the timing of this exhibition at a moment when abstraction was the dominant style and Pop Art and Minimalism were ascendant. Surely, nothing could have been at further remove from these forces than Albright's "more is more" aesthetic and insistent figuration. And, in fact, there was significantly less excitement and press coverage surrounding this exhibition than, for example, what the showing of *The Picture of Dorian Gray* in Chicago had generated nearly twenty years before. With this retrospective, the Art Institute seems to have been paying homage to a distinguished native son. The Whitney was presenting Albright as part of its program to showcase highly honored and accomplished American painters (for the most part, while it organized some exhibitions of abstract art, its roster in the 1960s reveals a preference

for the figurative). Most receptive to Albright's oeuvre were older New York-based critics such as Emily Genauer ("the work is . . . unforgettable") and John Canaday (he found Albright's oeuvre exemplified "a steady strength in American painting that exists underneath the froth"). But younger writers were less impressed: Lucy Lippard declared, "Detail is not enough. . . . Albright's vision wears thin."[141]

• • • • •

"For years I thought [that Albright was a midwestern-oriented artist], but I was wrong."[142]

Contemporary movements had spun far away from Albright's vision. Negative feelings he had about the art of this era stemmed from his belief that it had turned its back on the humanistic viewpoint to which he was committed.[143] Partially to remove himself from this "scene," he and Josephine decided to move to a small, New England town when the city of Chicago determined to tear down his studio. In 1963 they purchased two adjacent properties along the Ottauquechee River, in Woodstock, Vermont, and set about remodeling the existing structures. In 1965, when the property was ready, Ivan Albright, a Chicago resident for sixty-eight years, moved with his family to northern New England.[144]

Two years after they had settled in Woodstock, Katharine Kuh visited them there. She described her impressions of Albright at this time:

Nodding, joking, rushing, jerking, Ivan Albright piloted me through his new house in Woodstock, Vermont, or more correctly, his two houses, one for children, grandchildren, and guests, the other chiefly for his wife and himself. In contrast to Chicago's Near North Side, where until recently the Albrights lived, this romantic and elegant colonial setting gives the lie to any further theory that the painter is a Midwestern-oriented artist. . . . The same pulverized, uncompromising images emerge from Vermont as came out of Chicago. A serene New England landscape threaded by the lovely Ottauquechee River affects him no more than did the bleak sprawl of an industrialized city.[145]

Albright was anxious to show her his most recent work, *The Vermonter (If Life Were Life There Would Be No Death* (no. 60). Like *The Door* and *Poor Room*, this undertaking would require a prolonged effort—in this case, twelve years—before it was completed to the artist's satisfaction. The artist was in his late sixties and his model, Kenneth Harper Atwood, a member of the Vermont House of Representatives and retired farmer, was seventy-six when work began on the composition in October 1965. The strong bond that existed between artist and model is evident in a documentary photograph (fig. 27). Albright had previously told Kuh, "For some time now, I haven't painted pictures, per se. I make statements, ask questions, search for principles. The paint and the brushes are but mere extensions of myself or scalpels if you wish."[146] In this work, Albright was clearly aiming to make an image that would evoke the mysterious and miraculous process of life, how life transforms and transcends the body, and what aging can bring in its wake. He began with his usual detailed diagrams and plans (see fig. 28). During the first two years he spent on this composition, Albright concentrated on Atwood's face and hands, bringing them almost to completion. But still he struggled, as his notes reveal: "Get translucence of flesh, the rhythm of skin creeping up and down . . . hand. . . . Yellowish glow, translucent and white sparkle on skin, as temperature changes, the flesh, skin tightens or loosens and becomes flabby. . . . Make flesh close close and closer, until you feel it." Following this entry is an intriguing discussion of the way Old Masters depicted human flesh. Albright found Frans

Hals's "sloppy"; Jan Vermeer's "hard, hands of stone, unmovable"; Jan van Eyck's achieving "the start of feeling of flesh." And he asked rhetorically, "Who in all the world before . . . has painted flesh. Name one. Many have tried but none have ever come close to flesh-flesh."[147] When Atwood was not available, Albright used a dummy (as he had with earlier figure compositions), which he dressed in the clothes he had selected for his sitter. This allowed him to pay close attention to rendering the distinct textures of a velvety red cap, soft corduroy jacket, and worn, blue work clothes.

Adding immensely to the fantastic and jewel-like quality of the painting are the spots of color that float in front of and around the figure, enclosing him in a kind of halo. These were the result of at least two separate processes. In the first, Albright used his color

Figure 27. Ivan Albright (right) with Kenneth Harper Atwood (left), who served as the model for *The Vermonter* (nos. 59 and 60).

Figure 28. Working diagram for *The Vermonter* (no. 60), 1965/66. Graphite with red and orange fiber-tipped pens, blue ballpoint pen, and blue pencil on cream wove paper; 41.9 x 30.5 cm (16½ x 12 in.). The Art Institute of Chicago, gift of Ivan Albright (RX 14825/58/2).

wands to help him determine the colors and afterimage hues and shapes he wished to incorporate. And, as Jan van der Marck's observations (cited above) of the artist at work reveal, because he worked on such small areas at a time, he kept track of where he was by marking locations on the dummy using colored pins, which are indicated in the painting.[148]

Atwood's deeply weathered face, steady gaze, and regal posture exude both strength and mystery, even rapture. Atwood died in December 1975, two years before *The Vermonter* was completed. In an ironic turn of fate, the painting was seen in public for the first time—as a work in progress—in an exhibition that opened, at Dartmouth College, on the day Atwood was buried. Van der Marck could not resist remarking, "There is more than a little irony in the fact that [Albright's] sitters grow old, unsightly and die, . . . whereas the painter becomes more cherubic in appearance. Between Ivan Albright and Dorian Gray, the painter is having the last laugh!"[149]

The Vermonter was not the only composition on which Albright worked during these years. Dating from the late 1960s are a small but outstanding portrait of John Groover, an overseer of the Albrights' Georgia estate (no. 62) and an arresting self-portrait (no. 61). As mentioned previously, prominently featured in the background of this self-portrait are the color wands the artist used to study afterimages and color aftereffects, an interest that preoccupied the artist several years later in a pair of paintings, *Yesterday's Day* and *The Image After* (nos. 66a and 66b). During the 1970s, he worked in a number of mediums: *Pray for These Little Ones (Perforce They Live Together)* (no. 67) is an exquisite oil on silk that may reflect the influence of a long trip the artist made to the Far East in 1969; *Hail to the Pure (Portrait of Chigi Piedra)* (no. 68) is a drawing that he replicated in a lithograph. In addition, he made gouaches, etchings, and even metalpoints (see no. 65). During this time, he was named Visiting Artist at Dartmouth College and elected to the American Academy of Arts and Letters. He received a number of honorary doctorates and continued an active calendar of travel (see Chronology).

Nonetheless, age was taking its toll on Albright. By the time he finished *The Vermonter*, he was eighty and fast losing his eyesight, due to cataracts. By June 10, 1977, he was, he wrote in a notebook, "legally blind—10% vision in right eye, 24% vision in left eye."[150]

Figure 29. The Albright twins celebrate their eightieth birthday at the home of Malvin Albright, in Corea, Maine, February 1977. Left to right: Cornelia Fairbanks Albright, Ivan, Malvin, and Josephine Patterson Albright. Photograph courtesy of Marjorie (Tishie) Lins.

Figure 30. Ivan Albright. *The Sea of Galilee (Miami, Florida; Two Fish)*, 1977. Ink, watercolor, and gouache on Bainbridge board; 36 x 50.8 cm (14½ x 20 in.). Hanover, New Hampshire, Dartmouth College, Hood Museum of Art, gift of Josephine Albright.

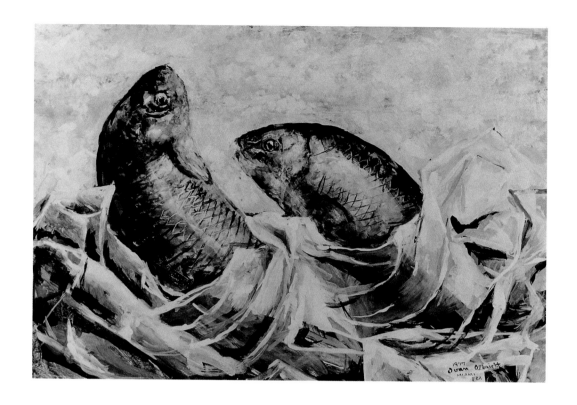

Luckily, the problem was correctable. On August 4, 1977, he underwent a successful corneal transplant in his right eye at the Bascom Palmer Eye Institute, in Miami. Always concerned with issues of perception and illusion, Albright considered his predicament with interest. On the night before the operation, he drew an image of his hospital room (Hood Museum of Art, Dartmouth College, Hanover, New Hampshire). In this drawing, space becomes as palpable as the objects it surrounds. Swirls of colored pencil create a feeling of animation where there is only air. The shape and solidity of the chair and bed, the room's walls and an open, curtained window are almost lost in the chaos. Two days after the operation, Albright's vision had improved to such a degree that he was able to start a new painting (fig. 30). That he chose to depict a pair of fish jumping out of paper wrapping and called the composition *The Sea of Galilee* indicates the extent to which he felt miraculously reborn through the restoration of his sight. One year later, the artist returned to Miami for a similar operation on his left eye, which was also successful. At the age of eighty, Albright had twenty-twenty vision. "Now I can see the leaves on all the trees . . . ," he exclaimed. "I can see the form of dust."[151] Thus, until his sight was corrected, in the last years of his life Albright must have struggled to see the minutiae he painted so meticulously and clearly.

· · · · ·

"Are there such things as death and decay? In any part of life,
you find something either growing or disintegrating. All life is
strong and powerful, even in the process of dissolution."[152]

The six years Albright lived after his first corneal operation were a testament to his sense that he had been reborn. In 1977, when he turned eighty, he presented much of his work

to The Art Institute of Chicago, including most of his major paintings. The following year, his biography, by Michael Croydon, was published. His prints were exhibited at Lake Forest College, Lake Forest, Illinois. He continued to work. In these years, he was preoccupied with the study of size and motion, lofty aesthetic principles that he explored with the most mundane of objects: potatoes and apples (see nos. 69–70b).

A group of at least twenty-four self-portraits (see nos. 71–93), dating from 1981 to 1983, has been described by Richard R. Brettell as Albright's "last great campaign as an artist."[153] The series was inaugurated with a request from the Galleria degli Uffizi, Florence, in 1981, for a self-portrait that it could add to its great collection of artists' images of themselves, in honor of the museum's four hundredth anniversary. The self-portraits that followed present such energy and freshness, as well as extraordinary variety—in medium, finish, pose, dress, and expression—that one would think that Albright had discovered an entirely new subject. "All self-portraits have the advantage," he wrote in 1974, "of having an available model when and where you want him. Both model and artist can rest at the same time. Conversation can be held to a minimum."[154] But convenience is clearly not the only reason the artist concentrated so intensively and insistently on his very old head, producing one moving image after another. He persisted even after suffering a severe stroke in August 1983, producing several haunting representations of himself in the hospital (nos. 89–91) and drawing his eyes and nose onto a prepared copper plate (no. 93) only a few days before he died.

Perhaps the key to Albright's absorption with this subject is suggested by Pascal Bonafoux, who wrote about the self-portrait in art: "These portraits of men who [are] going to die are a paradox. . . . The portrait denies death; it is memory"[155] Indeed, facing life, even or especially its most treacherous aspects—delusion, disillusion, decay—is the essence of this artist's unique voice. Albright's insistence on confronting "the way of all flesh" and making the "darkness visible" is itself an affirmation of life and one of the crucial values of art. Though death extinguishes us all, Albright also knew more importantly that life always comes first. In the end, the intransigence, feistiness, vulnerability, and courage that Albright's final work displays constitute a compelling vision that is both humbling and transformative in its impact.

Figure 31. Ivan Albright at work on *Self-Portrait (no. 7)* (no. 78), in his Woodstock, Vermont, studio, 1981. Photograph by Frank J. Lieberman. The Art Institute of Chicago, gift of Frank J. Lieberman (1986.1142).

Ivan Albright in Context

Susan S. Weininger

Alone among artists working in Chicago in the first half of the twentieth century, Ivan Albright has achieved canonical status. He is included in numerous major surveys of American art, beginning with Ralph Pearson's *Experiencing American Pictures* (1943), followed by John I. H. Baur's important *Revolution and Tradition in Modern American Art* (1951); and in such standard texts as H. H. Arnason's monumental *History of Modern Art* (1968) and Barbara Rose's *American Art Since 1900* (1975).[1] Despite this attention, few attempts have been made to situate his idiosyncratic vision in a larger context. To a certain extent, he has been considered an isolated artistic phenomenon, someone whose work is so personal and original that it stands apart, an attitude Albright himself vigorously promoted. In a typical summation, art critic Alexander Eliot concluded his discussion of the artist by stating, "Deriving from no school of art and pointing to none, resembling no other artist, Albright remains simply unique."[2] Indeed, while the contextualizing of his oeuvre firmly establishes his originality and achievement, it also reveals antecedents, contemporary parallels, and heirs. This essay will address the intersection of his profound individualism and singular vision with the art of the past that stimulated him, with art produced concurrently, and with the artists for whom he was influential or at least prepared the way.

Albright's Early Training: His Family

As is discussed here by Courtney Graham Donnell (see pp. 17 and 18), we must look first to Albright's own family for his earliest artistic formation. His father, Adam Emory Albright (1862–1957), was a successful painter specializing in bucolic, light-drenched landscapes populated by sweet children (see fig. 2). The elder Albright attended the Chicago Academy of Fine Arts (later The School of The Art Institute of Chicago) and the Pennsylvania Academy of the Fine Arts, in Philadelphia, where he studied with the renowned American painter Thomas Eakins. Known as an inspiring teacher who depended on the rigorous study of human anatomy based on nude models and cadavers, Eakins must have given Adam Emory a thorough knowledge of the figure before he made the then-obligatory trip to Europe. He studied in Munich with Carl von Marr (an expatriate from Milwaukee who was important enough to Adam Emory that he gave Ivan's twin, Malvin, the middle name Marr), and in Paris with academician Benjamin Constant. Adam Emory's pleasant, Impressionist-derived scenes seem more indebted to his European experience than to his exposure to Eakins, whose unvarnished realism and psychological probing are nowhere seen in his painting. (Perhaps the most visible influence of Eakins on Adam Emory was his extensive use of photography [see fig. 3; Donnell, figs. 3–5; and Chronology, figs. 2–5 and 7], which must certainly have been inspired by Eakins's devotion to the new technology.[3])

Figure 1. The party for Albright's *Picture of Dorian Gray* (no. 41) at Riccardo's Restaurant and Gallery, Chicago, February 26, 1946. Ivan Albright is seen in the far left foreground talking to Chicago artist William S. Schwartz; Malvin Albright is behind him, to the right (wearing a carnation in his lapel). Riccardo is the tall figure in the center; he wears a tie Ivan decorated with a replica of his *Dorian Gray* (see Chronology, fig. 16). Ivan Albright Archive, Ryerson and Burnham Libraries, The Art Institute of Chicago.

Figure 2. Left: Adam Emory Albright (American, 1862–1957). *Barnacles,* 1907. Oil on canvas; 35.6 x 19.1 cm (14 x 7½ in.). The Art Institute of Chicago, gift of Ivan Albright (1965.361).

Figure 3. Below: The Albright twins fishing, c. 1905. Photograph by Adam Emory Albright. Ivan Albright Archive, Burnham and Ryerson Libraries, The Art Institute of Chicago.

Figure 4. Opposite: Ivan Albright. *Landscape,* 1923. Oil on canvas; 63.5 x 76.2 cm (25 x 30 in.). Collection of Bram and Sandra Dijkstra. Photograph by Philipp Scholz Rittermann.

Indeed, Ivan's secondhand experience of Eakins may have been more important than his father's direct contact with the artist.

Ivan and his identical twin, Malvin, as well as their older brother, Lisle, served regularly as models for their father until they were about twelve, a duty that at least Ivan resented.[4] The senior Albright outfitted his young models from his collection of children's clothing, accumulated on the basis of color and evidence of use. Although the elder Albright painted out-of-doors, working fairly quickly—he was a prolific artist—these sessions must have seemed endless to an active youngster. Perhaps Ivan's extraordinary focus and patience, revealed in his own deliberate and slow working habits, developed from these experiences. Undoubtedly, his methodical and painstaking technique, his preference for working in the studio rather than outside, and his use of elaborate models and props that took him months to assemble were reactions to Adam Emory's procedures.

The twins' first art teacher was Adam Emory. The connection between him and these sons (not to speak of the bond between the brothers) was so strong that both twins eventually followed their father in their career choice. While this tie was obviously problematic for Ivan, who repeatedly and adamantly disclaimed any relationship between his oeuvre and that of Adam Emory, the early work of the son reveals a clear connection with the art of the father. Ivan's *Landscape* (fig. 4), for example, shares the pastel tonality and loose brushwork of Adam Emory's *Barnacles* (fig. 2). Residual influence of the father can even be detected in a later work by Ivan, *Heavy the Oar to Him Who Is Tired, Heavy the Coat, Heavy the Sea* (no. 16), in the lovely mauve, blue, and pink coastal view in the distance. The father's manner is seen as well in *Beneath My Feet* (no. 18) and in some of Ivan's later watercolor or gouache landscapes and travel sketches, executed quickly in the out-of-doors, from hotel rooms, and from the windows of moving trains or automobiles (see Chronology, figs. 28 and 29).

More important perhaps than the stylistic similarities of Ivan's work to that of Adam Emory, both father and son were thoroughly committed to a representational art in which the human figure and the natural world were the central subjects. While Ivan's rugged realism can be savage, it is realism nonetheless. His rejection of the sunny, Pollyanna-ish character of Adam Emory's works for a darker view of life was quite enough differentiation. By the time he came to artistic maturity, in the late 1920s, Ivan had been exposed to any number of modernist trends—Expressionism, Fauvism, Cubism, Futurism, as well as turn-of-the-century Post-Impressionism. It is significant that he never explored any of these modes, even momentarily, but remained constant in his dedication to the conservatism and realism that were his heritage.

Ivan never attempted to hide his aversion to the kind of pleasing, commercially successful superficialities that, in his judgment, his father and his father's generation produced. He objected particularly to the senior Albright's desire for sales and his unceasing cultivation of potential patrons. Ivan described Adam Emory as a "short-term" artist, driven by the market, in contrast to his characterization of himself as a "long-term" artist, compelled to produce a "bit of philosophy [like] a writer who writes a book."[5] For this reason, Ivan shunned most commissions. Even *Picture of Dorian Gray* (no. 41), contracted by Metro-Goldwyn-Mayer for the movie of the same name, remained his property after the film was completed, although he received a fee and his expenses were paid.[6] Furthermore, Ivan avoided sales by setting his prices excessively high, assuring that his art remained out of reach for most private and even institutional buyers (see below and Donnell, p. 28). He began to donate works to museums early in his career (see no. 3), because he wished to see them hanging alongside examples by the Old Masters he admired and to whom he felt heir.[7] He never established a regular association with a private dealer and, until late in his life,

sold very few works.[8] He was able to take these positions since, unlike many artists during the interwar period, he enjoyed some financial stability as a result of his father's successful career and wise real-estate investments in the 1920s.[9] After Ivan's marriage to heiress Josephine Medill Patterson in 1946, he ceased to have any worries about money.

In the same way that he repudiated the influence of his father's art, he consistently denied the significance of his experience as a medical draftsman during World War I (see nos. 1 and 2). Similarly, he disavowed any connection to the teachers from whom he received his formal artistic training, first at The School of The Art Institute of Chicago, followed by single terms at the Pennsylvania Academy and at the National Academy of Design, New York. "[Whom] I studied with didn't amount to anything," he declared.[10] In fact, Ivan's training at the Art Institute's school, from which he graduated in 1923 with honors in life and portrait painting, and at the other two institutions reinforced the conservative attitudes of his father and his circle, contributing to the solid, academic base from which his work developed.

At the Art Institute, Albright studied with portraitists Antonin Sterba and Leopold Seyffert, who was also well known as a character painter. Like Adam Emory, Sterba was educated in Chicago and in the Paris atelier of society painter Constant. Sterba's *Chris Marie (Girl with the Golden Shawl)* (fig. 5) exhibits the dark background, attention to detail, and idealization that characterizes fashionable portraiture of the early years of this century.[11] Ivan's early portrait of Marie Walsh Sharpe (Donnell, fig. 6), depicting a dewy, rosy-cheeked young woman, beautifully coiffed and elegantly dressed, reflects the romantic conventions seen in Sterba's work. Albright's carefully delineated, bust-length figure in *The Philosopher* (no. 3), emerging from a dark surround, also originates in traditional prototypes but exhibits elements that foreshadow his later figural work. Liberated from the limitations of representing a particular individual, Albright was able to pursue his interest in the interior life of his subject. Still using light and dark in a conventional way, and not yet absorbed in obsessive exploration of surface detail, Albright nevertheless provided a window into the soul of his sitter.

By the first decade of the twentieth century, Chicago had all of the components of an active art community, albeit a very conservative one: a museum, private galleries, patrons, critics, artist groups, and a comprehensive educational institution. The School of The Art Institute of Chicago was founded in 1886 as a traditional academy on the European model, favoring drawing over painting, and life drawing above all. Students learned first to draw from lithographic images, progressing to the study of plaster casts of antique sculpture and architectural fragments, and finally to the live model. As Ivan later recalled, "It was strictly academic, that period. And it wasn't until . . . the Armory Show . . . [that] the mood of the world and painting [changed]."[12] The Armory Show, or the "International Exhibition of Modern Art"—on view in Chicago in 1913 (where it was called the "Post-Impressionist Show")—introduced Americans to work by the European avant-garde in a plethora of challenging styles, yet had no effect on the Art Institute's school. Indeed, Norman L. Rice, a student there in the late 1920s, remembered being "kept to the hard discipline of cast drawing for our full first year."[13] Chicago's reaction to the exhibition provides a gauge of its conservatism at the time. Although the event drew nearly two hundred thousand viewers in its three and one-half weeks in the city, for the public and many critics it became the object of ridicule. Students at the School, unprepared for what they saw, burned copies of several paintings by Henri Matisse and tried him in effigy on the terrace outside the museum. In this, they had the active support of the faculty.[14] The Albright twins were sixteen years old when the benchmark exhibition arrived at the Art Institute from New York.

Figure 5. Antonin Sterba (American, 1875–1963). *Chris Marie (Girl with the Golden Shawl)*, before 1927. Oil on canvas; 127 x 81.3 cm (50 x 32 in.). Collection of Antonin Messager and Josephine S. Sterba. Photograph courtesy Barton Faist Gallery and Studio. Photograph by Gordon Meyer.

Figure 6. Charles W. Hawthorne (American, 1872–1930). *Calling of Saint Peter*, c. 1900. Oil on canvas; 152.4 x 122 cm (60 x 48 in.). Newark, New Jersey, Newark Museum, gift of Bernard Rabin in memory of Nathan Krueger, 1962.

Although there is no hard evidence that the twins actually saw the exhibition when it was in Chicago, it is reasonable to assume that they did. In any case, the uproar it generated must have impacted—if negatively—the steadfastly conventional art community of which Adam Emory was a part. Thus, while Ivan's relationship to modernism was always ambivalent, if not at times outright hostile, he was in any case exposed to it at an early age.

The import of the Armory Show was not lost on the city's more adventurous art enthusiasts. Two organizations were established in its wake—the Renaissance Society at the University of Chicago (1915) and the Arts Club of Chicago (1916). Both sponsored exhibitions of European and American modernism, including the art of Derain, Matisse, and Picasso, as well as of Demuth and Sheeler.[15] By 1920 the city had a number of serious collectors, most of whom favored the French Impressionists and Post-Impressionists. Chicago lawyer Arthur Jerome Eddy, however, assembled important work by Duchamp, Kandinsky, and Marc, among others.[16]

The entrenched traditionalism of the School of the Art Institute was relieved by a series of visiting instructors associated with the New York Ashcan School of urban realists: George Bellows (1919), Randall Davey (1920), and Leon Kroll (1924). Albright's years at the School (1920–23) also coincided with the emergence of a group of rebellious, young, local artists who formed the nucleus of the independent exhibition organizations Cor Ardens (founded in 1921) and the Chicago No-Jury Society of Artists (founded in 1922), both of which promoted jury-free exhibitions. It is also significant that Helen Gardner, whose textbook *Art through the Ages* has exerted such widespread influence since its initial publication in 1926, offered her first class in art history at the School in 1920.[17]

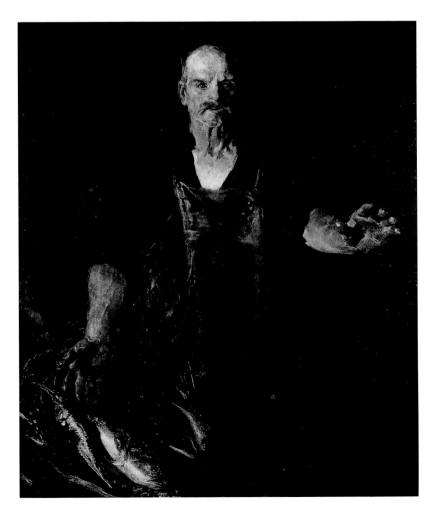

Gardner's own taste tended toward northern European Renaissance art—then still very much in the shadow of the Italian Renaissance—which Albright also favored (see below).

Following in their father's footsteps, the Albright twins continued their artistic studies in the fall of 1923 at the Pennsylvania Academy. In contrast to the School of the Art Institute, which Albright hyperbolically described as having "about four thousand students and [teaching] everything from knitting to weaving to hand printing; they would have taught finger painting if there [had been] such a thing in those days," the Academy appealed to him because it was smaller and "strictly fine arts."[18] Ivan's teachers there included landscapist Daniel Garber, portrait sculptor Charles Grafly (whose influence on Ivan is evident in his later forays into sculpture, such as his *Head of Adam Emory Albright* [no. 30]), and painter Henry McCarter. Only McCarter seems to have had any interest in progressive movements, having had contact with Henri de Toulouse-Lautrec when he studied in France.[19] Ironically, the legacy of Eakins, whom the Academy had dismissed in 1886 because of his unorthodoxy, was now invoked in support of the institution's commitment to academic realism.

The Albrights' semester in Philadelphia was followed by one in New York, where Ivan was hoping to study with Bellows at the Art Students League. Entering the School of the Art Institute in 1920, Albright undoubtedly heard about Bellows from students who had studied with him there the previous

year. They identified with his midwestern roots and were impressed with his innovative pedagogy—a belief in artistic freedom and originality, and an outspoken criticism of artistic convention—as well as the broad technique and bold, sometimes tough, urban subject matter that had become his hallmark.[20] Unfortunately, Bellows was not teaching, so Ivan enrolled at the National Academy of Design for classes with Charles W. Hawthorne, a popular instructor who also ran a successful summer school in Provincetown, Massachusetts. Best known for his sensitive portrayals of ordinary people executed in a conventional, yet painterly, manner, Hawthorne encouraged the pursuit of individual style and taught that "one of the greatest things in the world is to train ourselves to see beauty in the commonplace."[21] Considering Albright's previous training in portraiture and life drawing, as well as his developing interest in character studies, his choice of teacher was entirely reasonable. Hawthorne's *Calling of Saint Peter* (fig. 6) is typical of his work: he specialized in images of fishermen, a subject that Albright would take up a few years later in *Heavy the Oar* (no. 16).

Albright and the Old Masters

It is not insignificant that Albright descended, on his father's side, from a family of master gunsmiths and that his maternal grandfather and uncle were physicians. The catalogue of the 1964–65 retrospective exhibition of his work, organized with his active involvement, pays homage to the craftsmanship of his forebears, and is evidence of Albright's own perception of their significance for him.[22] Indeed, the intricate, engraved designs on the gunstocks produced by this family exhibit a meticulous linearity like that which Albright would develop in his own work. The importance he assigned to technique, to securing just the right objects for the setups he constructed for his paintings, to carefully plotting out his ideas in notebooks before he actually worked on canvas, as well as his laborious working methods, all relate to the skills and occupations of his ancestors.

Given his family background and academic training, it is not surprising that Albright was drawn to the art of the Old Masters. In part, he was attracted to their technical proficiency. As he declared, "When an artist fails to keep building up his knowledge and only keeps on repeating his feelings, . . . his art is limited and one-sided."[23] Albright's commitment to technique distinguishes him from many of his contemporaries—for whom execution was of secondary importance, a means to express emotion or social content—and is linked to his strong interest in traditional European art.

Around the entablature of the Art Institute's 1893 Beaux-Arts building, which the young Albright often visited with his family, are inscribed such names as Dürer, Michelangelo, Rembrandt, and Rubens. As a student, he copied Old Master paintings in the museums of Chicago, Philadelphia, and New York. His interests were not unique. Influenced by Kenneth Hayes Miller, a painter and teacher at the Art Students League, New York, beginning in the 1910s, artists from Reginald Marsh to Jared French sought to impart stability to their own art by emulating Italian Renaissance painting.[24] Even Regionalists such as Thomas Hart Benton had heroic High Renaissance prototypes in mind when they painted inspirational scenes drawn from American history and contemporary life. While Albright made numerous copies in his notebooks after the Old Masters, he never quoted anything directly in a finished work. Rather, his assimilation of the technique and spirit of earlier prototypes stimulated his imagination so that, as he worked from actual models, he was able to produce images at once securely based on observation, enhanced by historical associations, and therefore original and powerful in their impact. His *Nude (Fourteen-Year-Old*

Figure 7. Albrecht Dürer (German, 1471–1528). *Nude (from Behind)*, 1495. Pen and ink and wash; 32.1 x 20.6 cm (12⅝ x 8⅛ in.). Paris, Musée du Louvre, Département des arts graphiques. Photo © R.M.N.

Figure 8. Ivan Albright. *Nude (Fourteen-Year-Old Girl)*, 1931. Oil on canvas; 35.6 x 19.1 cm (14 x 7½ in.). The Art Institute of Chicago, Mary and Earle Ludgin Collection (1981.256).

Girl) (fig. 8) is suggestive of any number of Renaissance examples, such as one by Albrecht Dürer (fig. 7), in its pose, use of light and dark, balance of detail and generalization, and treatment of the ample flesh. But in *Nude*, the variation in paint thickness to render a sense of flesh hanging in folds, the garish pink highlights, and the model's unkempt hair combine to create a disturbing image. The flickering light that moves restlessly over the young sculptor depicted in *Maker of Dreams (Man with a Mallet, Maker of Images)* (no. 8) and the soulful expression on his deeply shadowed face reflect the influence of El Greco, whose altarpiece *The Assumption of the Virgin* (1577) the Art Institute purchased in 1906. Albright's *I Walk To and Fro through Civilization and I Talk as I Walk (Follow Me, The Monk)* (no. 9) and *The Lineman* (no. 10) recall the dramatic, full-length, single figures of Diego Velázquez and Francisco Zurbarán, as well as Edouard Manet's *Philosopher with Beret* (1865), acquired by the Art Institute in 1910.

Figure 9. Matthias Grünewald (German, 1475/80–1528). *The Small Crucifixion*, c. 1511/20. Oil on panel; 61.3 x 46 cm (24⅛ x 18⅛ in.). Washington, D.C., National Gallery of Art, Samuel H. Kress Collection.

Figure 10. Attributed to Quentin Metsys (Flemish, 1465–1530). *A Grotesque Old Woman*, c. 1525. Oil on panel; 64 x 46 cm (25³⁄₁₆ x 18⅛ in.). Reproduced by courtesy of the Trustees, The National Gallery, London.

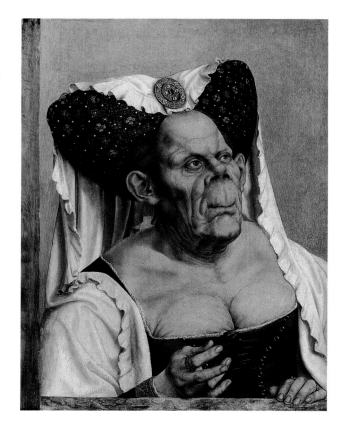

Despite his admiration for the Spanish masters, Albright seems always to have felt most connected to northern European art. In one of his earliest works, *Paper Flowers* (no. 5), the shy entreaty of the sitter's gaze, his unkempt appearance, and the awkward earnestness with which he holds an offering of flowers recall the simple shepherds of the Flemish painter Hugo van der Goes's *Portinari Altarpiece* (c. 1474–76; Galleria degli Uffizi, Florence). The play in *Paper Flowers* between the sonorous, dark background against which the figure is set and the concentration of brilliantly colored, lushly painted flowers in the foreground recalls luminous passages in the paintings of the German artist Matthias Grünewald, whose fascination with decaying flesh (see fig. 9) Albright shared. He must have felt deep kinship with the obsessive description and brutal distortions of Grünewald and other northern European artists. It is hard to look at his arresting *Woman* (no. 13), for example, without thinking of the unforgettable *Grotesque Old Woman* (fig. 10) attributed to Quentin Metsys. Finally, one must mention Rembrandt van Rijn, whose ability to express the soul of rich and poor, accomplished and ordinary, young and old, touched Albright throughout his long career. Following this example, Albright began early on to employ street people to pose for his compositions; later he would work with his neighbors, whether in Warrenville (see for example nos. 10, 12, 20, and 31), Georgia (no. 62), or Vermont (nos. 59, 60, and 68). Albright's dark palette, his use of glowing light to throw a figure into relief, and

his interest in character are also rooted in the art of this Old Master. His interest in Rembrandt was lifelong: in the 1980s, he initiated a series of etchings based on examples by the artist (Albright owned several Old Master prints[25]). Finally, Albright's self-portraits—from the brash artist beginning to enjoy success (nos. 28 and 29); to the middle-aged genius who knows what his audience expects of him (no. 45); to the late self-portrait series (nos. 71–93), where, at the height of his powers, he examined himself mercilessly and exhaustively—movingly chronicle, like those of Rembrandt, the artist's public and private life.

Albright and the *Vanitas* Theme

The *vanitas*, or *memento mori*, theme—a moralizing reminder that life's pleasures are momentary and that death is inevitable—originated in northern Europe in the late Middle Ages and continued to preoccupy painters into the eighteenth century. The subject allowed artists to indulge in seductive representations of these pleasures and then to subvert the seduction through various moralizing touches. The painter of a *vanitas* composition could draw upon a wide vocabulary of symbols, used alone or in a variety of combinations, to suggest the transience of the material world. These could include a beautiful woman regarding herself in a mirror; arrangements of fruit and/or fresh flowers (whose life span, from bud to perfumed fullness to withered end, occurs in a matter of days); the butterfly (indicating the escape of the soul from the prison of the body); objects of earthly knowledge (books and scientific instruments); references to sinful behavior (musical instruments, liquor, playing cards, dice); luxury items; and a human skull or skeleton. A Dutch Baroque example (fig. 11), since 1871 in The Metropolitan Museum of Art, New York, where Albright could have seen it, is inscribed *VANITAS* and incorporates a number of these elements—books, a musical score, a violin, assorted jewelry, and elegant tableware.

Albright's entire oeuvre can be viewed as a twentieth-century exploration of the *vanitas* in which he pondered the connection between the physical and spiritual and the relationship of growth and decay, time and space, the finite and the infinite. Among his most powerful statements of these themes is *Into the World There Came a Soul Called Ida* (no. 17). A comparison of *Ida* and *Portrait of Artist Hans Burgkmair and His Wife, Anna* (fig. 12) by Laux (Lucas) Furtenagel, a sixteenth-century German painter, provides instructive insights into the meaning of Albright's haunting composition. In the Renaissance painting, a man and woman confront their skeletal reflections in a large mirror held by the woman. Her expression—one of sadness and desperation—is not dissimilar to that of Ida. Like Albright's unforgettable female character, Burgkmair's wife is dressed in a fairly revealing garment and wears no head covering, indicating a level of intimacy with the viewer. The paintings share a somber palette, the use of strong chiaroscuro, and a careful rendering of form and textures. In addition to his searing characterization of Ida, a woman fully aware of the passage of time and of the inevitability of loss, Albright included a number of allusions to the fleeting nature of matter. The vase with dying flowers, the money on the dressing-table top, and the comb and powder puff that Ida uses in vain to obliterate signs of her physical decline all reinforce the feeling of an inexorable and irreversible process at work. Furtenagel's painting assumes a theological framework in which the decay of matter is contrasted with the eternal life of the spirit in the hereafter. Albright's image, on the other hand, does not posit everlasting life. Its pathos is located in the purely human dilemma it depicts. In 1960 the artist explained his interest in death and decay by asserting their legitimacy: "In any part of life you find something either growing or disintegrating.

All life is strong and powerful, even in the process of dissolution. For me, beauty is a word without real meaning. But strength and power—they're what I'm after."[26] In the poignancy and silent fortitude of *Ida*, Albright realized an image whose resonance and impact meet the challenge he set for himself.

Ida's complex pessimism stands out in relation to a more typical, contemporary image, *The Morning Sun* (fig. 13), by Chicagoan Pauline Palmer, a friend and contemporary of Adam Emory Albright.[27] With its bravura brushwork, Impressionist-derived palette, elegant backlighting, and conventional perspective, Palmer's canvas is a pleasing, unchallenging scene of an attractive, well-to-do woman beginning her day before her mirror. The colorful flowers on the dressing table reflect not the transitory quality of life but a beauty that is unchanging because it is superficial. The ambiguities that contribute to the force of *Ida* are lacking in this more decorative, ingratiating image. No doubt Albright would have dismissed a work such as Palmer's as "short-term."

Albright did not reserve his penetrating gaze solely for others; over his lifetime, he produced a significant number of self-portraits in which he considered himself and his circumstances with extraordinary honesty. In one from 1934 (no. 28) and another from the following year (no. 29), Albright showed himself sitting in elegant dinner clothes before a table replete with tobacco and drink. Both compositions feature a vase of flowers similar

Figure 11. Above: Edwaert Collier (Dutch, active c. 1662–c. 1706). *Vanitas*, 1662. Oil on panel; 94 x 112.1 cm (37 x 44⅛ in.). New York, The Metropolitan Museum of Art, Purchase, 1871 (71.19).

Figure 12. Opposite left: Laux (Lucas) Furtenagel (German, 1505–after 1548). *Portrait of Artist Hans Burgkmair and His Wife, Anna*, 1529? Oil on panel; 60 x 52 cm (23⅝ x 20½ in.). Vienna, Kunsthistorisches Museum.

Figure 13. Opposite right: Pauline Palmer (American, 1867–1938). *The Morning Sun*, 1922. Oil on canvas; 127 x 101.6 cm (50 x 40 in.). Rockford, Illinois, Permanent Collection of the Rockford Art Museum. Photograph: Steven Pitkin.

to that in *Ida*. In the 1935 portrait, the artist's image is mirrored, upside down, in the stopper of the glass decanter. Despite the prosperity and success Albright's accouterments would seem to indicate, the artist in both works appears jaded and aged beyond his years, a man who has clearly lived well, intends to go on doing so, but who fully questions the meaning of it all.

Albright also explored the *vanitas* theme in still lifes. Beginning in the early 1930s, he created some of his most masterful works in this genre. These typically have complex titles: *Wherefore Now Ariseth the Illusion of a Third Dimension* (no. 21), *That Which I Should Have Done I Did Not Do (The Door)* (no. 24), *Poor Room—There Is No Time, No End, No Today, No Yesterday, No Tomorrow, Only the Forever, and Forever and Forever without End (The Window)* (no. 40). A necessary ingredient for any *vanitas* composition is the idea of the passage of time, a dimension Albright introduced in a number of ways. All of these compositions contain abundant references to the transitory nature of the material world: decaying fruit and a pocket watch in *Wherefore Now Ariseth*; a funeral wreath with dying blossoms, a wrinkled hand, rotting and warping wood, and the casket-shaped composition of *The Door*; the disintegrating bricks, broken window casement, and plethora of detritus covered with dust in *Poor Room*. By presenting objects from a range of viewpoints, he captured a sense of his moving around and observing them from different places at different times. This, Albright hoped, would add the fourth dimension—time—to his works, literally incorporating its passage into the limited expanse of the two-dimensional canvas.[28] This concern relates to Cubist theories about the two-dimensional representation of three-dimensionality; however, rather than abstracting objects into a number of planar shapes, Albright always strove to retain the illusion of volumetric form.

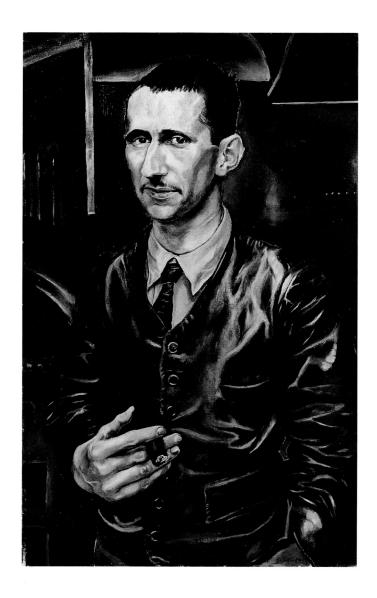

Albright and Contemporary European Art

Albright is spiritually closer to the Expressionist strain of European art than to any formalist approach. His early, lithographic self-portrait (no. 25), an image that, in its nervous tension, seems to fly apart, resembles any number of similar depictions by Expressionists. The twisted, bony creatures of Egon Schiele; the thin-skinned, shaky individuals of Oskar Kokoschka; and the flabby, brutalized subjects of Albright all bear witness to humankind's physical vulnerability and spiritual undernourishment.

The Neue Sachlichkeit (New Objectivity) movement offers a contemporary link to the work of Albright. In the aftermath of World War I—a conflagration of unprecedented scale that had resulted in destruction, death, and national defeat—a significant number of German-speaking artists rejected the modernist concepts that had dominated the European avant-garde before the war. Instead, they steeped themselves in northern Renaissance art, seeking in their own cultural heritage a strong, firm foundation and a more accessible style. While Neue Sachlichkeit artists tended to work in a highly precise and representational manner, they were rarely objective, for, in their often bitter and scathing works, the imagery can be grotesque and horrifying. These artists, like Albright, employed the drama of shadow and artificial light to suggest the worst secrets and fears of their subjects. Rudolf

Schlichter's haunting portrait of Bertolt Brecht (fig. 14)—the emphasis on the large hand emerging from darkness; the flickering light that hits the folds of the jacket; the intensity of the playwright's gaze—relates to images by Albright, such as his 1934 self-portrait (no. 28). The fact that Albright chose to depict himself in this painting and in that of the following year (no. 29) in formal dress brings to mind similar portraits by Max Beckmann and Christian Schad.[29]

A 1933 description of Albright's *And Man Created God in His Own Image (Room 203)* (no. 20) as a "diabolically realistic study of a bleary-eyed, red-faced, elephant-skinned reprobate, divesting himself of his rags,"[30] could be applied to any number of Neue Sachlichkeit images. There are many points of comparison between Albright's work of the 1940s—*Picture of Dorian Gray* (no. 41), *The Temptation of Saint Anthony* (no. 42), *Drama (Mephistopheles)* (Donnell, fig. 24)—and compositions such as Schlichter's 1937 *Blind Force* (fig. 15) or Max Ernst's menacing, apocalyptic landscapes, particularly in their exacting description of a flood of brilliantly colored, grotesque detail. But there is a major difference between them: Albright's art is entirely devoid of the social and political commentary so central to the work of these Europeans.

Figure 14. Opposite: Rudolf Schlichter (German, 1890–1955). *Portrait of Bertolt Brecht*, 1926. Oil on canvas; 75.5 x 46 cm (29¾ x 18⅛ in.). Munich, Städtische Galerie im Lenbachhaus.

Figure 15. Rudolf Schlichter. *Blind Force*, 1937. Oil on canvas; 179 x 100 cm (70½ x 39⅜ in.). Berlin, Berlinische Galerie, Museum für Moderne Kunst, Photographie und Architektur. Photograph: Hermann E. Kiessling.

Of all these artists, it is Otto Dix whose vision often comes closest to Albright's. Some years after his military experience during the war, Dix produced a series of nightmarish etchings, *Der Krieg*, inspired by what he had seen. While they are far more hallucinatory and exaggerated than Albright's war drawings, which were executed as medical documentation, the means by which each artist achieved his images are not dissimilar. "Every man's being expresses itself in his 'exterior,'" Dix stated. "The bearing of a man, his hands, ears disclose to the painter immediately something of the spirit of the model. . . . The painter does not appraise, he looks. My motto is trust your eyes!"[31] There is no romanticizing of impending motherhood in Dix's arresting 1931 study of a pregnant woman (fig. 16), whose swollenness seems immobilizing, humiliating, and painful. Albright's *Nude* (fig. 8), from the same year, seems more cruel than that of Dix, who has softened the shock of his model's immensity with a Rembrandtesque palette and chiaroscuro. It is not surprising that the *vanitas* theme informed much of Dix's work (see fig. 17), as it did Albright's. It has been noted that "the display [in the work of Dix, as well as that of George Grosz] of repellent anatomical details, the feeling of fleshy decay in the plump or emaciated female nudes and the ninety-year-old couples mercilessly stripped"

have their antecedents in earlier *vanitas* compositions.[32]

There is no documented, direct contact between Albright and his contemporaries across the Atlantic. An inveterate museum- and gallery-goer, he certainly saw their work, even though anti-German sentiment in the United States limited the exposure of Americans to German art in the wake of World War I. We know that Albright attended the 1926 Carnegie International, where he would have seen Dix's *The Actress, Anita Berber, in a Sketch*. In addition, he described in a notebook Carl Einstein's *Die Kunst Des 20. Jahrhunderts*, published in 1926, as a "good book."[33] This publication

discusses German Expressionism as well as the emerging Neue Sachlichkeit artists, reproducing work by Beckmann, Dix, and Grosz. He must also have seen reproductions of current German art in magazines or in other books, such as Franz Roh's *Nach-Expressionismus*, published in 1925.[34] Whatever the degree of his familiarity with the work of the Neue Sachlichkeit artists, Albright's firsthand involvement with the physical and emotional traumas of war helped shape a world view that was shared by these Europeans.

Albright and American Realism

Most attempts to position Albright in the history of American art have situated him within the strong realist movement that held sway in the United States in the interwar years. Given his highly idiosyncratic, hyper-realistic visions of corrupted flesh, his restless still lifes, and his lush images of the natural world, it has never been sufficient to call him simply a realist: over the years, he has been variously designated a surrealist, a mystic realist, a magic realist, a romantic realist, a subjective realist, and a realist-expressionist.[35]

Albright's realism is connected, like that of many of his Chicago contemporaries, to the New York-based Ashcan School, particularly the work of George Bellows and John Sloan. Albright's early *Hopi Indians* (no. 4), for example, exhibits the romanticized subject, conventional spatial relationships, and bravura brushwork of Bellows's *Pueblo Tesuque, No. 2* (fig. 18). Although produced in the Southwest, *Hopi Indians* evidences no familiarity with the more modernist experiments of Andrew Dasburg, Mardsen Hartley, or former Chicagoan Raymond Jonson, who also worked in Arizona and New Mexico.

In the 1920s, New York's Fourteenth Street School artists Isabel Bishop, Reginald Marsh, and Kenneth Hayes Miller, as well as independents Edward Hopper, Guy Pène du Bois, and others continued to work in the figurative tradition of the Ashcan School realists

Figure 16. Opposite top: Otto Dix (German, 1891–1969). *Pregnant Woman (Semi-Nude)*, 1931. Mixed media on panel; 83 x 62 cm (32¹¹⁄₁₆ x 24⅜ in.). Private collection. Photograph: Serge Sabarsky, Inc.

Figure 17. Opposite bottom: Otto Dix. *Girl before a Mirror*, 1921. Oil on canvas. Destroyed. Photograph from: Mattias Eberle, *Der Weltkrieg und die Künstler der Weimarer Republik: Dix, Grosz, Beckmann, Schlemmer* (Stuttgart and Zurich, 1989), p. 59, pl. 45.

Figure 18. Right: George Bellows (American, 1882–1925). *Pueblo Tesuque, No. 2*, 1917. Oil on canvas mounted on hardboard; 87.2 x 112.4 cm (35⁵⁄₁₆ x 44¼ in.). Kansas City, Missouri, Nelson-Atkins Museum of Art, gift of Mr. and Mrs. C. Humbert Tinsman.

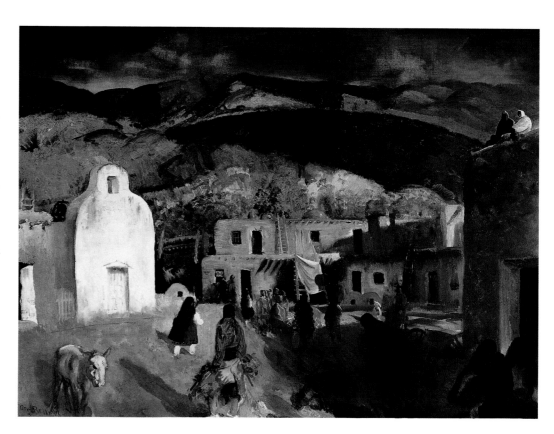

of the first decade of the century. Dedicated to the Old Masters and conservative in their devotion to the figure, they "set themselves against two opposing factions in the art world. . . . They continued to challenge the conservative National Academy of Design—with its rigid exhibition policies, artistic practices, and elite subjects. They also resisted the radical experimentation in abstract forms and deeply personal content of artists whose styles derived from advanced European modernism."[36] Much like them, Albright reacted against the slick, commercial manner of his father and subsequent teachers, actively spurned European-inspired abstraction, and was drawn instead to honest representations of ordinary people in a straightforward, readable style, rooted in a deep familiarity with the Old Masters. With few exceptions, Albright's early work consists of character studies in which the figures become archetypes, such as *The Lineman* (no. 10) and *Among Those Left (The Wheelwright, The Blacksmith)* (Donnell, fig. 13). These images have less to do with the shoppers and urban drifters of Marsh, the profoundly isolated figures of Hopper, or the office workers of Bishop than with conventional, academic depictions such as Eugene Speicher's *Red Moore* (fig. 19) or any number of works by regional artists such as Thomas Hart Benton and John Steuart Curry.

The Regionalists, like Albright, were interested in Old Master art (Grant Wood was also taken with the work of Neue Sachlichkeit artists he saw in Munich in 1928). They considered the hardworking, long-suffering individuals they preferred as subjects to be the backbone of America, citizens whose efforts would make it possible for the nation to recover from the Depression. Albright was certainly familiar with Wood's art by 1930, when his *American Gothic* (fig. 20) won a purchase prize at The Art Institute of Chicago's forty-third annual American Exhibition. In this instantly popular painting, the artist glorified the contemporary midwestern farm family in a style inspired by his study of northern European Renaissance art, which interested him, he said, because of its decorative quality and capacity for "story-telling."[37] Although Albright was never this explicit, these were areas of interest for him as well. His love of pattern is manifested in the densely covered surfaces of his paintings. The combination of elaborate titles with the representation of ordinary, yet evocative, objects often leads the viewer to imagine complex narratives in his works.

A series of federally supported art projects dominated the period from 1934 to the early 1940s. For thousands of artists, government patronage during the Depression provided a lifeline and an opportunity to develop their skills. In addition to employing artists, the mission of the various New Deal art programs was to bring art to citizens all over the nation who might not otherwise have access to it, by decorating public structures such as schools, hospitals, post offices, and other government buildings; and to produce images of American life in a clear, representational style. The mandate to depict the "American Scene" was interpreted broadly to include subjects as various as regional landscapes, views of small towns, industrial sites, events from American history, and urban life.

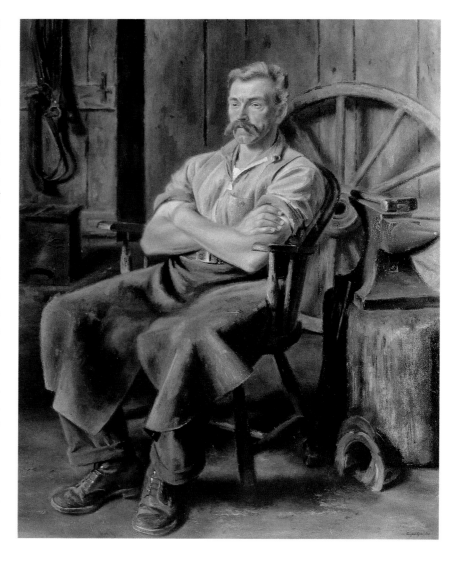

Figure 19. Eugene Speicher (American, 1883–1962). *Red Moore*, 1927. Oil on canvas; 170 x 137.2 cm (67 x 54 in.). Los Angeles County Museum of Art.

Figure 20. Grant Wood (American, 1891–1942). *American Gothic*, 1930. Oil on beaverboard; 75.9 x 63.2 cm (29⅞ x 24⅞ in.). The Art Institute of Chicago, Friends of American Art Collection (1930.934). All rights reserved by The Art Institute of Chicago and VAGA, New York, NY.

Figure 21. Thomas Hart Benton (American, 1889–1975). *The Lord Is My Shepherd*, 1926. Tempera on canvas; 84.5 x 69.5 cm (33¼ x 27⅜ in.). New York, Collection of Whitney Museum of American Art (31.100). Photograph: Geoffrey Clements, New York. © 1997 T. H. Benton & R. P. Benton Testamentary Trusts/Licensed by VAGA, New York, NY.

Although the state-administered projects were considered relief work and required a certain percentage of those employed to swear to an oath of poverty, this rule was not always strictly followed. For example, Increase Robinson—an artist and the owner of a progressive Chicago gallery who served as director of the artists' projects in Illinois from their genesis until 1939—was known for her reluctance to sacrifice quality by hiring artists purely on the basis of financial need. As Chicago artist George Josimovich later explained, "The Public Works of Art Project [PWAP] consisted of . . . better-known local artists who were invited by the project committee."[38] This would explain Albright's involvement with both the short-lived PWAP (which lasted from December 1933 to June 1934) and the Illinois Art Project (in which he participated in 1936).[39] For the first project, he painted *The Farmer's Kitchen* (no. 31), an image of a weathered, old woman peeling radishes in her modest home. The faded Victorian wallpaper, profusion of textures and patterns, and evocation of an earlier historical period is similar to contemporary images by Wood. Robinson's insistence that the artists working under her supervision adhere strictly to the mandated themes may account for the fact that the painting is as close as Albright ever came to depicting the American scene. Benton's *The Lord Is My Shepherd* (fig. 21), featuring a rural couple taking their meager meal in spare surroundings, conveys the message that faith and hard work will result in spiritual, if not material, rewards. Albright's much richer composition undermines any such moralizing by suggesting that the end results of a life of labor are exhaustion and old age. The only other image by Albright that bears any relationship to government-mandated themes is *In the Year 1840 (Second Storeys Are Popular, When Fall Winds Blow)* (fig. 22), a humorous depiction of a small-town street of the type

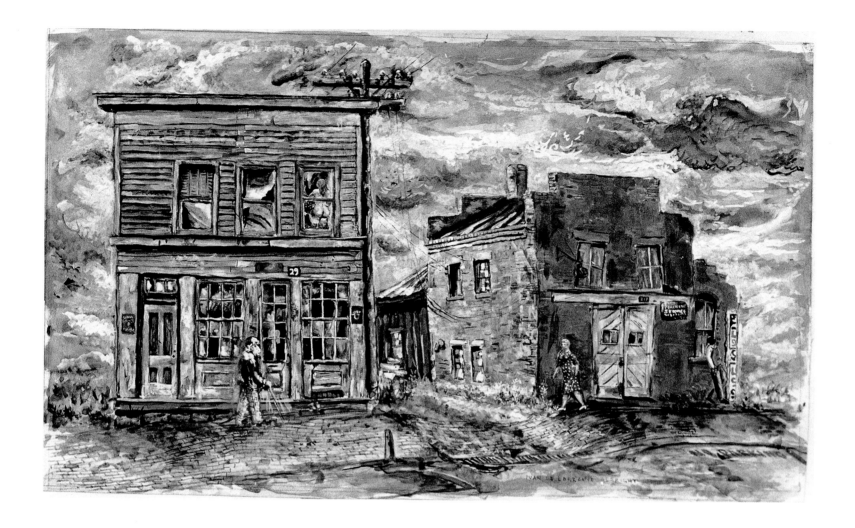

that his friends Aaron Bohrod and Francis Chapin (see below) and many others were producing at the time. Albright's negative opinion of the New Deal projects is conveyed in his statement: "Then there is that group of American Sceners whose pictures are more news bulletins than art."[40] His willingness to participate in the programs at all was probably based on the validation of his work that the invitation implied, as well as simple financial need during these difficult years.

Despite his connections to American realism, Albright's art stands apart from this movement in ways that are as crucial, if not more so, than the ways in which it relates. A comparison of Wood's *Woman with Plant(s)* (fig. 23) and Albright's almost contemporary *Flesh (Smaller Than Tears Are the Little Blue Flowers)* (no. 12) makes this clear. Wood's image (his mother served as his model) represents the ideal midwestern woman, as hardy, strong, and solidly rooted as the sansevieria she holds. Albright's figure appears to age before our eyes, her skin wrinkling and her clothes turning to rags. In contrast to the almost indestructible plant held by Wood's mother, the flowers floating in a bowl of water, poised precariously in the lap of Albright's model, are tiny and fragile; separated from their roots, they have only a short time to live.

The revival of interest in still life, particularly the American trompe-l'oeil tradition best exemplified in the work of nineteenth-century artists William Harnett, John Peto, and others, can be traced to a 1939 exhibition of Harnett's work at the Downtown Gallery in New York.[41] By this time, however, Albright had completed *Wherefore Now Ariseth* (no.

Figure 22. Above: Ivan Albright. *In the Year 1840 (Second Storeys Are Popular, When Fall Winds Blow)*, c. 1937. Tempera on paper; 35.6 x 55.9 cm (14 x 22 in.). Dallas, Texas, Dallas Museum of Art, gift of Mr. and Mrs. Malvin Albright (1960.164).

Figure 23. Opposite: Grant Wood. *Woman with Plant(s)*, 1929. Oil on upsom board; 52.1 x 45.4 cm (20½ x 17⅞ in.). Cedar Rapids, Iowa, Cedar Rapids Museum of Art. © 1997 Estate of Grant Wood/Licensed by VAGA, New York, NY

21), had undertaken *Show Case Doll* (no. 23), and was close to finishing *The Door* (no. 24). It is possible that Albright saw the work of some of these nineteenth-century still-life painters in public collections on the East Coast during his many visits to this part of the country. Clearly, in Albright's later Western still lifes (see nos. 46 and 52), the meticulous presentation of visual data, exploration of the relationship between surface and depth, and display of clichéd Americana relate to any number of nineteenth-century precedents (see fig. 24).

The eccentric viewpoints that Albright explored in his still lifes have parallels in the work of other artists, such as Charles Sheeler, who painted a series of room interiors seen from a bird's-eye perspective. In both Sheeler's *Americana* (fig. 25) and Albright's *Wherefore Now Ariseth*, the play of pattern and shape can be read as an abstract composition, rather than as an illusion of three-dimensional space. While Sheeler's geometric planes are enlivened by the numerous designs and spatial shifts, the painting offers respite for the eyes in the smooth rendering of forms, cool hues, and balance of plain and elaborated areas. On the other hand, the unrelieved profusion of detail, objects seen from multiple viewpoints, deeply saturated colors, and sparkling reflective surfaces of Albright's composition infuse the whole with an organic, pulsating energy, as if the contents are about to explode. As the artist stated, "I'm trying to

Figure 24. William Harnett (American, 1848–1892).
After the Hunt, 1885. Oil on canvas; 191.1 x 123.2 cm
(71½ x 48½ in.). The Fine Arts Museums of San Fran-
cisco, Mildred Anna Williams Collection (1940.93).

Figure 25. Charles Sheeler (American, 1883–1965).
Americana, 1931. Oil on canvas; 121.9 x 91.4 cm (48 x
36 in.). New York, The Metropolitan Museum of Art,
Edith and Milton Lowenthal Collection, Bequest of
Edith Abrahamson Lowenthal, 1991 (1992.24.8).

lead the observer back, sideways, up or down *into* the picture, to make
him feel tossed around in every direction, to make him realize that
objects are at war, that between them is constant movement, tension and
conflict."[42]

The fact that links can be made between Albright's work and that
of a number of other seemingly disparate artists who came of age in the
1920s and 1930s indicates the wide range of American realism, which
dominated the nation's art production in the 1930s. Indeed, Albright is
allied to other artists of the period in the very fact that his work, like
theirs, often defies easy categorization. Not only can parallels be drawn
between Albright and some Regionalists and Precisionists, as we have
seen, but also Charles Burchfield (in the creepy quality of his land- and
townscapes, not unlike a number of Albright's landscape gouaches) and
Hopper (in the profound isolation of his figures).[43]

By the early 1930s, in works such as *Room 203* and *Wherefore Now
Ariseth* (nos. 20 and 21), the objects Albright depicted resolve into pat-
terns covering the entire surface of the canvas, with an increasing profu-
sion of obsessive detail. In this sense, he anticipated "the general drift of
realistic American painting . . . toward a greater reliance on imagination
and fantasy and toward concern for the manipulation of color, as well as

of texture and pattern" in the late 1930s.[44] He developed this even further in the 1940s in visionary compositions such as *Picture of Dorian Gray* (no. 41), *The Temptation of Saint Anthony* (no. 42), and *Poor Room* (no. 40). This tendency can be seen in the work of artists ranging from Benton to Peter Blume, Paul Cadmus, and Andrew Wyeth; and was recognized in the 1943–44 exhibition organized by New York's Museum of Modern Art, "American Realists and Magic Realists," in which many of these artists, as well as the Albright twins, participated.[45] Although Albright continued to work in a figural mode, the increasingly dense web of detail that blankets the surfaces of his work led curator-writer Katharine Kuh to consider his art in ways that are more normally associated with such artists as Jackson Pollock and Mark Tobey.[46]

Albright in Chicago

Albright often stated that he would have produced the same work anywhere (he told Kuh in 1960 that if he "lived on the moon, it wouldn't matter"[47]). However, Chicago, where he resided for sixty-eight of his eighty-three years, provided him with a particularly rich environment in which to develop his idiosyncratic vision.

As we have seen, Chicago, in the early decades of this century, was home to a conservative cultural milieu that offered its visual artists relatively limited exhibition opportunities, as well as narrow views of the art world beyond the city. Even the most benign works were received by some Chicagoans with contempt. Thus, when Doris Lee's *Thanksgiving* (c. 1935; The Art Institute of Chicago), an image of bustling holiday preparation in a midwestern rural kitchen, won the prestigious Frank G. Logan prize at the Art Institute's annual American Exhibition in 1936, it prompted the incensed patron, Josephine Hancock Logan, to form the Sanity in Art movement, in order to restore "real art and [resume] progress along the line of established and universal principles . . . to help rid our museums of modernistic, moronic grotesqueries . . . masquerading as art."[48]

From 1926 on, Albright regularly submitted work to the annual American Exhibition, as well as to the two other juried annuals sponsored by the Art Institute, the Chicago and Vicinity and the International (or American) Watercolor exhibitions. The exclusive and traditional character of these events, together with the paucity of other exhibition opportunities (the few commercial art galleries came and went in quick succession), inspired some Chicago artists to establish independent exhibition groups. In the activist period of the 1920s, almost all of Chicago's progressive artists participated in at least one of these associations. Albright, however, was an exception, exhibiting only rarely with a liberal organization. In 1928, for example, he showed a now-lost painting, entitled *It*, in an exhibition sponsored by the short-lived Neo-Arlimusc group, founded by one of Chicago's leading modernists, Rudolph Weisenborn.[49]

Albright's relationship to modernism was never clear. While he seems not to have been put off by the appellation "modernist" and was consistently considered as such in the contemporary press, he exhibited regularly only with the moderate Chicago Society of Artists and the ultra-conservative All-Illinois Society of Fine Arts during the 1920s and 1930s.[50] His choice of the latter, in particular, is curious when one considers the highly individual character of his work by the late 1920s. In 1972 Albright told interviewer Paul Cummings about an experience he had as a student at the Pennsylvania Academy that reflects his pride in having been considered a modernist. In Henry McCarter's class, he was working on a still life with the canvas placed flat on the floor. McCarter, whom

Albright described as one of the few teachers he liked, was unique among his colleagues for his interest in abstraction. But even the progressive McCarter commented on the peculiarity of his student's methods. Apparently, the teacher reconsidered his critique, because, during the next class, he told the young man, "You're a real modernist. I've been thinking it over. That's all right."[51] But Albright also wished to connect himself with tradition rather than with experimentation. In an article in *Art Digest* reporting on the public outcry that caused the temporary removal of *Woman* (no. 13) from an invitational exhibition at the Toledo Museum of Art, Albright was paraphrased as saying that the painting "was not banished because of its modernism," since it was executed in the technique of the "primitives" (by which he meant early Renaissance painters from northern Europe).[52]

It may have been the prohibition of juries and prizes by the more liberal independent groups, rather than a dislike of modernism, that accounts for Albright's lack of interest in them. While other artists were eager to exhibit and willing to join together for the communal, artistic good, the highly competitive Albright dedicated himself, first and foremost, to his own individual progress, recognition, and reward. Financially comfortable, if not wealthy, he had minimal expenses, for he had no dependents and still lived with his family. He was not driven by the pressing financial needs that motivated many of his contemporaries to seize every possible opportunity for exhibitions and sales. Albright was consistently interested in exhibitions that awarded prizes, and he received many during his career. Indeed, his participation in the 1928 Neo-Arlimusc show may have been motivated by his competitive drive. The exhibition was organized to coincide with the renowned German art critic Julius Meier-Graefe's stop in Chicago on a tour of the United States. To Albright, this may have seemed like an opportunity for international recognition.[53]

Albright once explained his aversion to associations of any sort in this way: "To join some general movement in art . . . is to join a buffalo stampede. I say, let the artist be the hunter rather than the buffalo."[54] But his disinterest in joining anything must have been related as well to the constant presence in his life of his father and twin brother, Malvin. These three lived, worked, and traveled together until the twins were forty-nine years of age, providing Ivan with plenty of opportunity for regular artistic interaction and stimulation. While he had some artist-friends, with the exception of his forays into lithography (see below), it is unlikely that he worked closely with anyone outside his family. Indeed, Ivan was not isolated; rather, he was never alone. As we have already seen, he deliberately separated himself from his father's art in a number of ways. His relationship to his brother's work, however, is less easily defined.

Despite their agreement early on to pursue different mediums—painting for Ivan and sculpture for Malvin—the Albright twins each produced paintings, sculptures, watercolors, gouaches, and prints. They both preferred a representational mode, executing character studies and portraits, still lifes, and landscapes of the picturesque locales they visited together. The brothers often chose to work simultaneously on related projects, including portraits of each other (no. 8 and Donnell, fig. 10) and studies of Franciscan monks (no. 9 and Chronology, fig. 9). They shared models, as in the case of Ida Rogers (see Donnell, p. 27). Malvin's stylistic eccentricities matched his brother's; for example, the bulging, lumpy flesh of the backside of a female bather—a sculpture from 1930 (fig. 26)—brings to mind the puckered skin of Ivan's *Ida* (no. 17). Ivan's paintings at their best have a volumetric character that comes from his sound understanding of sculpture. Malvin eventually abandoned working in three dimensions (he said his sculpture began to fill up his studio) and, after 1940 or so, seems to have painted exclusively.[55] Based on the brothers' relationship, it would be safe to assume that Malvin looked to Ivan for direction much more than

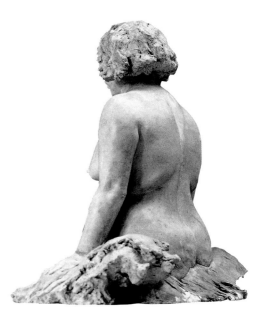

Figure 26. Malvin Marr Albright (American, 1897–1983). *The Bather*, 1930. Plaster; 83.8 x 83.8 x 58.4 cm (33 x 33 x 23 in.). Courtesy Barton Faist Studio and Gallery.

Figure 27. Opposite: Zsissly (pseudonym for Malvin Marr Albright). *Victoria*, 1935. Oil on canvas; 86.4 x 132.1 cm (34 x 52 in.). Private collection.

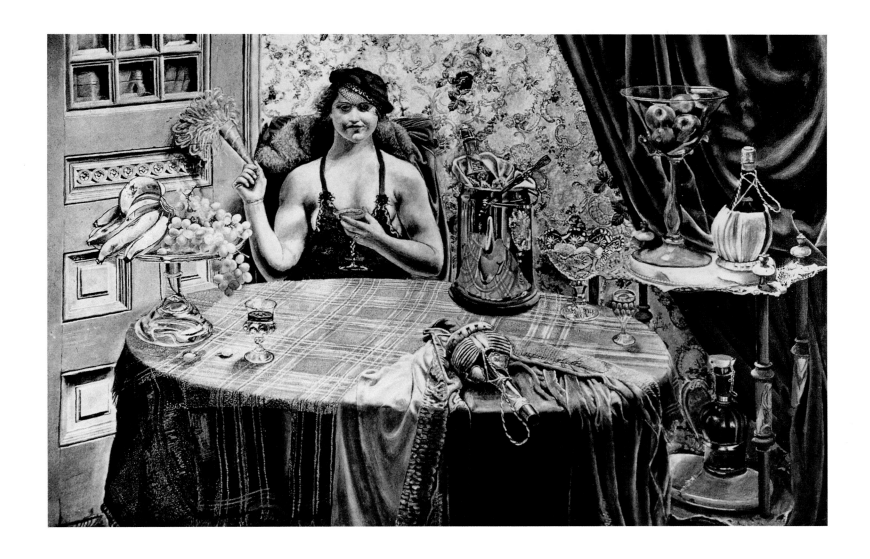

the reverse. Unfortunately for Malvin, his work is strongest when it resembles that of
Ivan. One of Malvin's most ambitious paintings, *Victoria* (fig. 27), is replete with objects,
textures, and patterns that allowed the artist to demonstrate his considerable technical
skill. The strange female subject, wearing a skimpy gown and a beret, has the mottled flesh
seen in many of Ivan's female figures. In comparison to Ivan's densely detailed, yet com-
pletely lucid compositions, however, *Victoria* loses its coherence in the abundance of minu-
tiae. Relative to Ivan's art, Malvin's has a passivity that parallels the less aggressive and
competitive aspects of his personality. Malvin's oeuvre often lacks the clarity of vision that
makes Ivan's unequivocally powerful.

By the early 1930s, the physically diminutive Ivan Albright was a larger-than-life fig-
ure in the Chicago art world. Reminiscing about the 1933 art fair in Grant Park, the young
Chicago painter Gertrude Abercrombie singled out only Albright from among the hun-
dreds of artists who participated. While the uniformly impoverished artists (the New Deal
projects were not yet in existence) were asking ridiculously low prices for their work, she
recalled that Albright priced one painting at $10,000.[56] This communicated not only his dis-
interest in selling but also his success in building a mythic image of himself that held local
artists, Abercrombie included, in thrall.

The critic Christopher Lyon has suggested that the "lack of critical discourse, or in-
deed of any broadly shared ideology or theory that would support radical experimentation,

may account for the conceptual self-sufficiency"[57] of art made in Chicago. This is evident not only in the idiosyncratic oeuvre of Albright but also in that of many of his contemporaries, including Abercrombie, Macena Barton, and Julia Thecla. It is also true of work produced by locally trained artists of succeeding generations, such as Leon Golub, Seymour Rosofsky, and the Imagists. These artists, like Albright, always maintained a strong connection to the visible world in their art. And, like Albright, their work has an element of narrative that critic Donald Kuspit, for one, has suggested is a hallmark of the city's art.[58] Both of these qualities are apparent in the paintings of Thecla. Born one year before Albright, she studied at the School of the Art Institute at about the same time as the Albright twins. Thecla developed an unusual technique that involved scratching contour lines

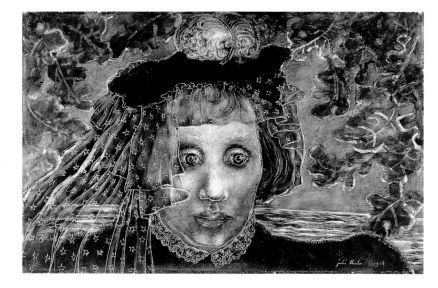

into the paint surface, creating shadows by rubbing away the top paint layers to reveal the colors underneath, and smudging the pigment. This allowed her to create works that are as strange and haunting as Albright's.[59] Her *Self-Portrait* (fig. 28), while more ethereal than Albright's *Memories of the Past* (no. 11), offers interesting parallels with that composition, in the evocative dark palette, mottled light defining the shape of the artist's face, the faraway gaze, and the sense of isolation. Abercrombie, who knew Albright well,[60] also made art characterized by a sense of the mysterious, a subjectivity, and an implied narrative. In her still life *There on the Table* (fig. 29), a peculiar assortment of objects (all personally significant) is set on a table behind which sits a truncated figure.

Outside his family, the Chicago artists with whom Albright was personally closest were William S. Schwartz and Francis Chapin. Schwartz and Albright are not linked so much stylistically as through a shared dedication to fine craftsmanship, an interest in a

Figure 28. Julia Thecla (American, 1896–1973). *Self-Portrait*, 1936. Opaque watercolor, charcoal, and metallics on gessoed cardboard; 45.7 x 61 cm (18 x 24 in.). Springfield, Illinois, Collection of Illinois State Museum.

Figure 29. Gertrude Abercrombie (American, 1909–1977). *There on the Table*, 1935. Oil on hardboard; 76.8 x 102.9 cm (30¼ x 40½ in.). Springfield, Illinois, Collection of Illinois State Museum, gift of the Gertrude Abercrombie Trust.

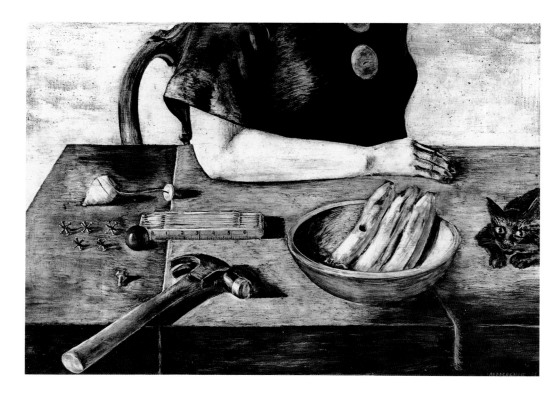

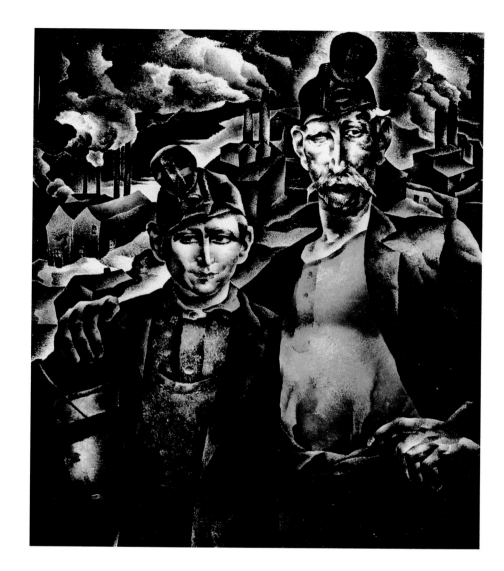

Figure 30. William S. Schwartz (American, 1896–1977). *Earn Your Bread by the Sweat of Your Brow*, 1935. Oil on canvas; 91.4 x 76.2 cm (36 x 30 in.). Union League Club of Chicago. Photograph © Michael Tropea, 1996.

Figure 31. Francis Chapin (American, 1899–1965). *Landscape with Town*, c. 1950. Oil on hardboard; 51.1 x 41 cm (20⅛ x 16⅛ in.). The Francis Chapin Estate Collection, Chicago.

variety of artistic mediums, and a reluctance to align themselves with the radical segments of the Chicago art community.[61] Evidence of Albright's influence on Schwartz might occasionally be seen in his titles, such as *I Am the Grass Let Me Work*, although he typically used straightforward designations.[62] Schwartz's art comes closest to that of Albright in works such as *Earn Your Bread by the Sweat of Your Brow* (fig. 30), an image of two miners—a youth and an older man—with its exaggerated description of flesh, obsessive quality of paint application, flickering light, and dark tonalities.

Albright's closest painter friend was Francis Chapin. In 1973, eight years after Chapin's death, Albright praised his "ability to reach the essence of his subject with a few seemingly casual lines. He was a wizard at the sketch pad, and this is perhaps why his finished paintings have such a quality of freshness and spontaneity."[63] Albright learned a great deal from Chapin. A master printmaker, he taught Albright the technique of lithography and even printed his earliest work in the medium (no. 25).[64] But their approaches, styles, and subject matter could not have been more different. While Albright worked slowly and privately in his studio, Chapin painted quickly, often in the out-of-doors, where, according to Albright, he actively encouraged the attention of curious bystanders.[65] In fact, a connection between the work of these two artists is

discernible only in Albright's less considered works, his travel sketches. Chapin's *Landscape with Town* (fig. 31) and Albright's *Toledo, Spain* (Chronology, fig. 28) both exhibit quick brushwork, bright colors, and conventional compositions.

Albright's Legacy

Albright's art influenced a number of midwestern artists slightly younger than he. Chicago-born Aaron Bohrod, a friend, began his career as an urban realist. By the early 1950s, perhaps in reaction to the dominant Abstract Expressionist style that he strongly opposed (a sentiment Albright shared), he began to create carefully crafted, trompe-l'oeil still lifes. While his works in this manner, such as his *Ivan Albright (Through a Glass Darkly)* (fig. 32), may owe something to the obsessive Western still lifes Albright was painting in these years, they are more precious in their scale and overt in their symbolism. The work of Ohioan Emerson Burkhart is often remarkably close to that of Albright. Burkhart's *The Light Is Greater, Hence the Shadows More* (fig. 33) bears a philosophical title and exhibits the obsessive attention to detail and fascination with corrosion and decay that clearly reflect the Chicagoan's impact.[66]

The art historian and critic Franz Schulze described Chicago art after 1945 as tending "toward highly personal, introverted and obsessive styles" produced by artists "infatuated with symbol, image, dream and pungent anecdote."[67] This characterization could easily be applied to Albright, and even a casual look at the art produced in the city in the

Figure 32. Above: Aaron Bohrod (American, 1907–1992). *Ivan Albright (Through a Glass Darkly)*, 1958. Oil on hardboard; 36.8 x 26 cm (14½ x 10¼ in.). Private collection. Photograph: Ali Eli, New York. © 1997 Estate of Aaron Bohrod/Licensed by VAGA, New York, NY

Figure 33. Left: Emerson Burkhart (American, 1905–1969). *The Light Is Greater, Hence the Shadows More*, c. 1949. Oil on canvas; 86.4 x 151.1 cm (34 x 59½ in.). Collection of Karl Jaeger. Photograph courtesy Keny Galleries, Columbus, Ohio.

Figure 34. Opposite: Lucien Freud (English, born 1922). *Naked Man, Back View*, 1991–92. Oil on canvas; 183 x 137.3 cm (72 x 54 in.). New York, The Metropolitan Museum of Art, Purchase, Lila Acheson Wallace Gift, 1993 (1993.71).

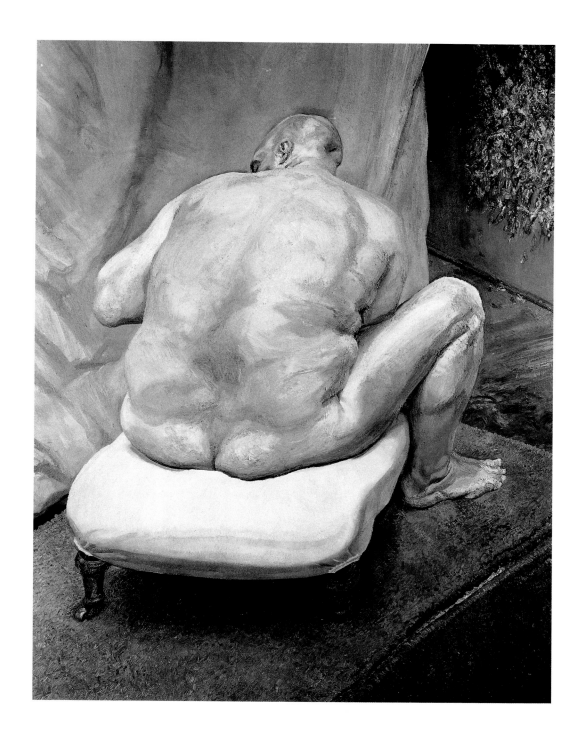

period after World War II reveals his importance. Before he left Chicago permanently in 1959, Leon Golub painted colossal, often fragmentary, figures, using highly textured, scabrous brushwork. While they often have mythical associations, these monumental images seem to be meditations on the passage of time and the disintegration it effects. The painter Seymour Rosofsky's pessimistic figurative compositions include an array of battered and distorted human forms.

Albright was first introduced to European artists when *The Door* (no. 24) was exhibited at the Tate Gallery in London in 1946, and when *Ida* (no. 17), the 1935 *Self-Portrait* (no. 29), and *The Door* were shown at the Musée national d'art moderne, Paris, in 1953. Two years before, Jean Dubuffet was so impressed by a visit to Albright's studio in Chicago (see Donnell, p. 41) that, some thirteen years later, he was able to contribute a

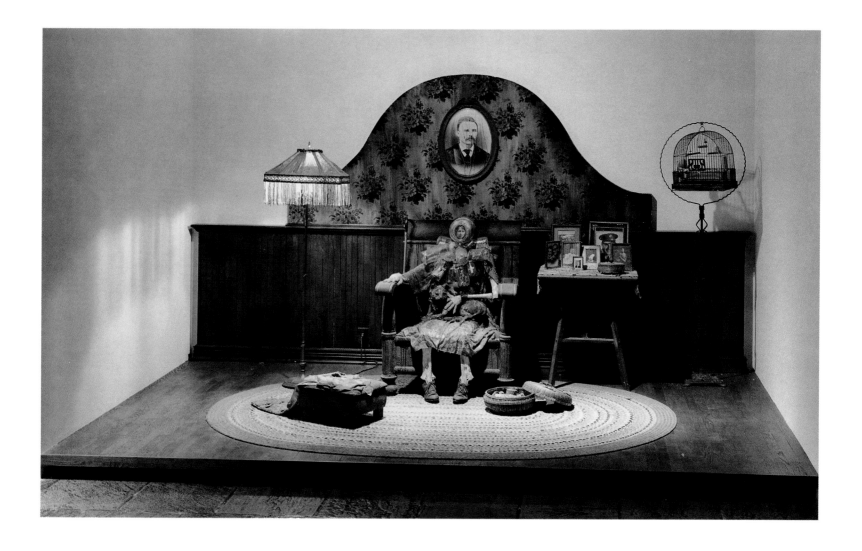

vivid description of the visit and commentary on Albright's work to the catalogue accompanying the Chicagoan's 1964–65 retrospective exhibition at The Art Institute of Chicago and the Whitney Museum of American Art, New York.[68]

Although Albright's work is now situated firmly in the history of American art, and far more horrifying images than his are widely available in both the mass media and in high art, it is important to remember how shocking his work was when it was first exhibited. Artists in succeeding generations have focused on subjects, both violent and sexual, that extend far beyond the limits Albright was testing. Thus, while his oeuvre may not have the power it once did to provoke an outcry, in its own time it was the equivalent of Francis Bacon's searing images of psychologically tortured individuals or of Dubuffet's raw, Art Brut figures. A younger generation of British artists, persisting in the figuration that Bacon and others practiced, have also produced work paralleling that of Albright. It is particularly tempting to consider, in this light, Lucien Freud's highly realistic, sometimes shocking depictions of the human body (see fig. 34).

Another aspect of Albright's legacy may be seen in the assemblage environments that have become an important art form since the 1960s. While Albright always thought of his elaborate setups as a means to an end, he saved many of them, actually exhibiting the one he had made for *The Door*, and he included several in his 1977 donation to The Art Institute of Chicago.[69] Although no direct influence can be established between Albright and

Figure 35. Edward Kienholz (American, 1927–1994). *The Wait*, 1964–65. Tableau: wood, fabric, polyester resin, flock, metal, bones, glass, paper, leather, varnish, black-and-white photographs, taxidermed cat, live parakeet, wicker, and plastic; 13 units, overall: 203.2 x 406.4 x 213.4 cm (80 x 160 x 84 in.). Collection of Whitney Museum of American Art, New York, gift of the Howard and Jean Lipman Foundation, Inc. (66.49a–m).

the proponents of this art form, it is interesting to consider the work of Edward Kienholz in this regard. Kienholz combined sculpture with existing materials, creating imaginative environments that communicate with the force of reality. While his interest in issues of a social and political nature—premarital sex, abortion, and poverty, for example—distinguishes him from Albright, one cannot help but think of *Ida* when contemplating a work such as *The Wait* (fig. 35). This reconstruction of a room, complete with old photographs and peeling, flowered wallpaper, is dominated by a female figure constructed of bones and clad in a housedress. Around her neck hang jars with photographs—memories—of events in her life, while her head consists of a picture of her youthful self encased in a bell jar. Like Albright, in this work Kienholz graphically depicted the process by which time takes its toll; he suggested the wholeness of existence in the way in which the old woman's internal vision is stable and youthful even as her flesh has deteriorated and disappeared.

When Ivan Albright is considered in context, he can be seen equally as a realist and a fantasist, a conservative and a modernist—in sum, as an artist whose work embodies seemingly irreconcilable differences. The most important theme in his work is the transience of matter. Yet, in all of his creative endeavors, he sought to find the overarching principles that would bring universal issues—time and space, the finite and the infinite, the material and the spiritual—into harmony. On the one hand, Albright asserted that "every person sees things in a way unique and peculiar to himself."[70] Still, he was significantly influenced by the Renaissance and Baroque artists he saw as his real peers, not only by their techniques and imagery but also by their engagement with timeless themes. In attempting to interpret contemporary existence in terms of age-old concerns, he found a place for himself as a modern Old Master.

Editors' Note

The authors and editors have relied upon Michael Croydon's biography, *Ivan Albright* (New York, 1978), and the Ivan Albright Archive for establishing the titles and dating of the artist's oeuvre. Croydon worked directly with Albright on these issues; the Archive has enabled us to make some of this information more accurate. At the beginning of the painting process, Albright assigned a simple working title that referred to the visible subject of the painting (for example, *The Window* and *The Vermonter*). When it was finished, he made a list of more elaborate titles, occasionally considering as many as twenty before he was satisfied. Sometimes, Albright changed the title of a painting over the course of its exhibition history before arriving at a final appellation; or, as in the case of at least one (no. 20), it was altered by others. In some instances, Albright gave works parenthetical titles; where known, these have been included. In this catalogue, after first mention, Albright's longer titles have been abbreviated to their shorter, alternative titles for convenience (i.e., *The Monk, Room 203, The Door*). Dimensions are listed with height preceding width preceding depth.

Plates

a

b

c

d

e

f

I

Pages from Medical Sketchbooks

September 7, 1918–January 14, 1919
Watercolor, pencil, and ink on cream wove paper;
each sheet 22.9 x 30.5 cm (9 x 12 in.)
Inscribed variously
Department of Special Collections, University of Chicago Library

With the onset of World War I, the Albright twins enlisted in the Army and were assigned to the American Expeditionary Forces' Base Hospital 11, at Nantes, France. While Malvin did guard duty, Ivan became a medical draftsman, assigned to document the wounds, surgery or treatment, and progress of the injured. He filled roughly eight sketchbooks; he gave some away, and at least one was stolen. Three are accounted for today: Two belong to the University of Chicago (no. 1). A third, in The Art Institute of Chicago (no. 2), was done for the fracture ward of a Dr. Leo Czaja.

The earliest extant examples of Albright's art, these illustrations are, for the most part, contour drawings, delicately shaded with pen or pencil hatchings, and enhanced with thin washes of color that, as Albright's biographer, Michael Croydon, put it, "burst like sea anemones."[1] Most images close in on the injured areas. When the heads and torsos of patients are included, they look rather like pale mannequins, displaying their wounds dispassionately.

Albright dated and signed almost every sheet "Medical Drawer" and was careful to list as well the name of the soldier depicted, his serial number, outfit, and the nature of his injury. He followed a case for ten days (Corporal Silverman, November 17–27). In the first drawing (no. 1a), we see a dramatic, deep wound spanning the length of the patient's side. In another (no. 2a), after surgery, a long, thin line of stitches appears where the gash had been. Many drawings are accompanied, on the adjacent page, by a sketch of the X-ray of the affected area (see nos. 2c and 2f). "Imagine, looking right through the body," Albright later exclaimed about X-rays, saying that the experience of studying them "was the best art training" he had ever had.[2]

a

b

c

d

f

e

2

PAGES FROM A MEDICAL SKETCHBOOK

September 7–November 27, 1918
Watercolor, pencil, and ink on cream wove paper;
each sheet 16 x 26 cm (6⁵⁄₁₆ x 10¼ in.)
Inscribed variously
The Art Institute of Chicago, gift of Dr. Phillip V. Festoso (1976.439)

Despite the documentary aim of Albright's medical drawings, many go well beyond mere visual transcription, achieving an expressive and evocative quality. Thinly applied washes of color capture the wet and fluid character of exposed muscle and organs. Red, green, orange, yellow—the wounds swell and threaten to spill out from the tears in the human body. The sight of a metal pin running through the fissure in the arm of an unfortunate private, his limb in traction, is shocking (no. 1f). In one drawing (no. 1d),

Albright meticulously recorded a piece of removed shrapnel lying next to the victim, who appears to be suffering from gangrene.

Albright's early experiences as a medical draftsman have been cited by many commentators as having profoundly affected his mature work, giving birth to his macabre vision. This he emphatically denied, although he did admit that working with X-rays was revelatory (see no. 1). In his early twenties when he did his military service (see Chronology, fig. 7), he could not have been unaffected by months of exposure to the horrors of war—both physical and emotional—as he observed, up close, terrible and often fatal injuries and dismemberments. His concern for detail—obsessively and clinically rendered—in these drawings reveals the character of the art to come. That he was not repelled but rather fascinated by the nature of the assignment is also telling. His first-hand observation of the vulnerability of the human body, how easily flesh and bone are destroyed, was clearly formative. In 1964 he stated, "We are a weak machine made to do weak things in a weak way. The body is our tomb."[1] Clearly, this is a conclusion he began to form some forty-five years before.

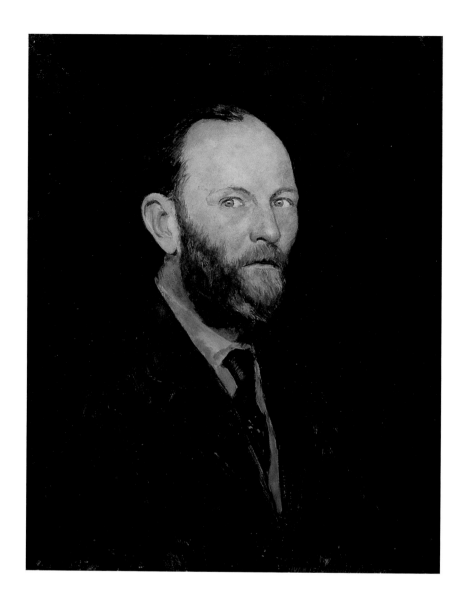

3
..............................

The Philosopher

1922
Oil on paper on panel; 61 x 45.7 cm (24 x 18 in.)
Signed and dated, lower right: *IVAN LE LORRAINE ALBRIGHT 1922*
Milwaukee Art Museum, gift of the artist (M1927.2)

Albright painted this imposing image during his third year at The School of The Art Institute of Chicago. The sitter's solidly rendered head, sensitive face, and luminous eyes become the focal points of the painting. More than any other early canvas by the artist, this one appears as a haunting prelude to the profoundly introspective and penetrating works to come.

The serious character of the image is echoed in the tone of the young artist's writings at the time. About 1922 Albright began keeping journals, using them as a place to consider the pictorial and philosophical issues that preoccupied him as he developed his work and his artistic theories. The notebooks became increasingly complex through the years; the artist wrote contemplative entries just days before his death. Early jottings such as "time is a dimension,"[1] or "you have to paint a picture so that what we see is complementary to [what] we do not see,"[2] suggest that Albright, at a young age, was formulating a philosophy of art that he would consistently evolve over many decades. This pensive portrayal of a philosopher steeped in thought and surrounded by darkness may have been inspired by two paintings by Edouard Manet he could have seen in the Art Institute, *Philosopher with Beret* and *Philosopher with Hat*. The canvas also may reflect the influence of Albright's father, the painter Adam Emory Albright, whose works from the early 1890s often feature dark tones and a cool manner reminiscent of Manet's early figure paintings.

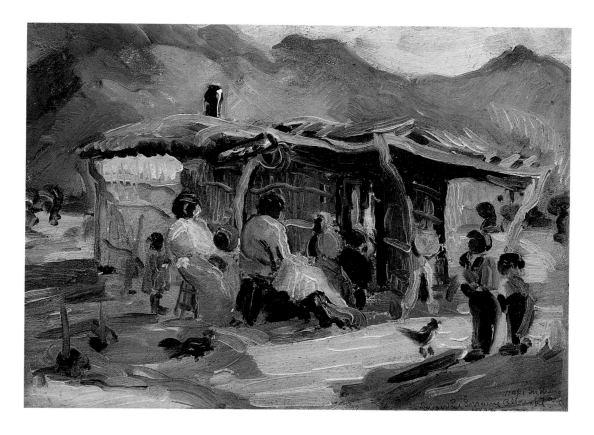

4
...........................

HOPI INDIANS

1925?
Oil on canvas; 29.2 x 39.4 cm (11⅝ x 15½ in.)
Inscribed, signed, and dated lower right:
Hopi Indians/Ivan Le Lorraine Albright aug/1924
Doris and Marshall Holleb

With its loose style, bright palette, and subject—a group of Hopi Indians gathered outside a dwelling in an arid mountain valley—this work appears to be an anomaly in Albright's art. The light tones and impressionistic brushwork relate the composition to mature works by the artist's father and by George Bellows, whom the young Albright admired (see Weininger, figs. 2 and 18, respectively).

By the early 1920s, the Southwest had become a popular locale for artists who were attracted by its climate, dramatic terrain, and Native American life. In 1924, the year inscribed on the painting, the Albright twins worked on the West Coast, and it is possible they visited the Southwest as well. However, Ivan is known to have inscribed, after the fact, the wrong dates on paintings (see also no. 62). According to a travelogue kept by Adam Emory, in 1925 the family explored the culturally rich area in which native peoples such as the Hopi were continuing to live according to traditions of their ancient forebearers. Whatever the painting's date, Albright seemed intent upon capturing a sense of the unrelieved heat of midday in this desert region, expressed through the brilliant light of the sky, in the clothing of the two main figures, and in a path of intense sunlight along the ground. Golden-yellow highlights dance on the figures and walls; a rich, deep blue suggests the relative cool offered by the shadows under the eaves of the dwelling.

If anything, *Hopi Indians* anticipates the travel sketches Ivan Albright made on extensive trips to various parts of the world much later in his life, including quickly executed drawings, watercolors, and gouaches (see nos. 53, 54, and 64).

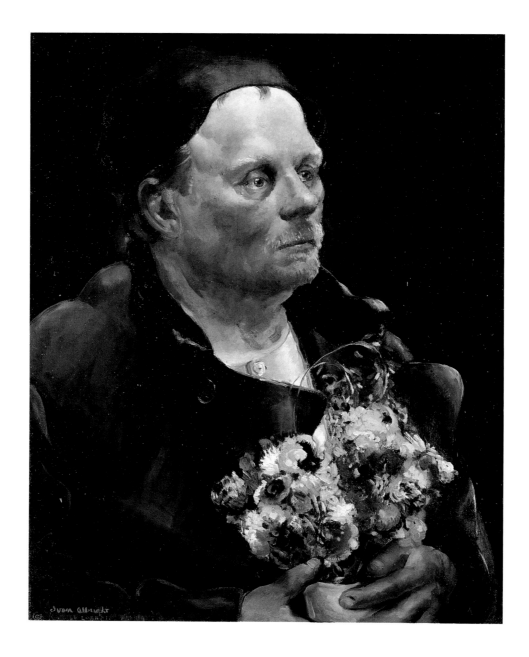

PAPER FLOWERS

1925–26
Oil on canvas; 66 x 50.8 cm (26 x 20 in.)
Signed, lower left: *Ivan Albright/© IVAN LE LORRAINE ALBRIGHT* (smudged)
Curtis Galleries, Minneapolis, Minnesota

In this canvas, Albright for the first time gave physical form to the pathos of the human condition, a theme that would engage him throughout his life. The title of the work refers not only to the bunch of paper flowers held by the model but to his actual circumstances. When Albright was living and working in Philadelphia, he encountered a man selling artificial bouquets on the street to pay for his next drink and asked him to pose. The artist made a concerted effort to understand and convey the humanity of the street vendor. That the sitter is unshaven, his eyes water, and he wears a dirty undershirt visible beneath his dark, heavy coat seems secondary to his innate dignity. He is somehow handsome, with his smooth, highlighted brow and fine bone structure; the steady gaze of his clear, blue eyes; and the tender way in which he holds his bouquet close to his chest. Albright did not paint the flowers to look fake—we probably would not recognize this detail were it not for the title's specificity. Rather, they relate in their scale and bright colors to the face, as if the artist intended to connect them.

Paper Flowers is further dignified by its clear relationship to Old Master prototypes. Its deep, brown shadows, strong chiaroscuro, limited palette, and subject relate it to the work of Rembrandt van Rijn which Albright deeply admired. Perhaps Albright was thinking of Rembrandt's compassionate studies of models found on the streets of Amsterdam when he noted in 1924: "Do not give too much variety of color else the greater strength and beauty of simplicity be lost and the painting poorer. It is better to have more bone and muscle under flesh and the outward appearance very simple so as to show there is more than externals."[1]

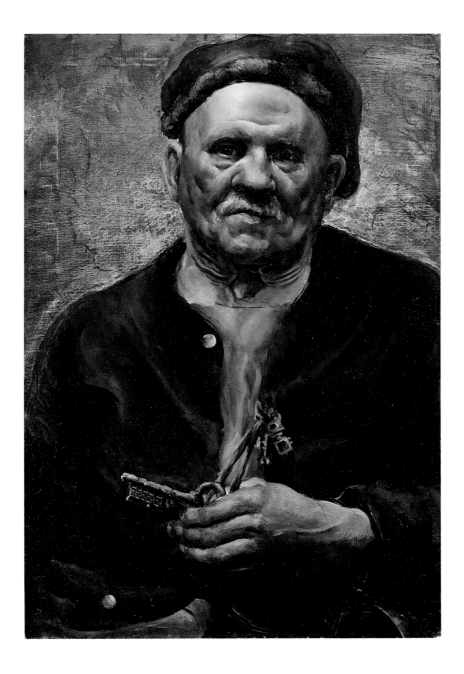

Burgomeister with Key

1925–26

Oil on canvas; 76.2 x 51.4 cm (30 x 20¼ in.)

Signed, lower left: *IVAN LE LORRAINE ALBRIGHT*

The Detroit Institute of Arts, gift of Dr. and Mrs. Irving F. Burton (65.364)

For this painting, as for *Paper Flowers* (no. 5), Albright used a sitter he found on the streets of Philadelphia. In working with nonprofessional models, he hoped to find the extraordinary within the ordinary. He reminded himself in a 1924 notebook entry always to "think of the character of the model."[1] In this, he followed the practice of his revered Rembrandt. Like the Dutch master, who often costumed his indigent models with fancy clothing and props, Albright here endowed a poor man with a furlined cap, the keys to a nonexistent city, and a civic title. The unknown model seems pleased to participate in the fantasy.

Albright rendered the figure with great care, modeling the face and hands with strong lights and shadows to create a sense of volume. Unlike the subject of *Paper Flowers*, he looks directly at the viewer and his emphatic blue jacket and dark hat clearly distinguish him from the background. Its contrasting, thinly painted surface seems almost scratched or scraped back to reveal the weave of the canvas. The result is a stronger, more forceful, and vivid presence. While the hands of the paper-flower vendor are nearly hidden under the bouquet they hold, here the model's hand stands out as it extends one of the keys, perhaps for our inspection. In the 1920s, the artist wrote, "If you have a pair of hands in [a] portrait, look at [the] head in relationship to [the] hands. . . . Sense their shape in [relation to the] head regardless of their individual shape. In this way you have a picture unified."[2] The arthritic-looking hand, puffy face, and wrinkled neck are the first signs in Albright's oeuvre to date of his lifelong preoccupation with aging and mortality, although he would not arrive at a suitable manner of transcription for another two years.

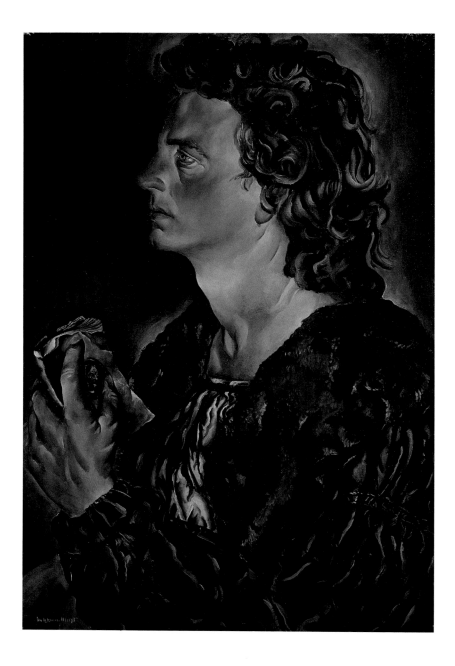

7
.........................

I SLEPT WITH THE STARLIGHT IN MY FACE
(THE ROSICRUCIAN)

1926
Oil on canvas; 76.2 x 50.8 cm (30 x 20 in.)
Signed, lower left: *IVAN LE LORRAINE ALBRIGHT* (stylized)
Wadsworth Atheneum, Hartford, gift of William Benton (1969.104)

Lost in thought, a young man looks up from a well-worn book cradled in his left hand. Bathed in light, he is a rare example of youthful beauty in Albright's work. His flowing mane of curly hair and elegant profile recall the early Renaissance artist Sandro Botticelli's depictions of handsome youths. Identified as a Rosicrucian (according to the artist, the model evidently took great pride in his Adam's apple, considering it a sign of spirituality[1]), the

young man evokes the romanticized depictions of poet-heroes lovingly painted by members of the Pre-Raphaelite Brotherhood. Indeed, he looks as though he were about to recite poetry or launch into a passionate soliloquy. *I Slept with the Starlight in My Face (The Rosicrucian)* is an early instance of the artist's inclination for long, evocative titles. He later confessed that such titles were a way to satisfy the frustrated poet in him.

Later, in 1961, Albright submitted *The Rosicrucian* to an exhibition at the National Academy of Design, New York, where the thirty-five-year-old work won a major prize for figure painting. The composition was purchased in 1965 by William Benton (1900–1973). A former United States senator from Connecticut, Benton was instrumental in forming one of North America's first corporate art collections as publisher and chairman of the board of Encyclopædia Britannica. He was particularly supportive of the art of Reginald Marsh, Jack Levine, and Ivan Albright, purchasing the latter's work for the company and his own personal collection (see also nos. 1, 8, 66a, and 66b).

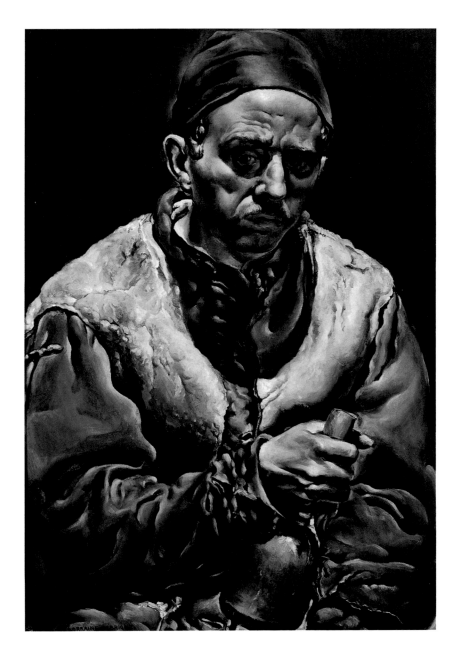

8

MAKER OF DREAMS
(MAN WITH A MALLET, MAKER OF IMAGES)

1926
Oil on canvas; 76.8 x 51.4 cm (30 x 20¼ in.)
Signed, lower left: ©*IVAN LE LORRAINE ALBRIGHT*
Marjorie and Charles Benton

The warm, brown tones and solid shapes of this portrait of Ivan's twin brother, the artist Malvin Marr Albright (1897–1983), present him as if he were a living sculpture. Wearing a cap and a lambskin jacket, he holds a classic attribute for sculptors, a mallet. Light moves across the surface of the figure and penetrates the folds of his jacket, suggesting the flickering illumination that characterizes the art of El Greco, whose technique and spiritual expressiveness much interested Ivan in these years. The earthy palette, the sitter's pose, and the serious tone of *Maker of Dreams (Man with a Mallet, Maker of Images)* recall a number of images of meditating saints by the great

Mannerist. Steeped in these associations, *Maker of Dreams* portrays the artist as an ascetic and suggests that artworks can become revelatory expressions of spiritual states.

At the same time that Ivan did this portrait of his brother, Malvin sculpted a bust of Ivan, *Ivan Albright, Portrait Painter* (see Donnell, fig. 10), which he first exhibited in 1928. During their student years, the twins had decided that Ivan would concentrate his studies on painting, and Malvin would pursue sculpture. Their talents and natural curiosity, however, quickly blurred the lines of the original agreement, and each became proficient in both mediums, although, in the end, they both favored painting. The twins enjoyed an intensely close relationship for nearly fifty years. They went to the same schools, shared studios, traveled together, and even accompanied each other on dates with young women. To distinguish himself from his better-known brother, Malvin invented the professional name of Zsissly, in order to make sure that he was listed at the end of exhibition catalogues, since his brother was to be found at the beginning. The twins' marriages effectively ruptured their close bond, prompting an estrangement that lasted until they turned eighty.

9

I WALK TO AND FRO THROUGH CIVILIZATION AND
I TALK AS I WALK (FOLLOW ME, THE MONK)

1926–27
Oil on canvas; 185.4 x 91.4 cm (73 x 36 in.)
Signed, lower right: *IVAN LE LORRAINE ALBRIGHT* ©
The Art Institute of Chicago, gift of Ivan Albright (1977.28)

The model for *I Walk To and Fro through Civilization and I Talk as I Walk (Follow Me, The Monk)* was a blacksmith, baker, and Franciscan friar, Brother Peter Haberlin (1845–1934). At the time Albright approached him, Brother Peter was serving an appointment at the San Luis Rey Mission, in Oceanside, California. In his early eighties when he posed for the artist, this monk was considered the last surviving link between the earliest Franciscan missionaries to California and their modern counterparts, which earned him the loving epithet "the last of the Spanish Padres," despite the fact that he was Irish-born. The painting's title evidently refers to the commitment of missionaries literally to walk and talk their way through the world in an attempt to bring their faith to others and to attract converts.

The meditative mood of this work relates it to the stark and moving depictions of Saint Francis by the Spanish Old Masters El Greco and Francisco de Zurbarán. Brother Peter appears absorbed in trancelike contemplation, his bulky form surrounded, from head to toe, by a radiance that adds to the intensity of the image. Despite the open window to the left, which serves as an actual light source, the glow seems unearthly, acting as a kind of halo that suggests the monk's purity of faith or contrition and makes him appear to levitate before us.

In this composition, Albright addressed head-on the process of aging, for which he had enormous fascination and respect. The thick, heavy folds of the monk's robe are reiterated in the strands of his rope belt, its twists and knots contrasting with the frail vine trailing from the windowsill. The monk's hair is matted down under his hood, his face is craggy, and his hands are gnarled. The large size and reddish highlights of the hands draw our attention to the crucifix they hold to the monk's heart. Albright recalled in a later interview that, while painting this canvas, he would sometimes implore Brother Peter, "Can't you feel more religious?" The monk would respond, "I'm doing the best I can."[1]

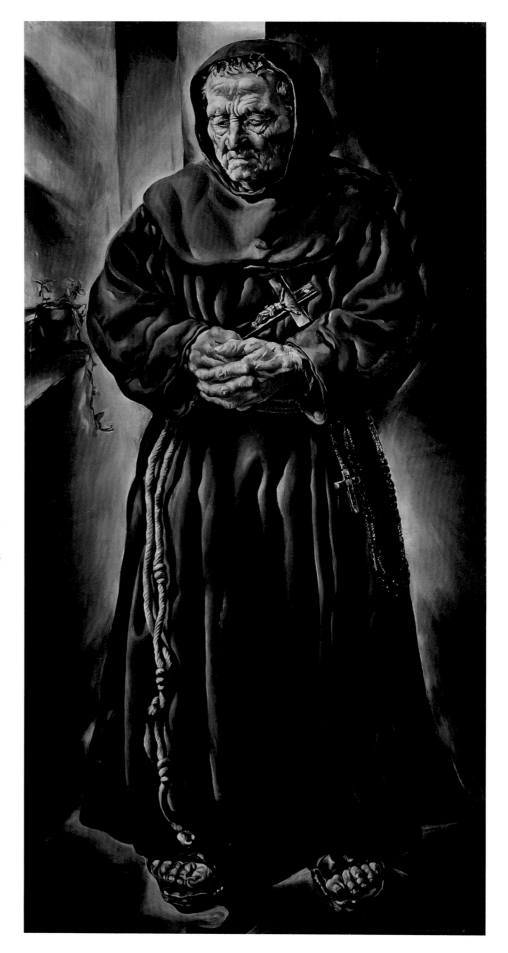

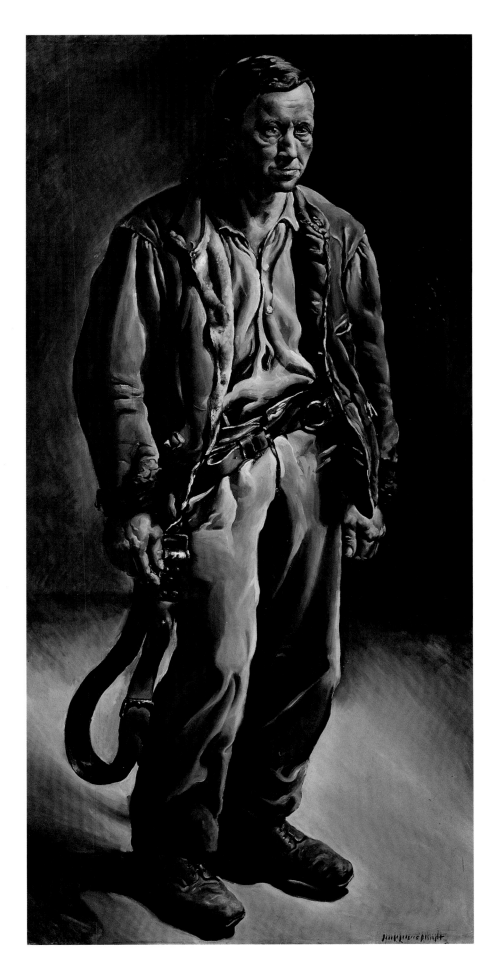

The Lineman

1927
Oil on canvas; 185.4 x 91.4 cm (73 x 36 in.)
Signed, lower right: *IVAN LE LORRAINE ALBRIGHT* (stylized)
The Art Institute of Chicago, gift of Ivan Albright (1977.27)

When this painting appeared on the cover of the magazine *Electric Light and Power* in May 1928 (see Donnell, fig. 12a), it sparked the first public controversy of Albright's career. The publication received and subsequently printed many letters from readers who were outraged by Albright's depiction of a worker, which they considered inaccurate and depressing. As one reader stated, "Frankly, all I can see in Mr. Albright's picture is a down-and-out tramp who has stolen a lineman's belt and pole strap."[1] In August a photograph of a much more enthusiastic and athletic laborer, captioned "The Modern Lineman," graced the magazine's cover (see Donnell, fig. 12b), in order to appease the publication's indignant readership. The incident was reported in *The Art Digest*, a national arts magazine, which called it "a storm."[2] Despite this negative reception from the industry, the canvas earned frequent praise from art critics and won prestigious awards. Indeed, *The Lineman* may first have been noticed by staff of the power-industry's magazine when the painting garnered a prize at The Art Institute of Chicago only a few months before it was featured on the cover.

Clearly the painting draws upon a long tradition of full-length treatments of single figures by Spanish artists such as Zurbarán and Diego Velázquez. In his student years, Albright was enamored of Velázquez; the posture and expression of the lineman recalls the Spanish Baroque artist's depiction of Aesop (Museo del Prado, Madrid). One can also trace the lineage of Albright's painting to images of laborers in the work of such nineteenth-century artists as painters Jean François Millet and Gustave Courbet and sculptor Constantin Meunier, in which the worker appears downtrodden or heroic (or both). Among Albright's contemporaries in the United States in the socially conscious era of the 1930s, Thomas Hart Benton and John Steuart Curry were just two of many who celebrated the "common" laborer in their art. While Albright was never interested in polemical meanings and, if anything, leaned to the right even in his youth, he clearly never meant to impugn the American worker in *The Lineman*.

Nonetheless, it is not difficult to see why the painting upset the industry. The figure seems exhausted, pulled down by the weight of his clothes and pole strap and by the demands of his work. His hands hang heavily beside him; his feet are massive. Only the robin's-egg blue of his shirt offers relief from the monochromatic beiges and browns of figure and background. The model, Arthur Stanford—employed as a lineman—posed for the artist in Albright's studio in Warrenville, Illinois, the small town outside Chicago where the artist worked, near his father and twin brother, for twenty years.

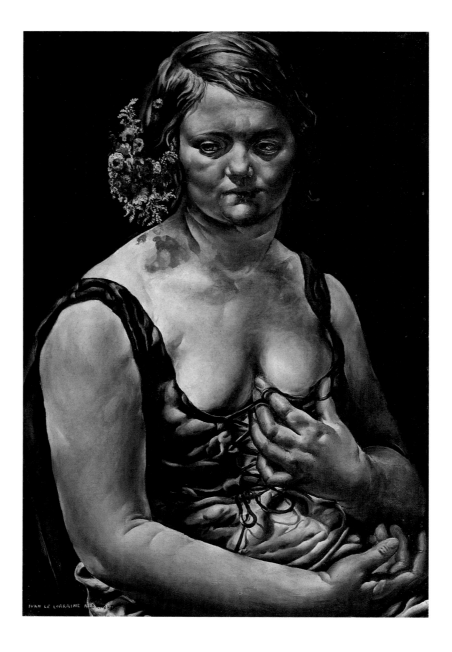

11
..............................

MEMORIES OF THE PAST

1927
Oil on canvas; 76.6 x 52.1 cm (30³/₁₆ x 20½ in.)
Signed, lower left: *IVAN LE LORRAINE ALBRIGHT*
The Art Institute of Chicago, gift of Ivan Albright (1977.30)

When this work was first exhibited, in 1928, some critics read it as an image of a courtesan, noting its resemblance to Renaissance portraits. Albright's main interest in this work was not content-related; rather, he wished to improve his technique and heighten the intensity of his figure studies. In a notebook, he annotated thumbnail sketches for this painting with such statements as: "Paint portrait as if figure . . . were in front of [actual] canvas," and "[Be] absolutely realistic . . . [as if form is under] magnifying glass."¹ He pushed these ideas further in *Flesh (Smaller Than Tears Are the Little Blue Flowers)* (no. 12) and *Woman* (no. 13).

Sad and reflective, this young woman appears to be totally absorbed in nostalgic thoughts, as the title indicates. The long fingers of her left hand move provocatively through the crossed ties of her bodice; she seems totally unaware of her gesture or of the presence of a viewer. Adding to the poignancy of the work is the model's beauty and the colorful arrangement of flowers in her hair. To convey an air of melancholy, the artist concentrated on the face and hands, whose exquisite modeling contrasts with the flatter, less detailed, and paler rendering of the chest and arms, except for the shadows that the flowers in the hair cast on her shoulders. By the time he painted *Into the World There Came a Soul Called Ida* (no. 17), where the model's left hand is positioned somewhat similarly across the chest, the artist was able to achieve greater integration of all parts of the figure. The sitter for *Memories of the Past* was a secretary from San Diego, California, whom the artist also photographed during a modeling session,² perhaps because he was concerned about her future availability as a model for this image. Albright rarely worked from photographs, and it is not entirely certain that he did so here.

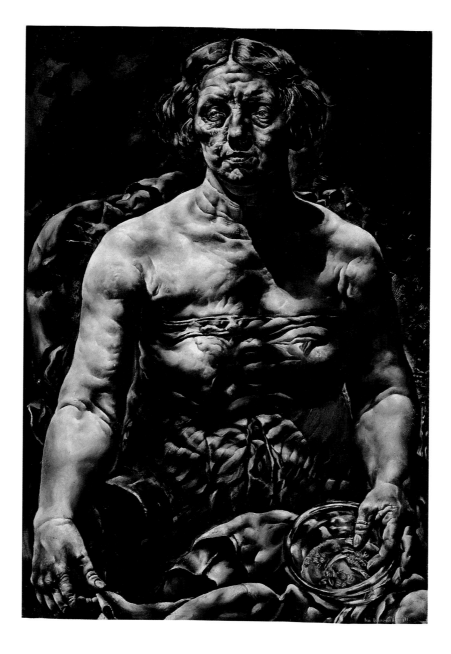

FLESH (SMALLER THAN TEARS ARE THE LITTLE BLUE FLOWERS)

1928

Oil on canvas; 91.4 x 61 cm (36 x 24 in.)
Signed, lower right: *IVAN LE LORRAINE ALBRIGHT* (stylized)
The Art Institute of Chicago, gift of Ivan Albright (1969.814)

Perhaps, when he executed this work, Albright was thinking of the strong figurative paintings of George Bellows, with whom he had hoped—in vain—to study in New York; or of realistic portraits done by the artist he did study with, Charles Hawthorne (see Weininger, fig. 6). Hawthorne had a one-person exhibition at The Art Institute of Chicago in November–December 1927; and Bellows had won major prizes at the museum in 1921 and 1923—when Albright was studying at the School of the Art Institute—for two straightforward portrayals of older women in dark interiors.

Mercilessly, Albright described the corrugated flesh of his sitter's face and upper body. A spectral quality is created by the flickering light and blue highlights that outline the right side of the head and neck, as well as both arms. Also eerie is the transparency of the bodice that just covers the breasts. Because of its skin tones and suggestive folds, it seems to have become one with her flesh, as if she were naked from the waist up. A glass bowl, cradled on her lap, is partially filled with water in which float delicate forget-me-nots. That the bowl seems to tip forward, threatening to spill its contents, adds to the poignancy of this meditation on the fleeting nature of beauty and its inevitable loss. The woman's right eye, accented by a dot of red in the corner, gazes sadly off to her right; her left eye, dark and lifeless, underscores the melancholic, inward quality of her expression. The *memento mori* character of this work is evident in the clear definition of the model's skull just beneath the surface of her skin. The sitter was Mrs. Arthur Stanford, wife of the model for *The Lineman* (no. 10).

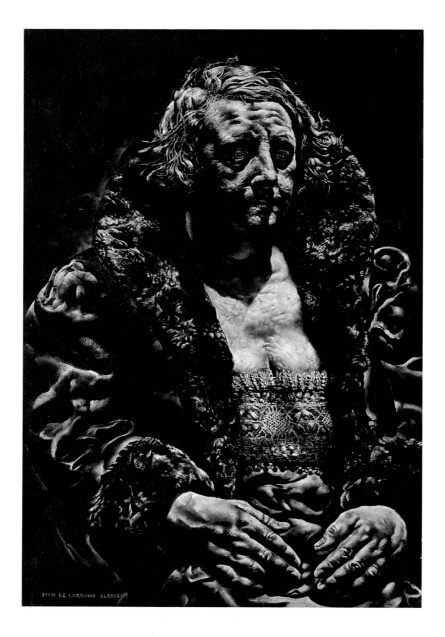

IVAN LE LORRAINE ALBRIGHT

13
...........................

WOMAN

1928
Oil on canvas; 83.8 x 55.9 cm (33 x 22 in.)
Signed, lower left: *IVAN LE LORRAINE ALBRIGHT*
The Museum of Modern Art, New York, given anonymously, 1948

In June 1927, Albright gathered his art around him in order to assess it. Displeased, he wrote in a notebook, "My painting calls for greater study. . . . I must thoroughly study my next portrait."[1] The outcome of his resolve was *Woman*, his most accomplished and powerful work to date. For this painting, he created a skylight in his Warrenville, Illinois, studio and placed his model, Mrs. Vina Marion Heywood, in the shaft of cold, natural light that emanated, unimpeded, from above. Many years later, he said, "A steady light with white clouds reflecting down I think is the best light you can have."[2]

In this forceful composition, the artist managed to strike a balance between strong, sculptural form and an emphasis on surface that resulted from his fascination with microscopic description. Dramatic chiaroscuro and exacting detail give weight and bring to life every texture: individual strands of hair and eyelashes, wrinkles and moles, fur and heavy cloth, lace and silk. Like a dowager queen, the seated woman fills the canvas, her monumental form made even more grand by the raised collar dramatically circling her shoulders and head. The rich, dark background, the proud carriage of the model, and the grandeur of the costume bring to mind portraits of European royalty from the Renaissance and Baroque periods. However, there is nothing aristocratic or sexually alluring about this bare chest and hint of breasts (in effect, the fact that the flesh appears to simultaneously grow and shrivel is disturbing); and the head—with its unkempt hair; dark shadows especially around the eyes, nose, and mouth; and faint mustache—seems almost masculine. As Albright's biographer, Michael Croydon, put it, Albright succeeded in creating here an "uncompromising disclosure of the human condition."[3]

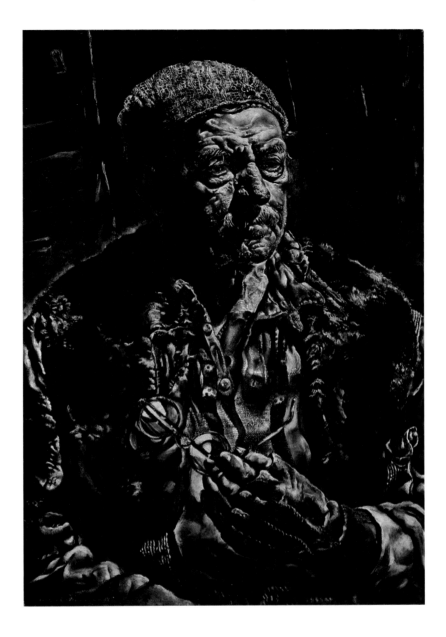

FLEETING TIME, THOU HAST LEFT ME OLD

1928–29

Oil on canvas; 76.8 x 51.4 cm (30¼ x 20¼ in.)
Signed, lower left: *IVAN LE LORRAINE ALBRIGHT*;
signed, over shoulder at left: *IVAN/ALBRIGHT*
The Metropolitan Museum of Art, New York,
George A. Hearn Fund (50.95)

This poetically titled image of a seventy-eight-year-old horse trainer named Byron McCain pushes the intense scrutiny with which the artist observed his female model in *Woman* (no. 13) to an even deeper level. As Michael Croydon wrote, "Few painters have rivaled this unflinching fidelity to the scars of time and even fewer have probed so mercilessly."[1]

Wearing an intricately rendered, crocheted skullcap, horsehair jacket, shirt, unknotted tie, and fingerless gloves, McCain posed in an old Warrenville, Illinois, barn for nine weeks. It is surprising that Albright completed the composition so quickly, considering the astonishing degree of detail and intimate treatment of the model. Albright's notes for the painting indicate his desire to create a sense of volume. He paid particular attention to the head because, as he wrote after planning this work, "A face is a soul looking out."[2] The head and upper body, defined by strong lights and darks, emerge dramatically from the shadowy depths of the barn, which is indicated minimally by knotted, brown wooden panels and an occasional nail. Contrary to the severity of his treatment of the aging process in his studies of women in *Flesh* (no. 12) and *Woman* (no. 13), *Fleeting Time, Thou Hast Left Me Old* is a sympathetic image. McCain's expression is not self-pitying or uncomprehending but rather honest, intelligent, and self-possessed; his aging body still looks strong, protected rather than exposed by his clothing (in fact only his head reveals his advanced years); and his gesture of having removed his glasses seems to signify that he does not need them to see clearly or to understand. The connection Albright obviously felt with McCain is explained by an episode that occurred during the painting's execution. As Albright related to Croydon, the old man "cried one day when he was posing for me—I asked him why—he simply said, 'I am getting old. My end is near.'"[3] This epiphany had great resonance for the artist. He would later write, "We are all marching to death side by side; let us be happy we are together."[4]

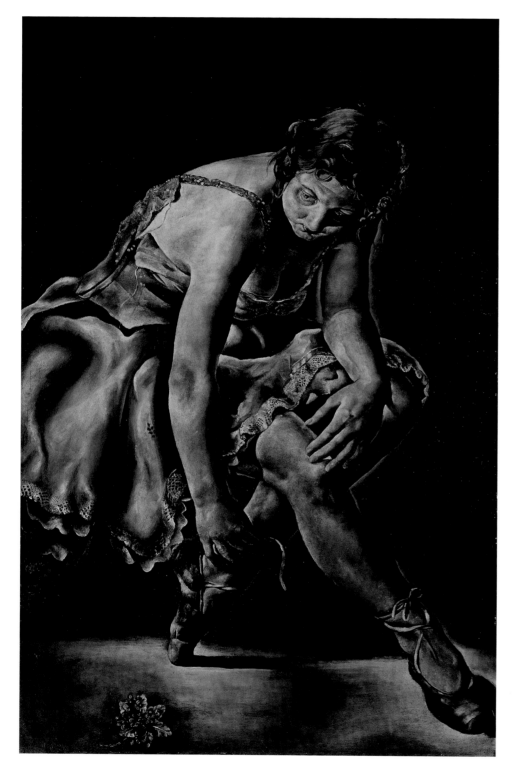

THERE WERE NO FLOWERS TONIGHT (MIDNIGHT)

1929
Oil on canvas; 123.2 x 76.7 cm (48½ x 30⅜ in.)
Signed, lower left: *IVAN LE LORRAINE ALBRIGHT*
National Gallery of Art, Washington, gift of
Robert H. and Clarice Smith (1972.7.1.[2611])

This painting of an aging dancer, pensive and ener-
vated after a possibly lackluster performance, was
described by a newspaper critic as "low in tone and
somewhat depressing in its effect."[1] Far from the
lightness and grace to which ballerinas aspire on
stage, she collapses over her lap as she absentmind-
edly unties her slipper. Rather than congratulatory
bouquets of fresh flowers, a single, tiny bunch of oak
leaves lies below her left foot. While the oak leaf sym-
bolizes faith and endurance in adversity, the dancer
appears too exhausted to draw any strength from it.

For this composition, painted in Laguna Beach,
California, the model was Lady Frances Curie Mil-
burne, a member of a local amateur theater group.
The peculiar angle at which Albright depicted her
seems intentionally unflattering. It emphasizes the
broad expanse of her back, the heaviness of her
breasts, the thickness of her abdomen. It also exag-
gerates the length and breadth of her nose, under-
scores the circles and shadow below her eyes, and
almost hides her mouth. Yet the arc of rose petals in
her hair, the delicacy of her long fingers as they untie
her slipper and touch her knee, and the elegant
turnout of her feet all attest to the grace that was.

A thumbnail sketch for the work in an early note-
book defines the figure within a cube, indicating Al-
bright's desire to use the surrounding space to impart
a sense of depth and give the figure volume.[2] The
enveloping darkness is so profound that we do not
know where she is or what she is sitting on. Albright
was soon to resolve more successfully the issue of
integrating figure and surround in one of his great-
est figure paintings, *Into the World There Came a Soul
Called Ida* (no. 17).

HEAVY THE OAR TO HIM WHO IS TIRED, HEAVY THE COAT, HEAVY THE SEA

1929
Oil on canvas; 135.2 x 86.4 cm (53¼ x 34 in.)
Signed, lower left: *IVAN LE LORRAINE ALBRIGHT*
The Art Institute of Chicago, gift of Mr. and Mrs.
Earle Ludgin (1959.12)

In the early 1930s, *Heavy the Oar to Him Who Is Tired, Heavy the Coat, Heavy the Sea* generated more enthusiastic response from critics than Albright had ever received. He executed this powerful painting in Laguna Beach, California, at a time when he was experiencing excruciating pain in his lower back (he later had a kidney removed). This illness made him determined to create something truly fine. Indeed, all of his faculties as an artist came together to produce this masterful composition, ambitious in its combination of figure and landscape, striking in its palette, and rich in its textural variety.

Albright wrote about his goals for this work: "Cut figure out as if it [were] in block. Let light and darkness both fall on figure. Let spirituality descend on the work that it may be good and survive. Let color flow from every part to all. Let there be movement and direction . . . [and] a terrific force within."[1]

A cigarette dangling from a holder in his mouth, the fisherman stands before an open window, holding implements of his work in his hands. He is monumental, his body made to look even larger and stronger by the heavy, impermeable clothes he must wear. He looks out with bloodshot eyes, dazed and exhausted from his latest struggle with the elements for his livelihood. While the artist claimed that he found the light in California "ghastly [and] . . . impossible,"[2] he was clearly affected by it here. Its vibrant yellows and blues are far removed from the darker tones of paintings done previously in Illinois (see nos. 12–14). Unlike other examples of Albright's art, which tended to dry to a mat finish, the pigment here is thick and wet-looking, seemingly as fresh as the day it was applied.

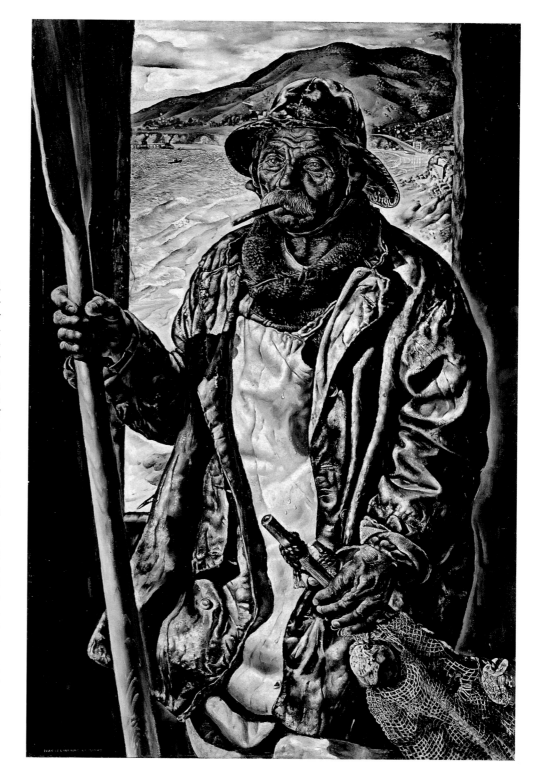

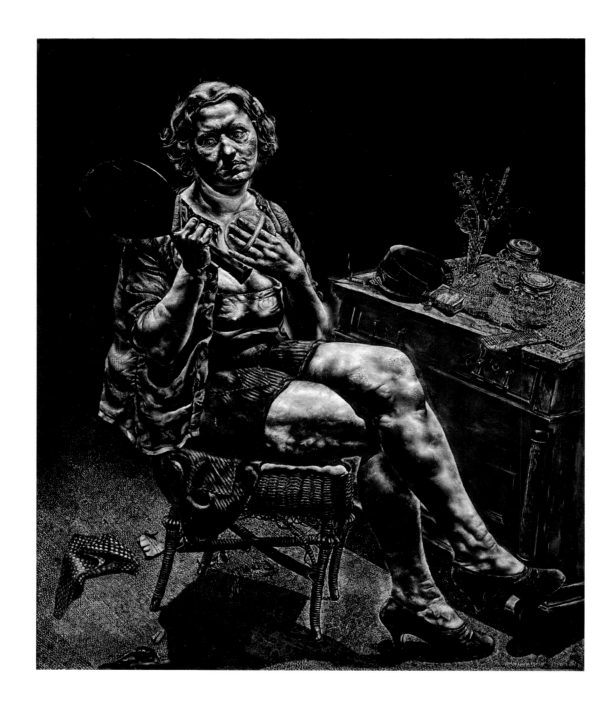

INTO THE WORLD THERE CAME A SOUL CALLED IDA

1929–30
Oil on canvas; 139.7 x 116.8 cm (55 x 46 in.)
Signed, lower right: *Ivan Le Lorraine Albright* (stylized)
The Art Institute of Chicago, gift of Ivan Albright (1977.34)

Like *That Which I Should Have Done I Did Not Do (The Door)* (no. 24), Albright's most popular work, this modern *vanitas* image is replete with traditional symbols of the fleeting pleasure of material possessions and the inexorable passage of time. In *Ida* they include a hand mirror, a powder puff and comb, a burning cigarette and extinguished match, money, and flowers.

The model for this unforgettable image, Ida Rogers, was actually a twenty-year-old wife and mother whom Albright described as "a very decent, nice girl."[1] That he chose

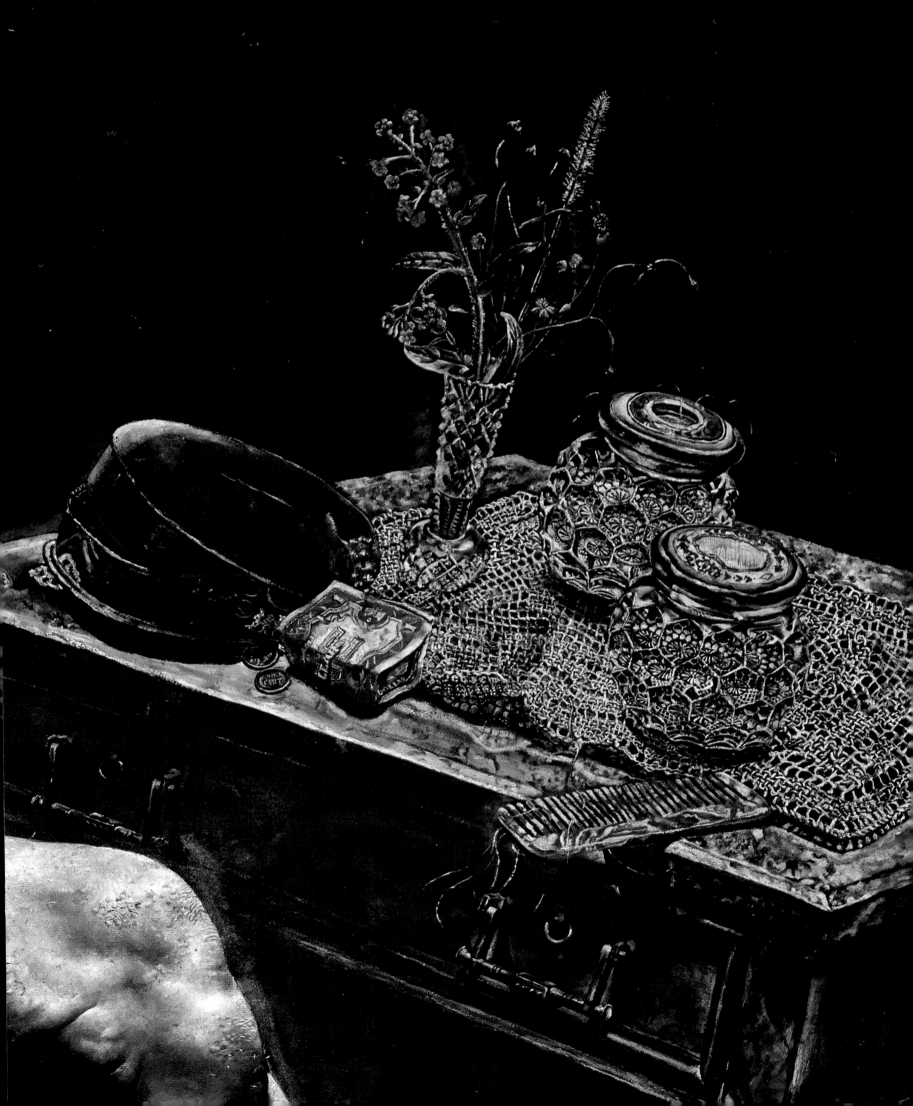

to work with someone this age was not capricious: clearly Albright's *Ida* was once young and beautiful, but now she has begun to age, something she fully recognizes as she glances sorrowfully at the mirror. Because of the angle at which she holds the mirror, it is not entirely clear whether she looks at it to see herself or rather to peer into the void behind her. The room is quite empty, its unraveling rug disappearing into an impenetrable and threatening darkness. The isolation in which Ida exists is as disturbing as the futility of trying to forestall the process of decay with a powder puff.

Dramatically lit, the model wears a thin, pinkish bed jacket; a semitransparent camisole that reveals her cleavage and the outline of her low-hanging breasts; and a short, patterned slip that falls across her heavy, puckered thighs. Albright often spoke about walking around objects or a model in order to understand and paint the total form. In *Ida* the figure and every other item, down to the worn and tattered rug, have been described from a different vantage point, thereby increasing the viewer's uneasiness about what is seen. The perspective of the rug and dresser makes the floor tilt precipitously toward the lower right. As the bureau slips downward, the objects resting on it look as though they will slide off. The figure is too heavy for the wicker chair; its thin legs bend under the load they carry. There is an odd, floating quality to many of the objects in the composition—even the checkered handkerchief at the lower left seems caught in midair (in fact, Albright painted it as it appeared draped over a platform, but did not depict the platform). Scraps of paper and a peanut shell on the floor allude to the relationship between artist and model. The shell invokes Rogers's habit—which much annoyed Albright—of eating peanuts during posing sessions to relieve the tedium of having to sit still for many hours over many months. The paper scraps may refer to scrolls that are often found in *vanitas* compositions or to poems that the artist, evidently infatuated with Rogers, wrote and presented to her. The young woman laughed at his words, as much out of embarrassment as amusement, which prompted him to tear them up.

18
..........................

Beneath My Feet

1929, 1940s
Oil on canvas; 50.8 x 59.1 cm (20 x 23¼ in.)
Signed, lower right: *Ivan Albright*;
signed, upper right: *IVAN LE LORRAINE ALBRIGHT*
Private collection

In this unusual oil, Albright depicted flowers and a nest or dried grass: undergrowth in a field, woods, or neglected garden. Referring to the composition in a letter to a patron in 1965, the artist stated, "[It] was [re]painted in Warrenville in the '40s and is the basis of a theory of motion that I have since elaborated on."[1] In the early 1920s, he wrote in a notebook about his desire to capture the sense of movement through a landscape, second by second, step by step.[2]

Here Albright evoked his own presence by showing us what he saw as he looked down at the ground. The unseen feet and body of the artist imply the continuation of the landscape beyond the picture frame, with an infinite progression of images, which shift and change as the artist walks along. Albright's keen sense of observation involves us in a small universe in which the life cycle seems to take place before our eyes, with dead grasses being pushed aside by burgeoning stems of leaves and flowers and even a small caterpillar. Michael Croydon aptly noted the connection of this work to Albrecht Dürer's breathtaking watercolor *The Great Piece of Turf* (Graphische Sammlung Albertina, Vienna).[3] Albright's concern with the relationship between the landscape he was observing and his own locus within it became obsessive in later years, when he literally made maps of the terrain he was attempting to depict.[4]

NOW A MASK

1930 (cast 1960s)
Bronze; h. 29.2 cm (11½ in.)
Private collection

Perhaps dissatisfied with the results of his efforts in three dimensions, Albright produced very little sculpture. Only six completed works are extant (see also nos. 27, 30, 50, and 92). *Now a Mask* was the first of Albright's sculptures to be cast, although when exactly this occurred has not been determined. The Italian foundry that produced the original bronze apparently lost it; this is a unique cast from the 1960s. The face's fluidity suggests its origin in soft clay; the melancholic, fleeting expression recalls the evocative, impressionistic heads of the late-nineteenth-century Italian sculptor Medardo Rosso. At the same time, its classical features and fragmentary character were clearly inspired by ancient bronzes, particularly Etruscan, which Albright so admired.

AND MAN CREATED GOD IN HIS OWN IMAGE
(ROOM 203)

1930–31
Oil on canvas; 121.9 x 66 cm (48 x 26 in.)
Signed, lower right: ©/*Ivan Le Lorraine Albright*
The Art Institute of Chicago, gift of Ivan Albright (1977.36)

In *And Man Created God in His Own Image (Room 203)*, a middle-aged man undresses for the night. Behind him are the posts of a wooden bed over which he has hung his shirt; a bare electric light bulb; and peeling, patterned wallpaper. Still wearing his hat, he removes his undershirt, which is partially tucked into pants that will shortly slip from his bulky frame. By cutting the figure off at the thighs and concentrating our attention on his lumpy arms and fleshy torso, suggestively covered by clothes only just above his loins, Albright completely disrupted the tradition of the heroic or beautiful male nude. Perhaps not since the German Renaissance artist Matthias Grünewald had decaying flesh been depicted with such a sense of the grotesque: it is pimpled and hairy, flabby and puckered, discolored in patches tending toward blue to suggest how cold and clammy it would feel if touched. One writer described the subject of the painting as a "Bowery bum who is preparing for the night in a flop house."[1] This interpretation is reinforced by the painting's short title, *Room 203*, possibly the number of a room in a single-room-occupancy establishment.

Albright often chose to paint, as he put it, "things that looked as though they have lived their life,"[2] a tenet he applied equally to the human subjects he portrayed. In this case, the model was George Washington Stafford, a bartender and community leader from Warrenville, Illinois. Under his bowler hat, the man stares out vacantly, as if exhausted or drunk; the glint of a bottle can be seen above his pocket at the lower left (in fact, the artist provided his model with alcoholic beverages[3]). The profound metaphysical, as well as physical, ill-health of the man relates him to contemporary images of traumatized, automatonlike figures created by Neue Sachlichkeit artists such as Otto Dix. As the painting's title indicates, Albright daringly hypothesized that God exists in our minds as a reflection of the poor specimens we are.

In what was a compositional breakthrough, Albright here extended to inanimate matter the technique he had been using since 1928 to microscopically render human flesh, and filled the canvas to its edges with an oppressive accretion of things examined in extreme detail (note, for example, the way in which the artist rendered individual threads of the shirt). The man's flesh aggressively pushes out toward the viewer, and is more likened to, than distinguished from, its surroundings. Albright was to explore the idea of all-over composition with greater frequency in canvases (see nos. 40, 42, and 52) with extraordinary surface patterns that would, in later years, lead some to consider his art in abstract terms.

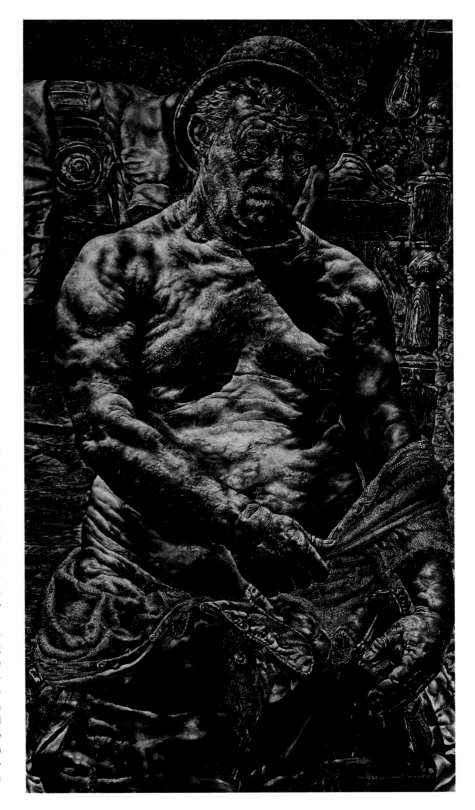

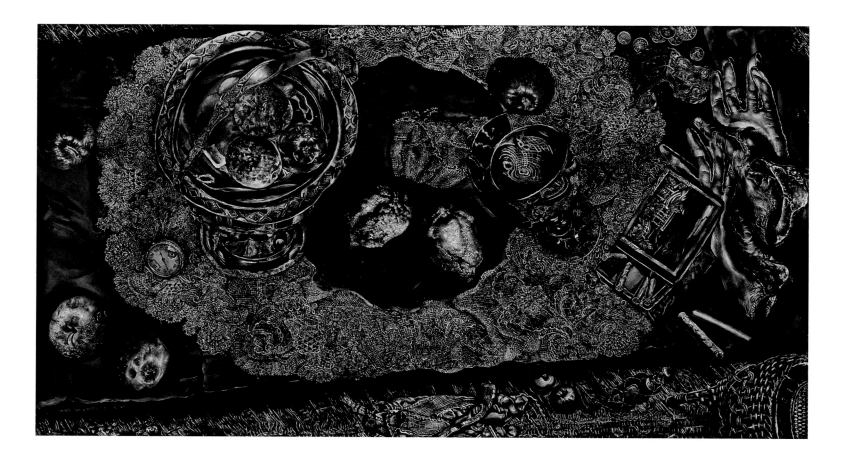

WHEREFORE NOW ARISETH THE ILLUSION OF A THIRD DIMENSION

1931
Oil on canvas; 50.8 x 91.4 cm (20 x 36 in.)
Signed, lower left: *IVAN LE LORRAINE ALBRIGHT*
The Art Institute of Chicago, gift of Ivan Albright (1977.23)

Wherefore Now Ariseth the Illusion of a Third Dimension is the full-blown expression of an interest Albright had from his student days in bird's-eye perspective. There is nothing "still" in this dynamic still life. The composition forces the eye to move in circles, from object to object, detail to detail. The tipped perspective of the goblet makes the apple above and lemons to the left appear to float around it. The rotting apples in the compote seem to jostle one another for space as the curved handle dramatically arcs over them. The much smaller scale of the objects on the floor, compared to that of those on the table, implies an abrupt shift in viewpoint. This induces a sense of movement through space, as well as through time.

In selecting and arranging a provocative, complex group of objects, the artist discovered a method on which he would come to depend for his signature figure and still-life paintings: an elaborate setup (see, for example, nos. 24, 40, 41, 46, 51, and 52). When considered together, the painting's various elements—including, on the table, the half-empty wineglass and pair of gloves, bloated as if filled with invisible hands (the artist had a model wear them); and, on the floor, a wine bottle and discarded girdle—imply a narrative that is never revealed. While the painting is generally hung and reproduced with the gloves at the upper right, Albright specifically eschewed any "correct" orientation for it. Rather, he hoped that its owner would enjoy it fully by regularly changing its direction, thereby replicating the action of the artist as he walked around his arrangement in order to best understand its components. In this the artist anticipated by some fifteen years the experiments of Abstract Expressionists with all-over surfaces.

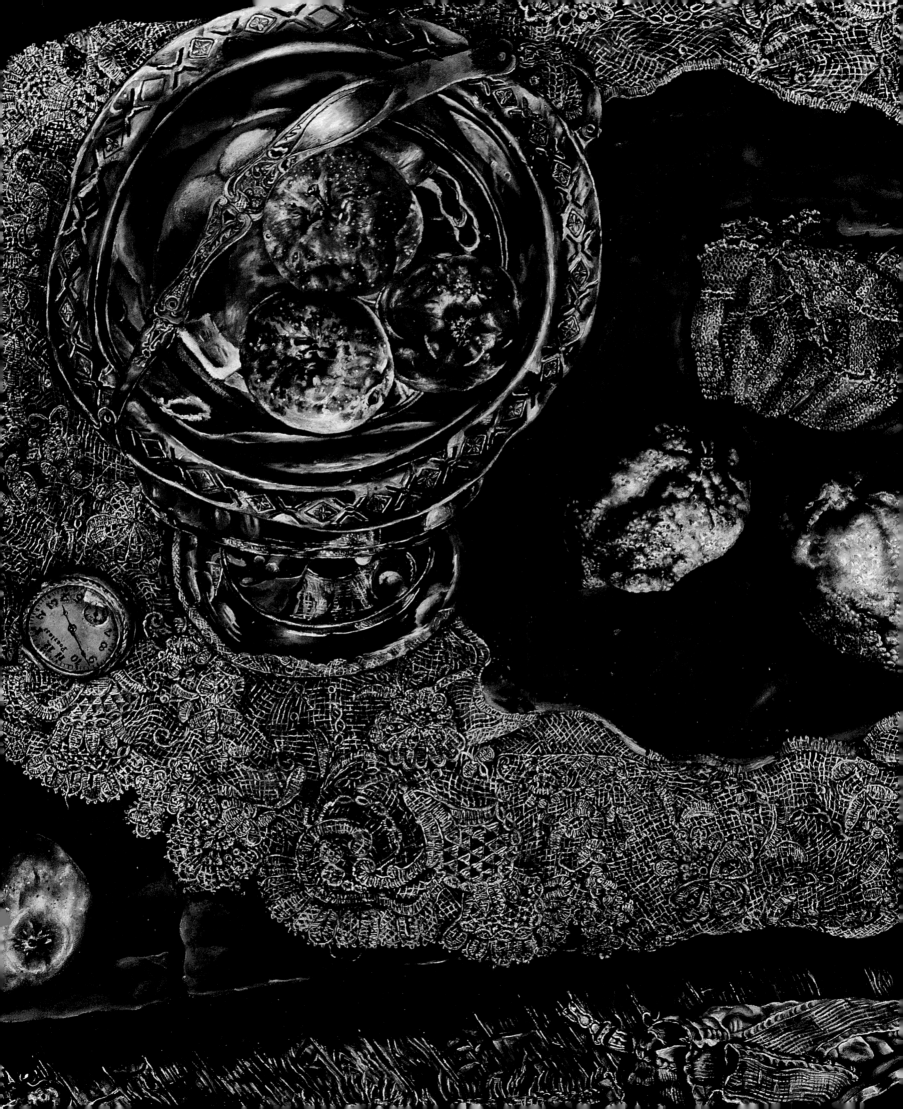

THREE LOVE BIRDS

1930
Charcoal with touches of oil on canvas;
198.7 x 106.7 cm (78¼ x 42 in.)
The Art Institute of Chicago, gift of Ivan Albright
(1977.38)

Unfinished works of art often reveal the thought processes of artists in a way that is more telling and complete than working sketches. Albright's use of a "patchwork" method of painting, which so amazed contemporary critics, can be observed clearly in his unfinished *Three Love Birds* (see also no. 23). Although it was not unusual for artists of Albright's generation and academic training to draw a composition in charcoal or pencil prior to executing it in paint, what fascinated artists and critics about Albright's technique was the meticulous and calculated manner in which he employed it. After stretching and gessoing a new canvas, Albright made an elaborate charcoal drawing on the white surface, sparing no detail. In some cases (see no. 24), this activity alone could take over a year. The work at the end of this stage was considered essentially complete, but without color. By itself, the charcoal resembled the artist's later lithographic reprises of his famous oils (see nos. 37, 43, and 47). Using the finished drawing as a guide, Albright would then concentrate on whatever area of the canvas that interested him at a particular moment. He could focus on separate sections until he considered each one finished, rather than bring the entire composition to an equal state of completion at once. Few artists are able or wish to work in such an obsessive manner. It is a testament to Albright's masterful vision and technique that he could proceed this way and, in the finished canvas, blend these sections seamlessly together.

At the left, a deteriorating, old chair, its insides spilling out onto the floor, has been carefully rendered in oil paint. The young girl's face and hair are nearly complete, and a few areas of her fleshy body have been colored in. But the ghostlike, transparent character of the unfinished elements—the drapery, the floor, the girl's shoes, and the cage that would have held the two other "love birds"—lend an evocative quality to the image. Albright ceased work on this painting when the rigorous measurements and observations he had made at the outset were thrown off by the fact that the model had become an inch and a half taller over the preceding eleven months. Contrary to what she had told Albright when he hired her, she was only sixteen, and still growing. A decade later, the artist took up the composition in a lithograph (no. 38), which provides an idea of how the canvas would have looked had he completed it.

SHOW CASE DOLL

1931–32
Charcoal and oil on canvas; 88.9 x 137.2 cm (35 x 54 in.)
Signed, lower right: *Ivan Albright*
The Art Institute of Chicago, gift of Ivan Albright (1977.24)

"For the *Show Case Doll*," Albright told interviewer Paul Cummings in 1972, "I had a case made as if it were in a store, with the doll and lace and different stuff all around."[1] The artist then used charcoal to execute the composition in all its detail, an exacting process that took him many months. But by the time Albright was ready to apply color—part of the doll's face and other small patches are painted—he was hard at work on another ambitious composition, one so compelling that he would devote over a decade to it. Although *Show Case Doll* eventually lost out to *The Door* (no. 24), its

unfinished state allows us to observe the artist's technique and to appreciate his accomplished draftsmanship (see also no. 22).

The long, rectangular format of *Show Case Doll* and its use of a coffinlike image to suggest death connect it compositionally and thematically to *The Door*. The beautifully dressed doll lies on an ornately decorated pillow, surrounded by an odd and ominous array of objects (the Victorian perfume spray resembles a syringe; the many layers of cloth on which the doll rests seem to swallow her up). The case, which warps and swells dramatically before our eyes, recalls Victorian glass shrines in which photographs of the deceased were surrounded by dried flowers, or photographic images from the same period of exquisitely adorned and presented corpses lying in state.

Despite the fact that Albright never finished *Show Case Doll*, it remained important to him. He produced a lithograph of it in 1954 (no. 48), and, near the time of his 1964 retrospective at the Art Institute, when he had predominantly harsh things to say about his oeuvre, he expressed satisfaction with the canvas's simple and clear presentation, noting that "it realizes its objectives."[2]

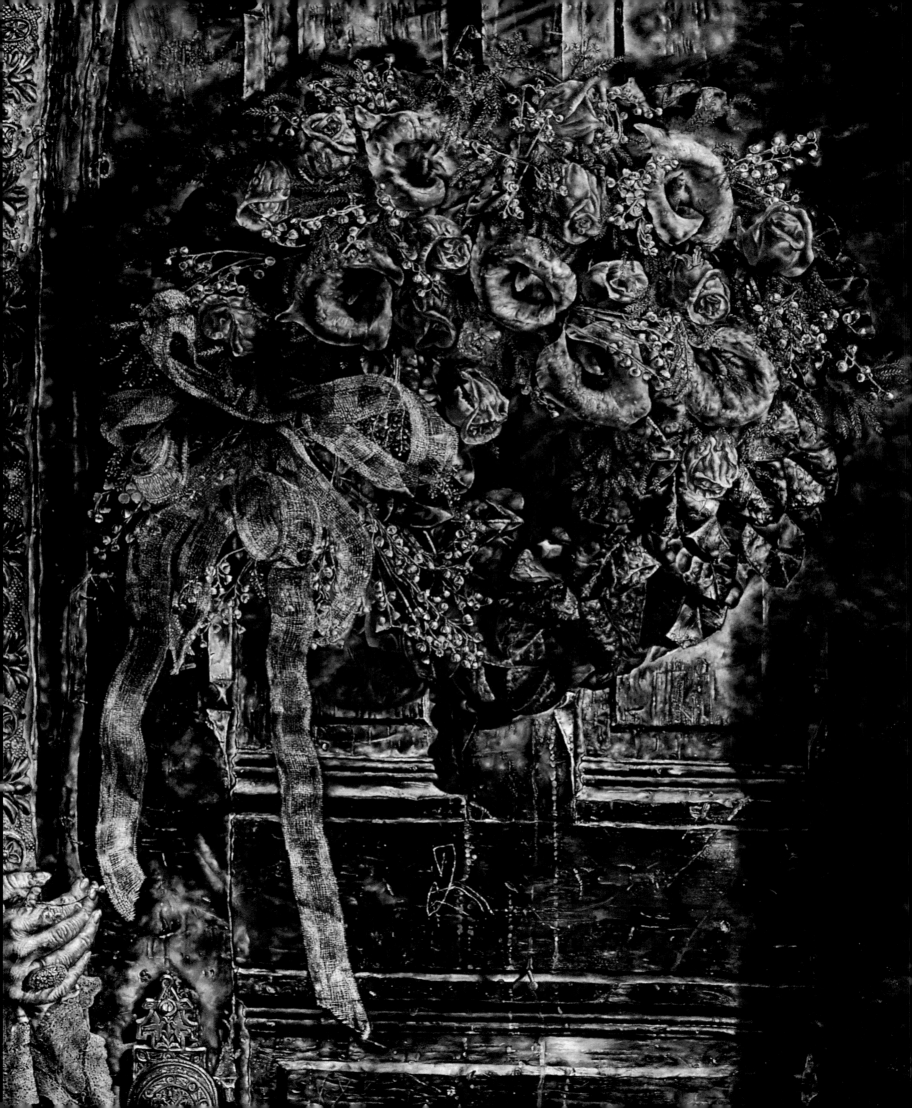

THAT WHICH I SHOULD HAVE DONE I DID NOT DO
(THE DOOR)

1931–41
Oil on canvas; 246.4 x 91.4 cm (97 x 36 in.)
Signed and dated, lower left: *IVAN LE LORRAINE ALBRIGHT 1941*
The Art Institute of Chicago, Mary and Leigh Block
Charitable Fund (1955.645)

As hallucinogenic as anything produced by the Surrealists, this master-
piece of American painting astonished critics and public alike when
Albright first showed it, as a work in progress, at the 1938 Carnegie
International Exhibition in Pittsburgh. By 1942, when it was selected as
best picture in the "Artists for Victory" exhibition at The Metropolitan
Museum of Art, New York, the composition had secured the artist's fame.

Every inch of its surface painted like a precious miniature, the eight-
foot-tall canvas occupied a decade of Albright's life. In this painting, he
consolidated many of the technical, compositional, and thematic ideas that
he had pursued in previous work. Like *Wherefore Now Ariseth* (no. 21),
The Door involved an elaborate setup that took the artist months to
assemble and then to arrange. Its carved frame came from an old house,

and the doorstep is a tombstone that he pumiced clean of inscription. On the door, he hung a funeral wreath of wax calla lilies, roses, and lilies of the valley. Forced to replace the wreath three times over the years, Albright evidently found that it only began to take on life when it faded, bent, and broke. The old, Victorian door, from a Chicago junkyard, features an elaborately decorated doorknob and plate embellished with doves. The brass key came from the artist's studio. He employed a female model for the hand, which rests with tender regret on the molding of a door that can no longer open, much as one would touch the edge of a casket in saying farewell, and which holds Albright's grandmother's handkerchief, which he dyed blue. The model posed every weekend for nearly a year; when she tired of the task, Albright was forced to make a plaster cast (see Donnell, fig. 15), whose spectral quality he found he liked. The canvas's narrow format, which barely contains the warped, rectangular form of the door, can also be seen in the contemporary, never-completed composition *Show Case Doll* (no. 23). The charcoal underdrawing alone for *The Door* required thirteen months. The application of paint with a fine, sable brush was slow-going; often Albright could complete only a quarter of a square inch per day. He constructed a frame for the painting that included carved female figures suggesting coffin handles, as well as real casket lining, but when he first exhibited the painting, in 1938, he felt that the frame attracted more attention than the work, so he replaced it with a relatively traditional surround. The first frame is presumed lost, and no photographs of it have been located.

In *Room 203* (no. 20) and *Wherefore Now Ariseth*, Albright had explored the tension between the two-dimensional reality of the canvas and the illusion of depth. Continuing this exploration here, he set the door at a slight angle, creating a long shadow at the right to suggest a shallow space at the left. The hand seems to move toward the doorknob; and we, the viewers, can imagine stepping onto the threshold. At the same time, he reinforced the sense of surface by obsessively describing every component, down to individual petals, nails, peeling paint, and grains of wood. With such a proliferation of exquisite detail, it is difficult to focus on a single area; yet one small portion after another yields surprises, such as the thin wisp of smoke (perhaps signaling the expiration of a soul) escaping through the keyhole. The sheer height of the painting and the fact that the doorknob is so low make the door appear to loom above us. It is probably not coincidental that the two inset roundels at the top resemble eyes.

Declared by a critic in 1942 to be "one of the most unusual and distinguished pieces of painting ever produced in the United States,"[1] this powerful meditation on life not lived is more than just macabre. *The Door* is a resonant image, possessing the potency of a talisman.

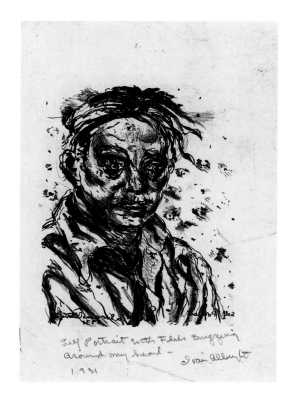

25

............................

SELF-PORTRAIT WITH FLIES BUZZING AROUND MY HEAD

1931
Lithograph (1 of 4); 15.2 x 11.8 cm (6 x 4⅝ in.)
Signed on stone, lower left: *Ivan Le Lorraine Albright*; inscribed on stone,
lower right: *Self-Portrait*; inscribed, dated, and signed on sheet:
Self Portrait with Flies Buzzing/around my head—/1931 Ivan Albright
The Metropolitan Museum of Art, New York,
bequest of Peter Pollack (1979.656.2)

Albright's first known self-portrait and lithograph, this small image was printed on a press in the basement of The School of The Art Institute of Chicago by Francis Chapin, a Chicago artist and friend of the Albright twins. Many of Albright's early attempts in lithography are tentative in design, as he experimented with the medium's distinct character; and the number of impressions he and Chapin managed to pull was often limited (in this case, there are only four).

Here Albright looks wild-eyed and jittery, encircled by a halo of swarming flies. The artist appears to have used an accident—the flies are actually smudges—to his advantage. The playful and energetic character of the lithograph, in comparison to the seriousness of later self-portraits in oil (see for example nos. 26, 28, and 29), shows the agility with which Albright handled diverse media. The most extensive display of the artist's varied approaches to a single image in different processes is best seen in the self-portraits he produced at the end of his life (see nos. 71–93).

Peter Pollack (1909–1978), who left this and many other lithographs by Albright to The Metropolitan Museum of Art, New York (that museum owns examples of nos. 37, 38, 43, 47, 48, and 56), collected the work of a number of Chicago artists. A photographer, he served as public-relations counsel to the Art Institute from 1947 to 1957 and, in 1954, became the museum's first curator of photography. In the 1950s, he took many photographs of Albright in his studio (see Donnell, fig. 25; and Chronology, figs. 19, 24, and 26).

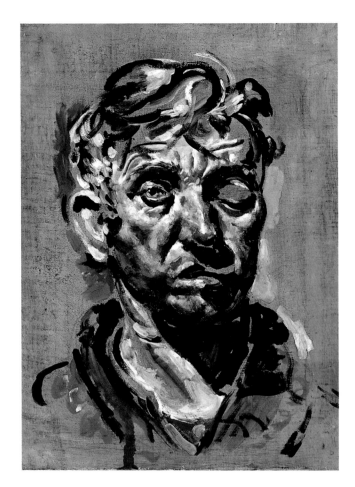

26

SELF-PORTRAIT

1933
Oil on canvas; 38.4 x 28.3 cm (15³⁄₁₆ x 11³⁄₁₆ in.)
Inscribed and signed, lower right:
To my pal, dear Hazel/Ivan Le Lorraine Albright
Los Angeles County Museum of Art, gift of Mr. and Mrs.
Berny Schulman in memory of Mr. Reuben L. Freeman

Unlike Albright's other works in oil from this period, this unfin-ished self-portrait was painted directly on the canvas, with no underdrawing, a technique the artist used again in the power-ful series of self-portraits he did at the end of his life (nos. 71–91). The absence of the figure's left eye makes the gaze of the right eye all the more intense and haunting. Fading and forming before us, the face of the thirty-six-year-old artist exerts an hypnotic power perhaps because of its incompleteness.

The artist gave this painting to Hazel Buntman, wife of Leo Buntman, a public-relations executive and art dealer who cofounded Chicago's Grant Park Art Fairs. Staged annually between 1932 and 1934, these events helped artists survive some of the most difficult years of the Great Depression. Leo Buntman may have been the one who provided Albright, in the late 1930s, with an introduction to the Associated American Artists, which presented a joint exhibition of the Albright twins in New York and Chicago in 1945–46.

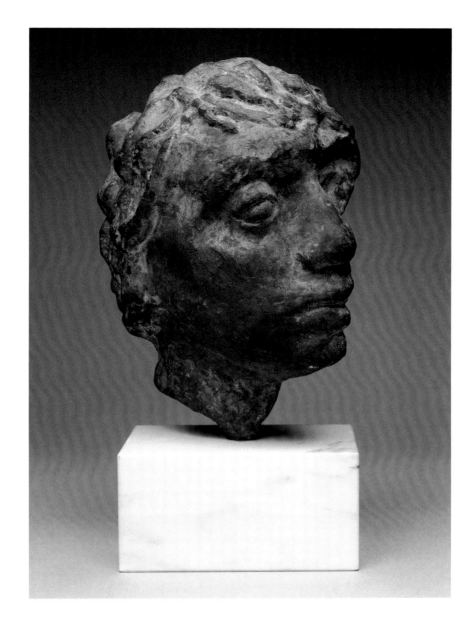

HEAD OF MARIE

1933 (cast 1933)
Bronze; h. 26.7 cm (10½ in.)
Private collection

The model for this sculpture, Marie Engstrand (1913–1981), was a romantic interest of the artist in the 1930s. Albright transformed the pretty and youthful features of the aspiring actress into a pitted and scarred piece of flesh, with one whole side of her face appearing as if blown off, her left eye an empty socket. A visage of sorrow, the image echoes some of Auguste Rodin's evocative sculptural fragments. As a student, Albright sketched at least one sculpture by the French master. The artist was preoccupied at this time by the idea of a dramatically disfigured face, as can be seen in a 1933 oil self-portrait (no. 26) and in a sculptured head of his father (no. 30).

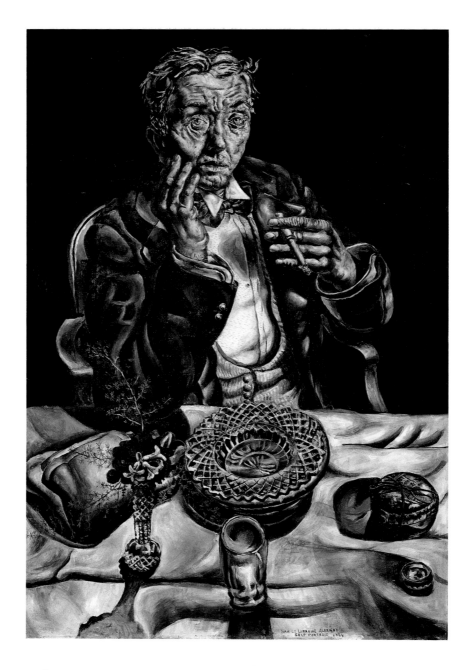

SELF-PORTRAIT

1934
Oil on canvas; 76.8 x 46.4 cm (30¼ x 18¼ in.)
Inscribed, lower right: *IVAN LE LORRAINE ALBRIGHT/SELF PORTRAIT 1934*
New Trier Township High School District 203,
Winnetka, Illinois

Among the art programs sponsored by the federal government during the height of the Great Depression was an easel-painting division, which allowed artists to execute small-scale works for dispersal to schools, libraries, and other government-supported institutions. *Self-Portrait* was produced as part of this program. Whereas many artists on the federal payroll would have felt compelled to compose a scene characteristic of American urban or rural life, or maybe an image of a typical or notable American, Albright submitted an almost irreverent depiction of himself.

This, his earliest-known, finished oil self-portrait demonstrates well his varied skills, for the painting is at once a figure study, a portrait, and a still life. Albright showed himself seated in a chair behind a table covered with rumpled cloth. He is dressed in a dinner jacket, complete with vest, and a cigarette in a holder dangles from his left hand. On the table are a folded napkin; a large, cut-glass ashtray; a small, covered box; a bottle top; a drinking glass, and a cut-glass bud vase with flowers. He appears to be focused on an unseen companion across the table, as if we are witnessing an after-dinner conversation. Other artists of the period, such as Thomas Hart Benton, John Steuart Curry, and Grant Wood, executed self-portraits in which they are seen as working artists or rural laborers. In contrast, Albright presented himself here as a sophisticated dandy—much like the protagonist in Oscar Wilde's *Picture of Dorian Gray*, a story with which the artist would become closely identified ten years later (see no. 41)—rather than the diligent artist he was. Never one to conform, Albright demonstrated in this engaging painting why he and the federal art projects were not a comfortable match.

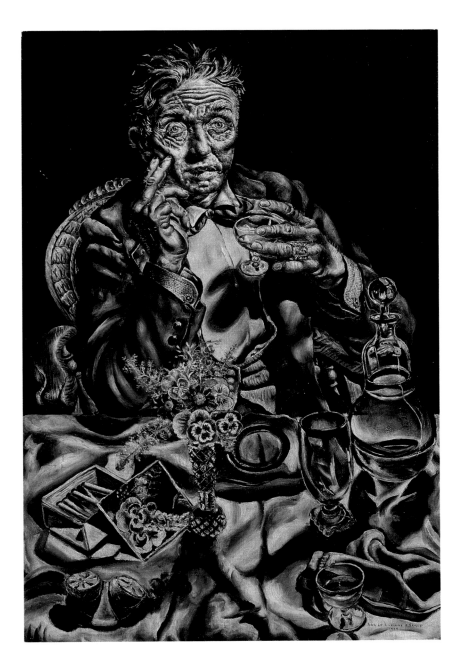

29
..........................

SELF-PORTRAIT

1935

Oil on canvas; 77 x 50.6 cm (30⅜ x 19⅞ in.)

Signed and dated, lower right: *IVAN LE LORRAINE ALBRIGHT/1935*

The Art Institute of Chicago, Mary and Earle Ludgin Collection

(1981.257)

When Earle Ludgin saw Albright's 1934 self-portrait (no. 28) at the Century of Progress exposition in Chicago, he was so taken with the image that he asked the artist to paint a similar one for him. The commission resulted in what is generally regarded as his most accomplished self-portrait.

Albright is again seated before a table, displaying items that are even more ostentatious than those in the original composition. Added touches include the artist's reflection, upside-down and in miniature, in the round, glass stopper capping a decanter. Rather than smoking a cigarette, as he

does in the 1934 self-portrait, Albright holds a wineglass that is reflected on the shaft of the decanter. (Prohibition ended in 1933.) Adding to the visual delights, at the lower left is a lime, split in two, which completes a still life of items that produce an array of distinct fragrances: tobacco, wine, tangy fruit, and flowers. Looking weary and worn well beyond his thirty-eight years, the nonetheless nattily dressed artist lifts his glass, pausing before sipping and gazing straight out as if to invite the viewer—presumably the collector Ludgin—to join him by taking up a second glass, found at the lower right.

In effect this commission marked the beginning of a lifelong friendship between Albright and the Chicago advertising executive, art collector, and Art Institute of Chicago trustee. Ludgin (1898–1981) and his wife, Mary (1894–1962), formed what was to become an important collection of works by the artist (see nos. 16, 30, 39, 43, 47, and 48; and Weininger, fig. 8). Although they periodically made gifts of works by Albright to the Art Institute, they retained this work until the end of their lives, which suggests that the image grew more meaningful to them as the years passed, their collection grew, and the friendship deepened.

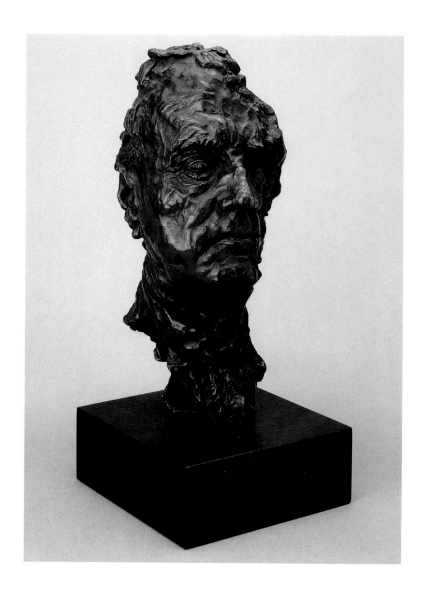

30
•••••••••••••••••••••••••••

Head of Adam Emory Albright (Head of My Father)

1935 (cast 1952)
Bronze; h. 38.1 cm (15 in.)
The Art Institute of Chicago, Mary and Earle Ludgin Collection
(1982.1838)

Perhaps Albright's finest sculpture, this work beautifully translates the expressive energy and surfaces of his painting style into three dimensions. The head of Albright's father, Adam Emory Albright (1862–1957), seems to expand and dematerialize at once, as if, by making an image of this powerful man, the son assumed control over his father's existence. The work, with its traces of fingerprints in the rough, bronze surface and its haunted and fragmentary look, shows strong affinities with sculptures by Alberto Giacometti, whose art Albright later came to admire. The Swiss artist would, some ten years later, push these ideas much further.

Part of the expressiveness of this head is the fact that it is not equally finished in all areas. The head's right side is more developed than the left; the back of the head is incomplete. Like other images of faces by Albright during this period (see nos. 26 and 27), the figure's left eye is a hollow pit. According to Albright, the unorthodoxy of the image infuriated his father, a response that the rebellious artist clearly enjoyed.[1]

THE FARMER'S KITCHEN

1933–34
Oil on canvas; 91.5 x 76.5 cm (36 x 30⅛ in.)
National Museum of American Art, Smithsonian Institution,
Washington, transfer from the U.S. Department of Labor (1964.1.74)

Despite the fact that Adam Emory Albright's art sales and his real-estate investments permitted his family to live relatively comfortably during the 1930s, Ivan Albright executed several paintings for publicly funded art programs, one of which is this skillfully rendered figure study (see also no. 28). In this painting, Albright managed to fulfill the government's desire that artists in its employ depict typical American scenes while pursuing his own, idiosyncratic interest in the effects of a hard, work-filled life on the human body and mind. In a sense, the painting can be read as a parodic critique of the domestic scenes favored by such contemporary regionalists as Doris Lee and Grant Wood. Unlike their warm, happy kitchens, Albright's is not a bustling center of activity, a place of nourishment, nor a meeting place for family and community, but quite the opposite.

An exhausted, old woman (the model was a Warrenville neighbor) sits before her large, iron stove, slicing radishes into a bowl. Her tired eyes seem to see nothing as her hands, painfully swollen from years of labor, perform their task automatically. Resembling a spider web or the fissures of a parched landscape, wrinkles pour out in a myriad of lines from around her eyes; their accretion around her mouth has reduced it to a bare line. The painting's energy comes from the animated patterns covering every surface in the room, from the woman's dress and apron to the rugs and tiles on the floor, and the flowered tiles, curtain, and paper on the wall behind. A cat in the corner shrinks back as if, unlike its mistress, it is alert to the observing presence of the artist or viewer.

32

AFTER THE RACE

1938
Oil on canvas; 91.4 x 50.8 cm (36 x 20 in.)
Signed, lower left: *IVAN LE LORRAINE ALBRIGHT*
Richard L. Feigen & Co.

Thinly painted in an eerie palette of grays and ochers, with accents of pink and red, this image of a large-bodied, young woman, caught in a reflective moment, emerges like an apparition from a dark surround. To judge from a preparatory drawing (private collection), vigorously executed in strong, bright pastels, the canvas was probably never finished, although Albright signed it. Given the artist's penchant for metaphoric titles, he may have meant to suggest that this athletic figure, partially covered by what appears to be a loosened bathing suit or a towel, has run a foot or swimming race, either literally or figuratively. The spectacular frame dates from the nineteenth century and was decorated with silver paint and embedded with bits of mirror by Albright. Most of Albright's works retain their original frames, many of which he refurbished and embellished, custom-designed, and/or carved himself.

33

BATHING ON THE ROCKS, MAINE

1940
Watercolor on paper; 33.6 x 48.9 cm (13¼ x 19¼ in.)
Signed, lower left: *IVAN LE LORRAINE ALBRIGHT*
Lawrence M. Pucci, Caryl Pucci Rettaliata

This watercolor of a full-figured sunbather (in notes the artist called her "Mary"[1]) seems to have none of the mythic overtones of *After the Race* (no. 32), perhaps because the artist was usually more straightforward in his works on paper than in his oils. Directly and quickly executed, the image shows the pink-skinned figure lying on a flat, smooth plane of rock along the Maine coast. She lifts her left arm to shield her face from the sun's bright rays.

This composition is part of a collection of works on paper (see also nos. 44, 53, and 55; and Chronology, fig. 28) by Albright that was assembled over two decades by Albright's friend Lawrence M. Pucci, a Chicago art patron. In the late 1940s, he had the opportunity to watch the artist working on a large painting entitled *Drama (Mephistopheles)* (Donnell, fig. 24). This experience had a lasting impression on Pucci, and he continued to build his collection with intimate examples that offer glimpses into Albright's life and travels.

34

MAINE COAST (BLACK CLIFFS; SCHOODIC POINT, MAINE)

1940
Gouache on white wove board; 64.5 x 49.7 cm (25 x 19 in.)
Signed and dated, lower right: *IVAN LE LORRAINE ALBRIGHT 1940*
The Art Institute of Chicago, gift of Mrs. Donald W. Baker (1981.387)

Over the years, the Albright family often vacationed along the Maine coast, which became a favorite spot and frequent motif for Ivan (see also nos. 33, 35, and 36). Albright went to Maine the year following his mother's death. Clearly still deeply affected by the loss of her, he painted this moody, expressionistic gouache. Here the coast becomes a desperate zone of conflict between land and sea, where cold waves crash and batter rocks.

During the war years, Albright could not return to Maine, because the coastal area was deemed to be particularly vulnerable. This situation frustrated the artist; in 1944 he told an interviewer for a Pennsylvania newspaper: "When the war is over, I am returning to the shores of Maine, which I think are finer than the White Cliffs of Dover."[1]

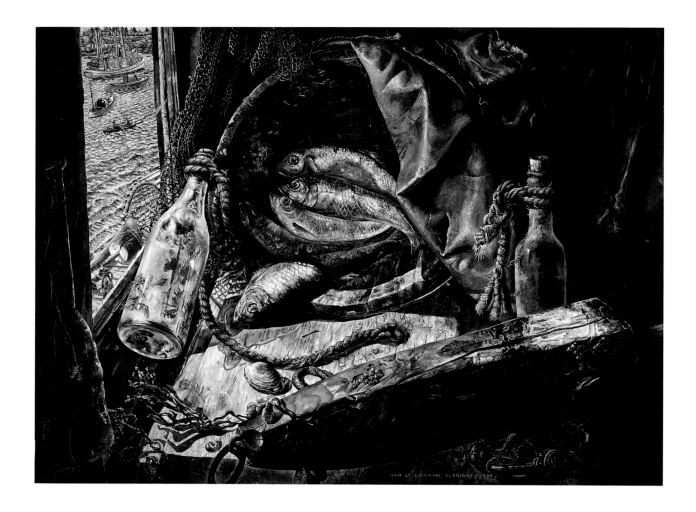

Ah God, Herrings, Buoys, the Glittering Sea

1940
Gouache with touches of smearing on ivory watercolor paper; 55.7 x 73.5 cm (22 x 29 in.)
Signed and dated, lower right-center: *IVAN LE LORRAINE ALBRIGHT 1940*
The Art Institute of Chicago, gift of Ivan Albright (1977.32)

Ah God, Herrings, Buoys, the Glittering Sea is the greatest of Albright's Maine still lifes and one of his most accomplished gouaches. In 1941 it became the first major work by the artist to be acquired by The Art Institute of Chicago.[1]

In a corner of a fisherman's shack, a haul of herrings lies in a basket on a pile of buoys, weights, and nets, all encrusted with salt and weathered by the elements. Through the window at the left is a view of a harbor filled with a veritable compendium of fishing boats. The brilliant light streaming in is soaked up by the various objects, which, normally submerged in water, only rarely see the sun or feel its warmth. Albright's feelings about the role of natural light in this composition are further revealed by the way in which he executed the gouache. Rather than observing the objects directly, he worked from their reflection in a mirror, because they were "too bright to look at," he told Paul Cummings in a 1972 interview. "I happened to have an old mirror," he continued, "and I painted . . . in reverse. . . . If I put a mirror up and you looked at [the painting reflected in it], you'd see it correctly."[2] The looking glass darkened the subject and gave it greater depth and focus (as well as reversing the correct rope ties and sail direction). The myriad details in *Ah God, Herrings* become mysterious, even hypnotic, in part because the painting is an image of an image, two removes from reality.

DIVIDED AND DIVIDED

1941
Oil on canvas; 68.6 x 106.7 cm (27 x 42 in.)
Signed and dated, lower left: *IVAN LE LORRAINE ALBRIGHT 1941*
The Art Institute of Chicago, gift of Ivan Albright (1977.31)

Divided and Divided is one of two canvases (the other is *Bride with a Cold* [1941; Hirshhorn Museum and Sculpture Garden, Smithsonian Institution, Washington]) that Albright painted as an experiment with "black oil." A medium that makes oil pigments more transparent and glowing, it is believed to have been invented by the Venetian Renaissance painter Giorgione and used by Titian and Tintoretto, among others. Albright learned of the technique from Jacques Maroger, a former Musée du Louvre conservator who taught a class that Albright attended at the School of the Art Institute in 1941.[1] Albright, who often ground his own pigments and experimented with various painting mediums throughout his life, probably prepared the "black-oil" mixture himself.

Albright was ambivalent about landscape. As he stated in a 1950 interview, "You can't represent [nature]. . . . Traveling around the world wouldn't move me any more than sitting right here in my studio. It's the meaning that you bring to your painting that's important. Nature herself can go only as far as your mind can bring it."[2] And yet landscape was a genre at which the artist worked consistently throughout his life. Executed in Deer Isle, Maine, this is perhaps his most finished landscape. The foreground, beautifully colored with amber, yellows, and browns, is a study of rocks, laced with crevices, much as the flesh of Albright's models is deeply wrinkled. This area is set off subtly by the blues and greens of the tidal basin in the background. Albright said he titled the composition *Divided and Divided* because of the way the hard surfaces of the ridges on the shoreline seem "chewed up" by the eternal weathering and resultant shifting of the earth that transforms one element, over time, into another.[3]

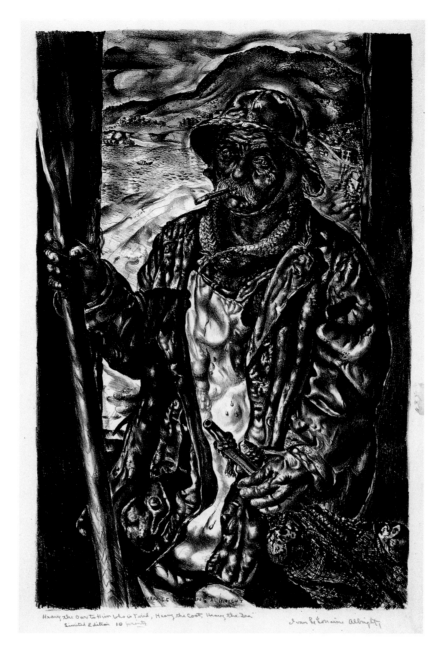

Heavy the Oar to Him Who is Tired, Heavy the Coat, Heavy the Sea
Limited Edition 10 prints Ivan Le Lorraine Albright

HEAVY THE OAR TO HIM WHO IS TIRED, HEAVY THE COAT, HEAVY THE SEA

1938
Lithograph on white wove paper (1 of 10); 42.9 x 26.9 cm (16⅞ x 10⅝ in.)
Signed on stone, lower center: *IVAN LE LORRAINE ALBRIGHT;*
inscribed on sheet, lower left: *Heavy the Oar to Him Who is Tired,*
Heavy the Coat, Heavy the Sea/Limited Edition 10 prints;
signed on sheet, lower right: *Ivan Le Lorraine Albright*
The Art Institute of Chicago, gift of Mr. Norman L. Rice (1940.79);
The Metropolitan Museum of Art, New York,
bequest of Peter Pollack (1979.656.3)

This lithographic version of a 1929 painting (no. 16) is the first of nine lithographs Albright created between 1938 and 1980 (see also nos. 38, 43, 47, and 48) in which he replicated or embellished upon previous works. Technically,

the execution of this print is far more sophisticated than that of any of his previous attempts at lithography. The body of the fisherman has been rendered with great facility and gives the impression of strength and solidity. However, the face and head are dark, and the details, such as the landscape, are lost in shadow. After the tenth impression was pulled, the lithographic stone broke. Five prints of the upper nine inches of the original image were subsequently made from a portion of the broken stone. Albright returned to the theme of *Heavy the Oar* forty-one years later in his largest and last lithograph, *Appears the Man* (1980), a skillfully rendered variation on the original oil.

Albright perhaps made such prints because he remained interested in his compositions long after their completion and welcomed a chance to revisit them in another medium. In contrast to the Depression-era artists who turned to printmaking to make their work available to more people at low prices, Albright, for the most part, produced very small editions of his prints (see, however, nos. 43 and 47), perhaps because he was limited by his lack of technical printing expertise, but perhaps as well because his attitude about printmaking, as about painting, was exclusive.

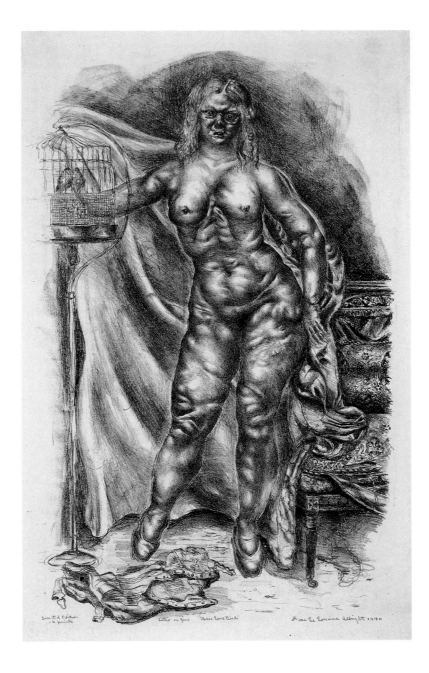

THREE LOVE BIRDS (EPHEMERID)

1940–41

Lithograph on ivory wove paper (1 of 12); 43.8 x 29 cm (17¼ x 11⅝ in.)
Inscribed on sheet, lower left: *Limited Edition/12 prints*;
inscribed on sheet, lower center: *Litho on zinc "Three Love Birds"*;
signed and dated on sheet, lower right: *Ivan Le Lorraine Albright 1940*
The Art Institute of Chicago, anonymous gift (1970.1233)

This is the second of three works, each in a different medium, in which Albright grappled with the subject of a nude woman standing next to a cage of birds. He abandoned the first attempt, an oil he began in 1930 (no. 22), when the young model had a growth spurt. The lithograph fills in parts left incomplete in the initial version, such as the birdcage at the left and, in the foreground area, an unidentifiable article of clothing. However, the girl's face, in comparison to that of the earlier, unfinished canvas, is masklike and strangely contorted; and her right arm remains unmodeled, disappearing behind the cage. In the lithograph, the figure's posture and weight seem forced and unconvincing. In 1972 the artist tried in vain one last time to find a satisfactory resolution for the subject, in the etching *Three Love Birds Modified*.[1] This image, a nightmarish vision of frustration and claustrophobia, is even further removed from reality. The tongue-in-cheek title of all three, which implies that a woman is a love bird, may indicate something about the feelings of the artist—very much a bachelor in the 1930s and early 1940s—toward the opposite sex. The alternate title of the lithograph, *Ephemerid*, may suggest the brief time that Albright had with his model or is perhaps a comment on love itself.

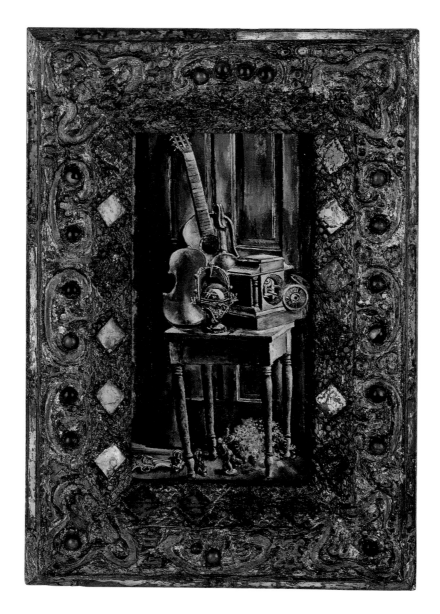

39

THIS ICHNOLITE OF MINE

1940
Oil on canvas; 35.6 x 17.8 cm (14 x 7 in.)
Dated, lower left: *1940*; signed, lower right: *IVAN LE LORRAINE ALBRIGHT*
The Art Institute of Chicago, gift of the Ludgin Children (1982.1837)

The longer a person studies this small-scale painting, the more disturbing it becomes. None of the objects on the unstable nightstand is functional. A stringless trio consisting of a guitar and two violins—one appears to lack its pegs, the other its entire neck—rests against a door. The latter prop, possibly the same used for *The Door* (no. 24), serves no apparent purpose, since it is barricaded by this odd arrangement. To the right is a broken clock; its face and crystal cover hang open, and the clock's mechanisms pour out. A bouquet of dried flowers has fallen to the floor below. Across the composition's bottom, an inexplicable drama takes place, involving a winged figure that rushes toward two figurines lying before a pointed pistol.

Although the meaning of the painting and of its odd title (an ichnolite is a fossilized footprint) remain elusive, it is possible that the artist intended to convey a philosophical or symbolic meaning, although it is equally possible that he was simply trying to stump even linguists with his choice of words, found most likely while scouring the dictionary, as he was known to do. Albright set the painting into an old carved, wooden frame, which he silvered, decorated with additional carvings, and inlaid with pieces of mirror and glass marbles.

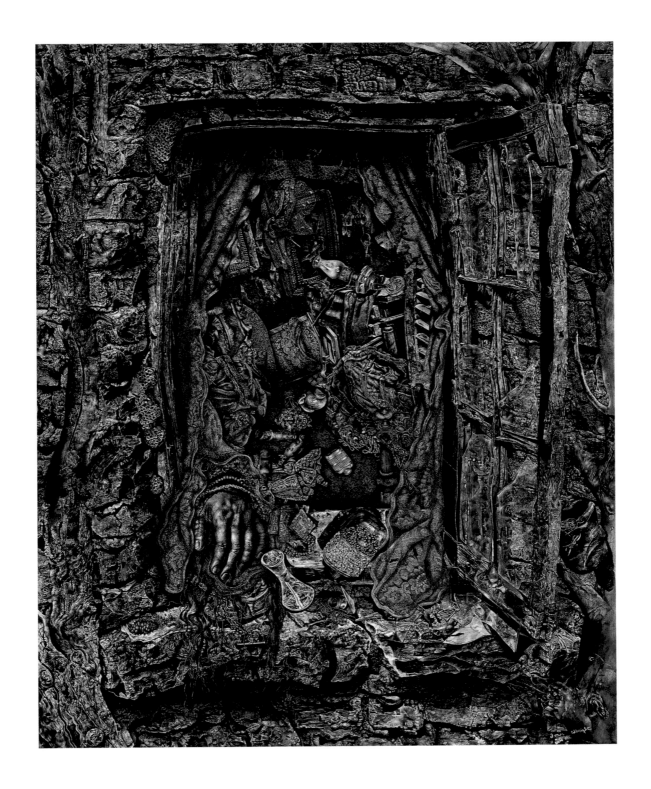

40

POOR ROOM—THERE IS NO TIME, NO END, NO TODAY, NO YESTERDAY, NO TOMORROW,
ONLY THE FOREVER, AND FOREVER AND FOREVER WITHOUT END (THE WINDOW)

1942–43, 1948–55, 1957–63
Oil on canvas; 121.9 x 94 cm (48 x 37 in.)
Signed, lower right: *Ivan Albright*
The Art Institute of Chicago, gift of Ivan Albright (1977.35)

The centerpiece of Albright's career, *Poor Room—There Is No Time, No End, No Today, No Yesterday, No Tomorrow, Only the Forever, and Forever and Forever without End (The Window)* took the artist twenty-one years to finish, in two separate studios, going through two versions, three elaborate diagrams, and at least six notebooks. Despite a meticulous attempt to document his arrangement, when he moved from his studio in Warrenville to one in Chicago, he could not replicate his original setup exactly. This meant having to make a second, complete charcoal underdrawing (see Donnell, fig. 25), which required seventeen months. His obsessive execution resulted sometimes in an inch or less of painted canvas a day. Periodically, other projects, such as *Picture of Dorian Gray* (no. 41) and *Portrait of Mary Block* (no. 51), interrupted his work on *Poor Room*.

Placing his setup on a moveable stand (see Donnell, fig. 26; and Chronology, fig. 25) allowed Albright to study each element from a different angle—some seventy angles in all, according to the artist. We look straight through the window into the room beyond, yet, at the same time, look down on the scene from above. And what a scene it is: filled with things, but devoid of life. The bricks are disintegrating, the mortar falling out, the wooden window frame warped and rotted, its interstices filled with wasps' nests. Framed by two dead apple-tree branches, the window has a shattered casement that has swung open to reveal a horrifying accretion of detritus. The room beyond is packed with objects that have been suddenly displaced, thrown down, turned over, twisted about. A toppled, but still-lit, kerosene lamp suggests that violence has recently occurred. A detached hand bearing a gash over the third finger tries to escape this "hell of forms," as artist Jean Dubuffet called it (see below). It is significant that one of Albright's vivid memories of his experience as a medical draftsman in World War I was finding a human hand in a wastebasket. In *The Door* (no. 24), as well as in *Poor Room*, a hand functions as a surrogate for a human presence; in each composition, the hand tries to make contact but fails. Clearly, the narrative he so powerfully evoked in *The Door* is continued in *Poor Room*. Among the various titles Albright considered for the later painting are the following: "This is the room [beyond] the door with a funeral wreath on it" and "Here am I. Here I live, here I will die."[1]

In 1951 Dubuffet visited the Chicago studio of Ivan Albright, and later recorded his impressions:

I was stupified to see in his studio, on a turntable, the dramatic ground floor of a devastated shack that he had had transported there after having numbered all the bricks, so that he could reconstruct it with his own hands and organize [a scene] behind it, with a diligence that was truly demonic, so that it appeared to be the interior of a room seen through a shattered window, the most alarming disorder of singular objects imaginable. I will never forget that. I have never seen anything as frightening.[2]

The relationship of this intense and disturbing painting to works by some of Albright's contemporaries is intriguing. Given Dubuffet's predilection for obsessively worked surfaces and his nihilistic fascination with the antirational and ugly, one can understand the strong response of the French artist to the Chicago painter: "A crumbling, rotting, grinding world of excrescences is offered to us in place of the one in which we had believed we lived. . . . Abolished here totally are what were our canons of beauty . . . ; nothing remains."[3]

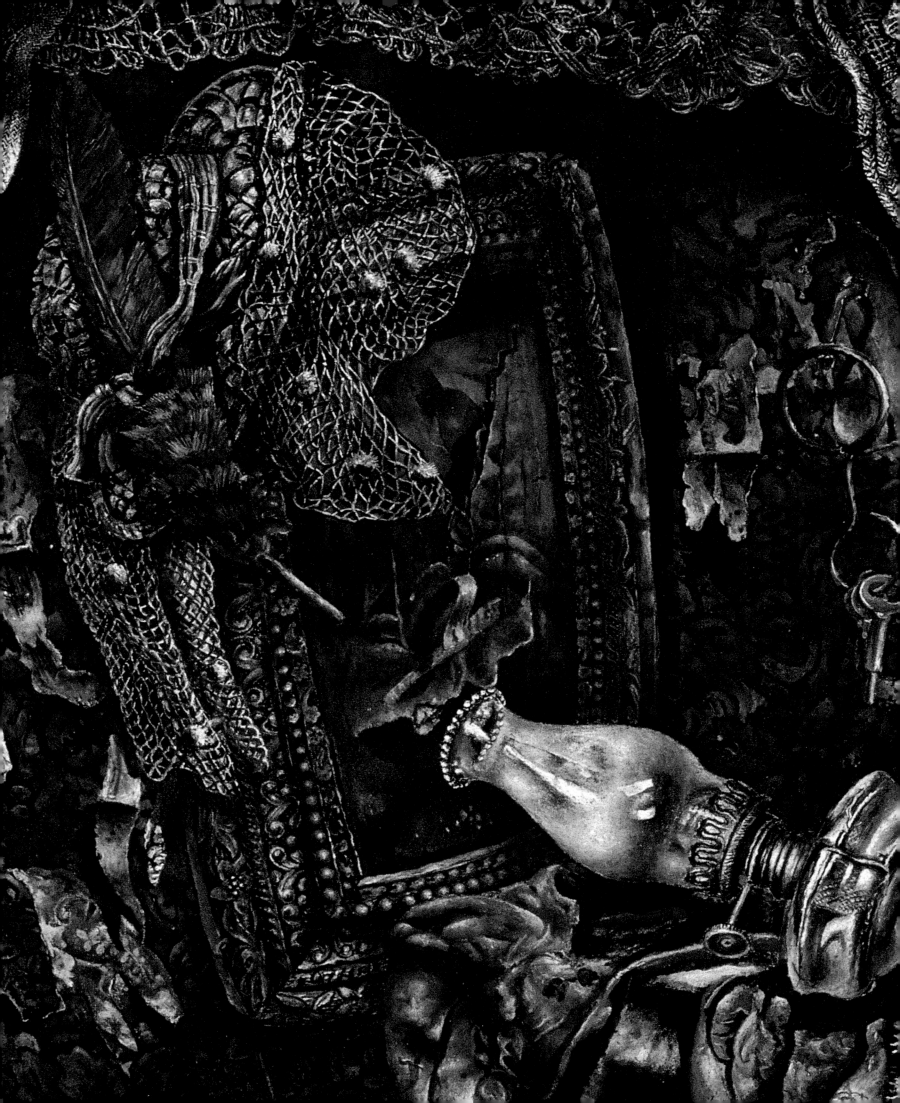

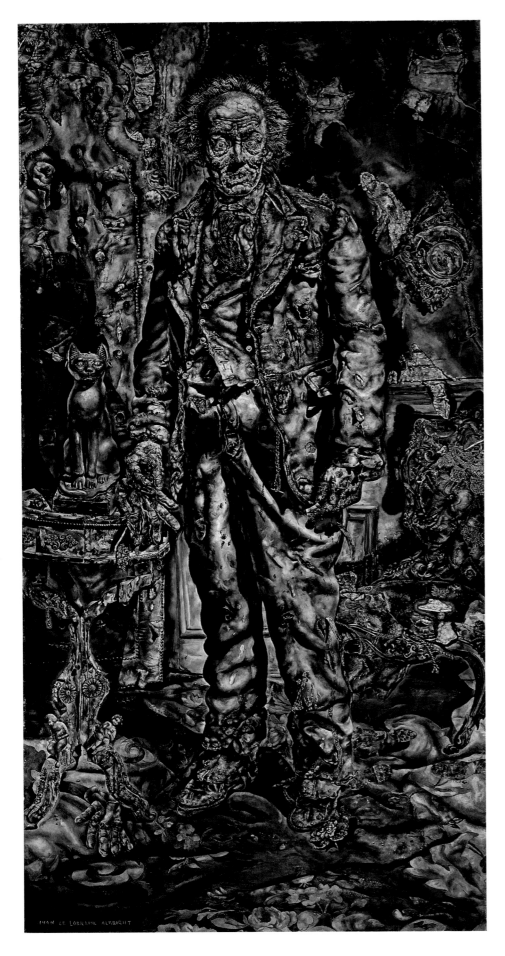

PICTURE OF DORIAN GRAY

1943–44
Signed, lower left: *IVAN LE LORRAINE ALBRIGHT*
Oil on canvas; 216 x 106.7 cm (85 x 42 in.)
The Art Institute of Chicago, gift of Ivan Albright (1977.21)

In Oscar Wilde's classic 1891 morality tale *The Picture of Dorian Gray*, the central character is thrilled with a portrait of himself that captures his youthful good looks. He exclaims: "How sad it is! I shall grow old, and horrible, and dreadful. But this picture will always remain young. . . . If it were only the other way. . . . I would give my soul for it."[1] His wish is granted: Gray's body remains unmarred as he lives a long and increasingly decadent life; his debauched character, as well as his actual age, is reflected in the portrait, which becomes so hideous that he keeps it hidden. Finally, in a desperate attempt to destroy it, he destroys himself, and his terrible secret is revealed.

In the fall of 1943, the screenwriter-director Albert Lewin, who was directing a Metro-Goldwyn-Mayer adaptation of Wilde's story, was looking for an artist to provide this macabre image. While we cannot determine precisely how he found Albright, he made the perfect choice. Albright insisted that his brother Malvin be hired to assist him. The two left Warrenville, Illinois, to spend eleven months in Hollywood. (Malvin's portrait of the young Dorian Gray [Donnell, fig.19], completed in four months, ultimately was not used in the movie.)

As had become his practice, Ivan first assembled and constructed an elaborate setup (see Donnell, fig. 18), which included a mannequin of the actor Hurd Hatfield, who played Dorian Gray, standing on a patterned rug. At the right of the composition is a Victorian chair, above which hangs a clock. To the left are a tall, leather screen and a pedestal table on which sits an Egyptian cat statuette. The room is a mess; the rumpled carpet is strewn with debris; the wallcovering is in shreds; the leather screen puckers and disintegrates before our eyes. Even more nightmarish is the image of Dorian Gray, standing before us in a now-frayed and torn suit. His hands are covered with the blood of a man he killed (a studio understudy, Skeets Noyes, who occasionally modeled for the painting, recalled having to endure posing with chicken blood congealing on his hands); and his grizzly, pockmarked face grimaces as if possessed by demons.

The palette, dominated by purples, hot reds, and cold blues, is high-keyed and lurid. Anticipating the harsh lighting conditions in which the canvas would be filmed, the artist worked under klieg lights to intensify the colors so they would not bleach out. Underscoring the fantastic, almost spectral quality of the work is the way the colors shift and bleed into one another, resulting from the artist's use of what he called "color wands" (see no. 61) to capture the image and afterimage of various hues. The movie was shot in black and white, except for the moments when the portrait of Dorian Gray appears and is revealed in vivid Technicolor.

The Oscar-nominated film drew the public's attention to Albright's horrific vision. For a Warholian "fifteen minutes," Ivan Albright was one of the most famous painters in America.

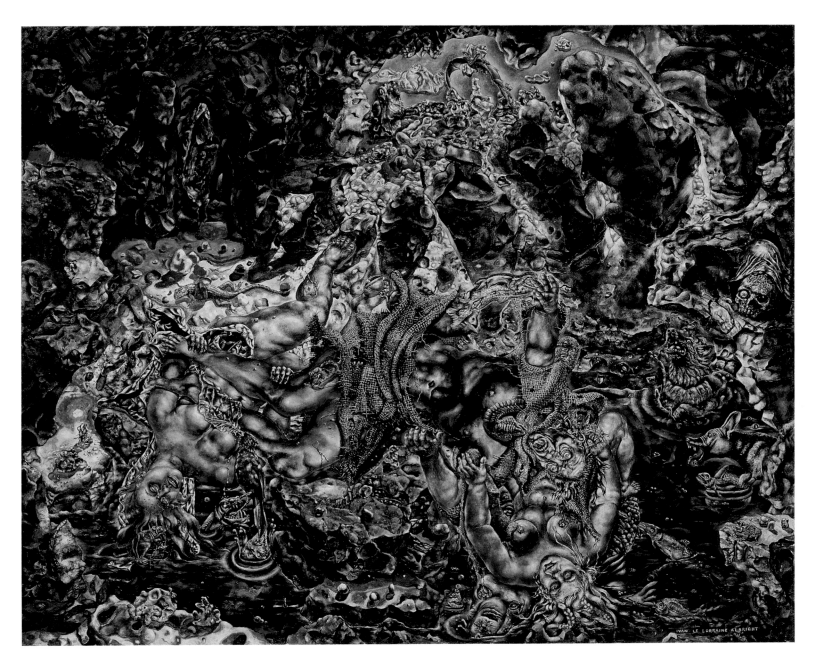

42

THE TEMPTATION OF SAINT ANTHONY

1944-45
Oil on canvas; 127 x 152.4 cm (50 x 60 in.)
Signed, lower right: *IVAN LE LORRAINE ALBRIGHT*
The Art Institute of Chicago, gift of Ivan Albright (1977.22)

The success of his collaboration with Albright on "The Picture of Dorian Gray" (see no. 41) encouraged Albert Lewin to consider a similar collaboration in connection with his next feature film, "The Private Affairs of Bel-Ami," based on a novel by the French writer Guy de Maupassant, in which a painting plays a symbolic role. Lewin held an international competition, asking eleven European and American artists, including Albright, to create a modern version of the Temptation of Saint Anthony. The winner was the Surrealist Max Ernst; Albright finished second (see Chronology, fig. 15).

Attempting to shed all need of material and pleasurable things after lead-ing a dissipated youth, Anthony isolated himself in the desert, where he was besieged by a veritable litany of temptations, including physical wealth, opulent feasts, and beautiful women, followed by frightening hallucinations. Albright was inspired by the treatment of the subject by northern European Renaissance artists such as Matthias Grünewald and Martin Schongauer. Without a horizon line, Albright's painting does not seem to have a top or bottom. It is as if we are looking into a watery zone, a bizarre coral reef teeming with unappetizing creatures—fish, lizards, insects, rats, a wolf—as well as reminders of death—anatomical parts and skulls—that could, at any moment, spill over the picture frame and engulf us. Anthony's naked body is splayed before us, held by a pair of demonic-looking, nude women, as a reptile, wrapped around his neck, tries to strangle him. He valiantly resists them, much as Laocoön and his sons in the ancient statue (Museo del Vaticano, Vatican City) struggle with a deadly snake coiled around their limbs. The painting's high-keyed, phosphorescent palette (prompted in part by Albright's knowledge that the lights required to film a painting tend to weaken its color) adds to its haunting effect.

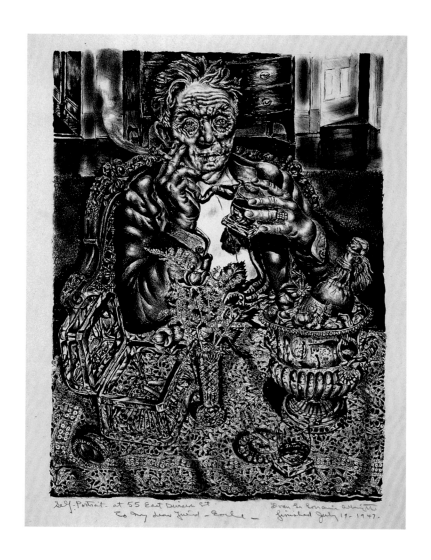

Self-Portrait at 55 East Division St /
To my dear friend—Earle— *Ivan Le Lorraine Albright /*
finished July 19 - 1947.

43

······································

SELF-PORTRAIT AT 55 EAST DIVISION STREET

1947
Lithograph on ivory wove paper (1 of 250); 35.8 x 25.7 cm (14⅛ x 10⅛ in.)
Inscribed on sheet, lower left: *Self-Portrait at 55 East Division St/*
To my dear friend—Earle—; signed, inscribed, and dated on sheet,
lower right: *Ivan Le Lorraine Albright/finished July 19, 1947.*
The Art Institute of Chicago, bequest of Mary and Earle Ludgin (1981.1165);
The Metropolitan Museum of Art, New York,
bequest of Peter Pollack (1979.656.6)

In this, one of Albright's most accomplished prints, he combined and elaborated
on two earlier self-portraits in oil on canvas. In the first of these (no. 28), he
smokes a cigarette; in the second (no. 29), he drinks from a wine glass. In this
lithograph, he does both. The only other item repeated from the second work is
a crystal flower vase. It is joined here by a range of objects, including a much
more elaborately carved chair, a bottle of champagne or wine on ice, and an inte-
rior setting. The setting is the house at 55 East Division Street, Chicago, where
Albright moved with his new wife, Josephine Medill Patterson Reeve (see no.
50), and her two children. The bottle on ice may indicate not only his newfound
happiness in marriage but also the fact that he and his wife were expecting the
birth of their son Adam. The complexity and multiplicity of patterns make the
drawing remarkably robust, with each form and object clearly and confidently
articulated and full of life. On the genesis of this print, see no. 47.

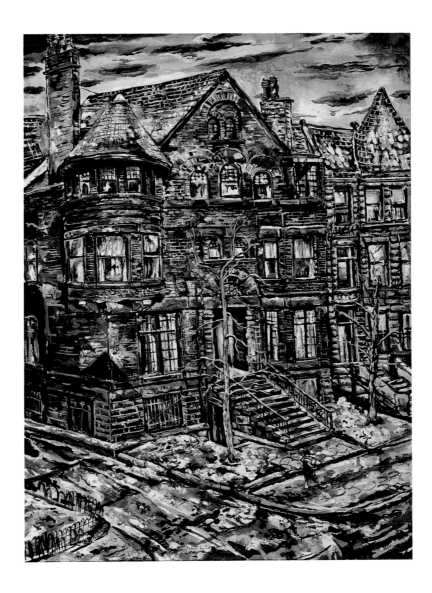

The House across from 55 East Division

1948
Gouache and watercolor on paper; 52.1 x 36.8 cm (20½ x 14½ in.)
Signed, lower center: *Ivan Le Lorraine Albright*
Lawrence M. Pucci, Caryl Pucci Rettaliata

This small-scale, obsessively detailed painting shows a late-nineteenth-century townhouse (now demolished) on Division Street in Chicago, which was across from the home and studio Albright and his family occupied from 1947 to 1963. White highlights of snow dot the red bricks and purple stone trim of the formidable residence, while a yellow glow shining from the doorway seems to offer warmth from the blistering cold of the city's wintry streets at the end of the day. Underscoring the large scale of the homes in this old and fashionable neighborhood are two tiny figures, both in red, one climbing the stairs of the house next door, the other passing by on the snow-covered sidewalk. The view is clearly from a second-floor window of the Albright home, whose triangular roof or turret may be the source of a dark shadow on the lower corner of the house opposite.

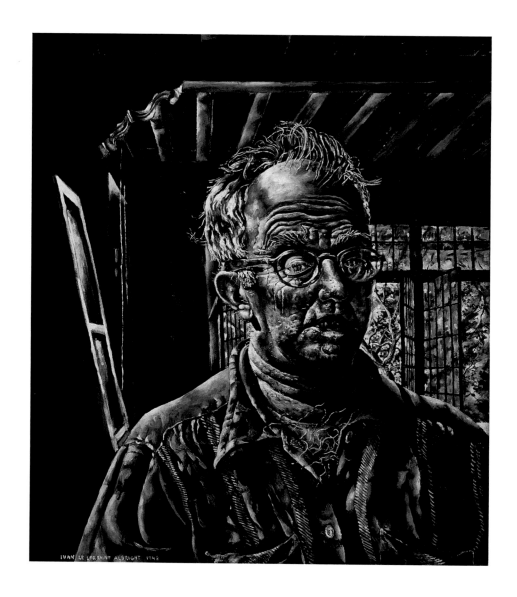

45

SELF-PORTRAIT

1948
Oil on canvas; 61 x 50.8 cm (24 x 20 in.)
Signed and dated, lower left: *IVAN LE LORRAINE ALBRIGHT 1948*
National Academy of Design, New York

In this, his presentation piece to the National Academy of Design, Albright depicted himself with a horrific, pale face, in the spirit of his portrait of Dorian Gray (no. 41). This image of the artist as a haunted man, with his balding head, furrowed brow, exhausted eyes, spidery wrinkles, moles, and demonic-looking mouth, belies his actual situation. Albright was now a happily married father, financially secure, famous, and feted with honors such as being named an academician. Perhaps he painted himself this way because he knew how the public expected him to look; more likely, he was either reflecting the anxiety that even positive changes can engender or he wished to signal the constancy of his vision, whatever his circumstances. New to his self-portraits is the large window, in his new State Street studio in Chicago, which not only lets in wonderful light but also provides a view of leafy branches outside. The appealing green of the trees and strong sunlight are juxtaposed with the disturbing face and dark interior, indicating the coexistence of deep pleasure and a continuing sense of its transitory and illusory nature.

The Wild Bunch (Hole in the Wall Gang)

1950–51
Oil on canvas; 77.5 x 106.7 cm (30½ x 42 in.)
Signed, lower left: *Ivan Albright*
Collection of the Phoenix Art Museum,
gift of Mrs. Thomas Hogg (67.38)

In the late 1940s, Albright began a series of "Western" still lifes, which culminated in *The Rustlers* (no. 52). These subjects were prompted by his visits to the ranch in Dubois, Wyoming, that was owned by his wife, Josephine (see no. 50). All of these compositions, filled to overflowing with standard cowboy paraphernalia—guns, holsters, boots, spurs, saddles, ropes, belts, and so forth—are discomforting in their suggestion of potential violence.

Despite its title, *The Wild Bunch (Hole in the Wall Gang)* is by far the calmest of these works, and quite possibly the finest. The composition, featuring an accrual of objects at the right and a window with a view into the distance at the left, echoes that of an earlier still life, *Ah God, Herrings* (no. 35). But whereas the herring and fishing equipment in the 1940 gouache are bathed in light, the components of *The Wild Bunch* are deeply shadowed. The textures and shapes of this dark maze are attributes of an outlaw gang, in this case Butch Cassidy's (according to the artist, Cassidy's gun was found on Josephine Albright's ranch, and is included in the still life). Albright took pleasure in the fact that, as he pointed out, each item came from someone who "had been a gangster. [The guy who] made the spurs had been in jail. . . . Just about everybody had been in jail . . . except our cowboy manager, George Conwell. . . . Later I heard that he had been in reform school. So that made it perfect."[1] In lavishing so much attention on the rendering of detail, particularly in the pistols, Albright may have been thinking of the precision with which his paternal forebears fashioned and decorated rifles.

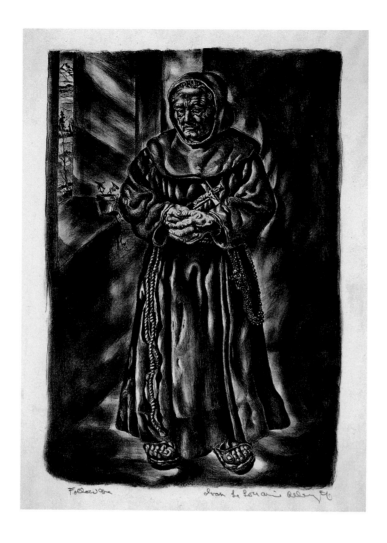

FOLLOW ME

1948
Lithograph on cream wove paper (43/250); 35 x 22.6 cm (13¹³⁄₁₆ x 8⅞ in.)
Inscribed on sheet, lower left: *Follow Me*;
signed on sheet, lower right: *Ivan Le Lorraine Albright*
The Art Institute of Chicago, bequest of Mary and Earle Ludgin (1981.1159);
The Metropolitan Musem of Art, New York, bequest of Peter Pollack (1979.656.9)

As a result of a very successful exhibition of the work of the Albright twins spon-
sored by the Associated American Artists and shown at their galleries in New York
in 1945 and Chicago in 1946, this organization commissioned Ivan to produce two
lithographs in addition to *Follow Me*: *Fleeting Time, Thou Hast Left Me Old* (1945), and
Self-Portrait at 55 East Division Street (no. 43).

 Follow Me is one of the lithographs in which Albright reprised a major painting,
in this case *The Monk* (no. 9). The major change from the original version to the
print is the light source. In the lithograph, the window in the monk's cell is larger,
allowing more light to enter. Rendered in black and white, the rays are more clearly
defined here than they are in color. Most important, however, is the view that can
be seen through the window—revealing a cumulus cloud floating in the sky and a
barren tree—which intensifies the solitude of the figure.

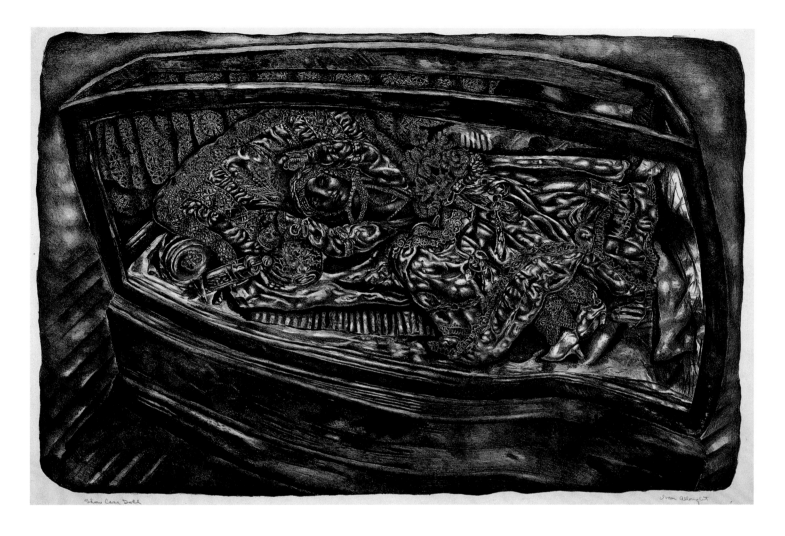

48
..........

SHOW CASE DOLL

1954
Lithograph on cream wove paper (1 of 44);
43.9 x 64.6 cm (17¼ x 25½ in.)
Inscribed, lower left: *Show Case Doll*; signed, lower right: *Ivan Albright*
The Art Institute of Chicago, gift of Earle Ludgin (1963.123);
The Metropolitan Musem of Art, New York,
bequest of Peter Pollack (1973.644)

In this masterful print, Albright returned to a subject that he had first
addressed over twenty years before. Even though *Show Case Doll* (no. 23)
remained an unfinished charcoal drawing on canvas, with only a few
painted areas completed, Albright considered it one of his most important
works. His lithographic reprise is very close to the version in oil and char-
coal on canvas, and yet it has the freshness and impact of a totally new
work. The print demonstrates the artist's strong conviction that art must
not necessarily be seen in terms of a finished product, but has value when
it reveals a dynamic, continuous process. Albright titled several of the
early prints in this edition *Dead Doll*, which indicates more specifically the
meaning of both this and the earlier work.

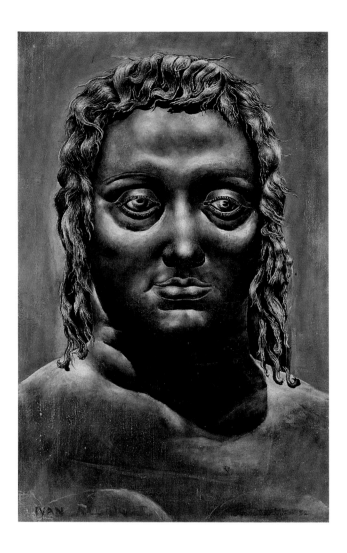

49

TROUBLED WAVES (SILENCE)

1952
Oil on canvas; 35.6 x 22.9 cm (14 x 9 in.)
Signed, lower left: *IVAN ALBRIGHT*;
signed and dated, lower right: *Ivan Albright 52*
Private collection

This unusual painting was most likely inspired by a trip to Greece taken by the Albrights in the summer of 1952.[1] There the artist would have seen archaic Greek kouroi and korai; their influence is felt in this small, nearly monochromatic painting of a head. In contrast to his usual, meticulous treatment of human physiognomies, *Troubled Waves* seems like a portrait of a piece of sculpture. There are no bumps, wrinkles, or imperfections; rather the surface of this head is smooth and without detail, except for eyelashes and hair. The titles Albright gave this painting suit the dark, mysterious face whose eyes avert the gaze of the viewer.

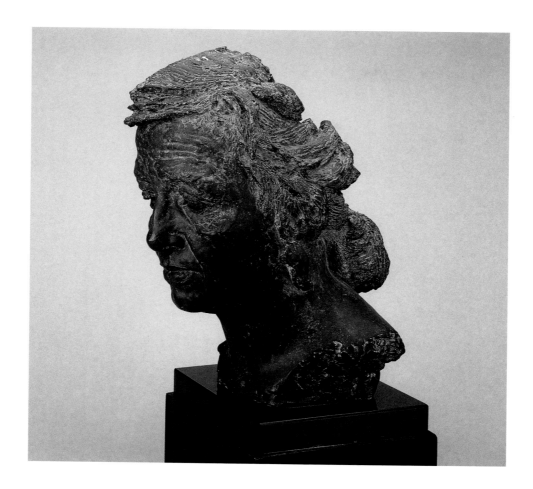

50
..........................

JOSEPHINE MEDILL PATTERSON ALBRIGHT

1954 (cast 1954)
Bronze; h. 34.3 cm (13½ in.)
The Art Institute of Chicago, gift of Ivan Albright (1966.374)

Josephine Medill Patterson Reeve (1913–1996) married Ivan Albright in 1946. A newspaper heiress, she was a remarkable and formidable woman whose several careers included licensed-mail piloting, newspaper reporting, dairy and pig farming, raising horses, and advocating animal-rights (see Donnell, pp. 38 and 39). She had a son and daughter with Albright, who also adopted her two children from a previous marriage. Some seventeen years the artist's junior, Josephine Albright proved to be a forceful and inspiring domestic partner for him. His admiration for her strength and intelligence is expressed in this, his most classic sculpture. It is devoid of the usual Albrightian touches, except for the sunken, hollow eyes, which seem heavy and sad, and the back of the head, which is abbreviated much like the bronze of Adam Emory Albright (no. 30).

For this head, Albright's first sculpture in nearly twenty years, Josephine Albright posed at their ranch in Wyoming over a period of three and one-half months. The sittings proved frustrating and the initial product unsatisfying to both artist and model. Later the same year, the artist reworked the head with powdered metal and shellac to, in his words, "make it look antique."[1] When he finished the clay maquette, he put it in the entrance hall of his Chicago residence. As he recalled, "We had about a dozen people over, and, during the course of the evening, after they'd had a cocktail, someone said, 'Ivan, where did you get this wonderful head? It's beautiful!' And then Joe came out and said, 'Gee, that's a nice head.'"[2] Unaware that her husband had persisted with her likeness, the model finally approved.

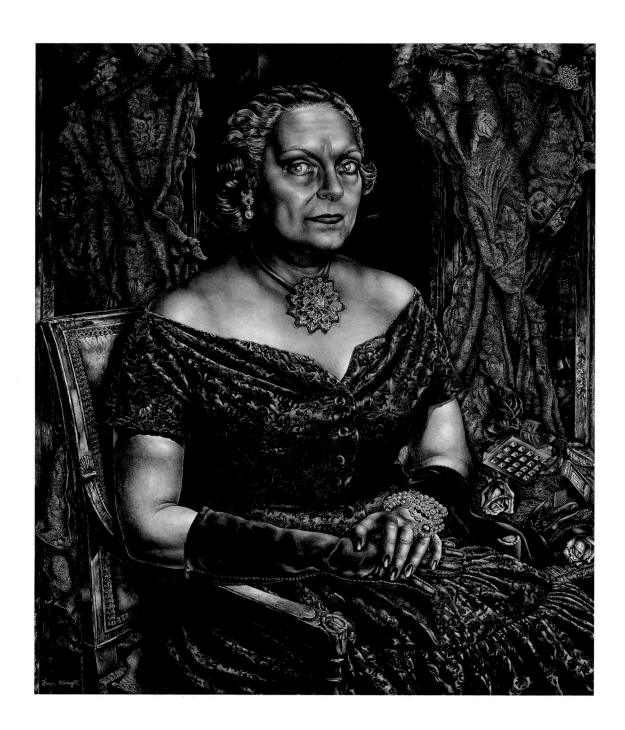

PORTRAIT OF MARY BLOCK

1955–57
Oil on canvas; 99.5 x 76.2 cm (39⅛ x 30 in.)
Signed and dated, lower left: *Ivan Albright/1955–57*
The Art Institute of Chicago, gift of Mr. and Mrs. Leigh Block (1959.7)

In 1955 the Chicago art collector Mary Lasker Block (1904–1982) asked
Albright, who was her neighbor, to paint her portrait. Initially he refused to
take the commission. But Block's persistence, as well as encouragement
from her good friend, Albright's wife, Josephine, eventually brought him
around to the idea, which led to the creation of his first penetrating portrait
in over two decades. An excellent model, Block posed initially as often as

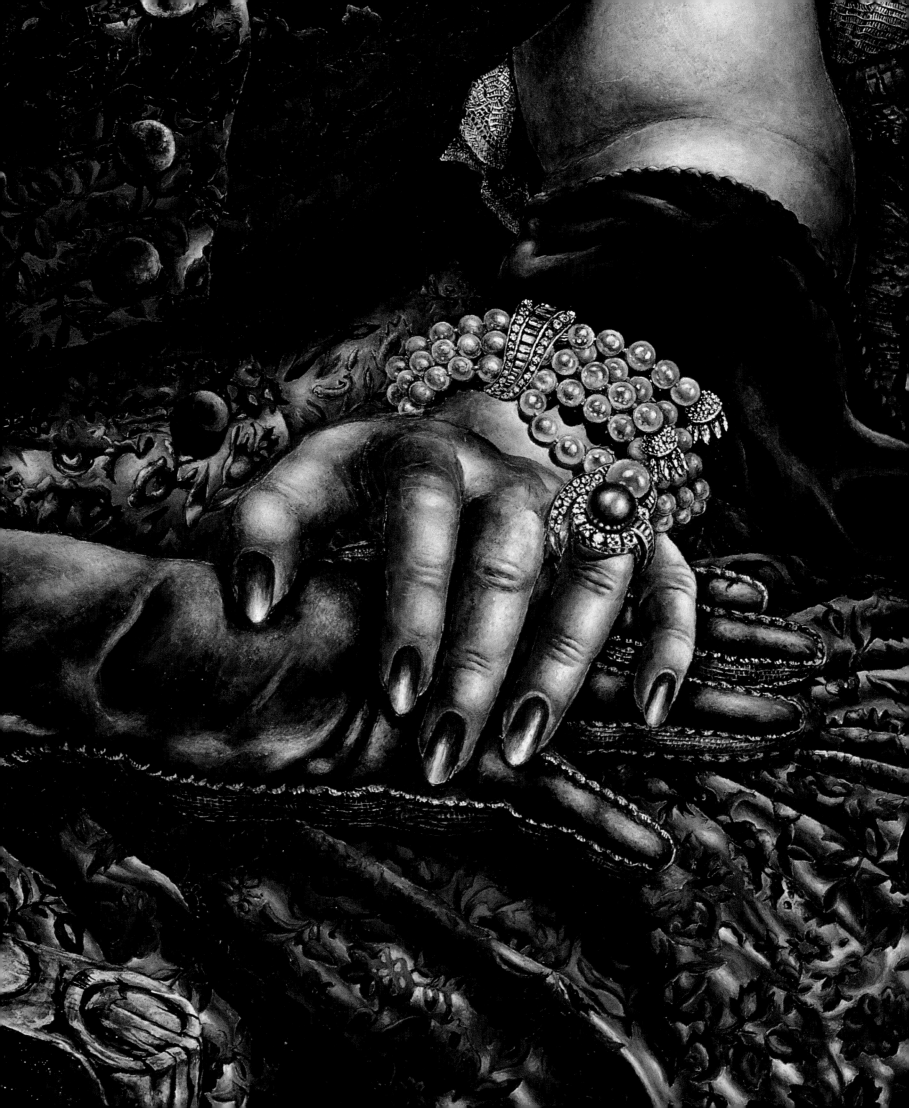

five times a week and then twice a week for two years. The artist also built a dummy that he could dress with her gown and work from when she could not be present.

It is no accident that, in this painting, Albright decided to use the back of the window of his setup for *Poor Room* (no. 40)—then still in progress—as a background and foil for the opulence of his sitter. He alluded to the fact that the materials were disintegrating all around Mary Block, and that eventually such decay would affect her as well.[1] The painting is a spectacular ensemble of textures: from the cut-velvet dress to lace curtains, from a black-velvet glove to a diamond pendant and a pearl bracelet. Each, in its precise rendering, seems magnified and perfectly realized, at once dazzling and mummified, like the magnificently costumed, coolly regal images of Renaissance nobility by artists such as Agnolo Bronzino.

Hard and chiseled like her polished nails, Block stares with impressive composure. She bravely gave herself up to Albright's vision, although he admitted that he had incorporated some of her reality into his work as well. "I asked her to bring me her nail polish and I copied that on my palette. . . . Also I asked her for her lipstick . . . a kind of cerise purple blue. . . . I did the same for that . . . [as well as for] her face powder; I copied it identically. It was rather ghastly in a way; it looks so close [to how she looked] that it's kind of scary."[2]

Albright considered this painting one of his most effective,[3] probably because of its technical brilliance. On viewing the portrait, a psychiatrist who was acquainted with Mary Block for many years told Albright, "You know more about Mary Block than I do."[4] Block and her husband, Leigh, were convinced of Albright's greatness, which might explain why she did not mind if he worked his particular brand of black magic on her image. The Blocks—each of whom served for many years on the Art Institute's Board of Trustees, including, in the case of Leigh Block, five years as its chairman—amassed a magnificent collection of modern art. They owned significant works by Braque, van Gogh, Matisse, Picasso, and Vuillard, among others. Albright considered it appropriate to have been asked by collectors of such discriminating taste to join such outstanding company.[5]

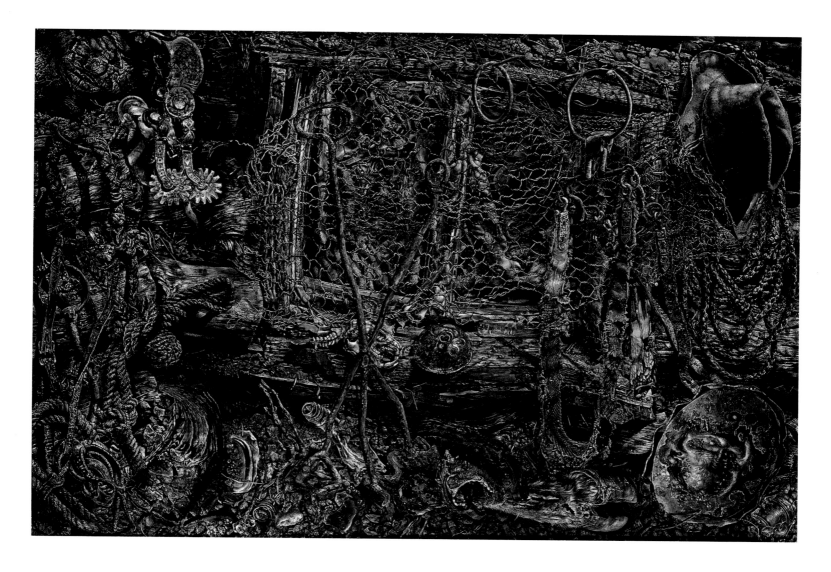

THE RUSTLERS

1959–62, reworked 1964–65
Gouache on paper mounted on hardboard; 68.5 x 98.1 cm (26⁹⁄₁₆ x 38⁵⁄₈ in.)
The Art Institute of Chicago, gift of Ivan Albright (1977.33)

This work began with a setup that Albright assembled and erected in his Wyoming studio in 1959. That same year he exhibited the gouache at The Art Institute of Chicago, evidently considering it finished, under the title *Flying W* (he subsequently called it *Cow Camp*). Five years later, he revisited and overpainted the work, transforming it into an obsessive and intensely detailed all-over composition, and renaming it *The Rustlers*.

Compared to the simplicity of the setup—a section of log-cabin siding with a windowlike aperture, around which are found only a few objects, such as a metal cup, a saddle, a sack, and pieces of scrap metal and cloth hung from nails (see Chronology, fig. 27)—the final work is an incredible accretion of things, a "battleground of forms," as Michael Croydon described it.[1] Looking at the composition from left to right, we can discern such items as spurs, ropes, chains, a horn, bottles, pottery shards, an animal skull and vertebrae, three branding irons, nails and rings, an overturned cup, a frayed snakeskin belt, a partial cattle hoof, a hat, more rope, and a corroding blue-metal flask. In the shallow space behind these items

is a decrepit, wooden frame around a window that is covered with chicken wire, but permits a view of yet another dense layer of hard-to-discern objects. While each thing is minutely rendered, the composition is so crowded and the linear and color patterns so repetitive that one is overwhelmed by the density and texture of the whole rather than able to easily make out the parts. This dense encrustation of forms not only seems to extend past the picture frame but through and beyond the painted window, into limitless depth.

Brimming with references to the Old West, *The Rustlers* is a memorial to a way of life that had long ago disappeared but that was being actively reinvoked and mythologized by Hollywood in sweeping Technicolor sagas produced throughout the 1950s. At the same time, this painting honors and pushes to an extreme the American tradition of trompe-l'oeil still lifes perfected in the nineteenth century by such artists as William Harnett (see Weininger, fig. 24). It is also possible to see *The Rustlers* as part of a much more contemporary idiom: the all-over compositions of Abstract Expressionists such as Jackson Pollock. While neither Albright nor the Abstract Expressionists would appreciate the comparison—Albright intensely disliked abstract art, and his insistent representationalism would have been far too literal and narrative for the New York School—it is hard, from the perspective that time provides, not to consider the parallels. Like Pollock's most ambitious drip paintings, Albright's work focuses on the relationship between chance and order, surface and depth, finite and infinite.



53

PARTHENON, GREECE

1960
Gouache on paper;
31.8 x 39.4 cm (12½ x 15½ in.)
Inscribed and signed, lower left: *Athens/Greece/Ivan Albright*
Lawrence M. Pucci, Caryl Pucci Rettaliata

The white-columned ruins of the ancient Athenian acropolis stand delicate, pale, and ghostly on the squarish, rocky outcropping that they crown. Here the ancient monument of a culture revered as a cradle of Western civilization is more articulated, and therefore appears to have more permanence, than the murky green and brown terrain on which modern-day Athens sprawls. Few works by Albright are as simple and direct as this; the gouache shows the acuity of his vision even when he worked quickly and at a considerable distance from a monument whose import and fame could prove daunting to the most confident artist. As his wife once remarked, "He could almost be a camera if he wanted to be."[1]



54

FEZ, MOROCCO

1960
Watercolor and gouache, with brush and black ink, on white wove paper;
35.7 x 51.2 cm (14 x 20⅛ in.)
Dated and signed, lower right: *1960/Ivan Albright*
The Art Institute of Chicago, gift of Ivan Albright (1977.246)

On a trip to Morocco, Albright situated himself at some remove from the ancient, walled city of Fez to depict its dramatic setting in a mountainous valley. He clearly took great delight in contrasting the valley's concentration of tiny, rectangular, white buildings—dotted with windows and punctuated here and there by towers—with the more broadly rendered, deeply shadowed, surrounding mountainsides. Trails of smoke rise from the white buildings; quickly sketched trees line the lower right of the composition; and dark-gray clouds hang in a lighter sky over the peaks—all abbreviations painted with assurance and zest.

55

LOST FOREST—A CYPRESS SWAMP, GEORGIA

1950
Charcoal and watercolor on paper;
55.9 x 76.2 cm (22 x 30 in.)
Signed, lower right: *IVAN LE LORRAINE ALBRIGHT*
Lawrence M. Pucci, Caryl Pucci Rettaliata

Albright painted many highly detailed watercolors of a swamp in southern Georgia, near the estate owned by Josephine Albright's sister, Alicia Patterson Guggenheim. In this fine example, as in others, thickly tangled trees twist and gesture anthropomorphically, a quality the artist loved to evoke. Almost primordial, the growth is so dense that, in the background, light is reduced to small flecks of white. Rather than inviting the viewer into a lush forest, the spectral trees splinter and fall to the ground, barring easy access into the swamp's ominous depths.

56

WOODS AT DEERFIELD (HOME AT DEERFIELD; OUR RETREAT IN THE WOODS, DEERFIELD, ILLINOIS)

1962
Lithograph on cream wove paper (1 of 4); 33.8 x 23.3 cm (25½ x 13¼ in.)
Inscribed on sheet, lower left: *There are Many trees in the Forest/ litho on stone*; signed on sheet, lower right: *Ivan Albright*
The Art Institute of Chicago, gift of Gilbert Kitt (1991.721);
The Metropolitan Museum of Art, New York,
bequest of Peter Pollack (1979.656.7)

This softly drawn lithograph shows part of an Illinois wildlife refuge in the Edward L. Ryerson Conservation Area, where Albright had a small cabin built for family retreats. The forest floor is dappled with white highlights, small areas of paper unsaturated by lithographic ink. Through the trees, a clearing can be discerned that the sun has filled with light, encouraging us to move toward it, at least with our eyes. Even though it is much smaller in scale than *Lost Forest* (no. 55), this lithograph manages to capture a similar sense of spatial recession and infinite detail.

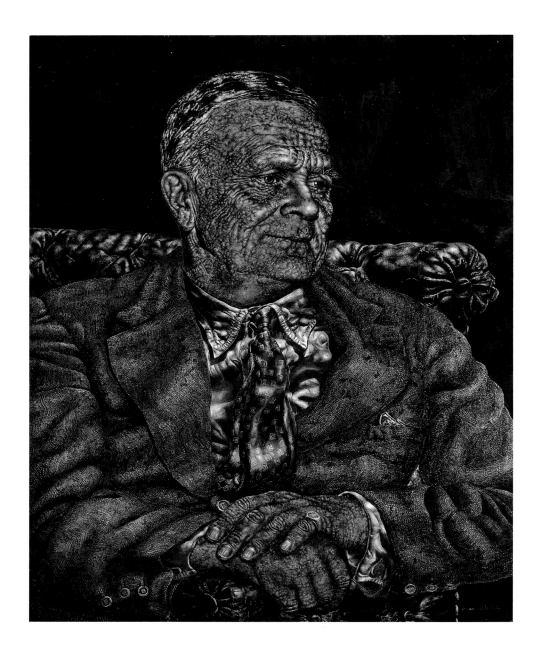

CAPTAIN JOSEPH MEDILL PATTERSON

1962–64
Oil on hardboard; 76.2 x 61 cm (30 x 24 in.)
Signed, lower right: *Ivan Albright*
The Art Institute of Chicago, gift of Ivan Albright (1977.37)

This depiction of Joseph Medill Patterson (1879–1946) is one of Albright's most unusual portraits. The sitter, who retained the designation he received serving in World War I, was the editor and publisher of the *New York News* and majority stockholder of the *Chicago Tribune*. He was also Albright's father-in-law.

This is the only known instance in which Albright executed a posthumous portrait. The distinguished newspaper publisher died the year his daughter Josephine married Albright, so this portrait, executed some sixteen years later, was based on photographs and memories. Although Albright met Patterson only once, he recalled liking him immediately. In planning the work, Albright initially made a fairly elaborate diagram in one of his notebooks, showing a portion of Patterson's library, in which titles are readable on the books' spines.[1] At an early point in the painting process, however, the artist abandoned the idea of placing anything behind the subject. Instead, for the background, he used a rich and velvety shade of maroon, which highlights the worn, leather couch on which Patterson sits, and makes the figure seem to glow.

Not an easy man, Patterson was especially hard on Josephine, whom he had hoped would be a boy, pushing his namesake continually to achieve. Something of his demanding nature, as well as of his intelligence, culture, and achievements, is expressed not by the inclusion of accouterments but rather by his elegant pose and confident expression. The artist lavished his attention and skill on rendering Patterson's wool jacket, his shirt, tie, pocket handkerchief, cuff links, and buttons with utmost precision. The most Albrightian note in this otherwise commanding and vigorous image is the strange, bumpy texture of the skin. The warm amber of the figure enhances our sense of a man whose influence was felt long after his death.

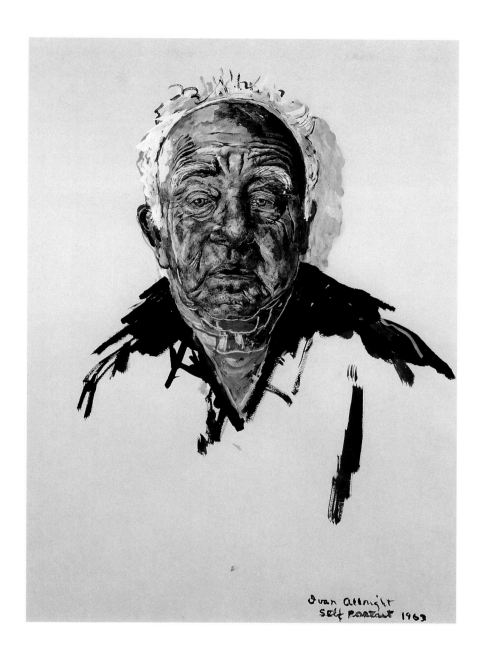

58

ASPEN SELF-PORTRAIT

1963
Gouache on paper; 61 x 43.2 cm (24 x 17 in.)
Signed, inscribed, and dated, lower right: *Ivan Albright/Self Portait* [sic] *1963*
Private collection

When Albright painted this gouache, while on vacation in Colorado, he was sixty-five years old. In contrast to his earlier self-portraits (see for example nos. 28 and 29), there is very little distortion or elaboration here. Rather, the painter used a broad and economical technique to arrive at a very immediate depiction of himself. For an artist so adept at meticulously filling every inch of surface and exaggerating the ravages of time on the human face, he seems here to have realized that he did not need to do more than confront his own image truthfully and simply. Not until the late self-portrait series (nos. 71–91) did he again choose to present himself so directly and without artifice.

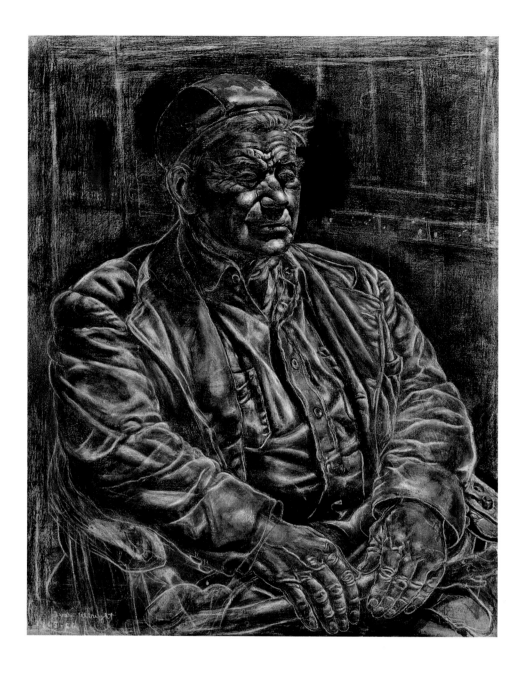

STUDY FOR "THE VERMONTER"

1965–66
Chalk with touches of oil on canvas; 88.9 x 68 cm (35 x 26⅞ in.)
Signed and dated, lower left: *Ivan Albright/1965–66*
The Art Institute of Chicago, gift of Ivan Albright (1977.237)

This study was Albright's second attempt (the present location of the first, a charcoal drawing on canvas, is unknown) to portray, as he wrote in a notebook, "the most human head ever made."[1] He chose as his model Kenneth Harper Atwood, a seventy-six-year-old member of the Vermont House of Representatives and retired maple farmer. When asked in 1966 by his friend the art critic and writer Katharine Kuh whether it is true that artists also paint themselves when they paint their sitters, Albright admitted that, for this project, he had indeed selected a model "who has lived and who feels as tired as I do" (see Donnell, fig. 27).[2]

As we have seen, Albright's normal practice was to make a detailed rendering of the composition in charcoal directly on the prepared canvas. Here, however, he reversed his standard method, overlaying a black ground with white chalk rather than working with charcoal on white gesso. Albright then proceeded to develop small, isolated portions in color. In painting parts of the hat, the bridge of the nose, an arm of the chair, and the left shoulder of the jacket, he became aware that the canvas weave was too evident and distracting. Consequently, he stopped and shifted to the smooth surface of hardboard (no. 60).

Because the background is relatively plain and there is no attendant clutter (except for the hint of a tree branch in the sitter's hands), the monumental figure dominates. In this sympathetic study, the face and hands are, for Albright, naturalistic, the textures and folds of suit and cap restrained. Clearly the artist was focused on conveying the humanity of his model, for he had challenged himself in his notes to "make [the head] great; eye sockets that tell the years, folds that bespeak flesh, eyes that bring pity . . . that have seen better."[3]

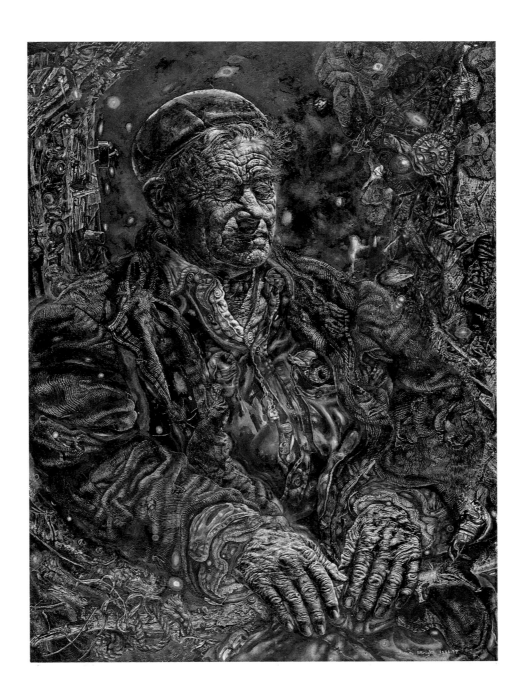

THE VERMONTER
(IF LIFE WERE LIFE THERE WOULD BE NO DEATH)

1966–77
Oil on hardboard; 78.2 x 50.3 cm (30⅞ x 19⅞ in.)
Signed and dated, lower right: *Ivan Albright 1966–77*
Hood Museum of Art, Dartmouth College, Hanover, New Hampshire,
gift of Josephine Patterson Albright

After two aborted attempts (see no. 59) to render his model, Kenneth
Harper Atwood, Albright decided to redo the figure on the smooth surface
of hardboard. During the first few years of work, Atwood posed for two
hours every day (at $1.50 an hour). As he had done with his portrait of
Mary Block (no. 51), the artist made a dummy that he could use when the
sitter was not available. To work on this late masterpiece, Albright was

aided immeasurably by a special easel he had designed in 1969, which allowed the work in progress to be held securely in place while the artist positioned it at virtually any angle he desired. It enabled him literally to paint the elements of his composition from any and all sides. He was able to bring the hands and face to a state of near completion by 1968; the development and elaboration of the body and background required nearly a decade.

In what was a dramatic departure from his usual methods, Albright composed largely as he painted, reinforced by the two detailed charcoal studies he had done previously. Three separate diagrams (see Donnell, fig. 28) and eleven notebooks assisted the artist as he struggled to control an increasingly involved method of execution.[1] The notebook entries indicate his goals for the work:

Make eyes literally move, make mouth tremble. . . . Make left hand act as if it would rise up . . . [and] right hand as if it would crawl around stick. . . . Have end of nose literally wiggle. . . . Have him as spiritual as I can make him but also flesh.[2]

Make the painting closer than ever. . . . more real than real so [that] reality seems by comparison a misty dream, an untruth against a truth.[3]

Indeed, the artist obsessively recorded with loving care individual hairs, wrinkles, and moles of face and hands; every stitch, knot, crease, and thread of clothing; each nail, twist of chain, debris and odd pieces such as an apple-corer and a mourning hat of lace and black velvet. Albright's technique turned every item into something precious and otherworldly. A sense of timelessness is conveyed by the sheer richness of textures and the model's sagelike expression. His red cap, large Ethiopian cross, and regal pose recall Renaissance and Baroque portraits of popes, such as those of Leo X by Raphael (Florence, Galleria degli Uffizi) and of Innocent X by Diego Velázquez (Rome, Galleria Doria-Pamphili). A kaleidoscopic flow of colors and phosphorescent glow of afterimages, both around and across the figure, envelop the sitter and make him appear like a vision. The mood is elegiac and celebratory.

The second title the artist gave this painting, *If Life Were Life There Would Be No Death*, further reveals the work's meaning. Albright accepted death as an essential part of living, a condition that gives life meaning. Many years before, he had written, "To live is one thing—to have died is to have lived longer. Death is the greatest event in the philosopher's life. Our bodies are our earthen shelters undercover of which we live. To really see ourselves, we have to step out from our shelters, and that time comes with death."[4]

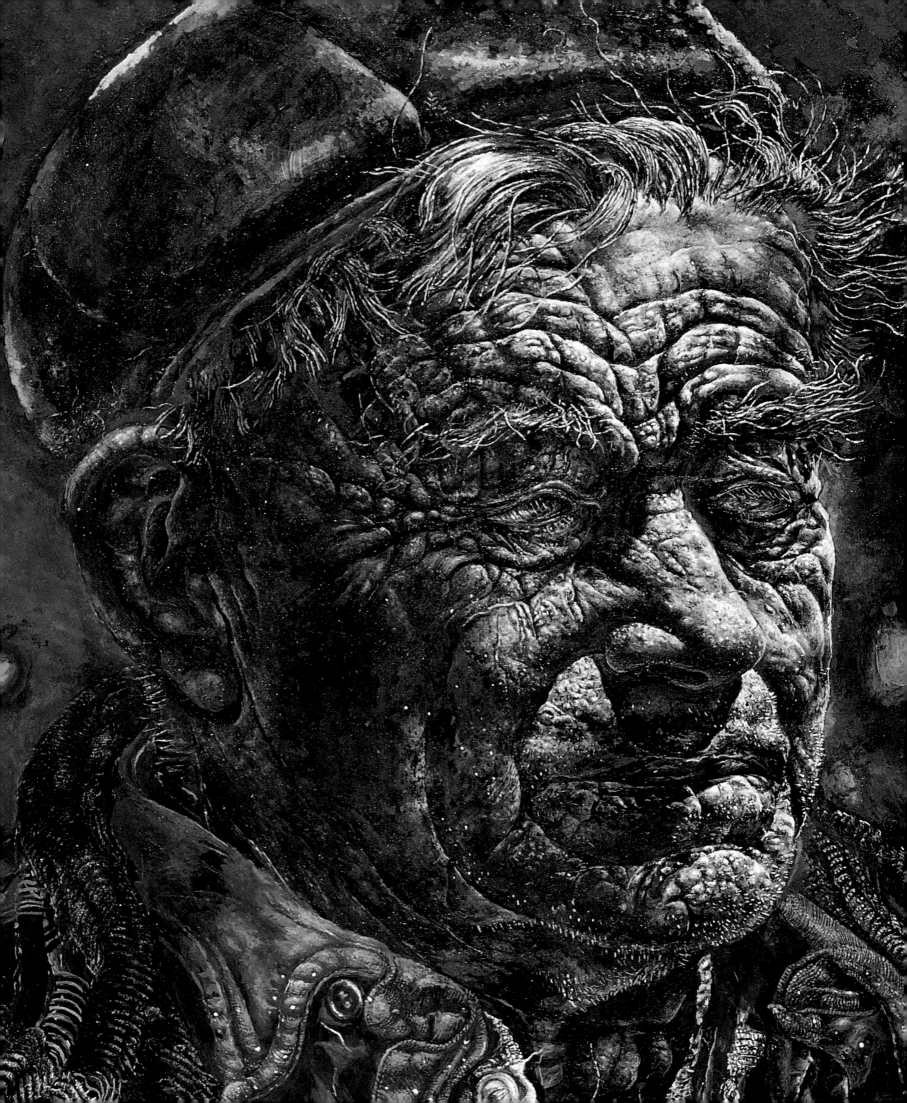

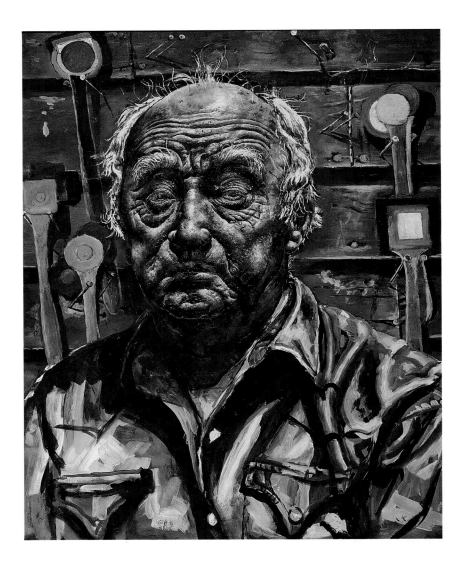

61

SELF-PORTRAIT IN GEORGIA

1967–68
Oil on canvas board; 50.8 x 40.6 cm (20 x 16 in.)
Signed, lower right: *Ivan Albright*
The Butler Institute of American Art, Youngstown, Ohio (969-0-150)

In this intriguing self-portrait, the artist combined the bold brushwork of his recent work (see no. 58) with his signature, obsessive description of aging flesh. With his sparse, white hair, deeply furrowed brow, heavy wrinkles around the eyes and mouth (which contribute to a sense of exhaustion and sadness), and double chins, he looks every bit his age of seventy-one. Nonetheless, the almost electrically charged hairs standing up on his head, the sheer mass of his purplish-pink face, and the vigorous rendering of his blue working shirt all express his continuing vitality and focus. The significance of art to Albright's life and sense of self is underscored by what hangs on the wall behind him, the so-called "color wands" he first developed in 1943 and employed for *Picture of Dorian Gray* (no. 41). He devised them to capture the eerie, fantastic effects of afterimages, the colored shapes perceived as a result of staring at a form and then closing one's eyes to view its color complement. The wood rods—colored triangles, squares, and circles with black handles—produced afterimages when examined under intense light for several minutes. The wands, here looking almost magical, played an important role in the artist's work into the 1960s and 1970s (see nos. 66a and 66b), when his perceptual capacities were threatened by blindness.

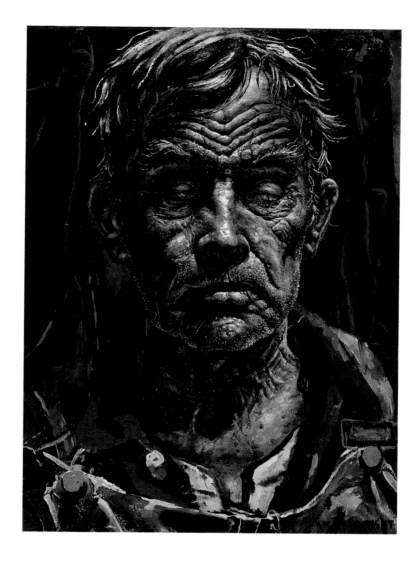

62

............................

A Face from Georgia

1969–70
Oil on canvas; 39.4 x 27.3 cm (15½ x 10¾ in.)
Dated, lower left: *1974*[1]; signed, lower right: *IVAN ALBRIGHT*
The Art Institute of Chicago, gift of Ivan Albright (1977.25)

The notes that Albright made while preparing to make an etched version of this portrait illuminate his goals for the painting: "Make face so fleshy it shines like flesh, eyes so alive they shine and glisten. Make head move. Make head heavy like [twelve pounds] of meat. Make head lumpy. Make hair like swamp hair. Make it breathe and crawl—not an insect. . . . Not a vegetable. Almost."[2]

Although small in scale, this portrayal of John Coleman Groover, a caretaker on the Albrights' Georgia plantation, which they had inherited from Alicia Patterson Guggenheim after her death in 1963, has insistent strength and presence. Albright paid particular attention to the patterns and textures of the man's face: the forehead's worry lines are chevron-shaped, the smile lines running from his nostrils down toward his mouth form dark crevices, whiskers emerge from his skin like the points of tiny needles (Groover shaved only on Sundays), and thinner lines resembling loose webbing trace the sagging skin below his weary eyes. Strong highlights in his uncombed hair and the raised portions between the wrinkles on his brow and around his eyes and mouth also emphasize the deep lines of his face and the sunken areas of his cheeks and neck. The contrast between the carefully worked head and the more summarily rendered clothing and background is a technique the artist also employed for dramatic effect in his self-portraits (see for example nos. 74 and 84).

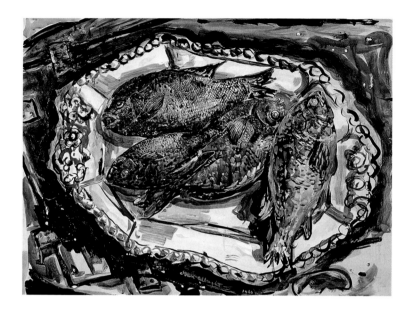

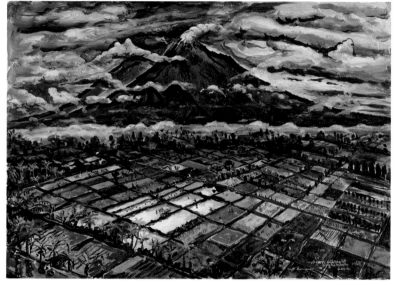





63

PLATTER UNDER GEORGIA FISH

1966
Gouache with watercolor and brush and black ink, on ivory clay-coated
paper; 40.6 x 50.8 cm (16 x 20 in.)
Signed and dated, center bottom: *Ivan Albright 1966*
The Art Institute of Chicago, gift of Ivan Albright (1977.259)

The subject of fish was particularly rich for Albright: in such works as *Platter under Georgia Fish*, they can signify the fruits of nature; in others they provide a livelihood (see nos. 16 and 35), and in at least one (see Donnell, fig. 30) they symbolize rebirth. On March 16, 1966, Albright produced a group of four colorful gouaches of fish on a serving platter (the Art Institute owns another [1977.260]; a third is in the collection of Lawrence M. Pucci and Caryl Pucci Rettaliata; and the fourth is missing). The artist noted that, in each of these energetic sketches, he was trying to catch the effect of "spontaneity,"[1] which for him meant a quick execution, one that lasted fifteen to forty-five minutes. Albright's technical facility and fine draftsmanship are fully demonstrated in this work, which is at once detailed and bold, decorative and expressive. While the fish are presented on a serving plate, they have not been cleaned, as if they have recently been pulled from their watery homes. In fact, with their strong colors, firm bodies, and clear, highlighted eyes, they look vivid and almost alive.





64

MOUNT SEMERU, JAVA

1969
Gouache on cream wove paper; 30.8 x 60.8 cm (12⅛ x 24 in.)
Signed, inscribed, and dated, lower right:
Ivan Albright/Jogkakarta 1969/Mt Semeru Java
The Art Institute of Chicago, gift of Dr. Harry Boysen (1988.553.1)

On a visit to southeast Asia, Albright painted this panoramic view of a smoking volcano rising majestically and ominously above a plain of rice paddies and fields that are neatly demarcated by palm trees and hedges. Here the artist attempted to integrate a densely patterned and colored surface with a dramatic, deep vista. A bank of low-lying clouds divides the composition nearly in two: on the one hand, civilized nature, tilled and populated by the tiny figures of workers, dominates the foreground; and, in the background, is nature untamed, with steep, high-peaked mountains and ribbons of clouds created by steam from the volcano's mouth floating across the expanse. The two zones are linked by the reflections of the clouds in the watery rice paddies and by the large diamond shape formed by mountains and fields.





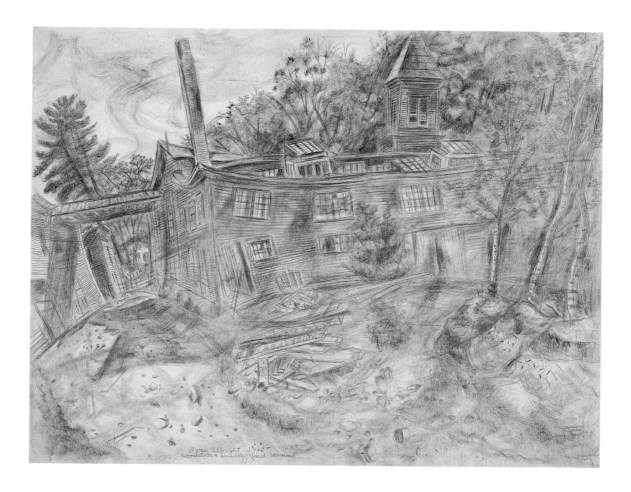

65

FIRST A CHURCH, THEN A LUMBERYARD, WOODSTOCK, VERMONT

1969
Platinum, gold, silver, brass, and copper point on
cream wove paper; 40.5 x 50.8 cm (16 x 20 in.)
Signed, dated, and inscribed, lower left:
Ivan Albright 1969/Woodstock Lumber Yard Vermont
The Art Institute of Chicago, gift of Ivan Albright (1977.16)

Late in life, Albright produced landscapes in which he attempted to work out complex theories of space and motion. Created in a very different spirit from the spontaneous way in which he dashed off his travel sketches (see nos. 53, 54, and 64), these carefully planned works involved painstaking research on the part of the artist, as well as meticulous execution. The Frost Lumber Yard, in Woodstock, Vermont (where the Albrights moved in 1965), occupied a wooden structure that began life as a church, expanded into a factory complete with skylights and chimney, and then was connected to ancillary buildings across a rocky road. The artist employed the delicate metalpoint technique, which had interested him since the mid-1950s, filling the image with details that are caught up in a play of unifying light and shadow, depth and dizzying movement. The buildings seem to stretch and sway; the roofline to dip and rise; the tower, skylights, and chimney to shoot off in different directions. Were it not for the old steeple and three trees in the foreground leaning to the right, everything else in the scene would pitch toward the left and virtually fall beyond the picture frame. For Albright, the essence of life was movement and change. In this dynamic image, a factory that was once a church continues to evolve.

66a

FROM YESTERDAY'S DAY

1971–72
Oil on canvas; 21.6 x 38.7 cm (8½ x 15¼ in.)
Signed and dated, lower center: *Ivan Albright 1971–72*;
signed and dated, upper right: *Ivan Albright/1971–72*
Marjorie and Charles Benton

66b

THE IMAGE AFTER

1972
Oil on canvas; 23.5 x 38.7 cm (9½ x 15¼ in.)
Signed and dated, lower center: *Ivan Albright 1972;*
signed and dated, top center: *Ivan Albright 1972*
Marjorie and Charles Benton

Albright's fascination with afterimages (the colored shapes perceived as a result of staring at a form and then closing one's eyes to view its color complement) dates back to at least 1937, when he mentioned them in a notebook in relationship to *The Door* (no. 24).[1] About 1945 Albright discussed plans in a notebook for a project that describes *From Yesterday's Day* and *The Image After*—achieved a quarter of a century later—with startling exactness: "Paint a picture with afterimages only with all the first colors gone—only afterimages—and carry it [further] so you have some third or fourth afterimages. Also paint afterimages of area and shape only, with original area all gone. Study the aftercolor of any and all objects and only paint the aftercolor."[2] He finally undertook the experiment in 1971, with *From Yesterday's Day*, a still life replete with objects associated with his parents and memories. But he discovered that he could not explore the problem fully in one canvas, and so he created *The Image After*. Even though his motives for producing this pair of paintings were purely conceptual, the associations connected with the objects depicted remained of primary importance. It is also interesting to consider Albright's need to produce a second image in order to achieve a total statement in light of his twinship.

The composition of both canvases combines a tintype of his mother with a pocketbook and sewing kit—objects that his father had taken with him when he left the family farm in Iowa to journey to Chicago to become an artist, and had carefully preserved over the intervening years. To this, Albright added an apple core, explaining, "If you want to give [the painting] the element of time, you just show the apple core as being old, make it half rotten—then, subconsciously, people know that the apple wasn't eaten half an hour ago. . . . Little things like that add."[3] He arranged these items on a revolving table, and, as he had done with *The Vermonter* (no. 60), used an easel that made possible the rotation of the canvas. The first painting is dominated by cool blues. The palette of the second canvas is hotter, and its brushwork broader, resulting in a degree of abstraction that is unprecedented in his oeuvre. Albright signed each canvas in two places and noted on each frame: "This picture is made so it can be hung on either side or on end. It can be changed from time to time for variety." In a letter of April 4, 1972, in which Albright offered the pair to his patron William Benton, he said, "This is the first time that I have ever done a painting entirely from afterimages, and I doubt that I will do another soon. The technique is taxing to the eyes, as well as to the mind, and involves much painstaking revision."[4]

a

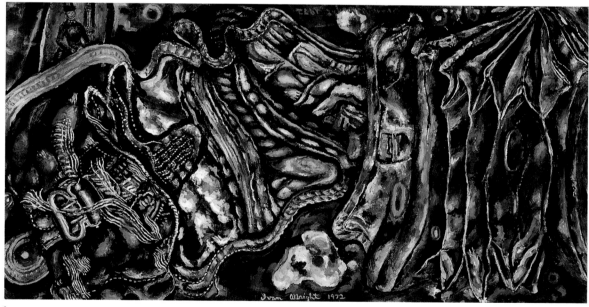

b

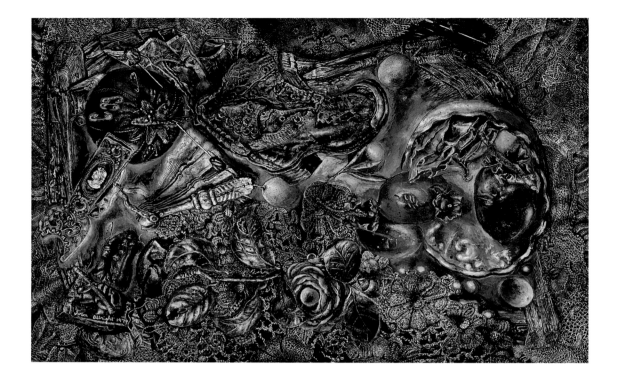

67
......................

PRAY FOR THESE LITTLE ONES (PERFORCE THEY LIVE TOGETHER)

1973–74
Oil on silk; 27.6 x 42.6 cm (10⅞ x 16¾ in.)
Signed and dated, lower left: *Ivan Albright 1974*
The Art Institute of Chicago, gift of Ivan Albright (1977.26)

After Albright's 1969 trip to the Far East, he became fascinated with Asian painting techniques and materials. *Pray for These Little Ones (Perforce They Live Together)* is one of several works he executed on silk.[1] This highly detailed, meticulously crafted work is actually quite small in scale; yet, its execution took eight months and required at least seven separate diagrams.

In this composition, Albright returned to a motif—a group of objects arranged on a flat surface seen from above—that he had explored over forty years before in *Wherefore Now Ariseth* (no. 21). The title of the earlier work indicates the artist's primary interest then in formal issues. In *Pray for These Little Ones*, his main concern is revealed in a notebook entry written when he was developing the composition: "Have to make painting very, very spiritual. . . . Pick out the good, no evil in picture—no bad thoughts, no degeneration."[2]

The components of the work are displayed on a primitive wooden tray surrounded by an elaborate, crocheted table covering. They include a pincushion shaped like a tomato, a child's boot, and kumquats; a seed pod and persimmons (despite his good intentions, Albright could not resist showing them in various stages of decomposition) in and around a white, scalloped bowl; a rose, a dried pepper, and an ivory-and-paper fan. These objects do not seem to make sense as a group; but, for the artist, their significance was to be found in their randomness. As he wrote, "Life is made up of . . . thousands of fragments. These . . . are connected with the passage of time. . . . They coexist."[3] At seventy-seven years of age, Albright placed great value in the Proustian associations of such objects. Rendering them in jewel-like colors, surrounding them with shimmering afterimages, he made them, in his own word, "holy."[4]

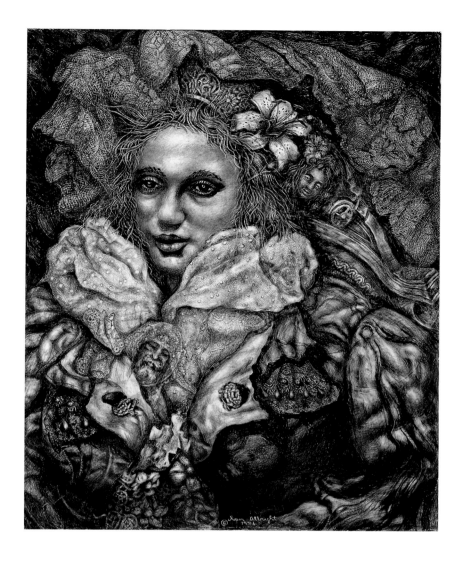

HAIL TO THE PURE (PORTRAIT OF CHIGI PIEDRA)

1976
Black crayon and graphite, with scratching and erasing, on white clay-coated paper;
50.3 x 40.2 cm (19¾ x 15⅞ in.)
Signed and dated, lower center: *Ivan Albright/© 1976*
The Art Institute of Chicago, gift of Ivan Albright (1977.285)

The pretty, young model in this drawing—Maria Lucille Gracia (Chigi) Piedra—is almost swallowed up by an elaborate costume in which she is encased, like a Spanish Baroque infanta. Her headdress includes lace, a tiara, a spotted lily, and a cameo; her garments are encrusted with jewels. She also wears an Ethiopian cross (also worn by the model in *The Vermonter* [nos. 59 and 60]) and a large brooch on which appears the image of Christ from the Shroud of Turin, an object that had long fascinated the artist. In the 1970s and early 1980s, he planned to do at least three works based on the theme of the head of Christ, of which he produced only one, an etching (1981).¹ In *Hail to the Pure (Portrait of Chigi Piedra)*, the artist seems to have returned to an idea he had explored in the 1931 canvas and 1954 lithograph *Show Case Doll* (nos. 23 and 48), in which an extravagantly dressed doll, surrounded by an odd assortment of Victoriana, lies on lace. While the eyelashes, in particular, of the model in *Hail to the Pure* look artificial, and she is as trapped by her attire as the doll by her case, she seems otherwise very much alive. Albright later used the drawing as the basis for a lithograph of the same title that was issued on the occasion of the publication in 1978 of the monograph on the artist by Michael Croydon.²

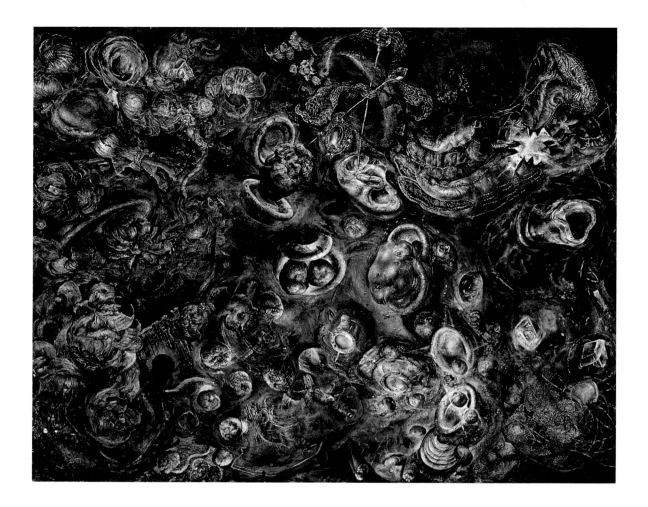

STILL LIFE WITH POTATOES IN MOTION

1978–80
Oil on hardboard; 40.6 x 50.8 cm (16 x 20 in.)
Private collection

This astonishing still life is anything but "still." It is Albright's ultimate response to a number of challenges he set for himself over the years: finding a balance between static and active, evoking the transmogrification from inanimate to animate and from living to dead, and exploring on a two-dimensional surface the complex issues of time and space.

Approximately thirty-six potatoes, as well as garlic cloves, green onions, mushrooms, china dishes, and a green bracelet, a glove, scraps of lace, and two crossed fancy hat pins float through space like bizarre cosmic detritus. A white-porcelain saucer, which appears a number of times, resembles the turntable on which the artist placed objects to observe them in motion. According to Albright, he painted the basic elements from 310 different perspectives so that the composition can be viewed from any angle. His entry in a notebook perhaps captures the spirit of this work best:

October 28, 1979. . . . Saucer, little potatoes all in slow motion. . . . The direction of all objects must include several inches above setup. The haze, the glow of all objects, the dust, the dirt, the potatoes, the porcelain butter saucers, are all moving together as a whirling unit, like a galaxy across my vision—bigger and smaller—the same objects grow dazzling, and . . . the light around them [becomes subdued]. . . . Its motion includes time, also life and death. In its movement, it's on its way to eternity.[1]

Although small, this work is greatly ambitious. At nearly eighty-three years of age, the artist continued to push himself with unflagging energy and to feel exhilarated by the act of creation.

70a

STILL LIFE WITH TWO APPLES

1981
Oil on hardboard; 25.4 x 15.2 cm (9½ x 6½ in.)
Signed and dated, lower left: *Ivan Albright/1981*
Private collection

70b

STILL LIFE WITH POTATO
(THE LONELY POTATO)

1981
Oil on hardboard; 16.5 x 24.1 cm (6½ x 9½ in.)
Signed and dated, lower right: *Ivan Albright/1981*
Jean and Alvin Snowiss

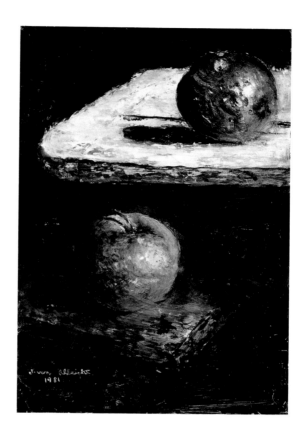

For these, among the last still lifes Albright produced, he continued his practice of making diagrams and placing objects on a turntable (much like a potter's wheel) in order to study their forms and colors in motion. The fresh palette and bold handling of these panels reappear in the artist's great, and last, series of self-portraits (nos. 71–91). Statements in his notebooks from the 1970s and into the 1980s confirm that he approached these intimate and sparse compositions as ruminations on the nature of the individual alone and in relationship to others.[1] The lovingly rendered apples in the first still life rest on planes that, while separate, are at close remove, with a raking light hitting each round form at the same angle. The single potato of the second still life turns and rolls. It is at once finite—a potato on a surface—and infinite—a form, in endless space, forever moving away and coming back. Early on, the artist wrote, "An object standing still in space is constantly causing a state of ripples in time like a stone thrown in water causes ripples."[2] Everything, then, even the most humble, has importance, affecting everything else, near and far.

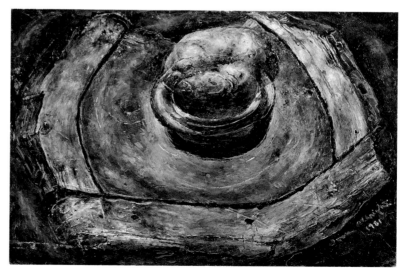

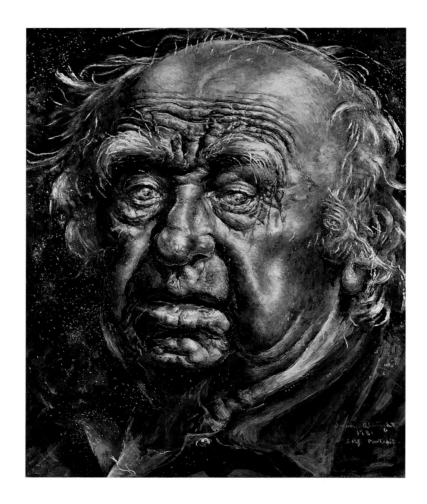

71

SELF-PORTRAIT
1981
Oil on hardboard; 30.5 x 25.4 cm (12 x 10 in.)
Signed, dated, and inscribed, lower right: *Ivan Albright/1981/Self Portrait*
Galleria degli Uffizi, Florence

SELF-PORTRAITS (NOS. 1–17), 1981/83

In April 1981, Albright was one of eleven Americans—the others being Isabel Bishop, Don F. Cortese, Sam Francis, Constantino Nivola, Jules Olitski, Richard Pousette-Dart, Robert Rauschenberg, Carl Schrag, Raphael Soyer, and Jerome Witkin—invited to contribute a work to the gallery of self-portraits at the Galleria degli Uffizi, Florence, in honor of the museum's four hundredth anniversary. Until this time, only five other Americans—Cecilia Beaux, William Merritt Chase, George Healy, Julius Rolshoven, and John Singer Sargent—had been included in this famed collection of artists' self-representations. Albright, who had received a pacemaker for his heart only one month before, threw himself into the project, thrilled not only to be included among such luminaries as Hans Holbein the Younger, Rembrandt, Rubens, Tintoretto, and Velázquez, but also determined to prove his worth in comparison.

The result was not only the potent likeness the Uffizi received (no. 71), but an avalanche of images of the artist: some twenty paintings and drawings (see nos. 72–91), a sculpture (no. 92), and two etchings (see no. 93). In their intensity and probing honesty, they at times equal the magisterial work of such great self-portraitists as Rembrandt, Francisco Goya, and Vincent van Gogh. Not only do Albright's late self-portraits mercilessly examine his relationship to old age, but, as Richard R. Brettell commented in a fine essay on the self-portraits, they assert "the power of art to generate life."[1]

Each portrait in the series was executed on hardboard, roughly twelve by ten inches in size and heavily gessoed for a smooth, hard surface. Set into thick, wooden stretchers, they project out from the wall, creating an insistent presence. This was intentional: "Paint next head," Albright told himself at one point in 1983, "so it is outside of canvas . . . , a foot away from canvas."[2] He eschewed his customary props to concentrate on his face and head, neck and collar. He limited the time he devoted to each work, wanting a quality of spontaneity in contrast to his usual elaborate and complex long-term projects. These constants established, he varied his view of himself—head-on, three-quarter views from left and right; with and without glasses; clothed in various shirts, a scarf, or with his neck uncovered. For the most part, he portrayed himself emerging from the dark, cavelike atmosphere of his Woodstock, Vermont, studio, whose walls he had covered with barn boards and painted mat black (see Chronology, fig. 31). But he also set himself against backgrounds of brilliant blue, warm brown, or gray. He varied the materials he used: charcoal and graphite, pastels and colored pencils, ink and gouache, watercolor and oil, even lithographic crayon; as well as the manner in which he worked: meticulous or broad, methodical or extemporaneous, using thin washes or thick impastos.

This range of approaches is matched by the range of emotion, expression, personality, and associations that Albright brought to bear upon his face, and that his face inspired in him. He appears alternately older, younger, quizzical, brooding, bewildered, exhausted, sad, infinitely wise, apprehensive, frail,

enduring. An early portrait (no. 72) has been likened, in its strength and determination, to a head from Mount Rushmore.[3] In several (nos. 73 and 76–78) that emphasize his flowing white hair and intelligent eyes, Albright becomes a sage. In one he appears bookish (no. 81), while in another (no. 84) he resembles a laborer made insensate by years of hard work. This painting, *Self-Portrait (no. 13)*, has been likened to the unforgettable specimen of humanity of his great composition of some fifty years before, *Room 203* (no. 20).[4] Albright pushed associations with Old Master prototypes, such as the haunting late self-portraits of Rembrandt, who seems almost present in *Self-Portrait (no. 3)* (no. 74), in which Albright peers out from under a leather cap. Rembrandt was on the artist's mind in these last years. Early in 1983, he made two etchings after prints by the Dutch artist, including one of a bearded older man wearing a floppy, velvet beret. Albright was also fascinated by the Shroud of Turin and intended to devote several works to the subject. While he never realized it, the theme emerges in *Self-Portrait (no. 4)* (no. 75), where the artist's masklike, oval head floats, like a spirit, in a sea of dark strokes.

Albright never once in this series depicted himself as an artist. However, he used it in part to demonstrate his artistic powers, showcasing his ability to work in many mediums, his observational skills, his mastery of traditional techniques, and his willingness to take on Old Master paradigms. But not content to rest on such laurels, he pushed himself further. While he probably did not initiate the self-portraits as a series, they quickly became one. As Brettell posited, "Dreams of the Uffizi vanished from his mind in the presence of the mirror, and his self-portraits spun one from the other as though each failed to succeed at some aim that the next would fulfill."[5] About *Self-Portrait (no. 1)* (no. 72), Albright wrote, "Made

washes real thin and modeled in oil while still wet, that way you have almost full control of form and color. . . . The next one [no. 73] I am going . . . [to carry] much farther than the last one. . . . I [will] intensify color force and have a translucent quality to my color and effect much stronger than otherwise."[6] A few months later, he was contemplating another work (no. 78), one of several three-quarter views (see also nos. 76, 77, and 82) he was to make: "Thinking about painting a self portrait. . . . In this head, . . . have every color rich in tone. Get feeling of flesh. Make it hang, crawl, tighten and loosen—perspire and freeze."[7] To end this miniseries, he executed an etching; his comments about the print illuminate his intentions for the preceding three-quarter views: "This is a thinking head . . . , a real taut talking head. This is a powerful head. All curves of etching tool have to follow curvature of lips, of chin, of cheek bones — make it as strong as granite sculpture."[8] In April 1982, around the time he was working on *Self-Portrait (no. 12)* (no. 83), he asked himself, "Do I want to paint the boundaries of a face or do I want to paint what wisdom the face can contain—a face that looks at a thousand years as if they were a second. A face that goes to the eternal force of life and has found it."[9] In the same year, perhaps formulating what would become *Self-Portrait (no. 14)* or *Self-Portrait (no. 15)* (no. 85 or 86), he knew he wanted to express something else: "I want a face that has been compassionate. A face that has shed tears, . . . that has been alive with joy, . . . that opens the door to you. . . . A face that has faith—a wrinkled face, an old face, a face ready for death."[10] In what is the series' most prescient, and perhaps disturbing, image, a drawing from June 1983 (no. 88), the artist looks over his shoulder, which is pressed up against the right edge of the panel, at something neither he nor we can see but that clearly terrifies him. Indeed, his own death was not far away.

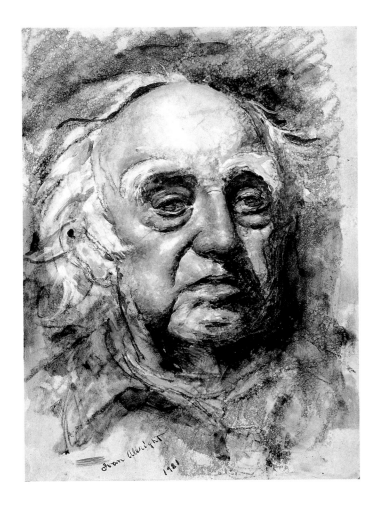

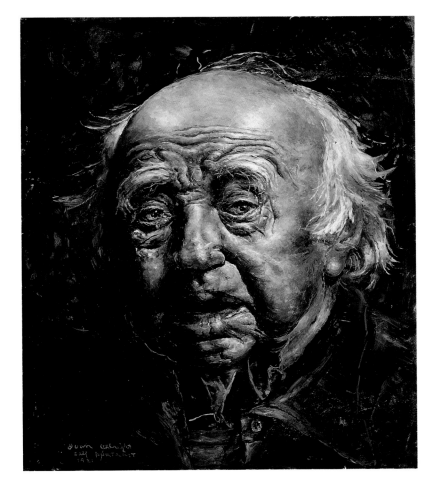



72
·········

SELF-PORTRAIT (NO. 1)
1981
Oil on hardboard; 33 x 23.5 cm (13 x 9½ in.)
Signed and dated, bottom left and center: *Ivan Albright/1981*
The Art Institute of Chicago, gift of Mrs. Ivan Albright (1985.417)





73
·········

SELF-PORTRAIT (NO. 2)
1981
Oil on hardboard; 30.5 x 25.4 cm (12 x 10 in.)
Signed, inscribed, and dated, lower left: *Ivan Albright/Self PORTRAIT/1981*
The Art Institute of Chicago, gift of Mrs. Ivan Albright (1985.418)



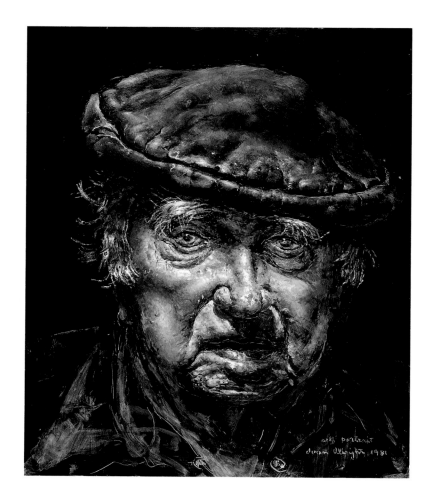

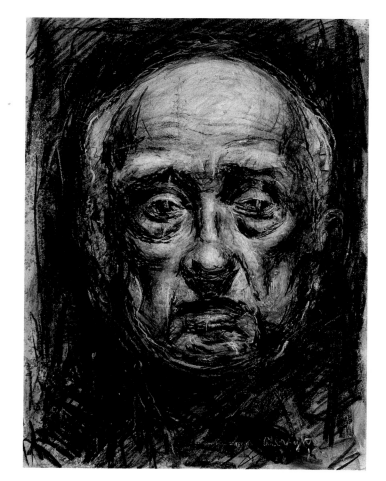

74
.........................

SELF-PORTRAIT (NO. 3)
1981
Oil on hardboard; 30.5 x 25.4 cm (12 x 10 in.)
Inscribed, signed, and dated, lower right:
self portrait/Ivan Albright/1981
The Art Institute of Chicago, gift of Mrs. Ivan Albright (1985.419)

75
.........................

SELF-PORTRAIT (NO. 4)
1981
Charcoal, lithographic crayon, and pencil on hardboard;
33 x 24.1 cm (13 x 9½ in.)
Signed and dated, lower right: *Ivan Albright/1981*
The Art Institute of Chicago, gift of Mrs. Ivan Albright (1985.420)

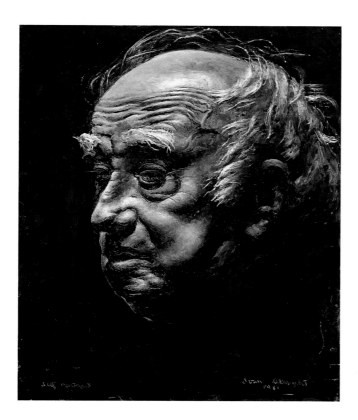

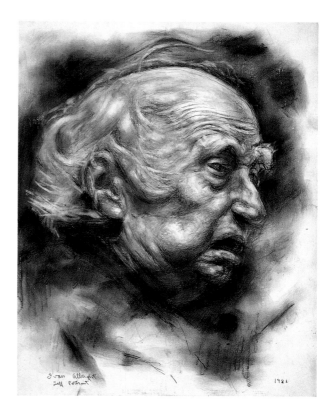

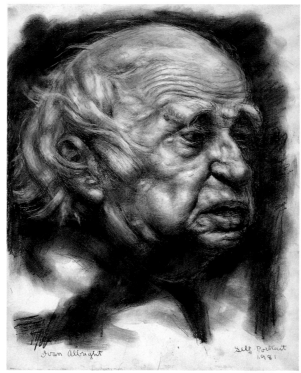

76

SELF-PORTRAIT (NO. 5)
1981
Oil on hardboard; 30.5 x 25.4 cm (12 x 10 in.)
Inscribed, lower left: *Self Portrait*; signed and dated,
lower right: *Ivan Albright/1981*
The Art Institute of Chicago, gift of
Mrs. Ivan Albright (1985.421)

78

SELF-PORTRAIT (NO. 7)
1981
Charcoal on hardboard;
33 x 25.4 cm (13 x 10 in.)
Signed, lower left: *Ivan Albright*; inscribed and dated,
lower right: *Self Portrait/1981*
The Art Institute of Chicago, gift of
Mrs. Ivan Albright (1985.423)

77

SELF-PORTRAIT (NO. 6)
1981
Charcoal on hardboard; 33 x 25.4 cm (13 x 10 in.)
Signed and inscribed, lower left: *Ivan Albright/Self
Portrait*; dated, lower right: *1981*
The Art Institute of Chicago, gift of
Mrs. Ivan Albright (1985.422)

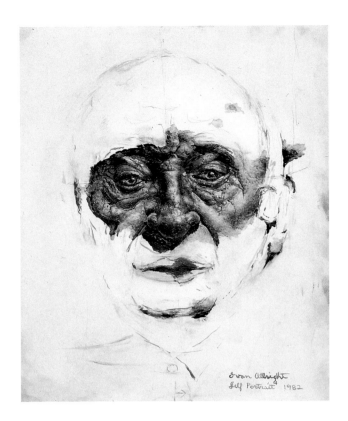

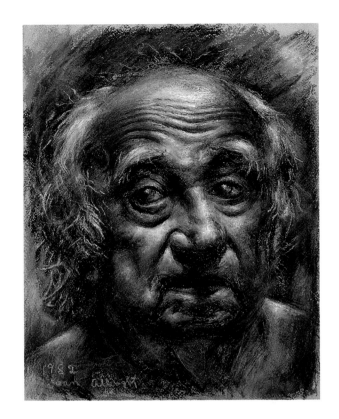

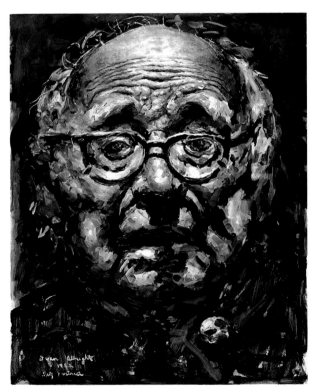

79	81	80
SELF-PORTRAIT (NO. 8)	**SELF-PORTRAIT (NO. 10)**	**SELF-PORTRAIT (NO. 9)**
1982	1982	1982
Oil and graphite on hardboard;	Oil on hardboard; 33 x 25.4 cm (13 x 10 in.)	Pastel on paper on canvas
30.5 x 25.4 cm (12 x 10 in.)	Signed, dated, and inscribed, lower left:	mounted on hardboard;
Signed, inscribed, and dated, lower right:	*Ivan Albright/1982/Self Portrait*	33 x 25.4 cm (13 x 10 in.)
Ivan Albright/Self Portrait 1982	The Art Institute of Chicago, gift of	Dated and signed, lower left: *1982/Ivan Albright*
The Art Institute of Chicago, gift of	Mrs. Ivan Albright (1985.426)	The Art Institute of Chicago, gift of
Mrs. Ivan Albright (1985.424)		Mrs. Ivan Albright (1985.425)

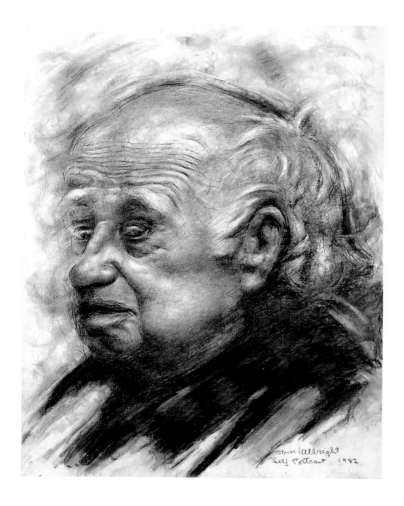

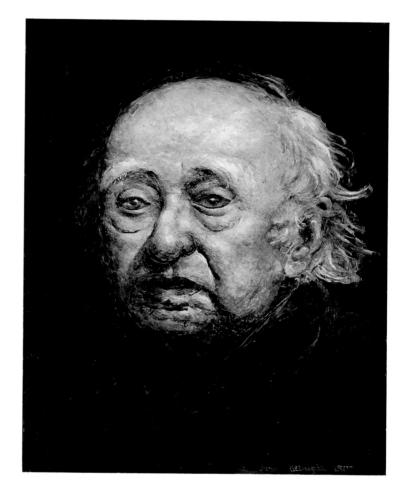

82
.....................

SELF-PORTRAIT (NO. 11)
1982
Charcoal and pastel on hardboard; 33 x 25.4 cm (13 x 10 in.)
Signed, inscribed, and dated, lower right: *Ivan Albright/Self Portrait 1982*
The Art Institute of Chicago, gift of
Mrs. Ivan Albright (1985.427)

83
.....................

SELF-PORTRAIT (NO. 12)
1982
Oil on hardboard; 33 x 25.4 cm (13 x 10 in.)
Signed and dated, lower right: *Ivan Albright 1982*
The Art Institute of Chicago, gift of
Mrs. Ivan Albright (1985.428)

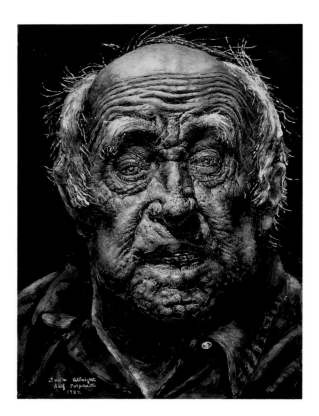

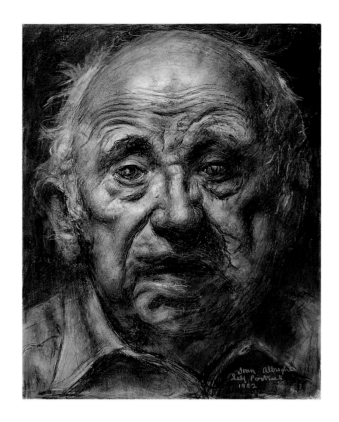

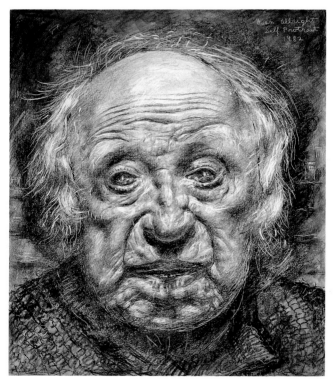

84

SELF-PORTRAIT (NO. 13)
1982
Oil on hardboard; 33 x 24.1 cm (13 x 9½ in.)
Signed, inscribed, and dated, lower left:
Ivan Albright/Self Porprait [sic]/*1982*
The Art Institute of Chicago, gift of
Mrs. Ivan Albright (1985.429)

86

SELF-PORTRAIT (NO. 15)
1982
Charcoal, colored pencil, and black crayon
on hardboard; 30.5 x 25.4 cm (12 x 10 in.)
Signed, inscribed, and dated, upper right:
Ivan Albright/Self Protrait [sic]/*1982*
The Art Institute of Chicago, gift of
Mrs. Ivan Albright (1985.431)

85

SELF-PORTRAIT (NO. 14)
1982
Charcoal, white chalk, and colored pencil
on hardboard; 30.5 x 25.4 cm (12 x 10 in.)
Signed, inscribed, and dated, lower right:
Ivan Albright/Self Portrait/1982
The Art Institute of Chicago, gift of
Mrs. Ivan Albright (1985.430)

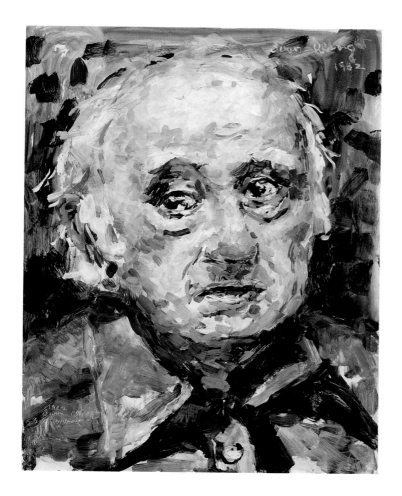

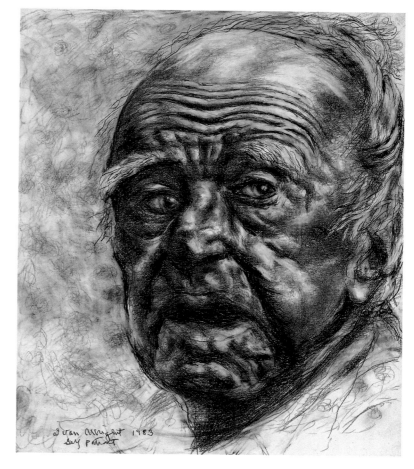

87
..................

SELF-PORTRAIT (NO. 16)
1982
Oil on hardboard; 33 x 25.4 cm (13 x 10 in.)
Dated, signed, and inscribed, lower left: *1982/Ivan Albright/Self Portrait*;
signed and dated, upper right: *Ivan Albright/1982*
The Art Institute of Chicago, gift of Mrs. Ivan Albright (1985.432)

88
..................

SELF-PORTRAIT (NO. 17)
1983
Charcoal, black crayon, and pencil on hardboard;
30.5 x 25.4 cm (12 x 10 in.)
Signed, dated, and inscribed, lower left: *Ivan Albright 1983/Self Portrait*
The Art Institute of Chicago, gift of Mrs. Ivan Albright (1985.433)

SELF-PORTRAITS (NOS. 18–20), 1983

In August 1983, Albright suffered a stroke that partially paralyzed him. As he lay in his room in Mt. Ascutney Hospital, near his Woodstock, Vermont, home, he made three self-portraits (nos. 89–91), almost as if to hold onto his fading flesh and frame. Again showing only his head and shoulders, they are haunting depictions of the confusion, trauma, and disbelief that may be experienced at the imminent approach of death.

Nowhere else in Albright's oeuvre can one find images to compare with these delicate expressions of a mind still possessed with the will to capture the effects of time, at what some would consider its cruelest moment. With this stroke, it seems that Albright's sense of the human figure shifted from, as poet Reginald Gibbons stated in an eloquent essay, "the image of living mortality to the image of a dying spirit."[1] In earlier works, the artist spared no physical detail, seeking to convey the most meaning, the most intense depiction of human vulnerability and mortality. Here, however, the palpable flesh and grotesque decay of his earlier figurations are gone, their very ommission conveying the power and meaning of these images. Indeed, where there was once fullness and strength, there now emerges frailty and fear.

In the work dated August 21 (no. 89), the artist's mouth pulls to the right, as a result of the stroke. Tentative parallel yellow lines—presumably indicating the wall behind him—can be seen as well in the head and robe, as if they are transparent. "The whiteness of the hospital," Gibbons wrote, "surrounds and contains him—it comes through him. . . . The eyes are looking to Albright's right, and seem to be saying much more than the mouth will ever be able to say again. They almost look pleading." Two days later, the artist again took up his colored pencils, and made *Self-Portrait (no. 19)* (no. 90). Soft marks capture his hospital robe, bandages, and ears, but his head is very faint, with the mouth almost disappearing into the blankness of the page. The eyes, like magnets, draw us in, even as they seem to cloud up and drift. Forms slip in and out of focus.

Self-Portrait (no. 20) (no. 91) has been considered the last of the series. However, with its vivid yellow background, pink flesh, and blue-green robe, it is so intensely realized that it could be seen more logically as preceding numbers 18 and 19. Whatever its place in the sequence, this drawing must have required every bit of strength and focus the artist had. Here, he refused to succumb to death's grip, asserting, one final time, the physicality of his being. Albright's eyes remain the focal point; like the reflective surfaces of his great still lifes and figure paintings, they glisten, but they no longer engage with the outer world. Instead, tired and mournful, they seem to have left it behind, to gaze within and beyond.

The sadness of loss, of letting go nobly but not without fear, is echoed in a poem Albright wrote in the same month that he made these self-portraits:

> I who have decreed all things
> Find myself an instrument of pain
> A stroke has laid me dormant
> Not subject to movement or amusement
> Things that I thought were mine
> Have been lost and in their place are sad memories of the
> past and present
> Things most important to me are lost
> And in their place rises colossal terror and fear and nights
> of eternal length
> Bring uncalled for colors and sounds
> And mirrors appear that were not there before and half alive
> They slip around the room waist high.

"Who," Gibbons aptly queried, "but the lifelong painter of the density, solidity, and decay of the flesh could have painted at the very last moment so astonishing a portrait of the spirit?"

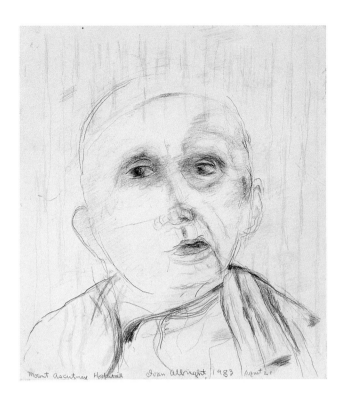

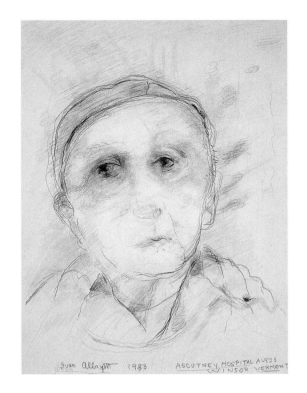

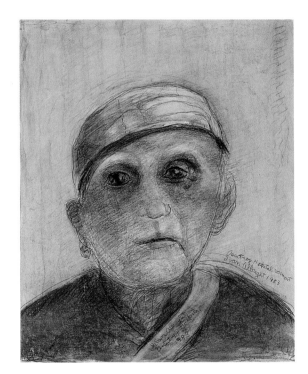

89
.....................

SELF-PORTRAIT (NO. 18)
1983
Colored pencil on hardboard;
30.5 x 25.4 cm (12 x 10 in.)
Inscribed, signed, and dated, across bottom: *Mount
Ascutney Hospital Ivan Albright 1983 Agust* [sic] *21*
The Art Institute of Chicago, gift of
Mrs. Ivan Albright (1985.434)

91
.....................

SELF-PORTRAIT (NO. 20)
1983
Pastel, pencil, and colored pencil on hardboard;
33 x 25.4 cm (13 x 10 in.)
Inscribed, signed, and dated, above shoulder at right:
Ascutney Hospital Vermont/Ivan Albright 1983;
lower center: *Ivan Albright/Ascutney Hospital/1983*
The Art Institute of Chicago, gift of
Mrs. Ivan Albright (1985.436)

90
.....................

SELF-PORTRAIT (NO. 19)
1983
Colored pencil and graphite on hardboard;
33 x 24.1 cm (13 x 9½ in.)
Signed, dated, and inscribed, across bottom:
*Ivan Albright 1983 ASCUTNEY HOSPITAL
AUG 23/WINSOR* [sic] *VERMONT*
The Art Institute of Chicago, gift of
Mrs. Ivan Albright (1985.435)

92
...........................

FRAGMENT OF A SELF-PORTRAIT

1983 (posthumously cast)
Bronze; 30.5 x 33.7 x 12.7 cm (12 x 13¼ x 5 in.)
Hood Museum of Art, Dartmouth College, Hanover,
New Hampshire, gift of Josephine Patterson Albright (S.984.31.2)

For what was to be his last sculpture, Albright made a life-size, clay self-portrait head, working on a moveable stand that allowed him to turn and manipulate the piece from all sides. Sometime during the summer of 1983, the sculpture broke in a fall. The portion that was saved was posthumously cast. It shows his bald pate, deeply furrowed brow, and sunken eye sockets separated by the sharply modeled bridge of his nose. While, as it happened, an accident determined that this part of his head must represent the whole, the fragment complements the striking, intentionally unfinished likeness in oil and graphite he made of himself in 1982 (no. 79), as well as the moving image of his eyes and nose he managed to draw on a prepared copper plate just before he died (no. 93).

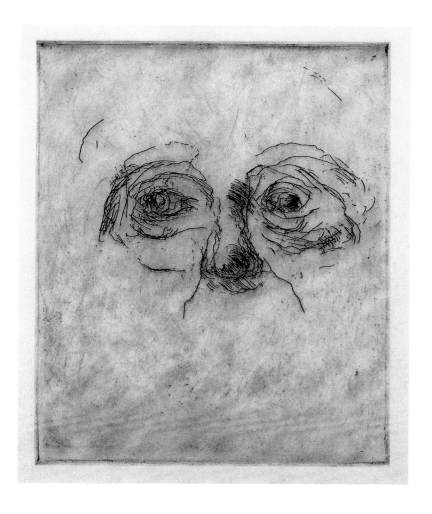

SELF-PORTRAIT

1983 (posthumously printed)
Etching on wove paper (3/16); 12.7 x 10.2 cm (5 x 4 in.)
Inscribed in pencil, left margin: *Ivan Albright's last print—*
drawn on a plate while in the last day or so of his life and etched
and printed by John Paulus Semple; inscribed in pencil across bottom:
Nov 23 #3 Printed by/John Semple/JPS (inscription not shown)
Philip J. and Suzanne Schiller, Chicago

On November 14, 1983, four days before he died from the effects of a stroke and just a few months short of his eighty-seventh birthday, Ivan Albright made his last work of art, a final image of himself. Tremulously, he indicated just his eyes and nose with short, concentric curves. His nose projects, his eyes recede like watery pools. While it may seem as though the artist has been reduced to a fragment of his former self, his eyes, ever vigilant, continue to take in the world. By focusing on the part of himself that still worked, he penetrated to the center of his being. In an undated entry from a late notebook, he had written, "The amount of life I can put through my eyes is the amount I can see."[1] Expressing the power and fragility of existence, he observed and made his specific marks, up to the very end.

Ivan Albright: A Chronology

Robert Cozzolino

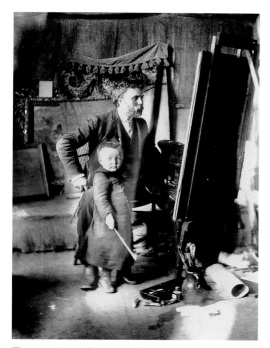

Figure 1. Adam Emory and Lisle Albright at the easel, c. 1895. Unless otherwise noted, all photographs illustrating the Chronology are in the Ivan Albright Archive, Ryerson and Burnham Libraries, The Art Institute of Chicago.

Figure 2. Ivan Albright on blanket with identification label, early 1897. Photograph by Adam Emory Albright.

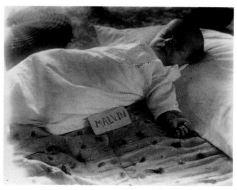

Figure 3. Malvin Albright on blanket with identification label, early 1897. Photograph by Adam Emory Albright.

Figure 4. The Albright twins and their brother, Lisle, Edison Park, Illinois, c. 1907. Photograph by Adam Emory Albright.

The primary source for the following Chronology is the Ivan Albright Archive (see pp. 197 and 198), now part of the Ryerson and Burnham Libraries of The Art Institute of Chicago. The Chronology was also compiled with information from Albright family sources, curatorial files in the Department of Twentieth-Century Painting and Sculpture at the Art Institute, and from the following publications: Adam Emory Albright, *For Art's Sake* (Chicago and Crawfordsville, Indiana, 1953); The Art Institute of Chicago and New York, Whitney Museum of American Art, *Ivan Albright: A Retrospective Exhibition*, exh. cat. (1964–65); Michael Croydon, *Ivan Albright* (New York, 1978); and Hanover, New Hampshire, Dartmouth College, Hood Museum of Art, *The Ivan Albright Collection*, exh. cat. by Phylis Floyd (1987).

1897

February 20: Ivan Le Lorraine Albright is born, along with his identical twin, Malvin Marr Albright (figs. 2 and 3), at North Harvey, Illinois, on the southern edge of Chicago. Like their older brother, Lisle Murillo (1892–1958) (fig. 1), the twins are named after artists by their father, Adam Emory Albright (1862–1957), a genre painter (fig. 1); and their mother, Clara Wilson Albright (1862–1939) (Donnell, fig. 2).

1898

Family moves to Edison Park, Illinois (now part of Chicago, bordering the northwest suburb Park Ridge). Adam Emory builds a house and studio (fig. 5) and begins to use the twins as models for his paintings (see Weininger, figs. 2 and 3). They will continue to pose for him until they are twelve.

1902–1906

Family summers at Annisquam, Massachusetts.

1905

Twins begin drawing under their father's direction and will study art with him until they are nineteen.

1909

Family summers at Noank, Connecticut.

1910

Family moves to northern Chicago suburb Hubbard Woods (now Winnetka), where Adam Emory builds a house and studio, an imposing complex that comes to be known as the Log Studio (fig. 6). Albrights summer at a maternal uncle's farm near Springfield, Missouri.

Figure 5. Adam Emory Albright painting outside his Edison Park, Illinois, studio, c. 1903.

Figure 7. Left to right: Ivan and Malvin Albright in their army uniforms, 1918. Photograph by Adam Emory Albright.

Figure 6. The Albright family residence, the Log Studio, Hubbard Woods, Illinois, c. 1910. Photograph by Adam Emory Albright.

1911

Twins spend summer in Hubbard Woods drawing the figure from plaster casts.

1911–15

Twins attend New Trier High School in Winnetka, Illinois.

1914–16

Family summers in Pennsylvania.

1915–16

Ivan attends Northwestern University, Evanston, Illinois; while Malvin enrolls at the Armour Institute in Chicago (today the Illinois Institute of Technology).

1916–17

Having failed to make passing grades at Northwestern, Albright enrolls at the University of Illinois, Urbana. He studies architecture and then engineering.

1917–18

Family travels to Caracas, Venezuela. While there, Ivan reportedly paints an altarpiece (location unknown) for a church.

1918

June 8–July 9: Exhibits *The Oaks in Winter* (location unknown) at The Art Institute of Chicago's annual Exhibition of Watercolors. This apparently is the first work Albright exhibits publicly.

With the advent of World War I, all three Albright sons enlist for military service (see fig. 7). Twins receive basic training in Des Moines, Iowa; and they are assigned to the American Expeditionary Forces Medical Corps, Base Hospital 11, at Nantes, France. Malvin does guard duty, while Ivan serves as "Medical Drawer." He fills eight sketchbooks with drawings of wounds and surgical procedures (see nos. 1 and 2).

1919

Spring: Twins are discharged from the army. They study briefly at the Ecole des beaux-arts, Nantes.

Summer: Twins return to Illinois. Ivan makes drawings (location unknown) for a Dr. Sylvester, from Oak Park, Illinois, a brain surgeon whom he met in France.

September: Undecided whether to study chemical engineering or architecture, Albright chooses the latter, enrolling at the University of Illinois, Urbana, but he stays only one week. He will later remark that, at this point, he knew only that he did not wish to become a painter.

Fall: Employed in the office of Chicago

architectural firm Perkins, Fellows, and Hamilton. Later, he executes illustrated advertisements for the hotel firm of Albert Pick & Company, headquartered in Chicago.

1920

January 5: Deciding that both architecture and advertising are too commercial for his taste, Albright finally resolves to enroll in art school. Twins enter The School of The Art Institute of Chicago, both on full-tuition scholarships, Ivan to study painting and Malvin sculpture.

1921

Receives his first known commission, to paint portrait of Marie Walsh Sharpe (Donnell, fig. 6), philanthropist and wife of a Chicago lawyer.

1922

Begins to use notebooks to write about the work of other artists, his own work, his approach to art; to ponder philosophy, science, and other disciplines; and to make sketches, after other artists and for his own projects (see fig. 8). He will keep up this practice until the last days of his life, filling at least fifty-five notebooks (fifty-one of which are in the Ivan Albright Archive and four in private collections).

1923

June 15: Twins graduate from the School of the Art Institute. Ivan receives faculty Honorable Mention for life and portrait painting.

Exhibits *Portrait of a Man* (possibly Donnell, fig. 7; or *The Philosopher* [no. 3]) at the Art Institute's annual Chicago and Vicinity exhibition.

Fall: Twins enroll for one term at the Pennsylvania Academy of the Fine Arts, Philadelphia, where their father had studied with Thomas Eakins many years before.

1924

February 1–April 3: Twins spend spring term in New York City, Ivan studying at the National Academy of Design and Malvin at the Beaux-Arts Institute of Design.

Adam Emory buys a former Methodist church in Warrenville, Illinois, which is remodeled into a studio (Donnell, fig. 14). Family moves to Warrenville.

Ivan exhibits *The Philosopher* (no. 3) at the Pennsylvania Academy of the Fine Arts.

October and November: Family resides in Laguna Beach and La Jolla, California.

1925

January: Visits Camelback, near Phoenix, Arizona.

February: Works in Old Laguna, New Mexico.

1925–26

Fall and Winter: Twins share studio at 1718 Cherry Street, Philadelphia.

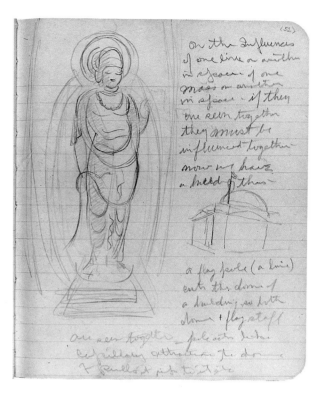

Figure 8. Ivan Albright. Notebook 3, p. 52 (c. 1924), showing artist's notations and sketch of an Indian sculpture.

Figure 9. Left to right: Ivan and Malvin Albright look at Malvin's sculpture *The Monk (Saint Francis)*, 1932, Chicago, private collection. Photograph by the *Chicago Daily News*, courtesy The Chicago Historical Society.

1926

Spring and Summer: Albrights are in Warrenville, Illinois. Ivan uses the balcony of the remodeled former church, Malvin the studio's main floor, and Adam Emory works outside. All three use the main-floor area to display their art for visitors and prospective buyers.

October through December: Twins work in Oceanside, California. Ivan probably conceives of and begins work on *I Walk To and Fro through Civilization and I Talk as I Walk (Follow Me, The Monk)* (no. 9), using as his model Brother Peter Haberlin. Malvin sculpts a bust, *The Monk (Saint Francis)* (see fig. 9), using another friar from the same monastery (Donnell, fig. 11).

Ivan receives Honorable Mention for *Paper Flowers* (no. 5) at the Art Institute's annual American Exhibition. This recognition

encourages him to become a professional artist.

1927

Winter: Twins work in Balboa Park, a section of San Diego. Ivan completes *The Monk* (no. 9).

Spring and Summer: Twins are in Warrenville, Illinois.

1928

February: *The Lineman* (no. 10) receives the John C. Shaffer Prize for portraiture at the annual Chicago and Vicinity exhibition at the Art Institute.

May: *The Lineman* is reproduced on the cover of the trade magazine *Electric Light and Power* (Donnell, fig. 12a). The image creates a controversy among the industry magazine's readers. The editors respond

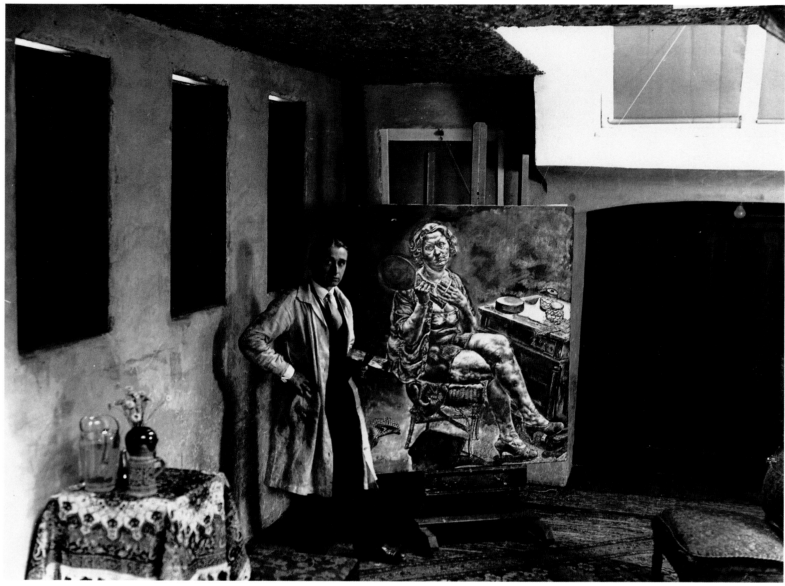

Figure 10. Ivan Albright in his studio, Warrenville, Illinois, with his painting *Into the World There Came a Soul Called Ida* (no. 17) in an unfinished state, 1930. Photograph by the *Chicago Daily News*, courtesy The Chicago Historical Society.

by featuring a more upbeat photograph of a worker on the front of the August issue (Donnell, fig. 12b).

In this very productive year, Albright begins to find his true subject matter and evolve toward his mature style in works such as *Flesh (Smaller Than Tears Are the Little Blue Flowers)* (no. 12), *Woman* (no. 13), and *Fleeting Time, Thou Hast Left Me Old* (no. 14).

1929

January–April: Twins work in Laguna Beach, California. Ivan has a ruptured kidney removed. He paints *Heavy the Oar to Him Who Is Tired, Heavy the Coat, Heavy the Sea* (no. 16) and *There Were No Flowers Tonight (Midnight)* (no. 15).

Twins each have a studio built, in a Spanish-Mission style, in Warrenville, Illinois,

alongside the former church that their father continues to use (Donnell, fig. 14). This new space provides Ivan with his first light-controlled studio environment (see fig. 10).

June: Exhibited at the Toledo Museum of Art, *Woman* (no. 13) evokes strong negative public response and is temporarily removed from view.

1930

Ivan completes his major composition *Into the World There Came a Soul Called Ida* (no. 17; see fig. 10), as well as his first sculpture since his student days, *Now A Mask* (no. 19).

August 15–September 15: Exhibits nine paintings at his first one-person exhibition, in the Gallery of the Walden Book Shop, Chicago.

1931

January: *Ida* (no. 17) receives the Chicago Society of Artists Gold Medal.

March: Begins charcoal drawing on canvas for *That Which I Should Have Done I Did Not Do (The Door)* (no. 24), a process that will occupy one year of the ten it will take to finish the painting.

July 23–October 11: Exhibits fourteen paintings at his first museum exhibition, in a joint show at the Art Institute with artist-brothers George and Martin Baer.

Executes his first lithograph, *Self-Portrait with Flies Buzzing around My Head* (no. 25), printed by his friend the Chicago artist Francis Chapin.

1932

Malvin begins to use the pseudonym Zsissly

to distinguish himself from Ivan in alphabetical catalogue listings. He will continue to use the pseudonym until about 1965, when he stops exhibiting his work.

1933

January/February: Ivan shows ten paintings in his first one-person museum exhibition, at the Dayton Art Institute.

Executes first known self-portrait in oil (no. 26).

1933–34

Employed by the Public Works of Art Project (PWAP), he produces *Self-Portrait* (no. 28) and *The Farmer's Kitchen* (no. 31).

1934–36

Serves as President of the Chicago Society of Artists.

1935

July 1–August 1: Shows fourteen oils, four watercolors, and a lithograph in a one-person exhibition at the Old White Art Gallery, The Greenbrier, White Sulphur Springs, West Virginia.

Chicago collectors Earle and Mary Ludgin purchase the first (no. 29) of many works by Albright.

December 14: Cosigns, with fellow Chicago artists Aaron Bohrod, Constantine Pougialis, and William S. Schwartz, a letter to the *Chicago Daily News* protesting the way their work is treated by the newspaper's art critic, C. J. Bulliet.

1936

March 11–June 4: Albright is hired by the Works Progress Administration (WPA) at rate of $94 per month (although records do not show he was ever paid); he supposedly paints one work, a landscape (location unknown).

August: *Esquire* reproduces four of Albright's works (see nos. 15, 16, and 20; and *I Drew a Picture in the Sand and the Water Washed It Away [The Theosophist]* [The Art Institute of Chicago]).

1937

January: *Ida* (no. 17) wins First Prize at the Annual Exhibition of the Springfield Art League, Springfield, Massachusetts.

1938

Executes a lithograph of *Heavy the Oar* (no. 37), the first of nine prints based on previous works on canvas.

Summer: Teaches figure painting at the School of the Art Institute.

1939

February 10: Death of Albright's mother, Clara Wilson Albright, at age seventy-seven.

April: Four poems by Albright appear in the magazine *Creative Writing*.

Figure 11. Left to right: Hermon More, Ivan Albright, and Edward Hopper serving as jurors for the twenty-second annual Exhibition of Watercolors, The Art Institute of Chicago, 1943. Photograph courtesy Archives, The Art Institute of Chicago.

Figure 12. Left to right: Malvin and Ivan Albright playing chess, January 1943. Photograph by Norman L. Rice.

Summers with Adam Emory and Malvin in New Harbor, Maine.

December 13: Review by Albright of *Modern American Painting*, by Peyton Boswell, Jr., appears in the *Chicago Daily News*.

1940

July 3: Review by Albright of *Modern French Painting*, by R. H. Wilenski, appears in the *Chicago Daily News*.

Twins summer at Corea, Maine.

1941

February 26: Review by Albright of *How to Study Pictures*, by Charles H. Laffin, appears in the *Chicago Daily News*.

Summer: Attends class at the School of the Art Institute taught by Parisian conservator Jacques Maroger, where he learns about Old Master painting techniques;

spends time in Cundy's Harbor and Deer Isle, Maine.

The Art Institute purchases its first work by Albright, *Ah God, Herrings, Buoys, the Glittering Sea* (no. 35).

November 24: Story about Albright appears in *Time*, with reproduction of setup for *The Door* (no. 24).

The Door (no. 24) wins the Norman Wait Harris Medal at the Art Institute's annual American Exhibition.

1942

January: *The Door* (no. 24) wins Temple Gold Medal at the Pennsylvania Academy of the Fine Arts Annual Exhibition.

March/April: Twins' first joint exhibition, Findlay Galleries, Chicago, attracts scant critical attention, perhaps because it includes only recent watercolors.

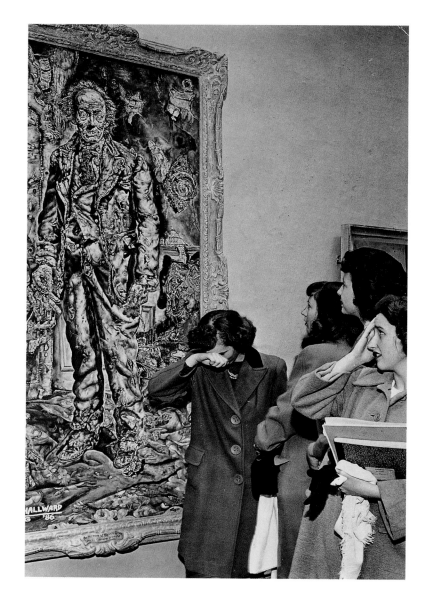

Figure 13. Movie-theater marquee featuring "The Picture of Dorian Gray," 1945. Photograph © Turner Entertainment Co. All rights reserved.

Figure 14. Ivan Albright, *Picture of Dorian Gray* (no. 41), installed at the fifty-sixth annual American Exhibition, The Art Institute of Chicago, 1945. Photograph by Al Risser, courtesy the *Chicago Sun-Times*.

May: Elected Associate Academician, National Academy of Design, New York.

July 6: Story about Albright appears in *Time*, with full-page reproduction of *Ida* (no. 17) and detail of his 1935 *Self-Portrait* (no. 29).

Begins *Poor Room—There Is No Time, No End, No Today, No Yesterday, No Tomorrow, Only the Forever, and Forever and Forever without End (The Window)* (no. 40; see figs. 25 and 26), on which he will work over the next twenty years.

December: Out of eight thousand entries, *The Door* (no. 24) wins purchase prize of $3,500 as best painting at the "Artists for Victory" exhibition at The Metropolitan Museum of Art, New York. The artist refuses to let go of this key painting for that amount, having valued it much higher. Instead, he accepts the First Medal, which carries no cash award.

1943

February 9–March 21: Albright twins both represented in "American Realists and Magic Realists," at The Museum of Modern Art, New York. Organized by Dorothy C. Miller and Alfred H. Barr, Jr., of the Modern, the show will travel over the next year to Buffalo, Minneapolis, San Francisco, Toronto, and Cleveland.

Spring: Albright serves, along with Whitney Museum of American Art, New York, curator Hermon More and painter Edward Hopper, on jury (fig. 11) for the annual Exhibition of Watercolors at the Art Institute.

November: Screenwriter-director Albert Lewin, perhaps after seeing Albright's art in "American Realists and Magic Realists," or in *Time*, invites him to Hollywood to paint a portrait for the Metro-Goldwyn-Mayer film adaptation of Oscar Wilde's

morality tale *The Picture of Dorian Gray*. Ivan arranges for Malvin to assist him, and it is agreed that Malvin will paint the other portrait required for the film.

November 29: Article about Albright appears in *Newsweek*.

1943/44

Through mutual friends, Albright meets Josephine Medill Patterson Reeve, the daughter of a newspaper publisher (see nos. 50 and 57). She is the mother of two young children and is separated from her husband.

1944

Ivan completes his portrait for "The Picture of Dorian Gray" (no. 41), and the film is released. Malvin's portrait of the young Gray (Donnell, fig. 19) is, in the end, not used. While the movie is not a great com-

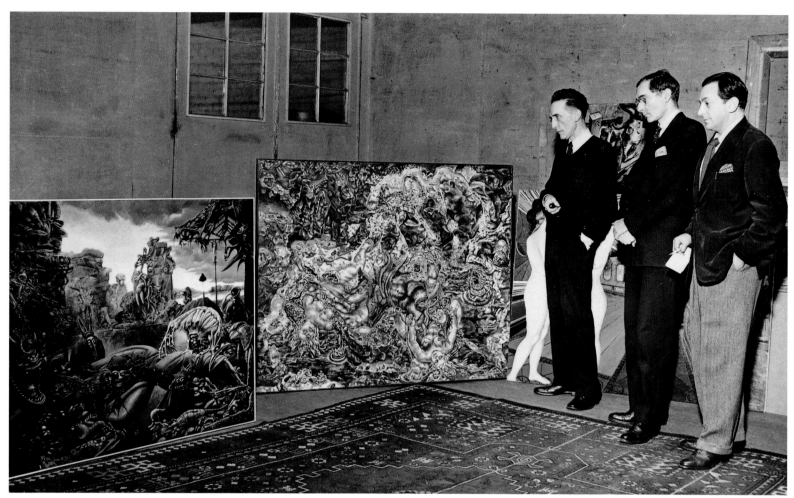

Figure 15. The judges—left to right: Marcel Duchamp, Alfred H. Barr, Jr., and Sidney Janis—of the Loew-Lewin Productions Bel-Ami Competition for a painting of the Temptation of Saint Anthony view some of the submissions, New York, 1946. Max Ernst's painting (Wilhelm Lehmbruck Museum der Stadt, Duisberg, Germany), at the left, won the competition. Albright's painting (no. 42), at the center, placed second. Photograph by World Wide Photos, Los Angeles Bureau, courtesy The Museum of Modern Art, New York.

mercial success, it greatly enhances Ivan's reputation.

April: *The Lineman* (no. 10) receives the Benjamin Altman Figure Prize at the National Academy of Design, New York.

1945

October 22–November 10: "First Joint Exhibition: The Albright Twins," at the Associated American Artists Galleries in New York. Ivan exhibits twenty-eight works, and Malvin twenty-nine. The exhibition's success prompts the organization to commission Ivan's first large-edition lithograph, *Fleeting Time.*

November 5: The Albrights' joint exhibition is favorably reviewed in *Newsweek.*

1946

Ivan and Malvin enjoy the celebrity "The

Picture of Dorian Gray" brings them, going to parties, decorating men's ties (see figs. 16 and 17), and so forth.

Ivan submits *The Temptation of Saint Anthony* (no. 42) to an international competition for another Albert Lewin film, based on the novel *Bel-Ami* by Guy de Maupassant. A distinguished jury—the Modern's Alfred H. Barr, Jr., artist Marcel Duchamp, and art critic Sidney Janis—picks the work submitted by the German-born Surrealist Max Ernst; Albright comes in second (fig. 15).

March 29–April 17: Twins' joint exhibition continues, in somewhat different form, at the Chicago branch of the Associated American Artists Galleries. Ivan adds his *Picture of Dorian Gray* (no. 41), exhibiting a total of thirteen oils, as well as works on paper. Malvin shows seventeen oils and a number of works on paper, all depictions of Maine.

June/July: *The Door* (no. 24) causes a sensation in the exhibition "American Painting from the Eighteenth Century to the Present Day," at the Tate Gallery, London.

August 27: Marries Josephine Medill Patterson Reeve at Red Lodge, Montana.

Albright adopts Joseph Medill (born 1936) and Alice Patterson (born 1940), Josephine's children from her first marriage (see fig. 20). The family moves to 55 East Division Street, Chicago. Albright commutes from Chicago to his studio in Warrenville, Illinois.

1947

January: Along with his brother Malvin and four other Chicago-area artists, Ivan receives a commission to paint a mural for Riccardo's Restaurant and Gallery, Chicago. His contribution is *Drama*

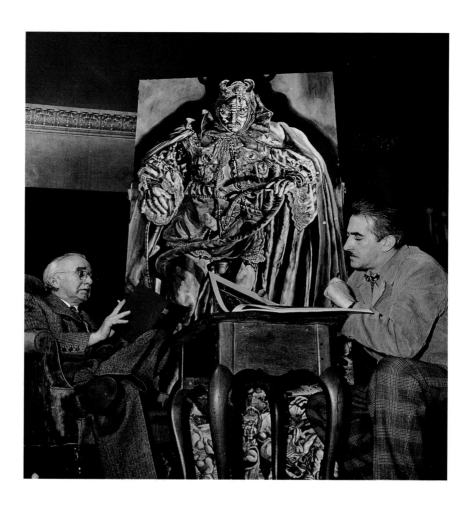

Figure 16. Ivan Albright. *Portrait of Dorian Gray*, 1945. Oil on silk tie. The Art Institute of Chicago, gift of Mr. and Mrs. Joseph Randall Shapiro (1996.389).

Figure 17. Ivan Albright. *Portrait of Byron Harvey, Jr.*, 1945. Oil on silk tie. Private collection, Chicago. Photograph © Michael Tropea, Chicago.

Figure 18. Left to right: Ivan Albright and restaurateur/art entrepreneur Ric Riccardo in front of Albright's mural for Riccardo's Restaurant, Chicago, *Drama (Mephistopheles)* (Donnell, fig. 24), c. 1947. Riccardo had posed for the painting. Photograph courtesy Archives, The Art Institute of Chicago.

Figure 19. Ivan Albright in his Ogden Avenue studio, Chicago, 1950. Photograph by Peter Pollack. Photograph courtesy Archives, The Art Institute of Chicago.

Figure 20. Clockwise: Alicia Patterson Guggenheim, Ivan, Joseph, Alice, Adam, and Josephine Albright at Three Spear Ranch, Dubois, Wyoming, 1947.

Figure 21. Adam Emory Albright, at age ninety-one, 1952. Frontispiece for his memoirs, *For Art's Sake* (Chicago and Crawfordsville, Indiana, 1953), photograph by Fernand de Gueldre.

Figure 22. Ivan Albright's painted decoration of his studio on the family's estate along the St. Mary's River, in southern Georgia. Photograph by Bertrand Goldberg.

(Mephistopheles) (Donnell, fig. 24; see fig. 18).

August 1: Birth of the Albrights' son Adam Medill (see fig. 20).

Moves his studio from Warrenville to 1521 North State Street, Chicago, and also works at home.

Returns to Maine for first time since end of World War II.

November 5: Albright's review of the Art Institute's annual American Exhibition, devoted this year to abstraction and Surrealism, appears in the *Chicago Herald-American*.

1947–68

Family summers at Three Spear Ranch, in Dubois, Wyoming (see Donnell, fig. 22).

1948

Purchases a building at 1773 Ogden Avenue, Chicago, and commissions architect Andrew Rebori to redesign it as a studio (Donnell, fig. 23).

Begins regular visits to the southern Georgia estate of Josephine Albright's sister, Alicia Patterson Guggenheim, along the St. Mary's River, north of Jacksonville, Florida. Its swampy surroundings will become the focus of a number of gouaches by the artist (see no. 55).

1949

February 8: Birth of the Albrights' daughter Blandina (Dina) (see Donnell, fig. 22).

1950

Elected Academician, National Academy of Design, New York. As his presentation pieces, he gives the Academy his 1948 *Self-Portrait* (no. 45) and a 1926 composition,

Fur Collar (The Baskerville Portrait) (Donnell, fig. 8).

April 1–31: "Albright Family Exhibition" staged at Riccardo's Restaurant and Gallery, Chicago, the first time the work of Adam Emory, Ivan, and Malvin is presented in a three-person show.

Ivan ceases to use his middle name, Le Lorraine, after realizing that the artist for whom he was named, Claude Lorrain, spelled his name differently.

1951

December: Albright's studio is visited by French artist Jean Dubuffet, in Chicago to present a lecture at the Arts Club, where his work is on view. For the catalogue of Albright's first museum retrospective (organized by the Art Institute and the Whitney Museum of American Art in 1964–65),

Figure 23. Mary Lasker Block, 1952. Photograph © Arnold Newman.

Figure 24. Ivan Albright painting his *Portrait of Mary Block* (no. 51), 1957. Photograph by Peter Pollack.

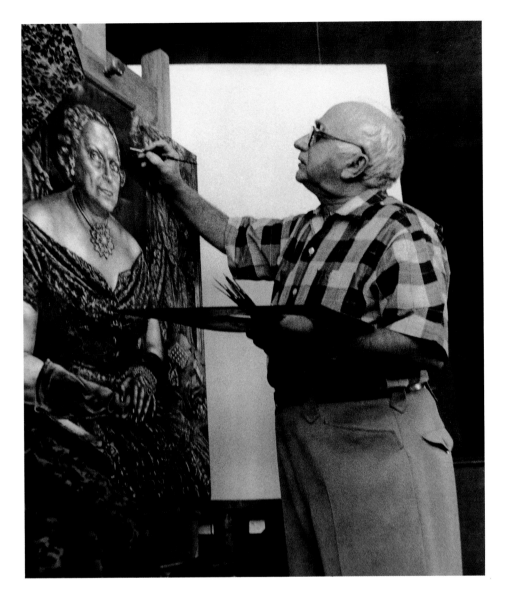

Dubuffet will write an enthusiastic and compelling statement about this visit.

1952
Travels to Greece with Josephine.

1953
February 1–28: Albright shows twelve paintings at a one-person exhibition at Riccardo's Restaurant and Gallery, Chicago.

Adam Emory Albright privately publishes his memoirs, *For Art's Sake* (see fig. 21).

1954
Returns to sculpture, after nearly eighteen years, making a bust of Josephine Albright (no. 50), for which she poses in Wyoming.

1955
January 27: Begins work on his first commissioned portrait in many years, that of

Chicago art patron and collector Mary Lasker Block (no. 51; see figs. 23 and 24).

Tin (1952–54; private collection) receives W. A. Clark Prize (Silver Medal) at the Corcoran Biennial, Washington, D.C.

1956
June 19–October 21: Although not yet finished, *Poor Room* (no. 40) is included in "American Artists Paint the City," organized for the United States Pavilion at the twenty-eighth Venice Biennale by the Art Institute's first curator of modern art, Katharine Kuh.

Winters in Aspen, Colorado.

1957
January 21: Elected member of the National Institute of Arts and Letters.

September 13: Death of Albright's father, Adam Emory Albright, at age ninety-five.

1958
February 10: Death of Albright's brother Lisle Murillo Albright, at age sixty-seven.

Visits the west coast of Canada and Alaska.

1959
Travels to Europe with Josephine (see fig. 28).

1960
Summer: Travels to Italy (including Venice), with his thirteen-year-old son, Adam, as well as to Greece and North Africa (see nos. 53 and 54).

1961
I Slept with the Starlight in My Face (The Rosicrucian) (no. 7) wins the Benjamin Altman Figure Prize at the annual exhibition of the National Academy of Design, New York.

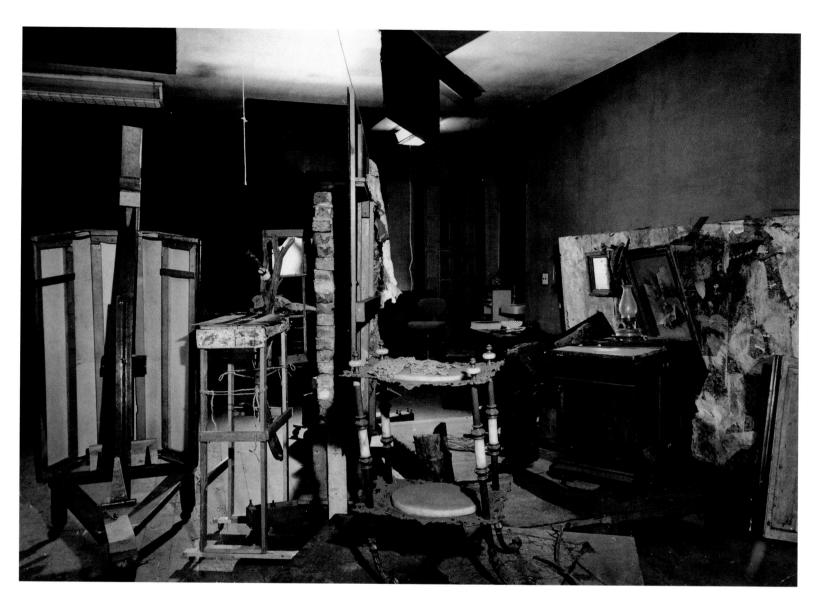

Figure 25. Ivan Albright's Ogden Avenue studio, Chicago, with the setup for *Poor Room—There Is No Time, No End, No Today, No Yesterday, No Tomorrow, Only the Forever, and Forever and Forever without End (The Window)* (no. 40), c. 1961. The unfinished canvas is seen from the back, at left. Photograph by Arthur Siegel.

Figure 26. Setup for *Poor Room* (no. 40) in Ivan Albright's Ogden Avenue studio, 1950. Photograph by Peter Pollack.

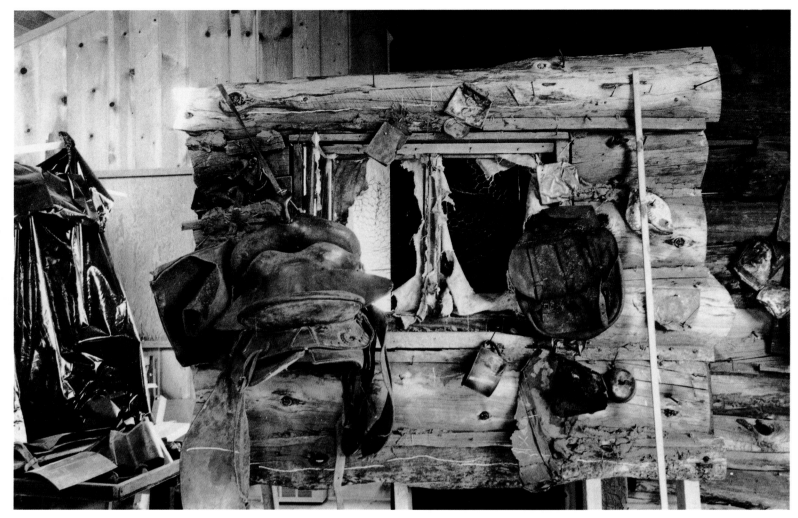

Figure 27. Setup for Ivan Albright's *The Rustlers* (no. 52), Three Spear Ranch, Dubois, Wyoming, 1959.

1962

Travels to Georgia and Colorado.

1963

Completes *Poor Room* (no. 40), over twenty years after he began it.

Learns that his Ogden Avenue studio building will be torn down to construct a shopping mall. Albrights purchase property in Woodstock, Vermont, and begin renovations.

Albrights inherit Georgia property of Josephine's sister, Alicia Patterson Guggenheim, upon her death. Ivan sets up a studio there (see fig. 22).

Travels in southwestern United States.

September 7–December 14: *Poor Room* (no. 40) wins $5,000 prize at the "Dunn International Exhibition," which opens at the Beaverbrook Art Gallery, Fredericton,

New Brunswick, Canada, and goes to the Tate Gallery, London.

1964

A film, intended for television, "The Enigma of Ivan Albright," is made by Lester Weinrott, narrated by the artist's patron Earle Ludgin, and produced by Creative Associates, Chicago. It is shown publicly only once, at the 200 Gallerie, Chicago.

1964–65

"Ivan Albright," the artist's first retrospective exhibition, is shown at the Art Institute (October 30–December 27, 1964) and continues at the Whitney Museum of American Art, New York (February 4–March 21, 1965). Sixty works are displayed, including forty-three paintings, four drawings, five lithographs, five sculptures, and three med-

ical sketchbooks. A catalogue is published, with a statement by the artist Jean Dubuffet, an essay by curator Frederick A. Sweet, and remarks by Albright.

1965

The Albrights settle into new home in Woodstock, Vermont.

October 1: Begins *The Vermonter (If Life Were Life There Would Be No Death)* (nos. 59 and 60; see fig. 31).

1966

Summers in Maine.

1967

September: Travels to Scandinavia.

November: Takes extended trip that includes the Soviet Union, Iran, Israel, and Italy.

Figure 28. Ivan Albright. *Toledo, Spain*, 1959.
Gouache on paper; 33.1 x 39.4 cm (12¼ x 15½ in.).
Lawrence M. Pucci, Caryl Pucci Rettaliata.

Figure 29. Ivan Albright. *Fast Train Made between
Nagoya and Odwara, Japan*, 1969. Fiber-tipped
pen and colored inks on off-white wove paper;
27.8 x 37.9 cm (10¹⁵⁄₁₆ x 15 in.). The Art Institute
of Chicago, gift of Ivan Albright (1977.268).

1968

February 3: Appointed Laureate of the
Lincoln Academy of Illinois.

Josephine Albright receives a bachelor's
degree in liberal arts from Goddard College,
Plainfield, Vermont.

Fall–Winter: Travels to the Middle East
(including Morocco and Israel), and later
to Hawaii.

1969–74

Visiting Artist at Dartmouth College,
Hanover, New Hampshire.

1969

October 31: Made Doctor of Humane
Letters, Mundelein College, Chicago.

Travels to the Far East, including stops at
Tahiti, the Fiji Islands, Japan (see fig. 29),
Indonesia (including Java; see no. 64),
Hong Kong, Malaysia, Singapore, and
Thailand.

1970

In a very heavy year of travel, Albright
visits Tunisia and various sites in northern
Africa; and, after an interval in Georgia,
journeys to Portugal and Italy. He later
goes to the Caribbean (Aruba), as well as
to South America (Peru, Ecuador, and
Venezuela).

1971

February 15–June 22: Albright returns
to Aruba, South America, and later to
Georgia.

August: Flies to Canada so that a specialist
can examine his eyes, which have begun to
bother him.

Fall: Special easel that Albright designed in
1969 is constructed; it enables him to work
on complex problems of perception and
motion with greater control and flexibility.

1972

February 5 and 6: Interviewed by Paul
Cummings for the Archives of American
Art.

June 10: Made Honorary Doctor of Fine
Arts, Lake Forest College, Lake Forest,
Illinois.

1973

Winters in Florida.

Travels to Greece, Cyprus, and Turkey.

December 4: Begins *Pray for These Little
Ones (Perforce They Live Together)* (no. 67).

1974

June 7: Made Honorary Doctor of Arts,
Columbia College, Chicago, Illinois.

Travels in this year include trips to Egypt and other sites in the Middle East, and to Cape Hatteras, North Carolina.

1975

Spring: Travels to Germany, as well as to Afghanistan, India, and Nepal.

June 18: Receives Governor of Vermont's Award for Excellence in the Arts.

Summers in Georgia.

1975–76

December 12, 1975–February 15, 1976: Still unfinished, *The Vermonter* (no. 60) is shown at the Strauss Gallery, Dartmouth College, Hanover, New Hampshire. The show opens on the day its model, Kenneth Harper Atwood, is buried.

Travels to the Yucatán, Mexico, as well as to Louisiana and Mississippi. Later he visits Holland, Germany, and Czechoslovakia.

Winters in the Virgin Islands and the Bahamas.

1977

On the occasion of their eightieth birthday, the Albright twins are reunited at Malvin's home in Corea, Maine, after nearly a quarter of a century of estrangement (see Donnell, fig. 29).

Albright presents to the Art Institute over eighty of his paintings, works on paper, and studio props. This gift includes almost all of his major works.

May 20: Made Honorary Doctor of Fine Arts, The School of The Art Institute of Chicago.

Summers in Maine.

August 4: Undergoes successful corneal transplant in his right eye at the Bascom Palmer Eye Institute, Miami, Florida, and resumes painting two days after the operation (see Donnell, fig. 30).

1978

Returns to Egypt and visits other Middle Eastern sites.

Receives honorary degree, Dartmouth College, Hanover, New Hampshire.

August: Undergoes successful corneal transplant in his left eye at the Bascom Palmer Eye Institute, Miami, Florida.

Ivan Albright, a major monograph by Michael Croydon, is published by Abbeville Press, New York.

Begins work on *Still Life with Potatoes in Motion* (no. 69), making many notes about the project over the next two years.

1979

Travels to mainland China and Shanghai, and later to Texas.

Receives a number of honors, including election as Fellow of the American Academy of Arts and Sciences, Boston, and a Centennial Award from the Art Institute.

Figure 30. Ivan Albright with his flock of geese, Woodstock, Vermont, 1972. Photograph by Matthew Wysocki.

Figure 31. Ivan Albright in his Woodstock, Vermont, studio with *The Vermonter* (no. 60), 1975. Photograph by Matthew Wysocki.

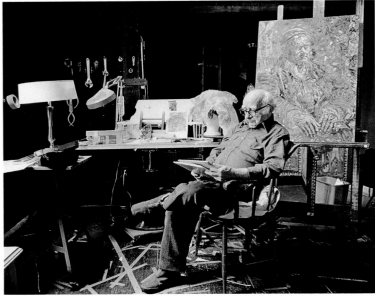

1980

Travels to Antigua, the West Indies, and later to Spain.

Given five-year appointment as Visiting Scholar in Art at Dartmouth College, Hanover, New Hampshire.

1981

March 10: Albright receives a pacemaker.

April: On the occasion of the four hundredth anniversary of its founding, the Galleria degli Uffizi, Florence, invites Albright, along with ten other American artists, to paint a self-portrait (no. 71) for its celebrated collection of self-portraits.

Begins series of small self-portraits (nos. 72–93), on which he will work until only days before his death.

1982

Travels to England and Egypt. Later, with Josephine, he tours northern Italy, where they visit the Galleria degli Uffizi, Florence, and see his self-portrait (no. 71).

1983

Winter: Begins a series of etchings after works by Rembrandt van Rijn.

Summer: Travels to Norway.

August–November: In August suffers a stroke. Between August 21 and 23(?), during his stay at Mt. Ascutney Hospital, Windsor, Vermont, he produces the last three works in his series of self-portraits (nos. 89–91).

September 14: Malvin Marr Albright dies from an aneurysm after surgery in Ft. Lauderdale, Florida, at age eighty-six.

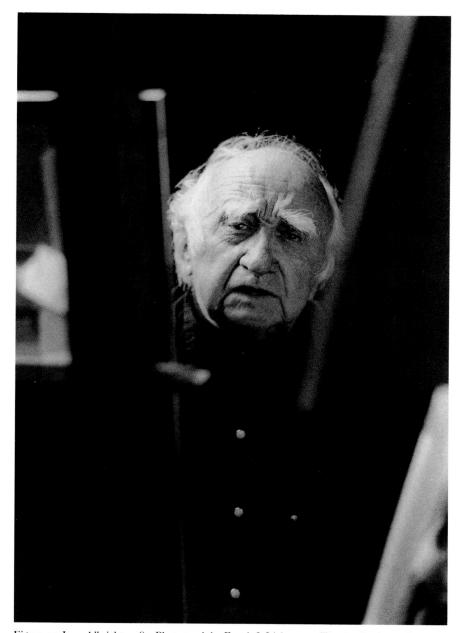

Figure 32. Ivan Albright, 1981. Photograph by Frank J. Lieberman. The Art Institute of Chicago, gift of Frank J. Lieberman (1986.1143).

November 14: Ivan makes his final etching, which is posthumously printed (no. 93).

November 18: Ivan Albright dies at home in Woodstock, Vermont, at age eighty-six.

1984

Josephine Patterson Albright presents Albright's notebooks, scrapbooks, and the late self-portrait series to the Art Institute.

April 14–May 26: The majority of the late self-portrait series is put on view at The Art Institute of Chicago.

1985

November 18–December 15: The American Academy and Institute of Arts and Letters, New York, hosts a memorial exhibition for recently deceased academicians

Ivan Albright, Jimmy Ernst, Armin Landeck, and Alice Neel.

1986

May 24–July 20: The late self-portrait series is exhibited in its entirety for the first time, along with several late etchings (see no. 93), two sculptures (see no. 92), several other works, and related pages from one of the artist's sketchbooks at the Hood Museum, Dartmouth College, Hanover, New Hampshire. A small catalogue, including essays by Richard R. Brettell and Phylis Floyd, is published.

1996

January 15: Josephine Patterson Albright dies, after suffering a stroke, in Woodstock, Vermont, at age eighty-two.

Selected Exhibition History

Robert Cozzolino

ONE-, TWO-, AND THREE-PERSON SHOWS

1930

"First Collected Exhibition of American Paintings by Ivan Le Lorraine Albright," Gallery of the Walden Book Shop, Palmolive Building, Chicago, Aug. 15–Sept. 15.

1931

"Paintings by George and Martin Baer and Ivan Le Lorraine Albright," The Art Institute of Chicago, July 23–Oct. 11.

1933

"Ivan Le Lorraine Albright," Dayton Art Institute, Dayton, Ohio, Jan./Feb.

1935

"Ivan Le Lorraine Albright," Old White Art Gallery, The Greenbrier, White Sulphur Springs, West Virginia, July 1–Aug. 1.

1942

Works by Ivan Le Lorraine Albright and Malvin Albright, Findlay Galleries, Chicago, Mar./Apr.

1945–46

"First Joint Exhibition: The Albright Twins," Associated American Artists Galleries, New York, Oct. 22–Nov. 10, 1945; Chicago, Mar. 29–Apr. 17, 1946.

1948

"Joint Exhibition: Karl Priebe and Ivan Albright," F. H. Bresler Gallery, Milwaukee, Wisconsin, Dec. 5–25.

1950

"Albright Family Exhibition," Riccardo's Restaurant and Gallery, Chicago, Apr. 1–31. (Included works by Adam Emory, Ivan, and Malvin.)

1953

Works by Ivan Albright, Riccardo's Restaurant and Gallery, Chicago, Feb. 1–28.

1964

"Ivan Albright: Prints and Drawings," Roosevelt University, Chicago, Nov. 5–14.

1964–65

"Ivan Albright," The Art Institute of Chicago, Oct. 30–Dec. 27, 1964; Whitney Museum of American Art, New York, Feb. 4–Mar. 21, 1965.

1972

"Medical Drawings by Ivan Le Lorraine Albright," Renaissance Society, University of Chicago, June 7–28.

1975–76

"Ivan Albright: The Vermont Farmer," Strauss Gallery, Dartmouth College, Hanover, New Hampshire, Dec. 12, 1975–Feb. 15, 1976.

1978

"Works by Ivan L. Albright from the Collection," The Art Institute of Chicago, Oct. 21–Dec. 10.

"Graven Image: The Prints of Ivan Albright 1931–1977," Donnelly Library, Lake Forest College, Lake Forest, Illinois, Oct. 18–Nov. 26.

"Ivanicana," Hopkins Center, Dartmouth College, Hanover, New Hampshire, Oct. 20–Dec. 20.

1982

"Ivan Albright: Travels of an Artist," Museum of Art, Carnegie Institute, Pittsburgh, June 12–Sept. 5.

1984

"The Last Works of Ivan Albright," The Art Institute of Chicago, Apr. 14–May 26.

"Ivan Albright Prints and Drawings," The Art Institute of Chicago, Apr. 14– July 15.

1986

"Ivan Albright: The Late Self-Portraits," Hood Museum of Art, Dartmouth College, Hanover, New Hampshire, May 24–July 20.

"Ivan Albright: Watercolors, Drawings, and Prints from the Collection of Lawrence M. Pucci," Arts Center Gallery, College of DuPage, Glen Ellyn, Illinois, Oct. 11–Nov. 3.

1987–88

"Ivan Albright as Draftsman and Printmaker," Hood Museum of Art, Dartmouth College, Hanover, New Hampshire, Nov. 21, 1987–Jan. 17, 1988.

1988

"Ivan Albright," Richard L. Feigen & Co., Chicago, Sept. 9–Oct. 15.

Group Shows

Ivan Albright participated in many annual, national art competitions from 1918 to 1975. His entries in these juried exhibitions have been grouped together by competition, arranged chronologically according to when Albright first exhibited in them. When Albright's work was honored with an award or honorable mention, this is signaled below the exhibition. For greater detail about the exhibitions and Albright's entries, see the series of indices by Peter Hastings Falk listed in the Selected Bibliography.

"Annual International Exhibition of Watercolors by American Artists," The Art Institute of Chicago

1918 (30th), 1934 (13th), 1935 (14th), 1936 (15th), 1937 (16th), 1939 (18th), 1940 (19th), 1941 (20th), 1942 (21st), 1943 (22nd), 1944 (55th), 1946 (57th), 1949 (59th)[1]

1. Awarded the Watson F. Blair Prize for *Roaring Fork* (1948; private collection).

"Annual Exhibition by Artists of Chicago and Vicinity," The Art Institute of Chicago

1923 (27th), 1927 (31st), 1928 (32nd),[1] 1929 (33rd), 1930 (34th), 1931 (35th), 1932 (36th), 1933 (37th), 1934 (38th), 1935 (39th), 1936 (40th), 1937 (41st), 1938 (42nd), 1941 (45th),[2] 1942 (46th), 1943 (47th), 1944 (48th), 1945 (49th),[3] 1946 (50th), 1947 (51st), 1948 (52nd), 1949 (53rd), 1950 (54th), 1951 (55th), 1953 (57th),[4] 1955 (58th),[5] 1957 (60th), 1959 (62nd), 1961 (64th), 1962 (65th), 1966 (69th)

1. Awarded the John C. Shaffer Prize for *The Lineman* (no. 10).
2. Awarded the Mr. and Mrs. Jule F. Brower Prize for *Shore Sentinels* (1939; private collection).
3. Awarded the Art Institute Print Committee Prize for *The Ephemerid* (no. 36).
4. Awarded the Clyde M. Carr Prize for *Silence* (no. 49).
5. Awarded the Municipal Art League Prize for *Calcification* (1942; private collection).

"Annual Exhibition of the Pennsylvania Academy of the Fine Arts," Philadelphia

1924 (119th), 1927 (122nd), 1929 (124th), 1930 (125th), 1932 (127th), 1933 (128th), 1935 (130th),

1936 (131st), 1938 (133rd), 1940 (135th),[1] 1941 (136th), 1942 (137th),[2] 1944 (139th), 1945 (140th), 1946 (141st), 1948 (143rd), 1949 (144th), 1951 (146th), 1956 (151st)[3]

1. Exhibited *Shore Sentinels*, under the pseudonym "James Fleming."
2. Awarded the Temple Gold Medal for *That Which I Should Have Done I Did Not Do (The Door)* (no. 24).
3. Awarded the J. Henry Scheidt Prize for *There is a Man in God* (an alternate title for *And Man Created God in His Own Image [Room 203]*) (no. 20).

"Annual Exhibition of American Paintings and Sculpture," The Art Institute of Chicago

1926 (39th),[1] 1927 (40th), 1928 (41st), 1929 (42nd), 1930 (43rd),[2] 1936 (47th), 1939 (50th), 1941 (52nd),[3] 1942 (53rd), 1943 (54th),[4] 1945 (56th), 1947 (58th), 1951 (60th), 1954 (61st), 1959 (63rd), 1962 (65th)

1. Awarded Honorable Mention for *Paper Flowers* (no. 5).
2. Awarded Honorable Mention for *Fleeting Time, Thou Hast Left Me Old* (no. 14).
3. Awarded the Norman Wait Harris Medal for *The Door* (no. 24).
4. Awarded the Norman Wait Harris Medal for *Lobster Salad* (1941; Richard L. Feigen & Co.).

"Annual [and Winter] Exhibition of The National Academy of Design," New York

1926 (Winter), 1928 (103rd), 1941 (115th), 1942 (116th), 1943 (117th), 1944 (118th),[1] 1945 (Winter), 1947 (121st), 1952 (127th), 1953 (128th), 1954 (129th), 1956 (131st), 1959 (134th), 1961 (136th),[2] 1975 (150th)

1. Awarded the Benjamin Altman Figure Prize for *The Lineman* (no. 10).
2. Awarded the Benjamin Altman Figure Prize for *Yesterday* (an alternate title for *I Slept With the Starlight in My Face [The Rosicrucian]* (no. 7).

"The Carnegie International Exhibition," Pittsburgh

1928 (27th), 1929 (28th), 1930 (29th), 1933, 1935, 1936, 1937, 1938,[1] 1939, 1940, 1943, 1944, 1945, 1946, 1947, 1948, 1949, 1950,[2] 1964

1. Exhibited *The Door* (no. 24), unfinished, in an elaborately carved frame (now lost).
2. Awarded fourth Honorable Mention for *The Purist* (1949; private collection).

"The Corcoran Biennial Exhibition," Washington, D.C.

1928 (11th), 1930 (12th), 1932 (13th), 1935 (14th), 1937 (15th), 1939 (16th), 1941 (17th), 1943 (18th), 1945 (19th), 1947 (20th), 1953 (23rd), 1955 (24th),[1] 1957 (25th)

1. Awarded the W. A. Clark Prize (Silver Medal) for *Tin* (1952–54; private collection).

"Annual Philadelphia Watercolor and Print Exhibition and Annual

Exhibition of Miniatures," Pennsylvania Academy of the Fine Arts, Philadelphia

1931 (29th/30th), 1934 (32nd/33rd), 1936 (34th/35th), 1938 (36th/37th), 1939 (37th/38th), 1940 (38th/39th),[1] 1941 (39th/40th), 1942 (40th/41st), 1943 (41st/42nd), 1944 (42nd/43rd), 1945 (43rd/44th), 1946 (44th/45th), 1947 (45th/46th), 1949 (47th/48th), 1950 (48th/49th), 1952 (50th/51st), 1953 (51st/52nd), 1957 (152nd), 1959 (154th), 1963 (158th)

1. Awarded the Philadelphia Watercolor Prize for *Ah, God, Herrings, Buoys, the Glittering Sea* (no. 35).

"The Annual and Biennial Exhibitions of the Whitney Museum of American Art," New York

1932, 1937, 1939, 1940, 1941, 1943, 1944, 1945, 1946, 1947 (2nd), 1948 (2nd), 1949, 1950 (2nd), 1952 (2nd), 1955 (1st), 1955 (2nd), 1956, 1957, 1958, 1961

1923

"The Thirtieth Annual Exhibition of the Works of the Art Students' League of Chicago," The Art Institute of Chicago, June 8–July 9.

1926

"Academy Fellowships Exhibition," Pennsylvania Academy of the Fine Arts, Philadelphia, Feb.

1927

"All-Illinois Society of the Fine Arts, Inc., Second Annual Exhibition," New Bismarck Hotel, Chicago, Nov. 1–15.

1928

"Fellowship of the Pennsylvania Academy of the Fine Arts," Art Club Gallery, Philadelphia, Feb.

"Chicago Society of Artists," Stevens Hotel, Chicago, Nov./Dec.

Illinois Academy of Fine Arts, Architects' Building, University of Illinois, Champaign-Urbana, Illinois, May 1–30.

"All-Illinois Society of the Fine Arts, Inc., Third Annual Exhibition," Stevens Hotel, Chicago, Dec. 1–15.

1929

"Fellowship of the Pennsylvania Academy of the Fine Arts Annual Exhibition," Art Club Gallery, Philadelphia, Mar. 1–31.

"Seventeenth Annual Exhibition of Selected Paintings by Contemporary American Artists," Toledo Museum of Art, June 2–Aug. 25.

"Autumn Exhibition by the Chicago Society of Artists," Stevens Hotel, Chicago, Nov. 17–Dec. 1.

1930

"Association of Painters and Sculptors of Chicago," Brooks Memorial Art Gallery, Cleveland, Apr.

1931

"Annual Exhibition of the Chicago Society of Artists," Studio Gallery Increase Robinson, Jan. (Awarded the Chicago Society of Artists Gold Medal for *Into the World There Came a Soul Called Ida* [no. 17].)

"Pan-American International Show," Museum of Art, Baltimore, Feb.

"Spring Exhibition" by the Chicago Society of Artists, Midland Club, Chicago, Apr. 11–25.

"Twenty-Fifth Annual Exhibition: Selected Paintings by American Artists," Albright Art Gallery, Buffalo, Apr. 26–May 31.

1932

"The Summer Exhibition of Paintings, Sculptures, and Drawings," The Brooklyn Museum, June 16–Oct. 3.

"Grant Park Art Fair," Chicago, Aug.

"Chicago Society of Artists Annual Exhibition," M. Knoedler & Co., Chicago, Nov./Dec.

1933

"A Century of Progress Exhibition of Paintings and Sculpture," The Art Institute of Chicago, June 1–Nov. 1.

"Grant Park Art Fair," Chicago, July/Aug. (Awarded the Logan Prize for *I Walk To and Fro through Civilization and I Talk as I Walk* [*Follow Me, The Monk*] [no. 9].)

1933–34

"Painting and Sculpture from Sixteen American Cities," The Museum of Modern Art, New York, Dec. 1934–Jan. 1, 1935.

1934

"Members of the Fellowship of the Pennsylvania Academy," Art Club Gallery, Philadelphia, Feb. (Awarded the May Audubon Post Prize for *Wherefore Now Ariseth the Illusion of a Third Dimension* [no. 21].)

"A Century of Progress Exhibition of Paintings and Sculpture," The Art Institute of Chicago, June 1–Nov. 1.

"Official International Exhibition of Contemporary Prints for a Century of Progress," The Art Institute of Chicago, June 1–Nov. 1.

"Grant Park Art Fair," Chicago, June/July.

"Eleventh Annual Exhibition of the Chicago No-Jury Society of Artists, Inc.," Chicago, July 9–Aug. 9.

1934–35

"Annual Exhibition of the Chicago Society of Artists," Michigan Square Building, Chicago, Dec. 5, 1934–Jan. 1, 1935.

1935

"Annual Exhibition of the Chicago Society of Artists," Michigan Square Building, Chicago, Nov. 20–Dec. 20.

1936

"Seventeenth Annual Exhibition of the Springfield Art League," Springfield Museum of Fine Arts, Springfield, Massachusetts, Feb. 1–23.

"The Annual Member Exhibition," Arts Club of Chicago, Apr. 5–30.

"Minnesota State Fair Fine Arts Show," Minneapolis, Sept.

1937

"Eighteenth Annual Exhibition of the Springfield Art League," Springfield Museum of Fine Arts, Springfield, Massachusetts, Jan. 16–Feb. 7. (Awarded first prize for *Ida* [no. 17].)

"Second National Exhibition of American Art," Municipal Art Committee, American Fine Arts Society Galleries, New York, June 16–July 31.

1939

"Exhibition of Professional Members," Arts Club Annual, Arts Club of Chicago, Wrigley Building Gallery, Chicago, Apr. 24–May 13.

"American Painting Today," New York World's Fair, June/Aug.

1939–40

"Half a Century of American Art," The Art Institute of Chicago, Nov. 16, 1939–Jan. 7, 1940.

1942

"Seventh Annual New Year Show," Butler Art Institute, Youngstown, Ohio, Jan. 1–Feb. 1.

"Second Annual," Society for Contemporary American Art of The Art Institute of Chicago, Jan. 13–Feb. 3.

"Dedicated to American Art," Sheldon Swope Art Gallery, Terre Haute, Indiana, Mar. 21–May 2.

1942–43

"Artists for Victory: an Exhibition of Paintings, Sculpture, Prints," The Metropolitan Museum of Art, New York, Dec. 7, 1942–Feb. 22, 1943. (Awarded First Medal for *The Door* [no. 24].)

1942–44

"Twentieth Century Portraits," The Museum of Modern Art, New York, Dec. 9, 1942–Jan. 24, 1943. A version of this exhibit traveled to: The Baltimore Museum of Art, Feb. 12–Mar. 7; Worcester Art Museum, Mar. 21–Apr. 18; Arts Club of Chi-

cago, May 4–31; California Palace of the Legion of Honor, San Francisco, June 14–July 12. A smaller version continued on to: City Art Museum, St. Louis, Oct. 1–29; Flint Institute of Arts, Nov. 20–Dec. 18; Munson-Williams-Proctor Institute, Utica, New York, Jan. 1–29, 1944; Norton Gallery and School of Art, West Palm Beach, Feb. 11–Mar. 10; Rollins College, Winter Park, Florida, Mar. 18–Apr. 8.

1943

"Eighth Annual New Year Show," Butler Art Institute, Youngstown, Ohio, Jan. 1–31. (Awarded first prize for best oil painting, *Heavy the Oar* [no. 16].)

"Meet the Artist, an Exhibition of Self-Portraits by Living American Artists," M. H. De Young Memorial Museum, San Francisco, Aug. 28–Oct. 24.

1943–44

"American Realists and Magic Realists," The Museum of Modern Art, New York, Feb. 10–Mar. 21. It traveled to: the Albright Art Gallery, Buffalo, Apr. 5–May 5; Minneapolis Institute of Arts, July 1–30; San Francisco Museum of Art, Aug. 23–Sept. 19; Art Gallery of Toronto, Nov. 12–Dec. 19; Cleveland Museum of Art, Jan. 1–29, 1944.

1945

"Gallery of Art Interpretation; Still Life Comes to Life," The Art Institute of Chicago, Apr. 2–Oct. 1.

1946

"American Painting from the Eighteenth Century to the Present Day," Tate Gallery, London, June/July.

Bel-Ami International Competition (contest for best portrayal of the Temptation of Saint Anthony [see no. 42]), Knoedler & Company, Inc., New York, Sept. 16–28.

1947

"The Print Competition," second annual exhibition, Associated American Artists Galleries, New York, Aug. 1–15. (Awarded $1,000 prize for his lithograph *Self-Portrait at 55 East Division Street* [no. 43].)

1947–48

"Fifty-eighth Annual Exhibition of American Paintings and Sculpture: Abstract and Surrealist American Art," The Art Institute of Chicago, Nov. 6, 1947–Jan. 11, 1948.

1949

Riccardo's Restaurant and Gallery, opening of permanent installation of artists' murals, Chicago, Apr.

"Society for Contemporary American Art," Associated American Artists Galleries, Chicago, Dec. 16–19.

1950–51

"American Painting Today—1950." The Metropolitan Museum of Art, New York, Dec. 8, 1950–Feb. 25, 1951.

1952–53

"American Watercolors, Drawings, and Prints," The Metropolitan Museum of Art, New York, Dec. 5, 1952–Jan. 25, 1953.

1953

"Douze Peintres et sculpteurs americains contemporains," Musée national d'art moderne, Paris, Apr./June.

1954

"The Ludgin Collection of Contemporary Painting," Corcoran Gallery of Art, Washington, D.C., Apr. 11–May 16.

1956

"American Artists Paint the City," United States Pavilion, twenty-eighth Biennale, Venice, June 19–Oct. 21. (Included *Poor Room—There is No Time, No End, No Today, No Yesterday, No Tomorrow, Only the Forever, and Forever and Forever without End [The Window]* [no. 40], unfinished.)

1958–59

"The Artist Looks at People," The Art Institute of Chicago, Nov. 13, 1958–Jan. 11, 1959.

1960

"American Painting 1760–1960," Milwaukee Art Center, Mar. 3–Apr. 3.

"Famous Families in American Art," Dallas Museum of Fine Arts, Texas, Oct. 8–Nov. 20. (Included works by Adam Emory, Ivan, Malvin, and Adam Medill Albright, as well as Aaron Bohrod's painting *Through a Glass Darkly [Portrait of Ivan Albright]* [Weininger, fig. 32].)

1963

"Dunn International Exhibition," Beaverbrook Art Gallery, Fredericton, New Brunswick, Canada, Sept. 7–Oct. 6; Tate Gallery, London, Nov. 14–Dec. 14. (Awarded $5,000 prize for *Poor Room* [no. 40].)

1964

"Between the Fairs: Twenty-Five Years of American Art, 1939–1964," Whitney Museum of American Art, New York, June 24–Sept. 23.

1965

"Three Centuries of American Painting," The Metropolitan Museum of Art, New York, Apr. 9–Oct. 17.

1968

"Doors," Cordier & Ekstrom, Inc., New York, Mar. 19–Apr. 20. (Exhibited the actual prop for *The Door* [no. 24].)

"The 1930s: Painting and Sculpture in America," Whitney Museum of American Art, New York, Oct. 15–Dec. 1.

1969–70

"Human Concern/Personal Torment," Whitney Museum of American Art, New York, Oct. 14–Nov. 30, 1969; University Art Museum, University of California, Berkeley, Jan. 20–Mar. 1, 1970.

1974

"American Self-Portraits 1670–1973," National Portrait Gallery, Washington, D.C., Feb.; Indianapolis Museum of Art, Apr. 1–May 15.

1975

"An American Dreamworld: Romantic Realism 1930–1955," Whitney Museum of American Art, New York, Jan. 29–Mar. 5.

"Selected Works from the Lawrence Marshall Pucci Collection," Mitchell Museum, Mt. Vernon, Illinois, Nov. 8–Dec. 14.

1976

"Portraits USA 1776–1976," Pennsylvania State University Museum of Art, University Park, Apr. 18–June 6.

1979–80

"One Hundred Artists—One Hundred Years Centennial Exhibition, Alumni of The School of The Art Institute of Chicago," The Art Institute of Chicago, Nov. 23, 1979–Jan. 20, 1980.

1980

"Amerika: Traum und Depression 1920/40," Neue Gesellschaft für bildende Kunst, Berlin, Nov. 9–28.

1980–81

"Les Réalismes," Centre Georges Pompidou, Paris, Dec. 17, 1980–Apr. 20, 1981; Staatliche Kunsthalle, Berlin, May 10–June 30, 1981.

1981

"Westkunst: Zeitgenössische Kunst Seit 1939," Museum der Stadt Köln, Cologne.

1981–82

"Amerikanische Malerei 1930–1980," Haus der Kunst, Munich, Nov. 14, 1981–Jan. 31, 1982.

1982

"Realism and Realities: The Other Side of American Painting, 1940–1960," Rutgers University Art Gallery, New Brunswick, New Jersey, Jan. 17–Mar. 26.

"Mary and Earle Ludgin Collection," The Art Institute of Chicago, Sept. 11–Oct. 31.

1983–84

"Artists by Themselves: Artists' Portraits from the National Academy of Design," National Academy of Design, New York, Nov. 3, 1983–Jan. 1, 1984.

1984

"In Quest of Excellence: Civic Pride, Patronage, Connoisseurship," Center for the Fine Arts, Miami, Jan. 14–Apr. 22.

"Woman," Terra Museum of American Art, Evanston, Illinois, Feb. 18–Apr. 22.

1985

"Memorial Exhibition of Deceased Members: Ivan Albright, Jimmy Ernst, Armin Landeck, Alice Neel," American Academy and Institute of Arts and Letters, New York, Nov. 18–Dec. 15.

1994

"American Realism between the Wars: 1919–1941," Nassau County Museum of Art, Roslyn Harbor, New York, Apr. 10–June 5.

1994–95

"George Grosz: Berlin, New York," Neue Nationalgalerie, Berlin, Dec. 21, 1994–Apr. 17, 1995; Kunstsammlung Nordrhein-Westfalen, Düsseldorf, Germany, May 6–July 30, 1995. (Included *Picture of Dorian Gray* [no. 41].)

1996–97

"Art in Chicago: 1945–1995," Museum of Contemporary Art, Chicago, Nov. 16, 1996–Mar. 23, 1997.

The Ivan Albright Archive

Robert Cozzolino

The Art Institute of Chicago is the center of Ivan Albright studies by virtue of two facts: it owns the largest and most significant collection of artwork by Albright; and it houses the most important archive of Albright materials. The Ivan Albright Archive was established through a fortuitous series of acquisitions, and the Art Institute's own efforts to document Albright's career-long association with the museum. It continues to evolve as more materials come to light.

Archival collections at the Art Institute are divided between two distinct groups, both of which are housed in the Ryerson and Burnham Libraries. The Archives of the Art Institute, founded in 1986, houses records, papers, photographs, publications, and ephemera related to the activities of the museum, The School of The Art Institute of Chicago, and their previous staff. The Ryerson and Burnham Archives comprises the special collections of the libraries, including artists' and architects' papers, small sketches, blueprints, memorabilia, and over twenty-five thousand photographs pertaining to various domestic and international subjects, artists, and architects. The Ivan Albright Archive is part of the second group, which includes as well the archives of Daniel H. Burnham, Bruce Goff, Ludwig Hilberseimer, Mary Reynolds, and Louis Sullivan.

In 1977 Albright gave the Art Institute most of his major paintings, sculptures, working diagrams, and works on paper. In 1984, the year after his death, Josephine Albright presented the museum with fifty-one of his notebooks, three extensive scrapbooks, poetry, and some photographs—all of which had been a promised gift of the artist. In November 1995, approximately one thousand glass negatives came to the archive through the settlement of Malvin Albright's estate. Ivan Albright's biographer, Michael Croydon, donated a group of materials in 1996 that the artist gave him during the preparation of his biography, *Ivan Albright* (New York, 1978), including writings and photographs. Croydon's own invaluable notes and research papers were also assimilated into the collection.

The following discussion describes more specifically the nature and scope of Albright archival materials in the holdings of the Art Institute. Examples of materials from the collection are cited throughout this publication.

NOTEBOOKS

Fifty-one notebooks in six boxes, Ryerson and Burnham Archives, 1984.6, Series I.

Albright's notebooks reveal his working methods and innermost thoughts. The notebooks include student sketches and notes; as well as quotations, absorbed from teachers such as Leopold Seyffert, Charles Hawthorne, Albin Polasek, and Henry McCarter, that Albright often elaborated upon as though he were thinking aloud. He made travel sketches and quick drawings of works by artists from El Greco to Ferdinand Hodler, accompanied by critical written observations of their methods. His textual and diagrammatic notes, which encompass even the most minor of projects, are as complex as the perspectives and techniques of his major paintings. He described nearly all the projects of his career in process, re-evaluated them years afterward, and often compared them with evolving interests and later projects. The notebooks also include short stories and journal entries; candid and stern self-appraisals; as well as meditations on religion, art, time, and death.

POETRY

Ryerson and Burnham Archives, 1984.6, Series II.

Handwritten poetry is scattered throughout his notebooks. In 1984 Ida Rogers's daughter, Marilyn Rogers Lowery, donated two handwritten poems to the Art Institute that Albright wrote during the painting of *Into the World There Came a Soul Called Ida* (no. 17). In 1988 The Archives of American Art, Chicago Project Office, transferred to the Art Institute 295 typescript poems dating from the 1930s.

PHOTOGRAPHIC MATERIAL

Ryerson and Burnham Archives, 1984.6, Series III, V, and VI.

The Art Institute of Chicago has the foremost collection of photographs that relate to the life and career of Albright. Containing over twelve hun-

dred images, the collection is diverse in subject matter, media, and date range. Photographs depict Ivan working on major paintings and document the artist's setups; works in progress; and the interiors of his studios in Illinois, Georgia, and Vermont. Also included are glass negatives, attributed predominantly to Adam Emory Albright, that capture the family and studio life of the Albrights.

SCRAPBOOKS

Three volumes, Ryerson and Burnham Archives, 1984.6, Series IV.

Albright kept a meticulous record of his public career. Aided by newspaper-clippings services, he collected nearly every piece of periodical writing on his work and activities from 1918 to 1983. Chronologically arranged by the artist into three scrapbooks, this material documents his exhibitions and critical reception, and has assisted in the dating of his work.

MICHAEL CROYDEN PAPERS

Ryerson and Burnham Archives, 1984.6, Series VI

Most of the material in this collection was assembled in preparation for Croydon's *Ivan Albright* (New York, 1978). The papers include original letters, writings, and discussions of paintings by the artist, as well as his comments on the developing text, and a number of Albright's own archival photographs. Also in the papers are Croydon's handwritten notes and correspondence, cassette interviews with collectors, and research completed after the book was published.

PROPS

Eighteen boxes, packages, and crates containing over seventy-five separate props, currently located in the collection of the Department of Twentieth-Century Painting and Sculpture.

Albright included in his 1977 gift to the Art Institute many of the objects that he selected, collected, and assembled for various paintings, such as *That Which I Should Have Done I Did Not Do (The Door)* (no. 24), *Poor Room—There Is No Time, No End, No Today, No Yesterday, No Tomorrow, Only the Forever, and Forever and Forever without End* (no. 40; see also Chronology, figs. 25 and 26), *The Vermonter* (no. 60); and *Pray for These Little Ones* (no. 67)— even the black velvet glove worn by Mary Block as she sat for her portrait (no. 51).

ADDITIONAL MATERIALS IN THE ARCHIVES OF THE ART INSTITUTE

This includes correspondence between Ivan Albright and various curators and museum directors, former faculty records, annual exhibition forms, curatorial files, exhibition records, student records from the School of the Art Institute, exhibition photographs, and snapshots of the artist.

Selected Bibliography

Books and Exhibition Catalogues

Albright, Adam Emory. *For Art's Sake*. Chicago and Crawfordsville, Indiana, 1953.

Barker, Virgil. *From Realism to Reality in Recent American Painting*. Lincoln, Nebraska, 1959. Pp. 70–77.

Baur, John I. H. *Revolution and Tradition in Modern American Art*. Cambridge, Massachusetts, 1951. Pp. 101, 143, and 158.

——, ed. *New Art in America: Fifty Painters of the Twentieth Century*. Greenwich, 1957. Pp. 198–202.

Canaday, John. *What Is Art?: An Introduction to Painting, Sculpture, and Architecture*. New York, 1980. Pp. 315, 316, and 318.

Chicago, The Art Institute of Chicago. *American Artists Paint the City*. Exh. cat. for the 28th Venice Biennale by Katharine Kuh. 1956. Pp. 15, 21, and 41.

Chicago, The Art Institute of Chicago, and New York, Whitney Museum of American Art. *Ivan Albright: A Retrospective Exhibition*. Exh. cat. by Frederick A. Sweet, with commentary by Jean Dubuffet and remarks by Ivan Albright. 1964–65.

Chicago, University of Chicago, Renaissance Society. *An Exhibition of Medical Drawings by Ivan Lorraine Albright*. Exh. cat. by Katharine L. Keefe and Harold Haydon. 1972.

Croydon, Michael. *Ivan Albright*. New York, 1978.

Cummings, Paul. *Artists in Their Own Words: Interviews by Paul Cummings*. New York, 1979. Pp. 49–66.

Dickson, Harold E. *Portraits USA 1776–1976*. University Park, Pennsylvania, 1976. Pp. 106 and 107.

Falk, Peter Hastings, ed. *The Annual and Biennial Exhibition Record of the Whitney Museum of American Art, 1918–1989*. Madison, Connecticut, 1991. Pp. 65 and 66.

——. *The Annual Exhibition Record of the Art Institute of Chicago 1888–1950*. Madison, Connecticut, 1990. Pp. 58 and 59.

——. *The Annual Exhibition Record of the National Academy of Design, 1901–1950*. Madison, Connecticut, 1990. Pp. 51 and 52.

——. *The Annual Exhibition Record of the Pennsylvania Academy of the Fine Arts. Volume III, 1914–1968*. Madison, Connecticut, 1989. Pp. 31, 37, 46, and 65.

——. *The Biennial Exhibition Record of the Corcoran Gallery of Art, 1907–1967*. Madison, Connecticut, 1991. Pp. 58 and 59.

Hanover, New Hampshire, Hood Museum of Art, Dartmouth College. *Ivan Albright: The Late Self-Portraits*. Exh. cat. with essays by Richard R. Brettell and Phylis Floyd. 1986.

——. *The Ivan Albright Collection*. Exh. cat. by Phylis Floyd. 1987.

Henkes, Robert. *Themes in American Painting: A Reference Work to Common Styles and Genres*. London, 1993. Pp. 22, 184, 217, 218, and 225–227.

Gibbons, Reginald. "Ivan Albright: Self-Portraits, 1981–83." In Chicago, The Art Institute of Chicago, *Transforming Vision: Writers on Art*. Ed. by Edward Hirsch. 1994. Pp. 76–79.

Jacobson, J. Z., ed. *Art of Today: Chicago 1933*. Chicago [c. 1932]. Pp. 34, 35, and 137.

Kahan, Mitchell Douglas. "Subjective Currents in American Painting of the 1930s." Ph.D. dissertation, City University of New York, 1983. Pp. 2, 3, 9, 11, and 73–110.

Kuh, Katharine. *Break-Up: The Core of Modern Art*. Greenwich, Connecticut, 1965. Pp. 84, 85, 89, and 90.

——. "Ivan Albright." *The Artist's Voice: Talks with Seventeen Artists*. New York, 1960. Pp. 23–37.

——. "Ivan Albright." *The Open Eye: In Pursuit of Art*. New York et al., 1971. Pp. 3–10.

Lake Forest, Illinois, Lake Forest College. *Graven Image: The Prints of Ivan Albright 1931–1977*. Exh. cat. comp. and ed. by Gael Grayson, intro. Michael Croydon. 1978.

Lucie-Smith, Edward. *American Realism*. New York, 1994. Pp. 152, 154–56, and 158.

Mavigliano, George J., and Richard A. Lawson. *The Federal Art Project in Illinois, 1935–1943*. Carbondale, Illinois, 1990.

McLanathan, Richard. *Art in America: A Brief History*. New York, 1973. Pp. 194 and 195.

New Brunswick, New Jersey, Rutgers University Art Gallery. *Realism and Realities: The Other Side of American Painting, 1940–1960.* Exh. cat. by Greta Berman and Jeffrey Wechsler. 1981.

New York, The Museum of Modern Art. *American Realists and Magic Realists.* Exh. cat. ed. by Dorothy C. Miller and Alfred H. Barr, Jr. Intro. by Lincoln Kirstein. 1943–44.

New York and Chicago, Associated American Artists Galleries. *First Joint Exhibition: The Albright Twins.* 1945–46. (Two separate catalogues.)

Pearson, Ralph M. "Ivan Le Lorraine Albright." *Experiencing American Pictures.* New York, 1943. Pp. 181–87.

Rose, Barbara. *American Art since 1900.* Rev. ed., New York and Washington, D.C., 1975.

———, ed. *Readings in American Art 1900–1975.* New York, 1975. Pp. 92 and 93.

San Francisco, M. H. De Young Memorial Museum. *Meet the Artist: An Exhibition of Self-Portraits by Living American Artists.* Exh. cat. by Walter Heil. 1943. P. 9.

Smith, Alson J. *Chicago's Left Bank.* Chicago, 1953.

Sparks, Esther. "A Biographical Dictionary of Painters and Sculptors in Illinois, 1808–1945." Ph.D. dissertation, Northwestern University, 1971. Ann Arbor, 1986.

Ward, John L. *American Realist Painting, 1945–1980.* Ann Arbor, 1989.

Weller, Allen S. *The Joys and Sorrows of Recent American Art.* Urbana, Illinois, 1968.

Yochim, Louise Dunn. *Role and Impact: The Chicago Society of Artists.* Chicago, 1979.

ARTICLES

Albright, Ivan Le Lorraine. "Chicago's Foremost Painter Takes Issue with Art Critic." *Chicago Daily News,* Dec. 13, 1939, Christmas Book section, p. 17.

———. "'Educationally This Is a Hollow Nut,' Says Ivan Albright." *Chicago Daily News,* Feb. 26, 1941, p. 14.

———. "Ivan Le Lorraine Albright, Chicago's Foremost Painter, Decries the French Moderns." *Chicago Daily News,* July 3, 1940, p. 7.

———. "Make Chicago an Art Center." *Chicago Sun,* Jan. 10, 1942, p. 12.

———. "Modernism Has a Field Day at Art Institute's U.S. Show." *Chicago Herald-American,* Nov. 5, 1947 (ill.).

Albright, Ivan Le Lorraine, and Aaron Bohrod, Constantine Pougialis, and William S. Schwartz. "Letter to the Editor, November 26, 1935." *Chicago Daily News,* Dec. 14, 1935, sec. 3, p. 4.

Art Digest. "Albright, an 'Old Master' from Illinois." 5, 1 (Oct. 1, 1930), pp. 5 and 6 (ill.).

———. "Albright's Aging 'Ida' Repeats Her 1931 Chicago Triumph in Springfield." 11, 9 (Feb. 1, 1937), p. 12 (ill.).

———. "Albright's 'Ida' Wins Chicago Gold Medal." 6, 6 (Dec. 15, 1931), p. 6 (ill.).

———. "A Storm." 5, 1 (July 1928), pp. 1 and 23 (ill.).

———. "Chicago Sets an Example in One-Man Shows." 5, 19 (Aug. 1, 1931), p. 8.

———. "Did Its Beauty Cause Toledo to Ban This?" 3, 20 (Sept. 1929), p. 5 (ill.).

Artner, Alan G. "Albright: Portraits of the Artist as an Old Man." *Chicago Tribune,* Apr. 15, 1984, sec. 13, p. 11 (ill.).

———. "At 81, Ivan Albright Enjoys His Gift of Second Sight." *Chicago Tribune,* Oct. 22, 1978, sec. 6, pp. 8 and 9 (ill.).

———. "Ivan Albright: His Art Focused on Ironic Realism." *Chicago Tribune,* Nov. 19, 1983, sec. 1, p. 9 (ill.).

Baro, Gene. "The Dunn International." *Arts Magazine* 38, 4 (Jan. 1964), pp. 51–53 (ill.).

Bonesteel, Michael. "In a Museum of Mirrors." *Art in America* 72, 11 (Dec. 1984), pp. 143–47 (ill.).

Boyden, Sarah. "The Art of Ivan Albright." *Chicago Sun Times,* Nov. 15, 1964, Midwest Magazine section, p. 4 (ill.).

Brenson, Michael. "Ivan Albright, 86, Dies; 'Magic Realist' Painter." *The New York Times,* Nov. 19, 1983, sec. 1, p. 31 (ill.).

Bridaham, Dorothy. "The Paintings of Ivan Albright." *Chicago* 1, 2 (Apr. 1954), pp. 20–25, 40, and 41 (ill.).

Bulliet, C. J. "Albright Tames Wild Baers at the Art Institute Summer Shows." *Chicago Evening Post,* July 28, 1931, Art section, p. 1.

———. "Artless Comment on the Seven Arts: Flying to Defense of Ivan Albright." *Chicago Evening Post,* Aug. 11, 1931, p. 8.

———. "Artless Comment on the Seven Arts: Albright's 'Dorian Gray.'" *Chicago Daily News,* Nov. 6, 1943, p. 7 (ill.).

Canaday, John. "Meet Ivan Albright." *New York Times,* Feb. 7, 1965, sec. 2, p. 19 (ill.).

Chicago Daily News. "Art Is a Family Affair for the Albrights." May 15, 1943, News-Views section, pp. 2 and 3 (ill.).

Chicago Daily News. "Hi–Jinks at an Artists' Party." Feb. 23, 1946, News-Views section, pp. 8 and 9 (ill.).

Chicago Daily Journal. "'Lineman' Winning Painting at Institute Stirs Workers." May 14, 1928, p. 4 (ill.).

Electric Light and Power. "Some Interesting Comment on Our May Issue Cover Design." 6, 6 (June 1928), pp. 115 and 117.

Emmons, Jim. "Ivan Albright Still a Presence: Hood Museum Exhibit Features Self-Portraits of Late Artist." *Rutland Daily Herald,* June 6, 1986, pp. 9 and 10 (ill.).

Esquire. "Latter Day Rembrandt: Four Paintings by Ivan Le Lorraine Albright." 6, 2 (Aug. 1936), p. 103 (ill.).

Farber, Manny. "Artists for Victory: Metropolitan Museum of Art Opens Great Exhibition for American Artists." *Magazine of Art* 35, 8 (Dec. 1942), pp. 274–80.

Frankfurter, Alfred M. "Directions, Detours, and Destinations in U.S. Painting: Carnegie Neophytes at Pittsburgh and Hand Picked Veterans at Chicago." *Art News* 40, 14 (Nov. 1–14, 1941), pp. 11–13, 36, and 37 (ill.).

Genauer, Emily. "Albright's 'Victims in a World of Shadow.'" *New York Herald Tribune,* Jan. 31, 1965, New York Magazine section, p. 31 (ill.).

Gibbs, Jo. "The Albright Twins—Decay, Charm, Confusion." *Art Digest* (Nov. 1, 1945), pp. 12 and 13 (ill.).

Hercher, W. W. "Don't Call a Spade a Spade, Says Artist of His Titles." *Boston Globe,* Apr. 13, 1942, p. 4.

———. "Famed Artist Will Paint Self in Red Underwear, Eating an Egg." *Milwaukee Journal,* May 28, 1943, Green Sheet section, p. 1.

Holland, Frank. "Albright's 'Door' Elevated to Masterpiece Distinction." *Chicago Sun-Times,* Nov. 21, 1954, sec. 2, p. 5.

———. "Albright, Twin Sons in First Joint Show." *Chicago Sun-Times,* Apr. 16, 1950, sec. 2, p. 6.

Inge, William. "Illinois Artist's Work Placed on Exhibit Here." *St. Louis Star Times,* Oct. 1943 (ill.).

Janis, Harriet. "Artists in Competition: Eleven Distinguished Artists Compete in a Struggle with the Temptation of St. Anthony." *Arts and Architecture* 63, 4 (Apr. 1946), pp. 30–33 and 52, 54, and 55 (ill.).

Janis, Harriet and Sidney. "Albright: Compulsive Painter." *View* 3, 1 (1943), pp. 24, 26, 31, and 35 (ill.).

———. "The Painting of Ivan Albright." *Art in America* 34, 1 (Jan. 1946), pp. 43–49 (ill.).

Jewell, Edward Alden. "Joint Art Display by Albright Twins." *New York Times,* Oct. 23, 1945, p. 15.

———. "Carnegie: American Painters at International." *New York Times,* Oct. 30, 1938, sec. 9, p. 9.

Jewett, Eleanor. "On Exhibit at Art Institute: Work of Baer and Albright Interestingly Presents Sharp Contrast of Sentiment with Reality." *Chicago Tribune,* Aug. 23, 1931, sec. 8, p. 4 (ill.).

Judge, Paul. "Light, Shadow and Ivan Albright,"

Woodstock Common 1, 1 (Summer 1983), pp. 5–7, 18, and 19 (ill.).

Kind, Joshua. "Albright: Humanist of Decay." *Art News* 63, 7 (Nov. 1964), pp. 43, 44, and 68–70 (ill.).

———. "Reassessing Albright." *New Art Examiner* 6, 3 (Dec. 1978), pp. 10 and 11 (ill.).

Kuh, Katharine. "Chicago's Ivan Albright Talks about the 'Unknown World' of His Art to Katharine Kuh." *Chicago Daily News*, Jan. 19, 1963, Panorama section, p. 7 (ill.).

———. "In the American Grain." *Saturday Review* 48, 44 (Oct. 30, 1965), pp. 68–70 (ill.)

———. "No Single Fact Is as It Seems: Ivan Albright, Veteran Maverick, Makes His Own World." *Saturday Review* 50, 6 (Feb. 11, 1967), pp. 23–27 (ill.).

Life. "Albright Twins: They Paint Gruesome Masterpieces in an Abandoned Methodist Church." 16, 13 (Mar. 27, 1944), pp. 63–71 (ill.).

Lord, Alice Frost. "New Harbor, Corea, Cundy's Harbor and Deer Isle Intrigue Hollywood Artist." *Lewiston Journal*, Nov. 25, 1944, Magazine section, p. 3 (ill.).

Lyon, Christopher. "'Synthetic Realism': Albright, Golub, Paschke." *Art Journal* 45, 4 (Winter 1985), pp. 330–34 (ill.).

Mayor, A. Hyatt. "The Artists for Victory Exhibition." *Metropolitan Museum of Art Bulletin* 1, 4 (Dec. 1942), pp. 141–43 (ill.).

McCauley, Lena M. "McCauley's Point of View: Stories about Our Artists." *Chicago Evening Post*, Feb. 12, 1929, Artworld Magazine section, p. 10.

Munro, Eleanor C. "Portraits in Our Time: The Age-Old Contest between Artist and Sitter Enlivens a New Boom." *Horizon* 1, 3 (Jan. 1959), pp. 95–105 (ill.).

Neugass, Fritz. "Ivan Le Lorrain [*sic*] Albright." *Das Kunstwerk* 33, 1 (1980), pp. 3–13 (ill.).

Newsweek. "A Look at the Albrights." 26, 19 (Nov. 5, 1945), p. 106 (ill.).

———. "Artist of Decay." 22, 22 (Nov. 29, 1943), pp. 82 and 84 (ill.).

———. "Growth and Death." 64, 21 (Nov. 23, 1964), p. 105 (ill.).

North, Sterling. "The Man Who Drew Wounds: Portrait of a Painter." *Chicago Daily News*, Aug. 5, 1931, p. 12.

O'Connor, John, Jr. "'Among Those Left' by Ivan Le Lorraine Albright." *Carnegie Magazine* 24, 6 (June 1950), pp. 384 and 385 (ill.).

Pollack, Peter. "The Lithographs of Ivan Albright." *American Art Journal* 8, 1 (May 1976), pp. 99–104 (ill.).

Probst, Audrey Neff. "A Voice for the Door." *University of Chicago Magazine* 47, 4 (Jan. 1955), pp. 24–26 (ill.).

Rich, Daniel Catton. "Ivan Le Lorraine Albright: Our Own Jeremiah." *Magazine of Art* 36, 2 (Feb. 1943), pp. 48–51 (ill.).

Robb, Marilyn. "Ivan Le Lorraine Albright Paints a Picture." *Art News* 49, 4 (June/July/Aug. 1950), pp. 44–47, 58, and 59 (ill.).

San Diego Union. "If He Paints He's Ivan; If He 'Sculps' He's Malvin." Feb. 13, 1927 (ill.).

Seznec, Jean. "The Temptation of St. Anthony in Art." *Magazine of Art* 40, 3 (Mar. 1947), pp. 86–93 (ill.).

Smith, Peter Fox. "Vermont's Hidden Master." *Boston Globe*, Feb. 8, 1976, New England Magazine section, pp. 18, 19, 28, and 29 (ill.).

Teller, Susan Pirpiris. "The Prints of Ivan Albright." *Print Review* 10 (1979), pp. 21–35 (ill.).

Time. "Grandeur in Decay." 84, 25 (Dec. 18, 1964), p. 82 (ill.).

———. "Lavender and Old Bottles." 38, 21 (Nov. 24, 1941), p. 81 (ill.).

———. "More Than a Portrait." 70, 4 (July 22, 1957) p. 56 (ill.).

———. "Not Nice, But Unique." 64, 6 (Aug. 9, 1954), pp. 56 and 57 (ill.).

———. "U.S. Art: Albright." 40, 1 (July 6, 1942), pp. 46 and 47 (ill.).

Tucker, Irwin St. John. "'Horror' Features Exhibit." *Chicago Herald Examiner*, Aug. 31, 1930, sec. 4, p. 2.

University of Chicago Magazine. "Early Albright Work Comes to the University." 65, 1 (July–Aug., 1972), pp. 15–17 (ill.).

Van der Marck, Jan. "Ivan Albright: More Than Meets the Eye." *Art in America* 65, 6 (Nov./Dec. 1977), pp. 93–99 (ill.).

Vickerman, Tom. "Albright's Ogres Unmask as Angels." *Chicago Evening Post*, Aug. 26, 1930, Magazine of the Art World section, p. 3.

Ward, Charles S. "Warrenville Residents Search for Albright Models." *Beacon-News*, Oct. 8, 1978, sec. A, p. 6 (ill.).

Weigle, Edith. "The Genius of Ivan Albright." *Chicago Tribune*, Jan. 27, 1963, sec. 6, pp. 24–27 (ill.).

Williams, Marguerite B. "Here and There in the Art World." *Chicago Daily News*, Aug. 29, 1928, p. 15 (ill.).

———. "In an Art Colony All Their Own." *Chicago Daily News*, Aug. 27, 1930, Midweek magazine section, p. 13.

Wolff, Theodore F. "The Many Masks of Modern Art." *Christian Science Monitor* 73, 156 (July 7, 1981), p. 20 (ill.).

FILM

Wilde, Oscar. *The Picture of Dorian Gray*. Directed by Albert Lewin. Metro-Goldwyn-Mayer, 1945.

The Enigma of Ivan Albright. Directed by Lester A. Weinrott and narrated by Earle Ludgin. A Creative Associates Production, Chicago, in association with Lester A. Weinrott and Dan Schuffman, 1964.

ARCHIVAL AND UNPUBLISHED SOURCES

Albright, Ivan. Archive. Ryerson and Burnham Libraries Archives, The Art Institute of Chicago. (See description, pp. 197 and 198.)

Anthony, Frank. "Ivan Albright. A 'Legendry' Interview." Vermont Public Radio, Celebrity Series. May 21, 1978. Transcription by Courtney Graham Donnell.

The Art Institute of Chicago Archives. Department of Twentieth-Century Painting and Sculpture curatorial files, Director's files, exhibition records, historic photograph collection, School of the Art Institute records.

Benton, William. Papers c. 1940–83. Archives of American Art. Smithsonian Institution, Washington, D.C.

Berman, Avis. Interview with Katharine Kuh. Oral History Collections of the Smithsonian Institution, Archives of American Art, Washington, D.C. 1982–83.

Chapin, Francis. Papers 1917–84. Archives of American Art. Smithsonian Institution, Washington, D.C.

Croydon, Michael. "Shadows of the Real: The Vision of Ivan Albright." Lectured delivered at Chicago, Arts Club, Oct. 14, 1993. Transcription by Courtney Graham Donnell.

Cummings, Paul. Interview with Ivan Albright. Oral History Collections of the Smithsonian Institution, Archives of American Art, Washington, D.C., Feb. 5–6, 1972.

Gair, Sondra. Interview with Ivan Albright. Chicago, WBEZ, "Options." C. 1978. Transcription by Courtney Graham Donnell and Jennifer Stone.

Ludgin, Earle. Papers 1930–81. Archives of American Art. Smithsonian Institution, Washington, D.C.

McCabe, Helen. Letters 1942–83. Archives of American Art. Smithsonian Institution, Washington, D.C.

Weinberg, Jack. Interview with Ivan Albright. Glencoe, Illinois. Oct. 1969.

Notes

DONNELL ESSAY

1. The Art Institute of Chicago, Ryerson and Burnham Libraries, Ivan Albright Archive, Poetry (1930s), p. 1.

2. Adam Emory Albright, *For Art's Sake* (Chicago and Crawfordsville, Ind., 1953), p. 48.

3. Ibid., p. 98.

4. Ivan Albright recalled the years he and Malvin modeled for his father: "We posed as models until we were about twelve years old. And I always got the worst position. . . . [My father] used to have a bag full of models' clothes. . . . He painted what you call American country children. . . . He dressed me up as a girl one time, put me on a rock at an angle of ninety degrees, . . . and then he said I made the worst-looking girl he ever saw. Thank God!"; see Frank Anthony, "Ivan Albright, A 'Legendry' Interview" (VPR Celebrity Series), Vermont Public Radio, May 21, 1978, transcribed by Courtney Graham Donnell, p. 6.

Adam Emory had one-person exhibitions at the Art Institute in 1900, 1902, 1911, 1912, and 1920 (the last entitled "Paintings of Children in South America and Southern California"). This is more than any other painter during this period; see Michael Croydon, "Shadows of the Real: The Vision of Ivan Albright," lecture at the Arts Club of Chicago, Oct. 14, 1993, taped and transcribed by Courtney Graham Donnell.

5. Among the Chicago-area artists who frequented the Albrights' home was Lucie Hartrath, who was known for her landscapes of Brown County, Indiana; Alfred Juergens, who studied in Munich along with Adam Emory; and Pauline Palmer, who studied with Charles Hawthorne (as Ivan Albright was to do) and who became associated particularly with Cape Cod scenes. East Coast artists who also visited the Albrights included Bostonians Frank W. Benson, Childe Hassam, Abbot Thayer, and Charles Woodbury. See Ivan Albright, interview with Paul Cummings, Feb. 5–6, 1972, Oral History Collection, Archives of American Art, Smithsonian Institution, Washington, D.C., p. 3; and Anthony (note 4), pp. 5 and 6.

6. Ivan Albright, taped interview with Dr. Jack Weinberg, Oct. 1969.

7. Lawrence Wright, "Double Mystery," *New Yorker* 71, 23 (Aug. 7, 1995), p. 49.

8. Ibid.

9. That Malvin followed Ivan everywhere was related by Alice Albright Arlen, letter to Courtney Graham Donnell, Jan. 23, 1996. In letters written in the 1930s to girlfriends Marie Engstrand and Dorothy Elfrink, Ivan often praised Malvin and listed his various accomplishments. I am grateful to Kristine McGuire (Engstrand's daughter) and Dr. Benjamin Odom (Elfrink's son) for sharing these two groups of letters with me. Stories abound about the twins' fierce competition with each other in games (see Chronology, fig. 12). For instance, an old Warrenville friend, Harold Bollweg, recalled, in a June 1996 telephone conversation with

Courtney Graham Donnell, their intense battles at ping-pong.

10. The only writer to date to raise the issue of the significance of Ivan's twinship and its relationship to his art is Joshua Kind; see idem, "Reassessing Albright," *New Art Examiner* 6, 3 (Dec. 1978), p. 10.

11. Headline, *Chicago Daily News*, May 15, 1943, News-Views sec., p. 2.

12. Ivan Albright, interview with Sondra Gair, "Options," WBEZ, Chicago, c. 1978, transcribed by Courtney Graham Donnell and Jennifer Stone, p. 4. I am grateful to Peter Fox Smith for lending me a tape of this radio show.

13. *New Trier Echoes* 13, 8 (June 1915), p. 23.

14. Cummings (note 5), p. 5.

15. *New Trier Echoes* (note 13).

16. Gair (note 12), p. 5.

17. Ibid.

18. On the altarpiece, see Sterling North, "The Man Who Drew Wounds: Portrait of a Painter," *Chicago Daily News*, Aug. 5, 1931, p. 12. *Oaks in Winter* is listed under no. 6 in the museum's exhibition catalogue.

19. Arlen (note 9).

20. In a letter of June 24, 1966, to his patron Senator William Benton, who bought two medical sketchbooks (no. 1) from Albright that year (he later donated them to the University of Chicago), the artist claimed, "From the point of view of history these sketches are unique as I was the chief if not the only medical drawer with the AEF." See Chicago, University of Chicago, Renaissance Society, *An Exhibition of Medical Drawings by Ivan Lorraine Albright* (1972), exh. cat. by Katharine L. Keefe and Harold Haydon, n. pag. In fact Ivan was neither the only army medical draftsman nor had he invented the job, as he claimed, for such documentation had been taking place since the Civil War; see Robert S. Henry, *The Armed Forces Institute of Pathology: Its First Century 1862–1962* (Washington, D.C., 1964), p. 170. The National Museum of Health and Medicine in Washington, D.C., has examples of work by World War I artists, but none by Albright. I am grateful to Michael Rhode, Archivist, Otis Historical Archives, National Museum of Health and Medicine, Department of Defense, Armed Forces Institute of Pathology, Washington, D.C. for providing this information.

21. Cummings (note 5), p. 9.

22. Albright reminisced about his brief apprenticeships in his radio interview with Frank Anthony (note 4), p. 7: "I didn't know enough about math, and I found out [architecture is] big business."

23. "[It was] the only recourse . . . ": ibid., p. 3. For the Albright twins' academic records, see The Art Institute of Chicago, School of the Art Institute, Registrar Records.

24. Marie Walsh Sharpe (1890–1985) was an astute businesswoman and philanthropist, providing significant support for the American Bar Association Fund for Public Education and establishing the Marie Walsh Sharpe Art Foundation to identify and nurture gifted,

young visual artists. I am grateful to Anne C. Campbell and Kathy Haase of the ABA, Chicago, and Joyce Robinson, President and Executive Director of the Marie Walsh Sharpe Art Foundation, Colorado Springs, Colorado, for the information they provided; and to Nicholas Juett, my former research intern and a recipient of a Sharpe Foundation grant, for bringing this early portrait to my attention.

25. The building's Greek Revival style earned it landmark status in the 1930s. Currently serving as Warrenville's Historical Society, and containing some Albright memorabilia, it bears today the sign "The Albright Studio" over its entrance. See Marguerite B. Williams, "Here and There in the Art World," *Chicago Daily News*, Aug. 29, 1928, p. 15.

26. Jan Van der Marck, "Ivan Albright: More Than Meets the Eye," *Art in America* 65, 6 (Nov./Dec. 1977), p. 97.

27. Headline, *San Diego Union*, Feb. 13, 1927; Ivan Albright Archive, Scrapbook, vol. 1, n. pag.

28. I am very grateful to Dr. David Teplica, a plastic surgeon and photographer who has photographed and studied twins extensively, for having determined that Ivan and Malvin were almost certainly mirror twins. The direction or pattern of their hair, smiles, eyebrows, facial wrinkles, and nasal structure, etc., was exactly, or nearly exactly, opposite, which meant that, when one looked at the other, it was as if he were seeing his very own reflection in a mirror.

29. Cummings (note 5), p. 74.

30. To the three half-length paintings in the present exhibition from this period should be added *I Drew a Picture in the Sand and the Water Washed It Away (The Theosophist)* (1927; The Art Institute of Chicago).

31. For more on Brother Peter Haberlin, see "Brother Peter Haberlin, OFM," *Franciscan Herald* (May 1934), p. 230; and Walter F. McEntire, "The Last of the Padres—Bro. Peter Haberlin, O.F.M.," *Franciscan Fathers of California: Historical Souvenir and Year Book* (Los Angeles, 1919), pp. 119–26. I am grateful to Robert Cozzolino for his research on the Albright twins' monk projects.

32. Cummings (note 5), p. 34.

33. Ibid., p. 37. The painting of Brother Peter bore a number of titles before receiving its final appellation. The 1927 newspaper article about it (note 27), refers to it as "The Last of the Padres." It may be the painting Albright exhibited in The Art Institute of Chicago's thirty-third Chicago and Vicinity exhibition (1929), no. 3, as "The Catholic." In his 1931 three-person exhibition at the Art Institute, "Paintings by George and Martin Baer and Ivan Le Lorraine Albright," it was called "He Verily Loveth Me and I Him." Two years later, in Philadelphia, at the Pennsylvania Academy of the Fine Arts 128th Annual Exhibition (1933), no. 116, the artist was calling it "Verily, Verily He Loveth Me and I Him." Only in 1943, when it was included in New York, The Museum of Modern Art, *American Realists and Magic Realists*, exh. cat. ed. by Dorothy C. Miller

and Alfred H. Barr, Jr., intro. Lincoln Kirstein (1943–44), no. 24, did it assume the title it bears today. The titles *Follow Me* and *The Monk* were added to the work's name in the catalogue of his first museum retrospective, The Art Institute of Chicago and New York, Whitney Museum of American Art, *Ivan Albright: A Retrospective Exhibition*, exh. cat. (1964–65), no. 12.

34. "My dad . . .": Cummings (note 5), pp. 33 and 34. "I get tired . . .": Grace Glueck, "An Artist in the Flesh," *New York Times*, Feb. 7, 1965, sec. 2, p. 20; cited in Michael Douglas Kahan, "Subjective Currents in American Painting in the 1930s," Ph.D. diss., City University of New York, 1983, p. 76.

35. Cummings (note 5), p. 34.

36. Katharine Kuh, "Ivan Albright," *The Artist's Voice: Talks with Seventeen Artists* (New York, 1960), p. 36.

37. Ivan Albright Archive, Poetry (1930s), p. 65.

38. Ivan Albright, cited in Katharine Kuh, "No Single Fact Is as It Seems: Ivan Albright, Veteran Maverick, Makes His Own World," *Saturday Review* 50, 6 (Feb. 11, 1967), p. 24.

39. "Some Interesting Comment on Our May Issue Cover Design," *Electric Light and Power* 6, 6 (June 1928), p. 115.

40. Cummings (note 5), p. 17.

41. Kuh (note 38), pp. 24 and 25.

42. Irwin St. John Tucker, "'Horror' Features Exhibit," *Chicago Herald Examiner*, Aug. 31, 1930, sec. 4, p. 2. That the painting was taken off view was reported in "Did Its Beauty Cause Toledo to Ban This?," *Art Digest* 3, 20 (Sept. 1929), p. 5.

43. John Canaday, "Meet Ivan Albright," *New York Times*, Feb. 7, 1965, sec. 2, p. 19.

44. Michael Croydon, *Ivan Albright* (New York, 1978), p. 46.

45. At the same time that Ivan executed this painting, Malvin was at work on a sculpture of a nude (Weininger, fig. 26), using the fisherman's granddaughter as a model; see Lucy Key Miller, "Front Views and Profiles: Heavy the Coat," *Chicago Tribune*, Mar. 26, 1954, sec. 2, p. 10.

46. C. J. Bulliet, "Albrights Peck's Bad Boys of Chicago," *Chicago Evening Post* [c. 1946]; see Ivan Albright Archive, Scrapbook, vol. 1, n. pag.

47. They would bring completed works into the church for one another to see and to display for potential customers; telephone conversation between Marjorie (Tishie) Lins, niece of Ivan and Malvin Albright, and Courtney Graham Donnell, July 31, 1996.

48. Cummings (note 5), p. 74.

49. "With tempera . . .": Harriet and Sidney Janis, "Albright: Compulsive Painter," *View* 3, 1 (1943), p. 35. The walls of Albright's studio on Ogden Avenue in Chicago were painted mat black. In a telephone conversation, July 1996, with Courtney Graham Donnell, the artist's daughter Blandina Albright Rojek confirmed that his studio in Woodstock, Vermont, had north light, but its interior walls were covered with barn boards painted black. She also mentioned that he wore black shirts when painting in order to reduce reflections. Katharine Kuh discussed Albright's dislike of "bright light or, for that matter, any kind of cheerful, flat sunlight. He prefers cloudy, gray skies which allow brooding shadows at once to define form and yet suggest the unknown"; see Kuh (note 38), p. 23.

50. Information from photo display for "Ivan Albright Day," Oct. 15, 1978; see files, Warrenville Public Library, Warrenville, Illinois.

51. The painting carried the title *God Created Man in His Own Image* in Albright's one-person exhibition "Ivan Le Lorraine Albright," at the Old White Art Gallery in the Greenbrier, White Sulphur Springs, West Virginia, in 1935. During the Depression, the resort served as a summer retreat for wealthy southerners, as well as an elegant resting spot for well-off travelers. In

the summer months, the Greenbrier also became an artists' colony, directed by Natalie and William Grauer, both of whom taught at Western Reserve University in Cleveland. Natalie Grauer had studied, among other places, at the School of the Art Institute, which is perhaps how Albright came to exhibit at the Greenbrier. Other artists who showed work there in these years included John R. Grabach and Rockwell Kent. I am grateful to Robert S. Conte, Greenbrier historian, for this information.

52. Ida Rogers, in an interview with Courtney Graham Donnell and Jennifer Stone, July 1, 1992.

53. Marguerite B. Williams, "Exhibit Shows Capabilities of Chicago Artists: Pictures at Institute Appear Favorably Beside French Works," *Chicago Daily News*, July 30, 1931, p. 11.

54. Ivan Albright Archive, Poetry (c. 1930).

55. "Cursing the model's habit": Croydon (note 44), p. 50. "Once [Ivan] gave me . . .": Rogers (note 52).

56. As discussed above (note 9), Albright corresponded with Engstrand. In one of his letters, he enclosed twenty-five typed poems, including some of his better-known verses, such as "A Painter Am I" (excerpted above; for full poem, see Kuh [note 36], p. 36).

57. Ivan Albright, "Chicago's Foremost Painter Takes Issue with Art Critic," *Chicago Daily News*, Dec. 13, 1939, Christmas book sec., p. 17.

58. Anthony (note 4), p. 9.

59. White Sulphur Springs (note 51; unpaginated catalogue annotated with prices of exhibited works, Ivan Albright Archive). Albright's highest price, $13,000, was for *Room 203* (listed under no. 10 as *God Created Man in His Own Image*), but he obviously had a sliding scale (see note 66). During these years, even established artists such as Thomas Hart Benton, John Steuart Curry, and Charles Sheeler only charged between $1,200 and $2,500 for their paintings; see, for example, the catalogue of The Art Institute of Chicago's fifty-third American Exhibition (1942), where prices for works by these artists are listed. In the 1940s, Malvin was asking $3,000 and $4,000 for his major gouaches, far beyond the prices set for comparable works by artists of equal accomplishment.

60. Malvin's artist's statement in *American Realists and Magic Realists* (note 33), p. 61, reads, in part: "Painting was just so easy after sculpture. . . . Of course I didn't need to study painting—I was just born a great artist I guess." For Ivan on Einstein, see Ivan Albright Archive, Notebook 29, p. 24 (Oct. 20, 1970); and Hanover, New Hampshire, Dartmouth College, Hood Museum of Art, *Ivan Albright: The Late Self-Portraits*, exh. cat. with essays by Richard R. Brettell and Phylis Floyd (1986), p. 44.

61. Josephine Albright, interview with Courtney Graham Donnell, Oct. 26, 1990.

62. Nonetheless, in the 1930s, Albright was active in the Chicago Society of Artists, serving as its president and organizing its artists' balls.

63. "Chicago's Ivan Albright Talks about the 'Unknown World' of His Art to Katharine Kuh," *Chicago Daily News*, Jan. 19, 1963, Panorama sec., p. 7.

64. See Croydon (note 44), pp. 219 and 220; and Cummings (note 5), p. 42.

65. Chicago, Associated American Artists Galleries, *First Joint Exhibition: The Albright Twins*, exh. cat. (1946), n. pag.

66. Albright's 1934 self-portrait is no. 516 in The Art Institute of Chicago, *A Century of Progress Exhibition of Paintings and Sculpture*, exh. cat. (1934). Albright actually charged Ludgin a reasonable fee—$500—for the commission, which he agreed to let the collector pay in $25 monthly installments over twenty months.

67. "Albright Twins: They Paint Gruesome Masterpieces in an Abandoned Methodist Church," *Life* 16, 13 (Mar. 27, 1944), p. 66.

68. Kuh (note 38), p. 24.

69. Van der Marck (note 26), p. 97.

70. Ivan Albright, in Chicago and New York (note 33), p. 17.

71. Kuh (note 36), p. 28.

72. Van der Marck (note 26), pp. 96 and 97. The first notes and diagrams made in his notebooks for a work in progress relate to *Poor Room* (no. 40); see Ivan Albright Archive, Notebooks 15, 17–19, and 21–23, *passim*.

73. The Albright twins actually made their own charcoal from swamp maple, and, in the 1930s, had a business called the All American Charcoal Company; see Cummings (note 5), p. 60; and Marilyn Robb, "Ivan Le Lorraine Albright Paints a Picture," *Art News* 49, 4 (June/July/Aug. 1950), p. 46. All through school, Ivan also made his own colors, grinding pigment on a granite slab. Later he used Winsor & Newton paints, but tried a number of other kinds, including Verheyden's and Blockx. On Albright's materials, see Robb, pp. 58 and 59; Cummings (note 5), p. 60; and Croydon (note 44), p. 108.

74. Van der Marck (note 26), pp. 96 and 97. There is some disagreement about whether Albright actually used one-haired paint brushes. In the late 1970s, Michael Croydon purchased brushes for Albright. Based on what he was asked to find, Croydon does not believe that the artist was using one-haired brushes, at least at this time; Croydon, in conversation with Susan F. Rossen, June 1996.

75. Cummings (note 5), p. 38.

76. "I looked around . . .": ibid., p. 32. "I thought a girl's hand . . .": Paul Cummings, "Ivan Albright," *Artists in Their Own Words* (New York, 1979), p. 54.

77. Anthony (note 4), p. 11.

78. In connection with his carved frames, it is interesting to remember that Albright was descended, on his father's side, from a line of rifle makers who carved their own elaborate, wooden stocks; see Frederick A. Sweet, "A Tradition of Fine Craftsmanship," in Chicago and New York (note 33), p. 11.

79. See Chicago, Walden Book Shop, *First Collected Exhibition of American Paintings by Ivan Le Lorraine Albright*, checklist (1930). Albright selected the following nine works for inclusion: *The Oarsman (Heavy the Oar to Him Who Is Tired, Heavy the Coat, Heavy the Sea)* (no. 16); *The Village Blacksmith* (an early title for fig. 13); *Vanity of Vanities, Vanity of Vanities, Said the Preacher, All is Vanity* (an early title for no. 9); *The Theosophist* (1927; The Art Institute of Chicago); and nos. 10, 11, and 13–15.

80. Chicago, "Paintings by George and Martin Baer and Ivan Le Lorraine Albright" (note 33). All of the paintings shown the previous year at Walden's gallery (see note 79) were included except no. 10. Also included were *Ida* (no. 17; this was its second showing), as well as nos. 5, 7, 8, 12, and 18. Malvin Albright apparently never had a one-person show. On October 31, 1931, the Art Institute's Board of Trustees turned down a request from him to have a solo exhibition there. However, on September 26, 1935, the trustees approved a show of works by the twins, to be held the following summer; for unknown reasons, this did not occur. I am grateful to Robert Cozzolino for bringing these records to my attention.

81. "Infernal skill": Tucker (note 42). "One of Chicago's strongest . . .": Marguerite B. Williams, "In An Art Colony All Their Own," *Chicago Daily News*, Aug. 27, 1930, Midweek mag. sec., p. 13.

82. In 1933 the Dayton Art Institute, Dayton, Ohio, hosted "Paintings by Ivan Le Lorraine Albright"; it is not known how this exhibition originated. Two years later, the artist showed work at the Greenbrier in White Sulphur Springs, West Virginia (see note 51).

83. "Latter Day Rembrandt: Four Paintings by Ivan Le Lorraine Albright," *Esquire* 6, 2 (Aug. 1936), p. 103. The article illustrates nos. 15, 16, 20, and *The The-*

osophist. The five reviews Albright wrote for Chicago newspapers are listed under "Articles" in the Selected Bibliography.

84. "A Look at the Albrights," *Newsweek* 26, 19 (Nov. 5, 1945), p. 106.

85. New York, The Metropolitan Museum of Art, *Artists for Victory: An Exhibition of Paintings, Sculpture, Prints* (1942–43) [no. 2]. When Albright turned down the major purchase prize, it was awarded to John Steuart Curry for *Wisconsin Landscape*. *The Door* also won the Norman Wait Harris Silver Medal at The Art Institute of Chicago's fifty-second annual American Exhibition (1941); and the Temple Gold Medal at the one hundred thirty-seventh Annual Exhibition (1942) of the Pennsylvania Academy of the Fine Arts, Philadelphia.

86. Daniel Catton Rich, cited in "Super-Realist Albright Bought by Chicago," *Art Digest* 16, 5 (Dec. 1, 1941), p. 16.

87. Van der Marck (note 26), p. 98, n. 14.

88. "U.S. Art: Albright," *Time* 40, 1 (July 6, 1942), pp. 46 and 47.

89. New York, The Museum of Modern Art, *Twentieth-Century Portraits*, exh. cat. by Monroe Wheeler (1942). The exhibition featured portraits by 160 American and European artists. In 1943 and 1944, the show traveled to a number of cities, including Baltimore, Chicago, St. Louis, San Francisco, and West Palm Beach. For "American Realists and Magic Realists," see New York (note 33).

90. Oscar Wilde, *The Picture of Dorian Gray*, in *The Portable Oscar Wilde*, selected and ed. by Richard Aldington (New York, 1946), p. 139.

91. "20th Century Portraits," *Christian Science Monitor*, Oct. 16, 1943; see Ivan Albright Archive, Scrapbook, vol. 1, n. pag. Lewin sent a telegram to The Museum of Modern Art in March 1943 asking for Ivan Albright's address; see Ivan Albright Collection File, Department of Painting and Sculpture, The Museum of Modern Art, New York.

92. "Albright is a writers' artist": Van der Marck (note 26), p. 98. Albright's transcription of passages from Wilde's novel: Ivan Albright Archive, Notebook 16, pp. 7–17 (1943).

93. Robbin Coons, "Hollywood Gossip," *The Pasadena Star-News*, Mar. 7, 1944. In fact, Malvin had used his given name until about 1932. Interestingly, Ivan not only took Malvin with him to Hollywood, but also some of his own paintings, including *The Door* (no. 24); see Cummings (note 5), p. 33.

94. "Artist of Decay," *Newsweek* 22, 22 (Nov. 29, 1943), p. 82.

95. I am grateful to Alice Albright Arlen for furnishing me with a copy of her father's contract with Metro-Goldwyn-Mayer.

96. Coons (note 93).

97. Erskine Johnson, "Artists Are Odd People," *Cincinnati Ohio Post*, Mar. 21, 1944; see Ivan Albright Archive, Scrapbook 1, n. pag.

98. Robert Hardy Andrews, "Some Stories That Didn't Get into My Book," *Chicago Daily News*, 1963, Panorama sec., p. 5; see Ivan Albright Archive, Scrapbook, vol. 1, n. pag.

99. In a letter to Courtney Graham Donnell of Aug. 3, 1993, Hurd Hatfield stated, "During the filming of 'The Picture of Dorian Gray,' I met both the Albrights but unfortunately couldn't pose for them, as I was busy acting." However, a studio stand-in, Skeets Noyes, did pose occasionally.

100. The film starred, in addition to Hatfield, George Sanders, Angela Lansbury, Donna Reed, and Peter Lawford; see Jay Robert Nash and Stanley Ralph Ross, *The Motion Picture Guide 1927–1983*, vol. 6 (Chicago, 1986), p. 2395.

101. On the Art Institute showing, see Frank Holland, "World of Art: Exhibition Hits Record," *Chicago Sun*, Dec. 30, 1945, p. 9. Early in 1946, Ivan's *Dorian Gray* was exhibited in Chicago at Riccardo's Restaurant and art gallery (Weininger, fig. 1), where it had to be guarded by a police detail because of the $100,000 value the artist had placed on it; see "Hi-Jinks at an Artists' Party," *Chicago Daily News*, Feb. 23, 1946, News-Views sec., p. 8 and 9. Ivan continued the "hijinks" around *Picture of Dorian Gray* by decorating at least one necktie with a replica of his painting (Chronology, fig. 16). It was given to the Art Institute in 1996 by Mr. and Mrs. Joseph Randall Shapiro, major Chicago collectors of Surrealism. Both Albright twins painted neckties with portraits of Byron Harvey, Jr., a Chicagoan who had assumed a bit part, as a brakeman, in the 1945 Hollywood film "The Harvey Girls," another MGM production. Ivan's is illustrated in the Chronology (fig. 17); Malvin's is apparently lost.

102. Harriet Janis, "Artists in Competition: Eleven Distinguished Artists Compete in a Struggle with the Temptation of St. Anthony," *Arts and Architecture* 63, 4 (Apr. 1946), pp. 30–33, 52, 54, and 55. The competition was an enlightened endeavor from many points of view. The artists selected embraced a range of aesthetic approaches, from Expressionism and Magic Realism to Neo-Romanticism and Surrealism. Clearly, an effort was made to include a broad spectrum of contemporary society: immigrants and refugees, Jews, an African American, women, and so forth. The artists were each paid $500 to cover their costs, including shipping. Their submissions were returned to them after the competition.

While the Maupassant story, about a rogue who uses women to advance himself in society, actually required a painting with the theme of Christ Walking on the Waters, the Hays Office, which was the branch of the Motion Picture Association of America that monitored the movies for possible moral and religious offenses, "suggested" that the theme of Saint Anthony's temptation be used instead; see Janis, p. 30.

103. While his loss to Ernst was disappointing, Albright had arranged a financial advantage for himself; unbeknownst to his competitors, he had arranged to receive a percentage of the movie's proceeds. He told Paul Cummings, "I wouldn't have entered the competition [otherwise]"; see Cummings (note 5), p. 42. The 1947 movie, which, like "Dorian Gray" starred George Sanders and Angela Lansbury, as well as John Carradine, was not successful.

Lewin continued his collaboration with artists in his 1950 movie "Pandora and the Flying Dutchman," for which he commissioned Man Ray to paint a Surrealist portrait of star Ava Gardner. I am grateful to Dennis Nawrocki for this information.

104. Janis (note 102), p. 54. In September 1946, all of the entries were exhibited at Knoedler Galleries, New York, with a brochure that included the longest poem Albright ever wrote, on the Saint Anthony theme. In 1981 nine of the paintings, including Albright's, were reunited in an exhibition held in Cologne at the Museum der Stadt, *Westkunst: Zeitgenössische Kunst seit 1939*, exh. cat. by Laszlo Glozer (Cologne, 1981), pp. 109–11, 380, and 381.

105. Croydon (note 44), p. 117.

106. *Drama (Mephistopheles)* (fig. 24) is actually filled with tiny figures.

107. Eleanor Jewett, "Albright Twins' Art Exhibition Opens Tonight," *Chicago Tribune*, Mar. 29, 1946; see Ivan Albright Archive, Scrapbook, vol. 1, n. pag.

108. "The Art Galleries, 'A' to 'Z' Including 'P,'" *New Yorker* (Nov. 3, 1945); see Ivan Albright Archive, Scrapbook, vol. 1, n. pag.

109. The Findlay Galleries exhibition was reviewed by W. W. Hercher, "What's In a Name?," *East Liverpool Ohio Review* (Apr. 14, 1942); see Ivan Albright Archive, Scrapbook, vol. 1, n. pag. Works by Albright mentioned include *Trees, Then Trees, and Reflections of Trees*; *If I Were Irish*; *And the Starlight Fell Upon Her Lips, and Her Lips Were Girls' Lips, Full Molded Under the Starlight* (see Croydon [note 44], pl. 45); and *Second Storeys Are Popular* (an early title for *In the Year 1840*; Weininger, fig. 22).

110. Malvin showed his best work in New York, where much of it had never been seen; see New York, Associated American Artists Galleries, *First Joint Exhibition: The Albright Twins*, exh. cat. (1945), n. pag. In Chicago he chose to exhibit only landscapes of Maine; see Chicago (note 65).

111. "Many visitors . . .": "A Look at the Albrights," *Newsweek* 26, 19 (Nov. 5, 1945), p. 106. "Zsissly's work is as deliberately simplified . . .": Frank Holland, "Thirty-Six Oils Exhibited by Famous Albrights," *Chicago Sun*, Apr. 7, 1946; see Ivan Albright Archive, Scrapbook, vol. 1, n. pag. "What has been long indicated . . .": "The Passing Shows," *Art News* 44, 14 (Nov. 1–14, 1945), p. 26.

112. Van der Marck (note 26), p. 94.

113. The artist admitted having used a dictionary to devise this title (Croydon [note 44], p. 103), but dictionary definitions do not clarify its meaning: "guttated" signifies "in the form of drops"; "nutant" is "drooping"; and "lycanthrope" refers to a wolfman or werewolf.

114. Albright used both lithographic stones and zinc plates to make his prints. For further information on Albright's printmaking, see Peter Pollack, "The Lithographs of Ivan Albright," *American Art Journal* 8, 1 (May 1976), pp. 99–104; Susan Pirpiris Teller, "The Prints of Ivan Albright," *Print Review* 10 (1979), pp. 21–35; and Lake Forest, Ill., Lake Forest College, *Graven Image: The Prints of Ivan Albright 1931–1977*, exh. cat. comp. and ed. by Gael Grayson, intro. Michael Croydon (1978).

115. London, Tate Gallery, *American Painting from the Eighteenth Century to the Present Day*, exh. cat. (1946). "Albright . . . stole the show": John Anthony Thwaites, "London Letter: The Tate Show: Misrepresenting American Art," *Magazine of Art* 39, 8 (Dec. 1946), p. 382.

116. Josephine Albright (note 61).

117. For more on the Patterson family, see John Tebbel, *An American Dynasty: The Story of the McCormicks, Medills and Pattersons* (New York, 1968); and Lloyd Wendt, *Chicago Tribune: The Rise of a Great American Newspaper* (Chicago et al., 1978).

118. Lawrence Van Gelder, "Josephine Patterson Albright, Colorful Journalist, Dies at 82," *New York Times*, Jan. 18, 1996, sec. B, p. 11.

119. "Pals": Josephine Albright (note 61). The marriage proposal: Helen Brooks, Woodstock, Vermont, taped recollections, date unknown.

120. Croydon (note 44), p. 249.

121. Albright used Riccardo as the model for *Mephistopheles* (Josephine Albright, however, posed for the figure's legs). The artist clearly had fun with this seven-foot canvas, including such visual puns as eggs ("deviled eggs") and such Boschian references as tiny female nudes in cauldrons and egg shells. When Riccardo's Restaurant was closed, in 1995, the murals that remained were removed and sold.

122. Frank Holland, "Albright, Twin Sons in First Joint Show," *Chicago Sun-Times*, Apr. 16, 1950, sec. 2, p. 6.

123. Eleanor Jewett, "Albrights Have an Outstanding April Exhibition," *Chicago Tribune*, Apr. 16, 1950, pt. 7, sec. 1, p. 5.

124. Cornelia Fairbanks Poole Ericourt was the daughter of Warren Fairbanks, president and publisher of the *Indianapolis News*; and the granddaughter of Charles Warren Fairbanks, who served as Vice-President under Theodore Roosevelt.

125. Arlen (note 9).

126. Jean Dubuffet, "A Commentary," in Chicago and New York (note 33), p. 7.

127. Cited in Robb (note 73), p. 45.

128. Albright had several odd ideas for *Poor Room* that, in the end, he did not carry out. As one newspaper reported, "Albright . . . is planning to build a brick wall, climb into a suit of red underwear and do a portrait of himself. The portrait will show him seated inside a ramshackle window, eating an egg. The egg is there, presumably, because Albright has a fascinating egg cup which gives off interesting light"; see W. W. Hercher, "Famed Artist Will Paint Self in Red Underwear, Eating an Egg," *Milwaukee Journal*, May 28, 1943, Green Sheet sec., p. 1. Another source revealed that he considered including a painting of a murderer's face in a red-plush frame that would hang on the wall opposite the window, and placing a bird that had died after only four days of life in a nest in one of the tree branches; see Croydon (note 44), p. 105. He must have realized that the sense of mystery and violence he was aiming for would be better achieved without such literal inclusions.

129. Robb (note 73), p. 82. In addition to this article, the setup and painting were documented by photographers Peter Pollack in 1950 (see fig. 25 and Chronology, fig. 26) and Arthur Siegel in 1961 (see fig. 26 and Chronology, fig. 25); and by Lester A. Weinrott in a 1964 film, "The Enigma of Ivan Albright," narrated by Earle Ludgin, produced by Creative Associates in association with Weinrott and Dan Schuffman, and apparently shown publicly only once, at the 200 Gallerie, Chicago.

130. Robb (note 73). In Croydon (note 44), p. 159, an important color plate (pl. 66) illustrates the painting in 1956, in an unfinished state, showing charcoal outlines on white-gessoed canvas before paint was applied. Comparison with the final work reveals only minor changes: he eliminated two small figurines, once situated inside the room at the lower right; he repositioned the floating feather; and he lengthened the bottom edge of the curtain that blows out of the window frame next to the hand, whose fingers he made less stubby and more elegant.

131. See *Sixty Years on the Arts Club Stage* (Chicago, 1975), pp. 15 and 32.

132. Dubuffet (note 126), p. 8. The translation from the French published in the catalogue of the 1964–65 exhibition (Chicago and New York [note 33]) was by Josephine Albright; it has been modified slightly here by the editors.

133. Cited in "Grandeur in Decay," *Time* 84, 25 (Dec. 18, 1964), p. 82.

134. Van der Marck (note 26), pp. 97 and 98.

135. Kind (note 10), pp. 10 and 11.

136. Cummings (note 5), p. 48.

137. Cited in "More Than a Portrait," *Time* 70, 4 (July 22, 1957), p. 56. One newspaper article said what most seem to have felt: "The painting . . . is technically stunning but most unflattering"; see Cholly Dearborn, "Job Ahead for Lunar-Tics," *Chicago American*, Nov. 13, 1958, p. 28.

138. Kuh (note 38), p. 24.

139. Canaday (note 43).

140. Chicago and New York (note 33).

141. Emily Genauer, "Albright's 'Victims in a World of Shadow,'" *New York Herald Tribune*, Jan. 31, 1975, New York Magazine sec., p. 31. Canaday (note 43). Lucy Lippard, "New York Letter," *Art International* 9, 3 (Mar. 1965), p. 58.

142. Katharine Kuh, "Ivan Albright," *The Open Eye: In Pursuit of Art* (New York et al., 1971), p. 3.

143. Phylis Floyd, "Ivan Albright: The Vermonter (If Life Were Life There Would Be No Death)," in Hanover (note 60), p. 19.

144. Albright told his biographer, Michael Croydon,

that, in moving to Vermont, he had "come home," since his ancestors on his mother's side had settled in the nearby town of Huntington two hundred years previously; see Croydon (note 44), p. 255.

145. Kuh (note 142).

146. Croydon (note 44), pp. 266 and 303, notes 108 and 109.

147. Cited in Hanover (note 60), p. 20; see Ivan Albright Archive, Notebook 39, p. 27 (Jan. 28, 1968).

148. Van der Marck (note 26), p. 97. Van der Marck reported that the old wooden boards that lined the studio interior had holes, some as small as nails, through which sunlight pierced and wandered the darkened interior, which the artist recorded in his painting. But, according to Albright's daughter Blandina Rojek (note 49), the studio was so well insulated that such openings probably did not exist. Rather, given the difficulties the artist was experiencing with his vision during this time, it is possible that he was seeing flashes or spots that he turned to his advantage by incorporating them into the painting.

149. The exhibition, "Ivan Albright: The Vermont Farmer," was on view in the Strauss Gallery of the Hopkins Center, Dartmouth College, Hanover, New Hampshire, in the winter of 1975–76. "There is more than a little irony . . .": Van der Marck (note 26), p. 97.

150. Ivan Albright Archive, Notebook 35, p. 35 (June 10, 1977).

151. Alan G. Artner, "At 81, Ivan Albright Enjoys His Gift of Second Sight," *Chicago Tribune*, Oct. 22, 1978, sec. 6, p. 8.

152. Ivan Albright, cited in New York, The Metropolitan Museum of Art, *American Painting in the 20th Century*, exh. cat. by Henry Geldzahler (1965), p. 154.

153. Richard R. Brettell, "Ivan Albright: The Self-Portraits," in Hanover (note 60), p. 6.

154. Cited in Washington, D.C., International Exhibitions Foundation, *American Self-Portraits*, exh. cat. org. by Ann C. Van Devanter and Alfred V. Frankenstein (1974), p. 158.

155. Pascal Bonafoux, *Portraits of the Artist: The Self-Portrait in Painting* (Geneva and New York, 1985), p. 68.

WEININGER ESSAY

1. Ralph M. Pearson, *Experiencing American Pictures* (New York, 1943), pp. 181–87. John I. H. Baur, *Revolution and Tradition in Modern American Art* (Cambridge, Mass., 1951), pp. 101 and 143. H. H. Arnason, *History of Modern Art* (New York, 1968), pp. 429 and 430. Barbara Rose, *American Art since 1900*, rev. ed. (New York and Washington, D.C., 1975), pp. 108 and 266. Interestingly, Albright was eliminated from the latest edition of Arnason's book; see ibid., 3rd ed., updated by Daniel Wheeler (New York, 1986).

2. Alexander Eliot, *Three Hundred Years of American Painting* (New York, 1957), p. 248.

3. The Ivan Albright Archive, in the Ryerson and Burnham Libraries, The Art Institute of Chicago, has one thousand glass negatives, many of which are photographs taken by Adam Emory Albright.

4. Ivan Albright, interview with Paul Cummings, Feb. 5–6, 1972, Oral History Collection, Archives of American Art, Smithsonian Institution, Washington, D.C., p. 2.

5. Ibid.

6. Albright's recently rediscovered 1921 portrait *Marie Walsh Sharpe* (Donnell, fig. 6) was probably commissioned, but is a student work. His only other early commission is the variant (no. 29) of his 1934 *Self-Portrait* (no. 28) that advertising executive Earle Ludgin ordered in 1935. It was not until 1954 that the

artist was persuaded to accept a commission, to portray the art patron Mary Lasker Block (no. 51). On the terms of his agreement with MGM, see Donnell, pp. 34 and 35.

7. In the 1920s, Albright gave *The Philosopher* (no. 3) to the Layton Art Gallery (now the Milwaukee Art Museum); and *Burgomeister with Key* (no. 6) to the Hackley Art Gallery (now the Muskegon Museum of Art), Muskegon, Michigan (the painting is now in The Detroit Institute of Arts).

8. Beginning in 1935, Albright sold a number of works to the Ludgins (see fig. 8; and nos. 16, 29, 30, 39, 43, 47, and 48). In the mid-1960s, the publisher of *Encyclopædia Britannica*, William Benton, became a patron of the artist (see nos. 1, 7, 8, 66a, and 66b). Peter Pollack and Lawrence M. Pucci also formed collections of Albright's lithographs and gouaches, respectively (for lithographs, see nos. 33 and 44; and for gouaches, see nos. 44, 53, and 55, and Chronology, fig. 28).

9. The twins contributed such services as carpentry and electrical work to the renovation of houses, which helped them to remain solvent, even during the Depression. In addition, Ivan seems to have been an astute investor himself. According to his friend the painter Francis Chapin, he assiduously watched the "stock boards" and made savvy acquisitions. See letter from Francis Chapin to David and Anne McCosh, Jan. 22, 1936, Francis Chapin Papers, Archives of American Art, Smithsonian Institution. I wish to thank Robert Harris for this reference and for the one in note 39 below.

10. Cummings (note 4), p. 10.

11. Little research has been done on Sterba. For a short biographical reference, see Esther Sparks, "A Biographical Dictionary of Painters and Sculptors in Illinois 1808–1945," Ph.D diss., Northwestern University, 1971, vol. 2, p. 624. The pamphlet file of the Ryerson and Burnham Libraries, The Art Institute of Chicago, contains two exhibition announcements (from 1927 and 1928) with some information about the artist.

12. Ivan Albright, interview with Sondra Gair, "Options," WBEZ, Chicago, c. 1978, transcribed by Courtney Graham Donnell and Jennifer Stone, p. 6.

13. Norman L. Rice, "Recollections," in Roger Gilmore, ed., *Over a Century: A History of The School of The Art Institute of Chicago, 1866–1981* (Chicago, 1982), p. 13. Rice, who later served as Dean of the School, became a friend of the Albright twins.

14. Milton W. Brown, *The Story of the Armory Show*, 2d rev. ed. (New York, 1988), pp. 203–14. Other examples of Chicago's conservatism in the 1910s and 1920s include the forced removal of a reproduction of Paul Chabas's *September Morn*, a sentimental academic nude, from a shop window in 1913; the confiscation of a painting of two nudes by Paul Florian from the 1927 No-Jury Society of Artists exhibition; and the seizure that same year by police of a postcard of Giorgione's *Sleeping Venus* from a shop.

15. See Stefan Germer, "Traditions and Trends: Taste Patterns in Chicago Collecting," in Sue Ann Prince, ed., *The Old Guard and the Avant-Garde: Modernism in Chicago, 1910–1940* (Chicago, 1990), pp. 171–91; and Richard R. Brettell and Sue Ann Prince, "From the Armory Show to the Century of Progress: The Art Institute Assimilates Modernism," in ibid., pp. 209–25.

16. See Paul Kruty, "Arthur Jerome Eddy and His Collection: Prelude and Postscript to the Armory Show," *Arts* 61 (Feb. 1987), pp. 40–47. See also Germer (note 15), p. 182.

17. Charlotte Moser, "'In the Highest Efficiency': Art Training at the School of The Art Institute of Chicago," in Prince (note 15), pp. 202–204 and 206.

18. Cummings (note 4), p. 16.

19. McCarter's contact with Lautrec may have stim-

ulated Albright's interest in the artist, whose prints he would later collect (see note 25 below).

20. Moser (note 17), pp. 202 and 203. While considered progressive by Chicago standards, Bellows was actually a fairly traditional artist by the end of the 1910s; even the Armory Show does not seem to have had any real impact on his work. Less focused on the gritty, urban realism of his earlier period, he devoted himself increasingly to landscape and portraiture, interests that coincided with those of the young Albright. On Bellows, see Fort Worth, Texas, Amon Carter Museum, *The Paintings of George Bellows*, exh. cat. by Michael Quick et al., intro. John Wilmerding (New York, 1992). Albright shared Bellows's interest in compositional theory, notably in the golden section and in Jay Hambidge's complex system of dynamic symmetry; see Quick, "Technique and Theory: The Evolution of George Bellows's Painting Style," in ibid., pp. 9–95. For Albright's notes on these systems, see The Art Institute of Chicago, Ryerson and Burnham Libraries, Ivan Albright Archive, Notebooks 1, p. 36 (Jan. 1923), and 3, *passim* (Winter 1924).

21. Cited in New York, The Metropolitan Museum of Art, *American Impressionism and Realism: The Painting of Modern Life, 1885–1915*, exh. cat. by H. Barbara Weinberg et al. (1994), p. 350. For Hawthorne, see also William H. Gerdts, *Art across America: Two Centuries of Regional Painting in America, 1710–1920* (New York, 1990), vol. 1, pp. 55 and 56.

22. Frederick A. Sweet, "A Tradition of Fine Craftsmanship," in The Art Institute of Chicago and New York, Whitney Museum of American Art, *Ivan Albright: A Retrospective Exhibition*, exh. cat. (1964–65), pp. 10–15.

23. Jan Van der Marck, "Ivan Albright: More Than Meets the Eye," *Art in America* 65, 6 (Nov./Dec. 1977), p. 96.

24. On Miller's significance as a teacher, see Milton W. Brown, *American Painting: From the Armory Show to the Depression* (Princeton, N.J., 1955), pp. 182 and 183; and Ellen Wiley Todd, *The "New Woman" Revised: Painting and Gender Politics on Fourteenth Street* (Berkeley, Ca., 1993), esp. pp. 43–48 and 70–82.

25. In addition to prints, Albright owned a few late nineteenth-century works, including a watercolor by Paul Cézanne and prints by Henri de Toulouse-Lautrec.

26. Katharine Kuh, "Ivan Albright," *The Artist's Voice: Talks with Seventeen Artists* (New York, 1960), p. 23.

27. On Pauline Palmer's friendship with Adam Emory Albright, see Cummings (note 4), p. 3. For more on Palmer, see Gerdts (note 21), vol. 2, pp. 313 and 314; and Sparks (note 11), vol. 2, pp. 543 and 544.

28. Kuh (note 26), p. 24.

29. See, for example, Beckmann's *Self-Portrait* (1937; The Art Institute of Chicago); and Schad's *Count St. Genois d'Anneaucourt* (1927; private collection).

30. Dorothy Grafly, "The Whitney Museum's Biennial," *Magazine of Art* 26, 1 (Jan. 1933), p. 8.

31. For *Der Krieg*, see London, Tate Gallery et al., *Otto Dix, 1891–1969*, exh. cat. (1992), pp. 151–54. "Every man's being . . .": Minneapolis Institute of Arts, *German Realism of the Twenties: The Artist as Social Critic*, exh. cat. by Emilio Bertonati et al. (1980), p. 80. See London (ibid., p. 134) for a slightly different translation: "body posture, hands, ears, also the way clothes hang immediately inform and explain the sitter's state of mind."

32. Emilio Bertonati, "Neue Sachlichkeit in a Wider Cultural Context," in Minneapolis (note 31), p. 58.

33. Carl Einstein, *Die Kunst des 20. Jahrhunderts* (Berlin, 1926). Albright's reference to this publication can be found in Ivan Albright Archive, Notebook 45, p. 11 (1926). *The Actress, Anita Berber, in a Sketch* is no. 173 in the catalogue of the twenty-fifth Carnegie Inter-

national (1926). Since it is not reproduced, it is not possible to determine which of the several depictions that Dix did of his good friend this was. His *Portrait of the Dancer Anita Berber* is reproduced and discussed in London (note 31), pp. 133 and 134.

34. Franz Roh, *Nach-Expressionismus: Magischer Realismus* (Leipzig, 1925).

35. "Mystic realist": Margarita Walker Dulac, "Ivan Albright: Mystic Realist," *American Artist* 30, 1 (Jan. 1966), pp. 32–37, 73, 74, and 76. "Magic realist": Lincoln Kirstein, "Introduction," in New York, The Museum of Modern Art, *American Realists and Magic Realists*, exh. cat. ed. by Dorothy C. Miller and Alfred H. Barr, Jr. (1943–44), see pp. 7 and 8. "Romantic realist": New Brunswick, N.J., Rutgers University Art Gallery, *Realism and Realities: The Other Side of American Painting, 1940–1960*, exh. cat. by Greta Berman and Jeffrey Wechsler (1981), pp. 120–23. "Subjective realist": Michael Douglas Kahan, "Subjective Currents in American Painting in the 1930s," unpub. Ph.D. diss., City University of New York, 1983, pp. 73ff. "Realist-expressionist": Arnason (note 1).

36. Todd (note 24), p. 71; see also pp. 70–77.

37. "Story-telling": see James M. Dennis, *Grant Wood* (Columbia, Mo., 1986), p. 68. Dennis suggested (ibid., p. 10) a connection between the Neue Sachlichkeit artists' returning to their cultural roots and a similar tendency among those Regionalists whose families had come to the United States from northern Europe and gradually migrated west. Arriving in the United States from Germany, the Albright family (originally named Albrecht) settled first in Pennsylvania, then Missouri, Wisconsin, and finally Illinois. See also Brady M. Roberts, "The European Roots of Regionalism: Grant Wood's Stylistic Synthesis," in Davenport, Iowa, Davenport Museum of Art, *Grant Wood: An American Master Revealed*, exh. cat. by Brady M. Roberts et al. (1995), pp. 19–40; and Minneapolis Institute of Arts, *Grant Wood: The Regionalist Vision*, exh. cat. by Wanda M. Corn (1983), pp. 28–33 and 70. Albright mentioned in a letter, postmarked Apr. 30, 1935, to a girlfriend, Marie Engstrand, that "Grant Wood was in town the other day. He's making plenty of jack and is getting paid 250 apiece for lecture[s] on 'himself'"; see note 53.

38. George J. Mavigliano and Richard A. Lawson, *The Federal Art Project in Illinois, 1935–1943* (Carbondale, Ill., 1990), p. 4.

39. Michael Croydon, *Ivan Albright* (New York, 1978), pp. 88, 97, 98, and 100. The Illinois Art Project (IAP; 1935–43) of the Works Progress (later Projects) Administration's Federal Art Project (WPA/FAP), the largest of the programs, supported the creation of easel paintings, murals, prints, and a variety of other visual art for public sites. Increase Robinson directed the Illinois program from 1935 to 1938; for Robinson, see Mavigliano and Lawson (note 38), pp. 14–45.
Tales of conflict between Albright and Robinson were legion. According to Josimovich, "the story went round the project that [Robinson] rejected Ivan Albright's canvas of a football game as not being American Scene"; see Mavigliano and Lawson (note 38), p. 4. It is hard to imagine Albright having painted a football game (no such work has been located), but perhaps Robinson did reject something by the artist, motivating him to conform more closely to the guidelines. Francis Chapin related another incident: "[Ivan and Malvin] have collectively and singly told Increase to go to hell and she didn't like it. She ordered a 'light, large, cheerful' painting from Ivan so it could be hung in a hallway of a public school: he painted a small one mostly black (a red chair against the wall of a studio and a nude in it, but finally he draped it partly)"; see letter from Francis Chapin to David and Anne McCosh, May 26, 1936, Francis Chapin Papers (note 9).

40. The nude figure seen through the second-story

window in Albright's *In the Year 1840* would not have been acceptable to Increase Robinson. "Then there is that group . . .": Ivan Albright, "Chicago's Foremost Painter Takes Issue with Art Critic," *Chicago Daily News*, Dec. 13, 1939, Christmas book sec., p. 17.

41. On the Harnett exhibition and its relation to the revival of interest in still life, see New Brunswick (note 35), p. 137.

42. Kuh (note 26), p. 24.

43. Another contemporary artist whose work relates to Albright's is the Californian Frank Califano, whose oeuvre has yet to be studied. He produced trompe-l'oeil still lifes and bizarre character studies with peculiar descriptive titles. His 1925 painting *Evening Usualty* (location unknown), a half-length image of a woman knitting, is close in feeling to the females Albright portrayed in *Flesh (Smaller Than Tears Are the Little Blue Flowers)* (no. 12) and *Woman* (no. 13). *Evening Usualty* was reproduced by John I. H. Baur in his 1951 book on American art and described as follows: "The texture, the blemishes, the folds and wrinkles of the woman's skin are painted with such exaggerated relish that she becomes as grotesque as one's face seen in a magnifying mirror"; see Baur (note 1), pp. 100 and 101, fig. 157.

44. Matthew Baigell, *Thomas Hart Benton* (New York, 1974), p. 152; cited in Erika Doss, *Benton, Pollock, and the Politics of Modernism: From Regionalism to Abstract Expressionism* (Chicago, 1991), p. 258.

45. New York (note 35). While the comparison of Albright to Wyeth might seem odd, it is interesting to consider that this Pennsylvania artist has always made images of ordinary people that suggest a story and that often stress their eccentricities; moreover, the surfaces of both artists' paintings are embellished with obsessive detail. Another artist whose magic-realist technique and interest in allegory relate his work of this period to Albright's is Pavel Tchelitchew, whose work Albright admired. Also of interest in connection with Albright is the Boston-based artist Jack Levine, whose preoccupation with humanity's greedy and immoral sides is seen in the grotesque characters that people his compositions.

46. See Katharine Kuh, "No Single Fact Is as It Seems: Ivan Albright, Veteran Maverick, Makes His Own World," *Saturday Review* 50, 6 (Feb. 11, 1967), p. 24.

47. Kuh (note 26), p. 28.

48. Josephine Hancock Logan, *Sanity in Art* (Chicago, 1937), p. 10; cited in Sue Ann Prince, "'Of the Which and the Why of Daub and Smear': Chicago Critics Take on Modernism," in Prince (note 15), p. 112 (see also pp. 113–16). This reactionary group quickly formed chapters in a number of other American cities.

49. In 1934 Albright exhibited with the No-Jury Society as well. The Neo-Arlimusc group espoused the integration of the arts and sciences, its name a combination of the first letters of art, literature, music, and science. Weisenborn's enduring commitment to Cubist-derived abstraction was a rarity in Chicago, where brief flirtations with avant-garde styles were more typical. On his leadership roles with various progressive artists' organizations in the city, see Paul Kruty, "Declarations of Independents: Chicago's Alternative Art Groups of the 1920s," in Prince (note 15), pp. 79, 80, and 88–93.

50. See for example Marguerite B. Williams, "Here and There in the Art World," *Chicago Daily News*, Aug. 29, 1928, p. 15; and "Albright, an 'Old Master' from Illinois," *Art Digest* 5, 1 (Oct. 1, 1930), pp. 5 and 6. For the conservative nature of the All-Illinois Society of Fine Arts, see Sparks (note 11), vol. 1, p. 198; and vol. 2, p. 692.

51. Cummings (note 4), pp. 16 and 17. Subsequently,

Albright recollected that the still life "wasn't a very good painting, but the idea was good"; see idem, "Ivan Albright," *Artists in Their Own Words* (New York, 1979), p. 52. Years later he would return to the bird's-eye view not only in *Wherefore Now Ariseth* (no. 21), but also in *Beneath My Feet* (no. 18) and would again use the floor to paint his eight-foot-high canvas, *The Door* (no. 24).

52. "Albright, an 'Old Master'" (note 50). On the controversy in Toledo, see "Did Its Beauty Cause Toledo to Ban This?," *Art Digest* 3, 20 (Sept. 1929), p. 5.

53. Albright became actively involved in only one organization, the Chicago Society of Artists, serving as its president in 1934 and as its vice-president in 1935. The group, established in 1887 and still active today, was a fairly venerable institution by the 1920s. Its longevity may be explained by the fact that its roster included conservatives such as Charles Dahlgreen and Rudolph Ingerle and progressives such as Julio de Diego and Harvey Gregory Prusheck, which might also explain Albright's willingness to become involved in it. Letters from Albright to Marie Engstrand, a romantic interest of his during these years, document Albright's efforts to organize the group's annual ball—the society's chief fundraising event—during his tenure as president. They were kindly made available to Courtney Graham Donnell by Engstrand's daughter, Kristine B. McGuire. For the Chicago Society of Artists, see Louise Dunn Yochim, *Role and Impact: The Chicago Society of Artists* (Chicago, 1979).

54. Kuh (note 26), p. 25. When he felt slighted or attacked, however, Albright could join forces with other artists in protest. The influential art critic for the *Chicago Daily News*, C. J. Bulliet, wrote a column in 1935 in which he suggested that certain artists, including Albright, Aaron Bohrod, Constantine Pougialis, and William S. Schwartz, had become "pets" of the Art Institute. In response, they cosigned a strong rebuttal, "Letter to the Editor, November 26, 1935," which appeared in the paper on Dec. 14, 1935 (sec. 3, p. 4). This ensured Bulliet's wrath. Between 1935 and 1939, he published a series of articles, "Artists of Chicago, Past and Present," comprising a minihistory of Chicago art going back to the nineteenth century, from which these artists are conspicuously absent. For more on Bulliet, see Sue Ann Kendall (Prince), "Clarence J. Bulliet: Chicago's Lonely Champion of Modernism," *Archives of American Art Journal* 26, 2–3 (1986), pp. 21–32; idem, (note 48), pp. 95–117; and Rockford, Illinois, Rockford College Art Gallery, *The "New Woman" in Chicago, 1910–1945*, exh. cat. by Susan Weininger (1993), n. pag.

55. In the late 1940s, Malvin seems to have decided to paint Maine scenes almost exclusively. By 1965 he stopped exhibiting publicly.

56. Susan Weininger, "Gertrude Abercrombie," in Springfield, Illinois State Museum, *Gertrude Abercrombie*, exh. cat. by Susan Weininger and Kent Smith (1991), pp. 13 and 14. By contrast, the artist Tunis Ponsen sold his entire stock one day for $250; see Susan Weininger, "Tunis Ponsen," in Muskegon, Michigan, Museum of Art, *The Lost Paintings of Tunis Ponsen*, exh. cat. by William H. Gerdts et al. (1994), p. 27. According to Dulac (note 35), p. 34, Albright placed a value of $11,000.59 on *Ida*.

57. Christopher Lyon, "'Synthetic Realism': Albright, Golub, Paschke," *Art Journal* 45, 4 (Winter 1985), p. 330.

58. Donald Kuspit, "The Madness of Chicago Art," *New Art Examiner* 13, 9 (May, 1986), pp. 22–26.

59. Springfield, Illinois State Museum, *Julia Thecla*, exh. cat. by Maureen McKenna (1984–85), pp. 2 and 3.

60. In various conversations, Abercrombie let it be known that she had been romantically involved with Ivan Albright. Whether or not this was true, in the early 1930s, Ivan did do a lithograph depicting her in the nude; see Lake Forest, Ill., Lake Forest College,

Graven Image: The Prints of Ivan Albright 1931–1977, exh. cat. comp. and ed. by Gael Grayson, intro. Michael Croydon (1978), fig. 4a.

61. Schwartz's figurative work includes nudes, character studies, portraits, and images of small town life and urban industrial scenes. Concurrently, he experimented with pure abstraction in a series he called *Symphonic Forms*, produced between 1924 and 1967. For Schwartz, see Manuel Chapman, *William S. Schwartz: A Study* (Chicago, 1930); and New York, Hirschl & Adler Galleries, Inc., *The Paintings, Drawings, and Lithographs of William S. Schwartz (1896–1977)*, exh. cat. by Douglas Dreishpoon (1984).

62. *I Am the Grass Let Me Work* is in the collection of the Sheldon Memorial Art Gallery; see Norman A. Geske and Karen O. Janovy, eds., *The American Painting Collection of the Sheldon Memorial Art Gallery* (Lincoln, Neb., 1988), p. 337.

63. Chicago, Fairweather Hardin Gallery, *Francis Chapin*, exh. cat. by Franz Schulze, with statement by Ivan Albright (1973), p. 38.

64. Michael Croydon, "Rediscovering Francis Chapin," unpub. ms. (1992), p. 5. I wish to thank the Francis Chapin Collection and Connie Bowen for making this available to me.

65. Cummings (note 4), p. 50.

66. On Aaron Bohrod, see Gerald Nordland, "Aaron Bohrod," in Milwaukee Art Museum, *Leaders in Wisconsin Art, 1936–1981: John Steuart Curry, Aaron Bohrod, John Wilde*, exh. cat. (1982), pp. 25–41; and Aaron Bohrod, *A Decade of Still Life* (Madison, Wis., 1966). On Emerson Burkhart, see Columbus, Ohio, Columbus Gallery of Fine Arts, *Paintings by Emerson Burkhart, 1905–1969*, exh. cat. (1971); and Parkersburg, West Virginia, Parkersburg Art Center, *Emerson Burkhart, The Early Work*, exh. cat. (1986).

67. Franz Schulze, *Fantastic Images: Chicago Art Since 1945* (Chicago, 1972), p. 5.

68. Chicago and New York (note 22), pp. 7–9.

69. Albright exhibited his setup for *The Door* in 1968 in "Doors," an exhibition held at Cordier & Ekstrom, Inc., New York. In the Art Institute's collection are props Albright used for *The Door* (no. 24), *Poor Room* (no. 40), *Portrait of Mary Block* (no. 51), *The Vermonter* (nos. 59 and 60), and *Pray for These Little Ones (Perforce They Live Together)* (no. 67).

70. J. Z. Jacobson, ed. *Art of Today: Chicago, 1933* (Chicago, [c. 1932]), p. 35.

COZZOLINO ENTRIES

No. 1

1. Michael Croydon, *Ivan Albright* (New York, 1978), p. 28.

2. Sterling North, "The Man Who Drew Wounds: Portrait of a Painter," *Chicago Daily News*, Aug. 5, 1931, p. 12.

No. 2

1. The Art Institute of Chicago and New York, Whitney Museum of American Art, *Ivan Albright: A Retrospective Exhibition*, exh. cat. (1964–65), p. 17.

No. 3

1. The Art Institute of Chicago, Ryerson and Burnham Libraries, Ivan Albright Archive, Notebook 4, p. 33 (1924).

2. Ivan Albright Archive, Notebook 1, pp. 50 and 51 (Jan. 27, 1923).

No. 5

1. Ivan Albright Archive, Notebook 2, pp. 2 and 3 (1924).

No. 6

1. Ivan Albright Archive, Notebook 3, p. 4 (1924).

2. Ivan Albright Archive, Notebook 6, p. 4 (1925).

No. 7

1. New York, The Museum of Modern Art, *American Realists and Magic Realists*, exh. cat. ed. by Dorothy C. Miller and Alfred H. Barr, Jr., intro. Lincoln Kirstein (1943–44), p. 25.

No. 9

1. Ivan Albright, interview with Paul Cummings, Feb. 5–6, 1972, Oral History Collection, Archives of American Art, Smithsonian Institution, Washington, D.C., p. 37.

No. 10

1. "Some Interesting Comment on Our May Issue Cover Design," *Electric Light and Power* 6, 6 (June 1928), p. 115.

2. "A Storm," *Art Digest* 5, 1 (July 1928), p. 1.

No. 11

1. Ivan Albright Archive, Notebook 4, p. 72 (early 1927).

2. There are two known instances of Albright's models posing for the camera as they appear in a finished painting. One is the woman in *Memories of the Past*; the other is the man in *I Drew a Picture in the Sand and the Water Washed It Away (The Theosophist)* (1927; The Art Institute of Chicago), whom the artist identified only as Mr. Pattison, a traveling salesman and theosophist; see New York (no. 7, note 1). Both paintings were executed in the Balboa Park section of San Diego, California; and both photographs are in the Ivan Albright Archive.

No. 13

1. Ivan Albright Archive, Notebook 4, pp. 75 and 76 (June 1927).

2. Cummings (no. 9, note 1), p. 74.

3. Croydon (no. 1, note 1), p. 43.

No. 14

1. Croydon (no. 1, note 1), p. 45.

2. Ivan Albright Archive, Notebook 6, p. 30 (1930).

3. Michael Croydon, "Introduction," in Lake Forest, Ill., Lake Forest College, *Graven Image: The Prints of Ivan Albright 1931–1977*, exh. cat. comp. and ed. by Gael Grayson (1978), n. pag.

4. Ivan Albright Archive, random notes (undated).

No. 15

1. C. H. Bonte, "In Gallery and Studio," *Philadelphia Inquirer*, 1930; see Ivan Albright Archive, Scrapbook, vol. 1, n. pag.

2. Ivan Albright Archive, Notebook 7, p. 25 (Jan. 1929).

No. 16

1. Ivan Albright Archive, Notebook 7, p. 24 (Jan. 1929).

2. Cummings (no. 9, note 1), p. 74.

No. 17

1. Cummings (no. 9, note 1), p. 37.

No. 18

1. Letter from Ivan Albright to William Benton, Jan. 8, 1965, William Benton Papers, c. 1940–83, Archives of American Art, Smithsonian Institution, Washington, D.C.

2. Ivan Albright Archive, Notebook 3, pp. 7 and 62–64 (1924). See also Notebook 2, pp. 16–26 (1923).

3. Croydon (no. 1, note 1), p. 81.

4. The most extensive mapping out of a landscape by Albright in preparation for a painting can be found in the Ivan Albright Archive, Notebook 24, pp. 27–36 (Nov. 25, 1964), for *To Tread between Sky and Field*

(1964; Marjorie and Charles Benton Collection). Some eight years after completing this work, Albright still considered this composition significant enough to refer to it during his interview with Paul Cummings to illustrate his theories about movement; see Cummings (no. 9, note 1), pp. 18, 19, 72, 79, and 80. He also made maps and wrote extensive notes for *Knees of Cypress (Georgia Swamp)* (1965; Marjorie and Charles Benton Collection); see Ivan Albright Archive, Notebooks 24, pp. 1–20 (Mar. 1965), and 27, pp. 46–54 (1965). In his charts, he noted the precise times during the day in which he worked on specific elements in this painting. That he treated landscape much as he did his setups can be seen in a diagram for *The Cliffs Revolve—But Slowly* (1965; Collection of Philip J. and Suzanne Schiller), in Notebook 26, pp. 34–39 (Aug. 1965).

No. 20
1. William Inge, "Illinois Artist's Work Placed on Exhibit Here," *St. Louis Star Times*, Oct. 1943; see Ivan Albright Archive, Scrapbook, vol. 1, n. pag.
2. Cummings (no. 9, note 1), p. 32.
3. Constantine Pougialis, "Back to Normalcy is Keynote of Local Art Exhibit," *The Greek Star*, Feb. 19, 1932; see Ivan Albright Archive, Scrapbook, vol. 1, n. pag. It is important to remember that Albright was serving liquor to his model at a time when the United States was still in the throes of Prohibition.

No. 23
1. Cummings (no. 9, note 1), p. 38.
2. Ivan Albright Archive, Notebook 23, p. 4 (Apr. 25, 1963).

No. 24
1. Walter E. Baum, "Art Show Is Gay, but Gloomy Subject Wins Crown," *Philadelphia Bulletin*, Jan. 24, 1942; see Ivan Albright Scrapbook, vol. 1, n. pag.; cited in Croydon (no. 1, note 1), pp. 88 and 302, note 43.

No. 30
1. Cummings (no. 9, note 1), p. 42.

No. 33
1. Ivan Albright Archive, Notebook 14, p. 6 (Aug. 1940).

No. 34
1. Alice Frost Lord, "New Harbor, Corea, Cundy's Harbor and Deer Isle Intrigue Hollywood Artist," *Lewiston Journal*, Nov. 25, 1944, Magazine sec., p. 3.

No. 35
1. The first work by Albright to enter the Art Institute was a lithograph (no. 37), which came as a gift in 1940. *Ah, God Herrings* was the first work the Art Institute purchased. In 1959 it was returned to the artist in partial payment for *The Door* (no. 24), which the museum had acquired, but not completely paid for, in 1955. In 1977 *Ah God, Herrings* re-entered the collection as part of the large group of Albright's work he presented the museum on the occasion of his eightieth birthday.
2. Cummings (no. 9, note 1), p. 26.

No. 36
1. Croydon (no. 1, note 1), p. 103. Maroger was the author of a much-consulted book, *The Secret Formulas and Techniques of the Masters*, trans. by Eleanor Beckham (New York, 1940).
2. Marilyn Robb, "Ivan Le Lorraine Albright Paints a Picture," *Art News* 49, 4 (June/July/Aug. 1950), p. 45.
3. Croydon (note 1).

No. 38
1. Lake Forest (no. 14, note 3), fig. 18.

No. 40
1. Ivan Albright Archive, Notebook 21, p. 10 (c. Jan. 1953).

2. Chicago and New York (no. 2, note 1), p. 7.
3. Ibid., pp. 7 and 8.

No. 41
1. Oscar Wilde, *The Picture of Dorian Gray*, in *The Portable Oscar Wilde*, selected and ed. by Richard Aldington (New York, 1946), p. 168.

No. 46
1. Cummings (no. 9, note 1), pp. 77 and 78.

No. 49
1. According to Michael Croydon (no. 1, note 1), p. 128, the Albrights traveled to Greece in the summer of 1951. However, two travel sketches in the Ivan Albright Archive, Notebook 20, pp. 14 and 17, bear the date 1952. This notebook is dedicated to sketches of Crete. Although there are no dates inscribed in Notebook 10, it too contains similar sketches, and its front cover bears a handwritten list of archeological sites and their pronunciations in phonetic English.

No. 50
1. Cummings (no. 9, note 1), p. 42.
2. Ibid., p. 43.

No. 51
1. Cummings (no. 9, note 1), p. 48.
2. Ibid., p. 49.
3. Katharine Kuh, "Ivan Albright," *The Artist's Voice: Talks with Seventeen Artists* (New York, 1960), p. 28.
4. Cummings (no. 9, note 1), p. 49.
5. Ibid.

No. 52
1. Croydon (no. 1, note 1), p. 261.

No. 53
1. Josephine Albright, interview with Courtney Graham Donnell, Oct. 26, 1990.

No. 57
1. Ivan Albright Archive, Notebook 23, pp. 12–17 (Apr. 25–May 12, 1963).

No. 59
1. Ivan Albright Archive, Notebook 30, p. 12 (c. 1968).
2. Katharine Kuh, "Ivan Albright," *The Open Eye: In Pursuit of Art* (New York et al., 1971), p. 9.
3. Ivan Albright Archive (note 1).

No. 60
1. Ivan Albright Archive, Notebooks 25, 27, 29, 30–35, 37, and 39.
2. Ivan Albright Archive, Notebook 25, pp. 23 and 24 (Mar. 7, 1966).
3. Ivan Albright Archive, Notebook 29, p. 49 (Fall 1972).
4. Ivan Albright Archive, Notebook 5, p. 64 (1926).

No. 62
1. Albright's sense of the chronology of his work was not unerring. For example, in his 1972 interview with Paul Cummings (no. 9, note 1), he could be extremely precise about historical facts, anecdotes, early memories, and family history, but his dating of works and estimate of the number of sculptures and prints he had made by this time were totally inaccurate. Albright inscribed *A Face from Georgia* with the date 1974, although Notebook 33 in the Ivan Albright Archive, pp. 1 and 2 (1969), indicates that he was working on it then. In Notebook 37, p. 1 (Mar. 13, 1973), he wrote about basing a print, entitled *The Groover Etching*, on what we can assume was the finished painting.
2. Ivan Albright Archive, Notebook 37 (note 1).

No. 63
1. Ivan Albright Archive, Notebook 26, p. 4 (Mar. 16, 1966).

Nos. 66a and 66b
1. Ivan Albright Archive, Notebook 12, pp. 6–9 (Sept. 8, 1937). This was not the first time Albright experimented with afterimages to obtain desired color effects. The artist described an afterimage process in Notebook 7, pp. 45 and 46 (1930). However, he did not call the resulting colors "afterimages" until 1937.
2. Ivan Albright Archive, Notebook 17, p. 9 (1945).
3. Cummings (no. 9, note 1), p. 84.
4. Letter from Albright to William Benton, Apr. 4, 1972 (no. 18, note 1).

No. 67
1. In his notebooks, Albright mentioned at least five works on silk, in addition to no. 67. Among these is *I Sleep, I Sleep, and in My Sleep I Dream and in My Dream I Am Awake* (1973; private collection).
2. Ivan Albright Archive, Notebook 23, p. 43 (1973).
3. Ivan Albright Archive, Notebook 38, pp. 1 and 2 (Mar. 9, 1974).
4. Ivan Albright Archive, Notebook 29, p. 67 (1973).

No. 68
1. As early as 1966 (Ivan Albright Archive, Notebook 25, pp. 18 [Jan. 2, 1966] and 20 [Jan. 1966]), Albright expressed interest in the legendary Shroud of Turin. He pursued his interest in the subject after a trip to Israel in 1967, planning at least three works on the theme, only one of which he seems to have realized, the etching *Head of Christ* (1981); see Hanover, New Hampshire, Dartmouth College, Hood Museum of Art, *Ivan Albright: The Late Self-Portraits*, exh. cat. with essays by Richard R. Brettell and Phylis Floyd (1986), p. 62, pl. 25.
2. The lithograph was printed in an edition of one hundred, to accompany a deluxe edition of the same number of Michael Croydon's biography, *Ivan Albright* (no. 1, note 1).

No. 69
1. Ivan Albright Archive, Notebook 44, pp. 47 and 48 (Oct. 28, 1979).

Nos. 70a and 70b
1. See, for instance, Ivan Albright Archive, Notebooks 43, pp. 4–8 (Jan. 28, 1978); 42, p. 11 (May 11, 1978); 44, p. 48 (Oct. 28, 1979); and 39, pp. 56–58 (Apr. 14, 1981).
2. Ivan Albright Archive, Notebook 3, p. 30 (c. 1924).

Nos. 71–88
1. Richard R. Brettell, "Ivan Albright: The Self-Portraits," in Hanover (no. 68, note 1), p. 6.
2. Hanover (note 1), p. 54.
3. Ibid., p. 14.
4. Ibid.
5. Ibid., p. 13.
6. Ivan Albright Archive, Notebook 39, pp. 59–61 (Apr. 15, 1981).
7. Ivan Albright Archive, Notebook 36, p. 44 (Aug. 18, 1981).
8. Ivan Albright Archive, Notebook 27, p. 33 (Feb. 28, 1982).
9. Ivan Albright Archive (note 7), p. 21 (c. Jan. 1982).
10. Ibid.

Nos. 89–91
1. Reginald Gibbons, "Ivan Albright: Self-Portraits, 1981–83," in The Art Institute of Chicago, *Transforming Vision: Writers on Art*, ed. by Edward Hirsch (1994), p. 76. All subsequent quotes in this entry are from Gibbons's essay, which is on pp. 76 and 78.

No. 93
1. Hanover (no. 68, note 1), p. 15.